10 Gilbert Place
London WC1A 2JD

THE LONDON
ART SCHOOLS

REFORMING THE ART WORLD,
1960 TO NOW

THE LONDON ART SCHOOLS: REFORMING THE ART WORLD, 1960 TO NOW

Edited by Nigel Llewellyn
with Beth Williamson

and further contributions from
Elena Crippa, Lucy Howarth,
Alexander Massouras and
Hester R. Westley

Tate Publishing

First published 2015 by order of the Tate
Trustees by Tate Publishing, a division of Tate
Enterprises Ltd, Millbank, London SW1P 4RG
www.tate.org.uk/publishing

A catalogue record for this book is available
from the British Library

ISBN 978 1 84976 296 0

Distributed in the United States and Canada
by ABRAMS, New York

Designed by ARPA
Colour reproduction by DL Imaging Ltd, London
Printed and bound in Barcelona by Grafos

Front cover: Details of 'Tuesday Evening
Projects', St Martin's School of Art, 1966 (see
fig.9.8, p.144)

*Editorial note: 'Central' and 'St Martin's' have
been used to refer to these schools prior to
their merger and 'Central Saint Martins' to
the institution after the merger and to their
joint archive.*

CONTENTS

FOREWORD

The subject of these essays is curriculum change in the London art schools in the period after the Second World War, especially the 1960s and 1970s. The topic reflects the importance Tate attaches to understanding how the artists represented in the Collection are influenced by the teaching and practice that they experience at art school.

'Art School Educated' is one of the first major research projects led directly by Tate, rather than in partnership with colleagues from the university sector. The project was supervised by the Tate Research Department between 2009 and 2014 and the team included members of Tate staff working with post-doctoral research associates, two doctoral students and support staff. It was led by Nigel Llewellyn and generously funded by The Leverhulme Trust.

The nature and purpose of art school education is again being actively debated in an age of student fees, an increasing emphasis on vocational training and the growing internationalisation of the art world. In 2008 we had noted the extraordinary levels of interest in the little-studied histories of the London art schools when we hosted an evening lecture to mark the centenary of the birth of Sir William Coldstream, an influential teacher and administrator whose Report established a new framework for art school education in 1960. In submitting our grant application to The Leverhulme Trust we had argued that an independent research organisation such as Tate would be well placed to take a more objective view of a subject that is still actively disputed amongst the original participants.

The research team discovered a large quantity of unpublished and unresearched material, much of it still in the possession of those students and tutors involved in teaching and learning a generation ago, or of their immediate descendants.

The outcomes of the project team's work include not only the essays published here but two innovative doctoral theses and the collection of a mass of archival and recorded material, which is being made available to researchers online and in the Tate archive. A number of scholarly publications have been completed – books and journal articles – and a collection display on the theme of 'Basic Design', was shown at Tate Britain and then, fittingly, at the Hatton Gallery in the University of Newcastle, where it was shown with support from the John Ellerman Foundation and Tyne & Wear Archives & Museums.

The project has confirmed that Tate can make a major contribution in safeguarding these kinds of materials for future scholars and is well placed to do this work, especially given the fact that the art schools themselves have been through an unprecedented sequence of mergers and re-organisations over the past twenty years.

I would like to thank Nigel Llewellyn and the project team for their diligence and insight in illuminating this important aspect of recent art history and for a collection of essays that allows for reflection on the contested topic of teaching and learning in the visual arts, and on the role of art schools, now often placed within universities, in shaping the practices and careers of artists.

– Nicholas Serota

1

INTRODUCTION: HISTORIES AND CONTEXTS

SETTING THE SCENE

Anecdotes recounted in two recent artists' obituaries, for the painters Alan Reynolds (1926–2014) and Frederick Gore (1913–2009), conveniently expose a number of issues that lie at the heart of this book. Even though we are discussing the lives of the art schools, we need to remember that there are also endings. In the later 1950s, Reynolds was a teacher at what was then the Central School of Arts and Crafts when, in his painting practice, he rejected neo-Romantic figuration in favour of an austere Nicolsonian abstraction.[1]

This dramatic change of heart was made despite the success of paintings such as *Summer* 1954 that had been acquired by Tate a few years earlier.[2]

↓ Fig.1.1 Alan Reynolds, *Summer: Young September's Cornfield* 1954, Tate

Reynolds never again painted in his early manner; his conversion was final. Our consideration of art teaching will take place against the backdrop of art production, and Reynolds's experience illustrates the stylistic diversity of post-war art in London and the battles waged over abstraction and figuration. In 1961, he moved his teaching to St Martin's School of Art where Gore – a figure from an earlier generation – was, from 1951 to 1979, Head of Painting. In a *Guardian* obituary, art critic Tim Hilton quotes Gore as taking the view that the 'pedantic side of art school is an appalling thing'. One of the many challenges of studying the recent history of art education is to learn what weight to place on casual remarks, and Gore's utterance may simply have been badly reported or loose talk around the distinction between pedantry and pedagogy. Nevertheless, for a senior teacher in an institution calling itself a 'school' even to appear to be dismissive of pedagogic concerns is puzzling.

The material that we have collected in this book is intended to throw some light on puzzles like this and to reveal some of the basic facts of life in the post-war London art schools: for example, that processes of teaching and learning were undertaken in the face of fierce disputes about figuration, abstraction and, in due course, conceptual art; that there were artist-tutors who were prepared to throw over long-established ways of working and adopt new sets of

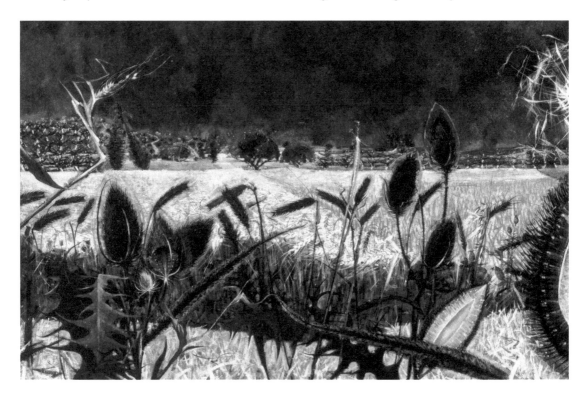

artistic aims while remaining faithful to long-standing but usually untheorised and often unarticulated systems of teaching; that there were arguments about the very place of pedagogy in the art schools; that lengthy terms of part-time teaching service were put in by artists, who claimed not to be teachers and who challenged the very legitimacy of their role, whether it be instructor, mentor, exemplar, agitator or demonstrator. Indeed, the list of roles adopted by the art school artist-tutors is a lengthy one. That these teachers were invariably men is another incontestable historical fact that, so far, has not been sufficiently taken into account. In the midst of these trying and often tempestuous circumstances the art schools adopted new curricula both in response to contextual circumstances but also more whimsically, in response to influential individuals. The published curriculum took the form of a programme of pedagogic activity leading to the awarding of a qualification, made up of the courses and topics listed on the syllabus – not always actually delivered, it seems – and it is the changing objectives of the London art school curriculum that is the main subject of this collection of essays. And, in looking to explain events in London, we have often had to turn our attention to art schools outside the capital.

THE STATE OF THE FIELD AND OUR APPROACH

The published literature on twentieth-century tertiary level art education and on the history of the London art schools in particular is scant and is dominated by four broad categories of material. There are a few institutional histories, Lisa Tickner's book on Hornsey being a distinguished example; there are some artist biographies, autobiographies and memoirs which mention their art school days; thirdly, there are pure pedagogical studies, though these are very few in number; finally, there are more generalised art-historical accounts of '-isms' and styles, some of which reference the art schools. These secondary sources, juxtaposed with the available primary material – the gathering of which for this

topic is still in its infancy – show that the biographical method tends to dominate. The lives of the art schools tend to be told through the lives of the students and the teachers. The assumed primacy of biography is a condition struggled against by art history over many years but it appears to retain a controlling hand on the art school literature.

Much of the source material considered here has been gathered using oral history techniques but how useful is this as a working method for the historian of art schools?[3] Our research team made a good deal of use of oral testimony, trying wherever possible to test claims made by individuals against documentary evidence. Oral testimony and other kinds of personal recollection look like an extremely attractive source for the historian but their use undoubtedly needs to be tempered by other documentary and archival methods. Take, for example, this evocative image of the post-war London art student conjured up in a recent reminiscence:

> [He was] a slightly restrained bohemian art student, very French looking … one of the returning ex-service personnel who formed the majority of our painting group at Chelsea School of Art, from 1946 on. He lived in a bed-sit, over a shop on the King's Road … another member of the small, enclosed art school world above the polytechnic in Manresa Road, headed by Harold Williamson, with associates such as Ceri Richards, Robert Medley and Henry Moore.[4]

In the absence of other evidence, it is easy for the historian to privilege such individual recollections, despite the risk that they are distorted by time, prejudice or an understandable wish for history to be neatly tidied up. Such errors of judgement are a risk for any kind of contemporary history – but are there distinct differences between artists' memories or views captured on tape and analysed by the art historian, and any other kinds of source material? Of course, the artist interview is probably the dominant genre within contemporary art criticism and there have been claims made that the founders of

modern art history did their research through interviews.[5] On the basis of carefully worded and ordered questions, such interviews generate text for magazines or catalogues that gives the artist the sense that theirs is the dominant voice and allows the critic to appear both analytical and sympathetic. Our project has shown that the art historian needs to use material gathered by these means with careful judgement and not in isolation.

HISTORICAL EVENTS

There are at least two foundational historical contexts for British twentieth-century art schools. First, there is the complex pattern of closures, re-namings and mergers that over time have resulted in the marked enlargement of the academic institutions that adopted and delivered the fine art curricula. Second, there is the changing pattern of degree and qualification structures across the national system, of which the London art schools formed a part.

1950s–early 1960s, LOCAL AUTHORITY ERA
 Local certificates

1965–1992, POLYTECHNIC ERA
 Council for National Academic Awards

Post 1992, UNIVERSITY ERA
 H and FE Act Degree awarding powers

A map of the UK art schools in the immediate post-war period (we can refer to this as the Local Authority Era) would show a very large number of mostly small institutions located in very many towns and cities across the UK.[6] These schools awarded certificates (not many of them awarded their own degrees) and were run by local boards or education authorities; many of them had their origins in mechanics institutes and similar organisations. They offered a mix of fine art, technical and craft skills teaching. Important exceptions amongst the major London schools are the Slade School, a part of University College London since the nineteenth century, and the Royal College of Art (hereafter RCA), which

had its origins in the Government School of Design (1837) and was eventually granted independence in the form of a university charter in 1967. During the Local Authority Era, UK art schools tended to recruit their students locally, in contrast with the university sector, from which they were almost completely independent. In the immediate post-war period, the university sector had remained small in scale, but around the publication of the Robbins report in 1963 it was to experience a dramatic growth as a set of new universities was established: Sussex, Essex, UEA, Warwick, Lancaster, Kent and York.[7] There was then a second larger increase in the university sector in the 1990s.[8] For the art schools, still not part of the university system, this period of university expansion corresponds to the Polytechnic Era (1965–92) when many individual art schools were closed and when many others merged with other faculties to deliver programmes – eventually degree programmes – in new tertiary-level polytechnic institutions.[9]

From 1964, certification in the polytechnic sector was the responsibility of another Robbins recommendation, a new national body, the Council for National Academic Awards (CNAA). The polytechnics that took up numbers of the existing art schools and awarded CNAA degrees tended to be based in the larger metropolitan centres. For example, the Leeds College of Art, founded in 1846, became part of the city's polytechnic in 1970 and then, in due course, part of Leeds Metropolitan University (after the Higher Education Act of 1992). This pattern was repeated at Bristol where the Royal West of England Academy became part of Bristol Polytechnic and then of the University of the West of England. Teaching quality was assured and certification organised in the polytechnic system through the CNAA and in 1974 they launched their own honours degrees (not diplomas) at BA and MA level in fine art.

In parallel with this development, the so-called 'New Universities' established in the 1960s tended not to include art schools in their academic profiles. Where they did offer fine art programmes they were in art history and were not practice-based. Alongside

these changes in the New University sector, the Polytechnic Era in the art schools was also an age of reform; in particular, it was the age of the government-appointed committee chaired by the Director of the Slade School (1949–75) and Professor of Fine Art, Sir William Coldstream (1908–87), of whom much more will be written in later chapters, and of new kinds of certificated programmes. In particular, in 1960, a new model for art education was introduced in the art school sector, the Diploma courses in Art and Design (DipAD) which gradually replaced the NDD.[10] Coldstream's committee placed a limit on the numbers of applications to offer the DipAD that would be approved, specialism-by-specialism, but the London art schools were relatively successful in the national competition that ensued. A piece in the *Times Educational Supplement* of 10 May 1963 noted that DipAD programmes had by then been approved as follows:

Wimbledon:	Theatre
Camberwell:	Painting, Woven/Printed Textiles
St Martin's:	Graphics, Fashion
Goldsmiths:	Painting, Sculpture
Central:	Painting, Graphics, Industrial Furniture, Ceramics, Woven/Printed Textiles

What were the key curricula features of the DipAD? Alongside their studio work, all students working towards it took history of art and design and also complementary studies, those two elements together comprising 15% of the total learning load. Secondly, all DipAD programmes were labelled generically as qualifications in 'Fine Art'.[11] Thirdly, the competitive selection process for the DipAD allowed Coldstream's committee to impose some order on the unruly national provision in an attempt to turn the art schools into higher education institutions that were more academic in their outlook. Coldstream had promised institutional autonomy but, as shall see in several of the essays that follow, his committee's reforms led to increased centralisation and to the closure of almost two hundred art schools across Britain.

Discussions in the 1970s were acutely focused on distinctions between art schools, art academies, conservatoires and universities. Despite the efforts of Coldstream's committee, it was perhaps because the New Universities of the 1960s felt that what was being offered in the art schools (increasingly within the polytechnic sector) left valuable room for degree-level academic teaching about the visual arts that several of them – Sussex, UEA and the others – introduced honours degree programmes with names that now mislead. For example, in its earliest days at East Anglia,[12] the subject was taught in the School of Fine Art and Music (acronym FAM), but the model for UEA was the Courtauld Institute, not the Slade. The fine art degrees offered at UEA were art history degrees and there was no studio work or practical element in their assessment.

THREE CONTEXTS

The connections that can be made between the training or formation of an artist and the works of art that that artist produces is always elusive and often contrary. But this does not mean that there are not historical contexts for the study of art education and these need to be borne in mind when reading the chapters in this book. In particular, three such contexts strike us as important: the status of the artist, the place of art theory and the political and financial infrastructure within which art education is organised.

The status and character of the artist is an issue from which the history of art education cannot be separated. Art educators have always given thought to the artist's image, to their particular social place and cultural position, and this issue always develops in parallel with the history of art itself.[13] Behind every discussion about art teaching lies assumptions about the kind of artists that that teaching will produce. An influential contribution to the long discussion about the artist's image and function has recently been made by the French curator, Nicolas Bourriaud (b.1965), whose concept of relational aesthetics (or indeed relational art) assumes

that the contemporary artist should play a catalytic role in human relations, not operate in a removed, independent or private space. Bourriaud's ideas were formulated in response to the increasing heterogeneity of contemporary art practice in the early 1990s. Rather than seeking to reconstruct an imagined reality, Bourriaud sees the 'relational' work of art as seeking to create a social environment within which people can participate. Art's meanings are arrived at collectively not via a single, unique or privileged 'viewer-object' encounter.[14]

The second context – art theory – directly concerns the design of the curriculum and the pedagogic decisions that are taken about what knowledge and which skills artists should be taught and how that knowledge and those skills should be instructed and learned. The knowledge and skills that artists are taught amounts to the prevailing theory of art as it is understood at any particular moment, and it forms a powerful context for the decisions that are taken in art schools to adopt a particular pedagogy and to shape a particular curriculum.

The third context relates to structural and systemic questions beyond the boundaries of the art school itself. Into which particular section of the broader educational system should art education be placed? If government planning is working with a spectrum of academic to vocational, where should art be placed? What conclusions can be drawn about the standing and skills of the artist from an analysis of how the art schools are organised, governed and funded at a particular historical moment? The art school curriculum has too often been discussed only in self-referential terms, reflecting on its monotechnic culture. Better would be to give proper consideration to overall educational objectives in relation to the role and value of fine art or design and of creativity and other life skills. Until quite recently artist-teachers were famously averse to acquiring or even being seen to be acquiring pedagogic skills through formal training. This is a question that several chapters in this book seek to engage with.

We also need to consider the structural role that prevailing economic conditions have on attitudes towards art education and their

impact on funding, student access, capital investment, student numbers, among other factors. How should the history of the London art schools be told in relation to broader social and economic changes? A list of such changes might include the period of nationalisation and welfare provision at the end of the Second World War, the social 'revolutions'[15] of the 1950s and 1960s, the economic instability of the 1970s, the restructuring of the boundaries between public and private in the 1980s, the recessions and booms since then and the New Labour agendas of cultural diversity and increased student numbers. Present day art students, like all university students, are generally described as fee-paying customers and some would say that as a result of the imposition of this model the quality of public sector art education is in decline. Public tertiary level art education is certainly an environment under enormous pressure, which it expects to have to live with for many years to come.[16]

These three contexts – artistic status, art theory and the infrastructure – are not only important for themselves in relation to the history of the art schools but are deeply intertwined with one another. The changes in art school practice, towards or away from the teaching of theory or of particular theories, relate to the long drawn-out imposition of policies, which have affected the funding of the institutions themselves. These policy changes have had a dramatic impact on the various mechanisms for funding art schools within the higher education sector – processes such as the Research Assessment Exercise or the procedures that ensure the quality of teaching and learning, or the competition that happens when an art school engages with government funding bodies such as the research councils. All these processes, some of them mandatory and all of them necessary for survival, demand of art schools that they introduce systems of audit and manage their staff and resources to high professional standards. Whatever art school teachers may say or feel privately, these days there is no place for public dismissals of pedagogy as 'an appalling thing'. In relation to practice-based research, will the 2014 version of the

research assessment exercise (the Research Excellence Framework [REF], its outcomes just announced), a process which emphasises the impact of research on the public beneficiaries of the research outcomes, encourage artistic researchers to use more quantifiable methods, perhaps those developed by the social sciences rather than the humanities? Will the 'relational' trend, noted by Bourriaud and once so influential, come to be seen as leading directly to 'impact' as it is understood within the REF?

The research that we undertook for this book suggests that the changes that took place in the design and delivery of the London art school curriculum were less responses to comprehensive institutional policy and more the result of individual or local (within London and outside) and quite short-lived campaigns. With this in mind, we should note in passing that the word 'school' – as in 'art school' – is a problematic term within the discourse of the history of art. We are not seeking to show that art schools generically or individually sought to create 'schools' in the art-historiographic sense (for example, as the term is still sometimes used within conservative curatorial practice about post-Renaissance European art)[17] of a set of artists following one another by a process of emulation, through generations of teachers and pupils, often linked by region or city. The assumption that the 'school' was based on tutor-pupil relations helped build the early historical literature on art history from the sixteenth century onwards. Usually in the form of artists' lives, these biographical compendia – the Vasarian tradition – sought to explain the education and formation of artists as having a determining effect on their careers.[18] The lives of the post-war London art schools cannot be told in such neat patterns and continuities.

These three major contexts for the history of art education – the image of the artist, the role of art theory and questions of structural condition – each have histories which form the long background to the issues that are explored in this book. In particular, art theory has long been linked to art pedagogy. As with their successors in the post-war London art schools, the early modern European writers who set out the criteria against which painting could be judged acceptable – it is the defining of these criteria that is the core purpose of art theory – touched too on the means by which those criteria should be taught, as precepts or guiding principles. One example from the many that could be cited is the policy paper that Felix da Costa (1639–1712) wrote for the Portuguese Council of State in the 1690s, *The Antiquity of the Art of Painting*.[19] Da Costa's stance is both defensive and supplicatory: he knows that artists are not highly regarded and he wants to do what he can for them. He claims that painting is a noble practice that warrants the attention of the king because in its creativity it follows God's example, the practice of the visual artist being analogous to the creativity of God (the first Creator). This was an argument put in order to boost the social standing of artists, although in an orthodox religious culture such as late seventeenth-century Portugal there must have been dangers for artists who dared to liken themselves to God! In da Costa's view, a noble practice such as painting requires a noble pedagogy based on the 'liberal' arts, the exact definition and number of which was much disputed in da Costa's day. It is enough to note here that in the seventeenth century arts – we would call them academic disciplines or topics on a syllabus – were regarded as liberal (that is, free) precisely and only when they were not mechanical or manual. As da Costa puts it, 'the more the arts belong to intellect and understanding, the more decent and noble they are'.[20]

Another linked, early-modern belief was that foremost amongst all the visual arts were the three arts of design – painting, sculpture and architecture – which were in that period all grounded in the study of the idealised human form, made familiar to the student through drawing. A direct line can therefore be drawn between the high status of the early modern arts of design and, as we will see, Sir William Coldstream's emphasis on the Fine Arts as an overarching, intellectually respectable species of qualification for artists.

For art pedagogy that privileged the gaining of skills and understanding through

the practice of drawing, the physical space of an academy was required, and across early modern Europe most academies were run on the French model established in the mid seventeenth century by Charles Le Brun (1619–90) on behalf of his royal master Louis XIV. The portrait of Le Brun by Nicolas de Largillièrre (1656–1746) in the Louvre shows how the processes of art instruction could interrelate with questions of artistic status and princely patronage, which together with instruction in drawing were standard requirements for early modern European academies.[21]

↓ Fig.1.2 Nicolas de Largillière, *Charles Le Brun: Premier peintre du roi*, Musée du Louvre, Paris

On an enormous canvas about two metres square, Largillièrre portrays Le Brun, the Sun King's court artist, towards the end of a long life but presented as still at the height of

his powers. Le Brun points elegantly towards the visual records of his worldly success – an engraved version of his famous rendering of an episode from the ancient life of Alexander the Great and an oil sketch for one of the many ceiling paintings he undertook for the Galerie des Glaces at Versailles. These motifs, together with the dignity of Le Brun's apparel, the luxurious setting and his noble demeanour indicate the painter's high social status. We also see tokens of the academic training with which he was so closely associated and which was his European legacy: the plaster casts, the small and easily handled antique nude statuettes in the kinds of poses imitated by trained artists, and the leather-bound tomes indicating their learning.

Largillièrre's portrait epitomises the image of the educated artist as someone capable of painting history paintings (in Le Brun's day, the most demanding artistic level). This was the image of the trained painter that da Costa sought and which dominated public European discourse until well into the nineteenth century and even beyond: the painter as an intellectual whose manual skills are discreetly hidden, who has attained high social status, a professional whose education is based on carefully organised training (centred on drawing) and aimed at acquiring a correct formal vocabulary based on the close study of classical antiquity and of more recent interpreters of those idealised styles.

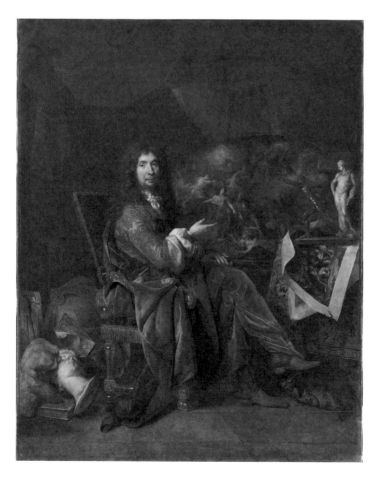

→ Fig.1.3 Unidentified artist (formerly attributed to William Hogarth), *A Life Class*, early nineteenth century, Royal Academy of Arts, London

The history painting that such artists undertook was the ancestor of the public intellectual engagement that resulted from the curriculum reforms in the art schools in the 1960s.[22]

These links between training, drawing, intellectualism and social acceptability were re-forged for a British public in Sir Joshua Reynolds's founding theories, which were expounded to the public at London's own Royal Academy in the second half of the eighteenth century. The product of an academy that teaches the arts of design through this kind of liberal curriculum is what da Costa called the 'complete Painter'. Such a being – probably mythical – has qualifications that would lift the heart of any contemporary art school admissions tutor: such a student needs 'a good power of understanding… a pliant mind … a noble heart … high spirits (without being exhausted) … good disposition and perfect health … [and] steadfastness in study'.[23] The artist's standing as a 'complete Painter' is attained through their exposure to an extremely challenging curriculum. In fact, da Costa claimed that the arts of design are harder to learn than are the core liberal arts, which at that time mostly involved word skills. Painting 'require[s] both a talent and a disposition capable of attaining consummate perfection in theory and in practice alike'.[24]

This balance of theory and practice is still an issue for the art schools. As this Introduction is being written, the findings of the 2014 REF are being announced and the results suggest that academic art practitioners are becoming ever more adept at presenting themselves as researchers.[25]

Da Costa's 300-year-old voice, from a relatively unexpected quarter, has a powerful echo in the current debates about how notions of 'research' can be applied to the activities of the art academies.[26] The Le Brunian academic system had principles that were rigorously drawn up, just as they were in the most famous twentieth-century academy, the Bauhaus, where artists gained skills both for their own sake and in the service of an idea.[27] The Bauhaus skills adapted by Harry Thubron and Tom Hudson and many others for post-war art students in the UK included the following topics: Areas and their Divisions; Planes; Complementary and Harmonic Shapes; Colour; Analytical Drawing; Modelling and Carving Mass; and Space Penetration and Division.[28] However, current art school staff report that the Bauhaus no longer has the residual influence that it once had.

MODERN AND ANCIENT: SIX POINTS OF AGREEMENT

Although there are obvious limits for an analogy between the development of the art school curriculum in later twentieth-century London and the polemical writings of early modern art theorists, it is clear that what happened in the London art schools – and what still is happening – is linked to causes and trends that have prevailed over long sweeps of history and that continue to be contested in the present era of research selectivity and practice-based doctorates. Despite important differences in scale, gender specificity, private and public patronage systems and the class and social formation of artist practitioners, and despite the confusing metamorphoses of the institutions concerned (mergers, name changes and so on) and the changes in patron-relations and market dealings between students, teachers, artists,

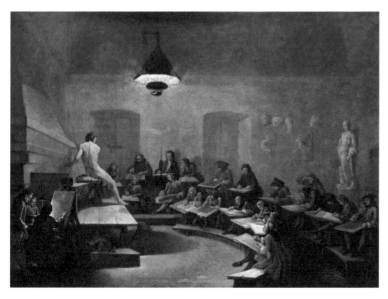

buyers and commissioners over the three or four hundred years that have elapsed, certain patterns continue to recur in the historical cycle of the developing art curriculum.[29] At least six points of connection between the long drawn-out history of art education and what happens in our period in the London art schools are worth noting.[30]

First, there is the question of difference – that is, the argument that art schools are in a unique category. University of the Arts London academic Malcolm Quinn points out that there is a strong prevailing narrative that art schools differ in essential ways from other institutions of higher education, even into the present day when, in denial of that narrative of difference, art schools have been thoroughly integrated into the university system.[31] In the nineteenth century the signs of difference focussed on teaching style, between 'precept' (giving lectures) and 'practice'. The twentieth-century version of this distinction tends to be expressed as between 'non-studio' and 'studio' work. Anchored to this sense of difference is the virtually

unbroken history of suspicion directed by artist practitioners at the management of art teaching institutions. Both students and teachers habitually struggle with the notion that it might be appropriate to have a non-artist in charge. This was the struggle against interference that saw Coldstream's proposal to introduce art history and complementary studies as an imposition; in fact, it was seen as such an authoritarian act that it tarnished the teachers of those subjects in the eyes of their colleagues, sometimes with disastrous results. Distinctiveness and the tendency to regard art as an entirely separate discourse is also a feature of art theory. When Goethe's *Theory of Colours* first appeared in English, the translator of what was after all a book on a subject central to art practice, written by a passionate and acute commentator on the visual arts, felt that he had to explain its relevance to art education.[32]

Second is the fact that art and its theory have always been understood as operating within an international republic of ideas and contacts. We have already noted parallels

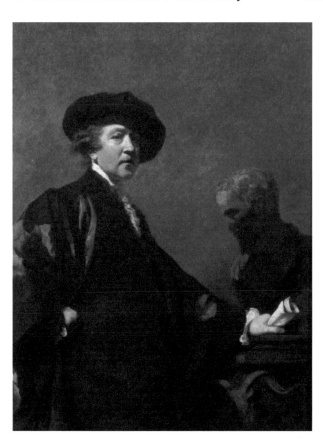

between Le Brun and Reynolds – France and Britain – and between the Bauhaus *Vorkurs* and the Basic Course taught in the UK. Such connections have always been present despite the many and seemingly contradictory attempts to establish art teaching institutions for political reasons of national advancement and pride.[33] In 1672, the scholar Gian Paolo Bellori (1613–96) gave a lecture about the theory of The Ideal to the academy in Rome of a kind that Reynolds was to give 100 years later in London.

← Fig.1.4 Joshua Reynolds, *Self-portrait* c.1780, Royal Academy of Arts, London

Later, the essay, which was heavily reliant on classical Greek philosophy (neo-Platonism), was appended to Bellori's collection of artists' lives, the publication of which was dedicated not to an Italian but to the leading European politician of the day, Cardinal Richelieu (1585–1642) – who happened to be

French.[34] The essays in this collection indicate that these international influences continued to be important in our period (see, for example, Westley and Williamson on Johnstone, and Crippa on the US influence at St Martin's). Academic art theory has always made use of an international menu of ideas. In our own day Jacques Rancière and Bourriaud still carry huge weight in London art school teaching.

The third of these long historical themes concerns the artists' resistance to being placed, yet alone contained, within any named set, party, team or faction, especially if that process of categorising is being done by a non-practitioner such as an art historian. One of our research team's findings has been that the delivery of the art school curriculum is maintained today in a culture of individualism. For example, candidate anonymity in the examination process tends to be rarer in the art school sector than it is elsewhere in higher education.

Nevertheless, distinctive and consistent institutional differences between art schools are, in fact, harder to locate. Judging by their resistance to merger, we would expect to find the art schools differ distinctly on an institutional level, but the differences tend to be individually based – in the contributions of particular tutors or departments – rather than truly institution-wide. There have been occasional moments when departments or wider groupings bonded around a moment of changing style – for example, the work undertaken in the Sculpture Department at St Martin's in Frank Martin's time – but these are rare. Harry Thubron (1915–85), often cited in the chapters that follow, took employment in a range of institutions – in London and well beyond – despite his frequently quoted opinion that the enemies of art are in the art schools – 'And, mostly running them.' Signs of marked disparity abound in the sector: for example, the 2014 REF process revealed that there is no agreed set of leading research journals in the fine art subject area. As is not the case in other subject areas, in art and design individual likes and dislikes still outweigh collective prioritising. There are few agreements on the boundaries of the fine art field and, in consequence, little agreement about what is central to that same field.[35]

Fourth, there are the arguments about the relative primacy of particular media or genres: should painting or sculpture be regarded as the senior art? What subjects might or might not be included in the fine arts? How should we categorise the reproductive or moving image-making arts of photography or video? The category of fine art has often been in and of itself a point of contestation. One major Coldstream reform focused on the new award – the DipAD – and another recommended the creation of a common foundation course for the diplomas in fine art, graphic art, three-dimensional design and textiles/fashion. All students working towards the diploma took a common award, whatever their specialism, rather than a medium-specific award, but there was no sector-wide support for this uniformity and within a few years fine art and design were drifting apart. At the same time it was agreed that it should no longer be mandatory to assess the art history learning that the students had undertaken. Coldstream's committee envisaged that art tutors would be practitioners and successful ones at that and that they would accordingly work part-time as art school teachers for one or two days per week. Schools would examine their own students (with the support of externals) and the whole education offered would aspire to match honours degree standards. In emulation of university teaching cultures, discursive pedagogies were developing – group discussions, collaborations between student groups, peer-crits, the writing and sharing of texts, etc. There was also a training mission in these new arrangements: the curriculum was meant to make artists and to form future generations of art teachers. The changes that resulted were most marked in respect of artistic identity and the relationships between the art market and the art students. It was the structural disparateness of the art school sector that marked the reception of Coldstream's recommendations.

Because of the vagueness of some of the wording in the Coldstream Report – as well as the strength of local views and the independence of mind of the artist-tutors – all the

art schools went in different directions. The vision of a nationally unified curriculum post-Coldstream was diversely interpreted to create a heterodox pedagogic culture, still visible and now enshrined in the intellectual independence of the universities with which the art schools have merged. This heterogeneity is still maintained locally through individual and departmental rehearsals of post-Romantic beliefs in artistic freedom.

Next – fifth – in this list of long-term issues for art education comes a topic that takes us right to the heart of questions about teaching and learning in the visual arts, the arguments about the basis for artistic competence. Is it a question of getting the mind right, or of teaching intellectual and manual skills – or indeed of teaching anything at all? The balance between these elements has always been shifting and has always been disputed. In the early modern period, it was not thought antithetical to the gaining of manual skills for students to undertake art-historical study, for example, through the imitation of the Old

Masters. In 1959, when Coldstream was appointed to chair the National Committee, the official position was that there were too many art programmes being offered by too many institutions and that they were over-specialised and under-intellectualised.

Coldstream's committee's recommendations were carried through by the National Council for Diplomas in Art and Design, chaired by John Summerson (1904–92), which granted diploma-awarding powers to successful applicant institutions.

Fig.1.5 Walter Bird, *John Newenham Summerson* 1966, National Portrait Gallery, London

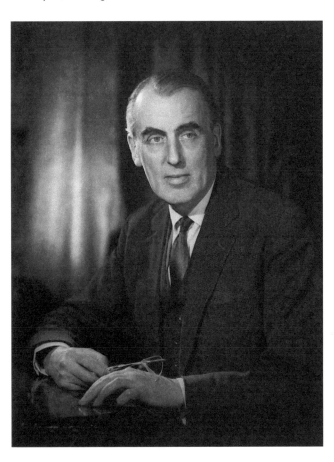

Only seventy-two programmes applied for permission to teach the DipAD and fewer than half of the applicants succeeded. The introduction of some art history teaching by Coldstream was regarded as a step that would give the diploma intellectual rigour but, as Potter points out, 'The extent to which art teachers were constrained in their use of art-historical examples was limited only by their creative ambitions'.[36]

The extent to which art teaching embraced art history in the new syllabus varied in response to changing conditions. Given the location of Coldstream's own institution, the Slade School, within the supporting confines of the long-established, multi-faculty University College London – and with (from 1964) a distinguished Department of History of Art to call on – we can imagine that he would not have found it hard to bring about a close integration of art history with the art school.

For example, he could bring John White (b.1924) in from the art history department to discuss his work on pictorial space, as he had earlier persuaded Rudolf Wittkower (1901–71) to talk to the students about architectural theory, or he might invite Ernst Gombrich (1909–2001) to cross the road from the Warburg Institute and talk about iconography or perception.[37]

Across the sector, the relationship between art history teaching and art education also changed in concert with prevailing theories of artistic purpose and creativity. The teachers of complementary studies were described neither as art history professionals – there were relatively few such, in the early 1960s, with whom to draw comparison – nor as studio specialists, although the official line was that they were to be 'constantly in touch with the values of the studio'.

A distinguished member of Summerson's committee, Nikolaus Pevsner (1902–83), perhaps concerned about the low level of the minimum entry requirements to the new diploma programmes, regarded the proposed discipline area of complementary studies as a dilution of the intellectual strength and purpose of his own discipline of history of art.

In consequence, he walked out of the committee leaving only a 'Note of Dissent' to record his fears that what art students would experience at that complementary point in the curriculum would be vague and ill-disciplined.[38]

↪ Fig.1.7 Paul Joyce, *Nikolaus Pevsner* 1975, National Portrait Gallery, London

Finally comes the question of where governance and public responsibility lie for the institutions of art teaching and learning, and for providing the resources that they need in order to function. Throughout their long history, art academies have often been associated with the state, whether in the form of princely or ideological preference: many of them were and remain royal establishments or operate under government control. However, as Pevsner himself pointed out in his path-breaking survey *Academies of Art Past and Present* (1940), the art school system in England was different: it was never centralised as it tended to be in continental Europe.[39] Any discussion of an art school system needs to take account of the number of schools in that system and of the students managed within each institution and overall. Throughout the period covered by these studies, the ranks of UK art students have swelled enormously, their rising numbers an index of the increased size of the sector overall. This trend has been apparent for a very long time. The Higher Education Statistical Agency figures for student enrolments by level of study and subject area for the academic years 2009/10 to 2013/14 show that creative arts and design students number about 15,000 at postgraduate level and about 150,000 at undergraduate level.[40]

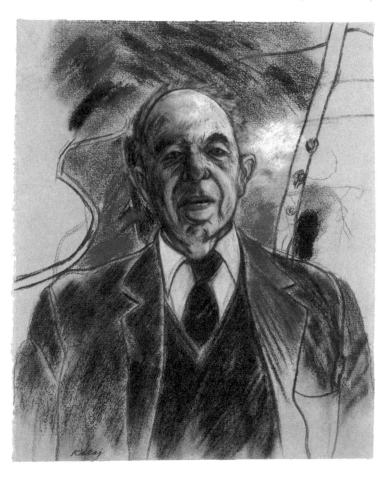

Gerald Cooper, Principal of Wimbledon School of Art from 1930–64, saw his student numbers rise from 150 to 650 over those thirty-four years.[41]

Writing about the famous sixteenth-century artist and art historian Giorgio Vasari (1511–74), Luigi Lanzi (1732–1810) lists the strengths and weaknesses of the academy founded under Vasari's patron, the Grand Duke of Tuscany, Cosimo I. His terms accord quite closely with the list that we have just run through: the Tuscan institution has benefited from the liberal support of the ruling family; it has adopted a theory of art – 'in all its branches [partaking] strongly of' Michelangelo's style (Michelangelo being at that time a by-word for excellence) – and its relationship with practice has often been troubled. In fact, Lanzi regarded the Florentine curriculum as ill-founded, and rehearsed the wide-spread opinion that 'academies have had a baneful influence on the arts since they have [constrained] all to follow the same path', to the point where Italy in Lanzi's day is 'fruitful to adherents to systems but barren in true painters'. Even then, there was a lively disagreement about pedagogy, with Lanzi claiming that academies founded on the Carracci method are 'highly useful'.[42] The key characteristic of the Carracci academy – and one that echoes in current debates about the role of practitioner teachers in the London art schools – was that it taught both pupils and masters that learning is ongoing, indeed never-ending, the Carracci axiom being that 'the shortest method of learning much is teaching'. What Lanzi recommended were exchanges that were not unlike the intensive St Martin's crits described here by Crippa: in the Carracci academy, 'scholars … were also taught to give due praise or blame to the works of others [and] to criticise their own works, and whoever could not give good reasons for what he had done, and defend his own work, must cancel it upon the spot'. The results,

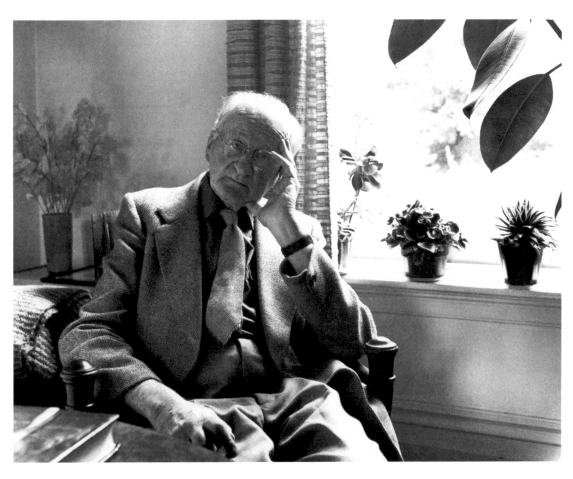

then as now, were heterodox. There was no slavish uniformity of style, 'since each scholar was at liberty to pursue what path he pleased, or rather each entered upon that to which nature had best adapted him'.[43] The foundations of study according to the Carracci formula were 'nature' and 'the imitation of the best masters'.[44]

THE CONTENT

The set of eight thematic chapters that follows is supplemented by an appendix setting out short institutional histories: these are intended to be descriptive rather than analytical. The overall aim of the research team has been to describe the distinctive journey that the London art schools have made: their 'lives', as we have put it in the title. In this introduction we have considered the long histories of some of the arguments that have changed tertiary art education in London over the last fifty or so years, and we have described the complex contexts to the subject. The eight chapters – arranged in a loose chronology – are about what their authors judge to be the key issues: we have not set out to write comprehensive histories of our target institutions. Beth Williamson and Hester R. Westley start by considering the international and interdisciplinary interests of the remarkable William Johnstone (1897–1981), who worked at Camberwell and led the Central School in search of new pedagogic models to apply in the UK context. Alexander Massouras then describes how c.1960 art schools started to integrate with the wider art world of markets, dealers and critics and started turning art students into emerging artists. In Chapter IV, Westley focuses on the historical moment just prior to the so-called death of the life room, which by tradition had been the definitive art-school space over many generations: this was a moment when arguments about art education were poised between the competing paradigms of the Bauhaus-derived Basic Design and the standard teaching model that existed before the influential recommendations of the Coldstream committee.[45]

Williamson then considers one of the best-known Coldstream reforms, the intellectual enrichment of the fine art curriculum via the teaching of art history alongside other forms of so-called 'complementary study'. In her final contribution, Westley tackles another major Coldstream innovation, the pre-diploma Foundation course intended to bridge secondary and tertiary level teaching – an innovation that led to competing and even contradictory patterns of Foundation teaching at different art schools across the country. Taking as her case study the new Chelsea building erected off the King's Road in 1965 and demolished in 2010 just as our research project was getting underway, Lucy Howarth considers how architects designed art schools in the face of the many and unpredictable changes in art practice and art pedagogy. In her final chapter, Williamson asks how we should interpret the relative absence of colour instruction from the formal teaching agenda: why, over time, did a topic like colour become anachronistic? Was it simply a reflection of the general prejudice against the acquisition of skills? In Chapter IX, Elena Crippa considers how the new pedagogic practices developed at St Martin's in the mid 1960s started to promote a fresh but still enduring image for the artist as a species of public intellectual rather than as a studio-based maker of objects. In a brief conclusion, we note the more recent impact on the art schools of their integration into mainstream tertiary education: the mergers to create larger management and budgetary units; the impact of research assessment and the adaptation to art-school cultures of concepts of practice-based research and of teaching quality assurance.

The chapters that follow are intended to show how rich yet contradictory have been the lives of the London art schools in the post-war period and how the processes of change in art school teaching and learning continue to accelerate through to the present day. In many senses the remaining London art schools – larger but smaller in their number – are institutions that are productive to a degree undreamed of in years past. They educate huge numbers of UK and

international students with a degree of formal rigour and professional standards, by means of a curriculum that is hardly recognisable as the direct descendant of the pattern adopted by Coldstream and his colleagues. Yet concerns continue to be voiced that these standards are reached at too high a cost, and a powerful sense of nostalgia lingers over what is thought to have been lost. One of the yarns told and retold endlessly to our research team was that the most important teaching happened not in the classroom itself but in the local pub afterwards. There are still debates in art schools about the balance in the curriculum between instruction in manual skill or process and instruction in communication or theory, and the eventual impact of university and research cultures on art school teaching remains unclear.

11

WILLIAM JOHNSTONE: INTERNATIONAL AND INTERDISCIPLINARY ART EDUCATION

INTRODUCTION

Born into a farming community in the Scottish Borders region, William Johnstone (1897–1981) trained as a painter at the Edinburgh College of Art and then in Paris where he worked in various studios. Turning to education as a means of earning a living, Johnstone worked in London as the Principal at both Camberwell School of Art (1938–46) and the Central School for Arts and Crafts (1947–60), retiring finally from the latter aged sixty-three. He then returned to Scotland to paint and to farm. Always a great traveller, he associated with significant German and American artists and educators such as Walter Gropius and Frank Lloyd Wright, and was employed by UNESCO to advise on art education in Israel. Key influences on his pedagogy were his early exposure to studio practice in modernist Paris; his interest in child art; and his keen sense of the legacy of his British pedagogical forebears, especially William Lethaby. This chapter is a collaboration between Hester R. Westley and Beth Williamson, whose contributions are marked (HW) and (BW) respectively.

→ Fig.2.1 William Johnstone in his
 studio, 1981

THE EDUCATOR AND THE ARTIST (HW)

William Johnstone's curse is being misunderstood: he is remembered as an art educator and he had to work as one, though he thought of himself primarily as a painter.[1] As an educator, Johnstone left an under-appreciated and misunderstood legacy, which has eclipsed his achievements in painting. Principal at both Camberwell and the Central School, he also initiated many of the most progressive changes in higher art education before the Coldstream reforms of the 1960s. But despite his unwavering commitment, Johnstone's painting failed on the contemporary art market: 'I haven't really been successful as a professional artist.'[2] Despite this, many critics and artists heralded the prescience of Johnstone's painterly idiom – an abstract expressionist manner – in Britain,

and the art theorist Anton Ehrenzweig (1908–66) described Johnstone as an artist who had 'developed his present style long before the current wave of action painting reached the British shores'.[3] John McEwan claimed that Johnstone's 'work in the late 'twenties and early 'thirties pre-dates established academic precedence, setting him quite apart'.[4] There are several possible partial explanations for Johnstone's commercial failure as a painter: Ehrenzweig noted Johnstone's 'mercurial and individualistic' nature, seen by others as a truly difficult temperament, although Johnstone himself saw his idiosyncrasies not as irascibility but as a preference for anonymity. Moreover, despite the progressive nature of his early painting, he could never entirely relinquish his interest in surrealism when formalism triumphed.

In addition, financial pressures forced Johnstone into the art school. As he puts it with typical directness: 'I never had any intention of being an art teacher, but when you have to live on fish n' chips you have to pay for them.'[5] Despite this, Johnstone brought a rare seriousness to his task as art educator, at a time when there was a sharp division between art teacher and artist. He 'was determined to counteract this superior elitist notion disseminated by the Bloomsbury set that no real artist could have anything to do with art teaching'.[6] Johnstone anticipated one of the greatest transformations in post-war tertiary art education – namely, that art teachers were themselves artists.

Schooled in both European and British art curricula, Johnstone skillfully reconfigured British educational paradigms; his legacy, mostly unacknowledged and overlooked, still informs art teaching today. He created a synthesis of international models of art education and represented them as the dominant British style. In short, Johnstone internationalised British art education and made British art international. In his teaching and administrative interventions, Johnstone's idiosyncratic view of a British 'Basic Design' course drew on his own formative experiences to form an international bedrock on which to build a new British art pedagogy.

THE BEGINNINGS OF BASIC DESIGN (HW)

Johnstone credited Jesse Collins and Albert E. Halliwell (1905–87) and followed their lead in taking up Bauhaus pedagogy to create Basic Design courses in the 1930s.[7] The introduction of Basic Design at the Central School was intended as a re-education in seeing and taught the student a crucial 'grammar of art' that led, ultimately, to an artist's own distinct idiom:

> *A student would often come to a senior art school already cluttered up with a great amount of undesirable and obsolete techniques while still lacking a realistic grammar of art from which he could begin his more advanced study of design.*[8]

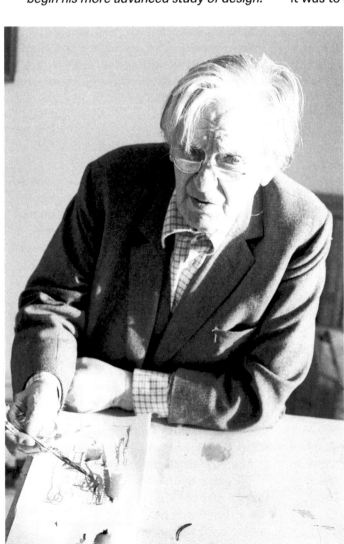

Reflecting towards the end of his life on the relationship between his teaching and his training, Johnstone was quick to identify his own formative experience in the studios of modernist Paris: 'I don't think I had any theories about teaching. I taught as L'Hote [sic] taught me, as an artist.'[9] However, this disarming anti-intellectualism – simply letting good artists 'get on with the job' – sits uneasily with the impact of his decisions as a senior educator.

His prescient development of a Basic Design course at Central was motivated by two convictions. He was convinced that art and design students needed a common starting point, and in characteristically acerbic terms he asserted how essential it was to destroy preconceptions about the nature of art that students acquired at their primary and secondary schools:

> *Senior art teaching is seriously handicapped by the aesthetic backwardness of most students entering art schools at seventeen or eighteen ... Their poverty of expression is in striking contrast to the richness of the junior child. What is wanted of the adolescent is his child's vision plus a dawning sense of values arising from new and real experience.*[10]

Johnstone was looking for a way to 'un-teach' his students and his Basic Design course relied on the recovery of what he terms 'a dawning sense of values arising from new and real experience'. The challenge was to decide how best to present such new artistic experiences to the student.

While this view might have begun to be formed in his Paris student days, where he had encountered larger-than-life modernist heroes, Johnstone

himself maintained that his earliest formulations of Basic Design were played out in 1927 on his return to Scotland to take stock and to teach day-release students at the South of Scotland Technical College. Attempting to trace the connection between ancient art and modernism and the nature of a tradition, he arrived at an absolutely clear conviction that his own teaching should bear no resemblance to the sort of teaching he himself had received: 'Did ancient works of art have any relevance to modern art? What was tradition? Why bother with history of art at all? … I wanted to teach with the new approach to art which I had learned in Paris.'[11]

Such questioning of the canon was to flow in the art teaching mainstream some three decades later and his progressive view that teaching 'should be a really creative process' was to become the superstructure for later British art school curricular reforms. Johnstone describes his discovery of a 'Basic Design' course:

> So I introduced a method (not used at that time in this country) of teaching art from abstract shapes, from a series of patterns, from a series of relationships … For want of a better word, I introduced what is now termed a 'basic design' or 'foundation' course, and this turned out to be a great success.[12]

But there was another, equally important element in Johnstone's introduction of 'Basic Design' that would become one of the cornerstones of later, self-styled 'progressive' models of art education: rather than 'teaching', the tutor would be a collaborator, engaging intellectual, artistic play.

> I was determined that I would bring a new approach to art teaching which would keep my own interest alive. I taught, not as an art teacher, but as an artist, as if I were inviting the children to paint pictures with me in my studio. I wanted to teach them the art of their own time … These new ideas increased their sensitivity and observation. We used patterns and shapes, patterns and forms, stemming

from my Cubist training in Paris … I treated the problem as if I had been at an art school or at a studio like L'Hote's [sic] where you did not have a teacher coming round to criticise all the time; they could all help each other when needed … One thing dominated the situation and that was the element of fun, of play, rather than a sense of work. I was teaching these children, as a creative artist, to be more creative people.[13]

This account reads almost as a brief for courses developed in art schools after the Coldstream reforms. Informing Johnstone's model was his view that the art work was an expression of an idea but also an expression of play – and that by emphasising the ludic quality of art education, Johnstone could, effectively, shape 'more creative people'. These discoveries, of course, arose during his time teaching schoolboys, but they had a tremendous impact on how he approached professional art instruction.

CHILD ART TO MAN ART (HW)

The child, in Johnstone's view, is very much the father of the man and he was not alone in his interest in children's art. For a number of artists in the early 1900s, the recovery of a child's perspective was a crucial component for a new artistic idiom.[14] In 1934, R.R. Tomlinson published *Picture Making by Children*, in which he writes about the significance of his encounter in 1920 with art teacher and child art pioneer Marion Richardson at the Grafton Gallery. Richardson's 1938 exhibition *Drawings by London Children at County Hall*, attracted many progressive art instructors. Johnstone does not mention that show directly, but it is not difficult to imagine that he and his then-wife Flora – his collaborator on their groundbreaking work, *Child Art to Man Art* (1941) – might have seen it.

Another source for Johnstone on this subject was the Viennese pedagogue Franz Cižek. Tomlinson had contributed to the first and only substantial volume on Cižek to be published in the UK, *Child Art and Franz Cižek*

(1936) by Wilhelm Viola, himself a former pupil of Cižek. Aware that the progressive ideas about children's art education developed on the Continent were only slowly appearing in mainstream British education, Johnstone shifted the locus of interest from infancy (which was Cižek's preoccupation) to adolescence. As he frames it: 'My problem had been the decline in spontaneous expression as children reach puberty, and how to bridge the gap between the naïve visions of childhood.'[15]

In *Child Art to Man Art*, Johnstone lays out many of the principles that were to underpin his later views on higher level art education and anticipate many of the major and progressive pedagogical innovations of the 1960s. Education 'is not an end but a process', he wrote, and should not be based on 'fixed routines' or 'rigid formal methods however efficient' , but rather on 'vision, enthusiasm and flexibility'.[16] His advice to teachers was that they should avoid the kind of 'conventions, inhibitions, and prejudices' that prevent them from becoming childlike. Indeed, Johnstone thought that being childlike was the only way to teach. He also uses pedagogical terms, which would later be associated with Basic Design, such as 'the blank slate' and 'tabula rasa'. Insisting upon seriousness of art instruction but removing its traditional grim solemnity, Johnstone sought to invigorate British art curricula, establishing the Central as a site of radical pedagogies and effectively redefining an art school's mission: to explore connections not through imitation but, in Friedrich Nietzsche's words, to rediscover the seriousness of a child at play.

CONTEMPORARY AND HISTORICAL INFLUENCES (HW)

Johnstone's interest in child art was balanced by his enthusiasm for the pioneers of continental modernism and for artists affiliated with the Bauhaus. Being Principal of the Central gave Johnstone his opportunity to create a British equivalent of the great Weimar institution and he regarded its founder, Walter Gropius, as an exemplar for his students.[17] Gropius had served on the advisory committee of the Central School and he and László Moholy-Nagy had long speculated that a Bauhaus might be established in London.[18]

Johnstone's efforts were in part motivated by the desperate circumstances of post-war Britain where industry was in need of revitalisation and the art schools swirled in cultural despond and were shackled to an outmoded arts-and-crafts curriculum. Under these circumstances, Johnstone looked abroad to appreciate the relationship between design and industry and glimpse a new vision for British art pedagogy. Funded by the London County Council, he travelled to the United States to study industrial design training and encountered luminaries such as Marcel Breuer, George Nelson, Raymond Loewy, Serge Chermayeff and Ludwig Mies van der Rohe, and was invited by Frank Lloyd Wright to remain and work permanently at Taliesin.

Moving well beyond the influence of his immediate continental modernist precursors, Johnstone reached into the history of the Central School in order to find a way forward.

His writings, both published and unpublished, reveal that he was inspired by the mission of William Lethaby (1857–1931), architect and co-founder of the Central School. At Lethaby's centenary, Johnstone wrote with irritation to the Ministry of Education and referred to the gravitas of his predecessor's legacy:

> [Lethaby] believed in freeing the designer student from the hampering effect of formal examinations: he felt that these were completely irrelevant. He believed that the maker of beautiful things had a social duty to serve the community in which he lived … Lethaby's ideas gave the basis for the teaching of Frank Lloyd Wright, Walter Gropius and Moholy-Nagy, the three great art teachers of our time … This is in striking contrast to the Ministry of Education's recent report on art education in London … in which all art schools related to the Ministry of Education are measured by an examination system called the National Diploma in Design. Thus we are back again with Victorian reactionary

policy from which we were extricated 60 years ago by William Lethaby.[19]

Following Lethaby by freeing students from a Victorian policy would be the first step towards reviving art pedagogy. Johnstone agreed with Lethaby that art education had 'a social duty to serve the community' and that a student's work should be assessed not by staid examinations but by the artist's aesthetic contributions. Johnstone's championing of the Lethaby legacy was also a sound argument that the 'Central School became the parent of Bauhaus'.[20] When Lethaby founded Central in 1896, he employed part-time master craftsmen to demonstrate their skills to student apprentices. The German diplomat and patron of modern art, Count Kessler (1868–1937), suitably impressed, had returned to Germany to spread these ideas and in time they directly influenced Bauhaus pedagogy, which to Johnstone was already British, since its principle of a unity of design and form had begun with Lethaby.

When Johnstone became Principal of Central he retained the administrative divisions between the arts and crafts and design but reformed the institution to revisit Lethaby's ideas, which he regarded as in accordance with Gropius's: '[A]t the Central as well as at the Bauhaus under Gropius ... the emphasis was placed on drawing ... to be related to the needs of the individual crafts as well as being a general cultural background.'[21] Furthermore, the whole college was geared towards industry, and its teachers – mostly part-timers – were either artists or craftsmen actively engaged in the industrial world. In Johnstone's eyes, the affinity between industry and art was indisputable:

> *The Central School is no factory, nor a vocational training centre; its workshops and studios are the arena of experiment and adventure in new art forms relating to the industrial age. It was the first school in the world to grasp the relationship between designer and the machine ... It is fair to say that modern art colleges throughout the world having relations with industry have, directly or indirectly, taken their pattern from the Central School of Arts and Crafts.*[22]

Even before his retirement from the Central, Johnstone's contribution was recognised by his successors.[23] As the catalogue to *The Developing Process* (1959) explained, 'most of the subsequent basic design courses in British art schools owe something of their character to work done at Central'.[24]

↙↘ Figs.2.3 and 2.4 Principal William Johnstone and Mme Gerhardsen meeting a student (left) and looking at an example of student design (right), 1956. Central Saint Martins Museum and Study Collection

Anxious to avoid the stranglehold of a new academy, Johnstone tended to align himself with the pre-Bauhaus Lethaby mission, rather than with the Gropius-model Bauhaus directly, although his successors saw him still in relation to that tradition. Pasmore, for example, explained that Johnstone's Foundation courses at

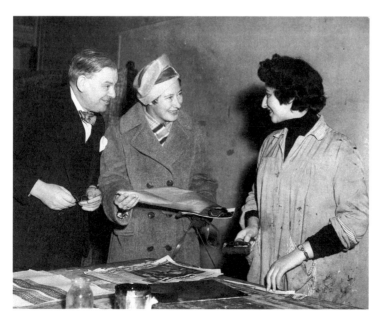

Camberwell and the Central 'were essentially Bauhaus because he [employed] fine artists (painters and sculptors) to teach it to industrial and other craft designers'.[25] Similarly, Richard Hamilton saw a precedent in Gropius, who had put artists like Klee, Kandinsky and Schlemmer in the design and craft departments at the Bauhaus: 'Johnstone … would get young artists … to act as a kind of stimulus and throw in some different ideas'.[26]

JOHNSTONE'S INTERDISCIPLINARITY (BW)

Johnstone's interest in fine art and design training, coupled with his tendency to work in an interdisciplinary manner, emerged long before he took up his first major teaching post. From 1929 onwards, he regularly undertook commissions in book illustration and book jacket design and in the early 1930s he taught design.[27] In 1931 he attended the first British exhibition of Swedish design held in Dorland House in Regent Street, London and organised by a pioneering Swedish design educator, Åke Stavenow (1898–1971).[28] European modernist design, art and architecture were becoming increasingly influential across Britain in the 1930s, and the associations between art, design and industry more firmly established than ever before. The inaugural issue of *Design for Today* (May 1933) included a special feature on the German art and design schools.[29]

Nevertheless, recalling the 1931 exhibition, Johnstone later lamented: 'I had seen this exhibition and had been amazed … In the Scandinavian scheme of things, manufacturers understood design and employed artists in their factories, thereby generating a new and vigorous approach. The artist was considered an essential part of the production team, not a decorative embellishment as seemed to be the case in Britain.'[30] Johnstone's early teaching roles had included design in hairdressing and in tailoring at Regent Street Polytechnic (1932–5) and, until 1938, in design classes at the Royal School of Needlework.[31] For an artist with his training these diverse pedagogic duties must have called for a certain degree of openness and flexibility on his part, so it is not surprising that he expected others to show these qualities. As has already been mentioned, Ehrenzweig noted Johnstone's lack of concern with rules and conventions and his interest in cultivating creative flexibility.[32] In his own work, Johnstone brought together an eclectic mix of styles and methods in a search that lay behind his life-long interest in interdisciplinarity. As Principal, he recruited his teaching staff, all practising artists, from an international field. For example, at Camberwell, there was Toni del Renzio (1915–2007), active in British Surrealism and at the Institute of Contemporary Arts (ICA).

Johnstone's Basic Design course at the Central School brought the six different schools at Central into a more integrated structure and taught 'a grammar of art in such a way that each student could develop any particular medium he or she happened to choose'.[33] He created an environment that was formative for young teachers such as Richard Hamilton (1922–2011), Nigel Henderson (1917–85) and William Turnbull (1922–2012), who were among those young

artists who went on to form the Independent Group at the ICA. Another initiative was to foster a liberal exchange between art and design schools or disciplines to encourage the 'cross-fertilisation' of skills: the painter Alan Davie (1920–2014) was placed in the Jewellery School, while Eduardo Paolozzi (1924–2005) was employed in the Textiles School, intended as a temporary arrangement until Paolozzi could be employed in the School of Painting and Drawing. In the event, Paolozzi became a textile designer in his own right.

The aim of this interdisciplinary strategy was to enable a freer development of ideas, unshackled by training or historical precedent. 'Integration between graphic, typographical and printing students was indispensable' since it engendered a new synthesis and unity of practice that facilitated a free flow of creative thinking.[34] By working beyond previously established limits of existing crafts and disciplines, a new creativity emerged that displayed a previously unseen degree of inventiveness and originality.

JOHNSTONE AND COLDSTREAM (BW)

Given this approach, it might be imagined that Johnstone would have been in agreement with Coldstream's reforms from the early 1960s. In 1966, however, Johnstone's criticism had been pronounced. Peter Townsend (1919–2006), editor of *Studio International* (1965–75), invited him to respond to a series of interviews about art education conducted by Victor Willing (1928–88) with Misha Black (1910–77), Herbert Read (1893–1968) and Richard Hamilton.[35] Johnstone made various comments – sometimes scant – on the gallery proofs of the September issue interviews, which reveal how radically different was his starting point, especially with Hamilton and his own approach at Newcastle:

> The first aim of our course is a clearing of the slate. Removing preconceptions. People come to art school with ready-made ideas of what art is. We have to do some erasure. Then we have to build up a new sense of values. We try to put

across the idea that any activity should be the outcome of thinking.[36]

Johnstone responded:

Ha! Ha! where did you come from?[37]

He valued the Bauhaus principle of clearing the slate but his teaching was ultimately grounded in an intuitive approach quite different to Hamilton's emphasis on a rational process – what the latter called 'the outcome of thinking'. Johnstone responded to Townsend in the boldest of terms:

> I must say that it depresses me that the same points about first principles are still being debated in 1966 in the same debased theological manner as they were when I taught at the Hackney School of Art and the Borough Polytechnic over thirty years ago. Like theologians, your contributors seem unable to agree even to define their terms and I would not like to add any 'active ideas' to the outcome of profound thought – pace Mr Hamilton. I am sorry that, as an old ptotoge [sic] of mine, Mr Hamilton is out to deny experience in his syllabus. My own experience, when I had to deal with all these problems – and more – as Principal … was to employ real live artists to teach. By their practice they solved formal problems which still seemed to defeat the committees. Indeed, it is a sad paradox that Victor Pasmore and William Coldstream should have been more effective when apprentice-teachers (but practising artists) than they are now as figure-heads of an Establishment they are unable to control.[38]

Twenty years later, Johnstone was contemptuous both of the reforms and for those responsible for them:

> The committee sat for about two years without coming to any decision until someone in the Government became restless. Further discussions culminated in the Coldstream Report which, in my view, was destined for the biggest muddle

that had ever been known in art educa-tion. The previous committee might have been stupid, and others even more stupid right back to Victorian times, but the one under Coldstream was the worst of all.[39]

Johnstone's own contribution to the theory of art pedagogy and the dialogue between art, design and industry had first been formalised in his 1948 article 'Unity of Art and Industry', published in the *Times Review of Industry*.[40] Despite a long estab-lished unity of art and industry stretching back before the Industrial Revolution, in his own day, Johnstone notes that art and industry are 'scarcely on speaking terms'.[41] The sort of craftsmanship espoused by William Morris (1834–96) at the Central School of Arts and Crafts in London in the late nineteenth century had set new standards, Johnstone claims, and Gropius had 'modelled his famous Bauhaus' on the Central School.[42] Johnstone presents perspectives from three sides – the industrialist, the art student and the art teacher – and explores various ways of negotiating the dialogue between art and industry in a new sort of art education already emerging in 1948:

> *The new kind of art training is already coming into being. At the Central School of Arts and Crafts, which pioneered the first serious attempts to relate art to industries in the [eighteen] nineties, selected students, after reaching a certain degree of proficiency of hand and eye in the normal modes of training, are now encouraged to spend a part of each week in an engineering college and at a tech-nical college for the study of mechanical processes, casting, and the use of plastics. In this way a new instrument is added to their curriculum. Out of this venture we may yet see a new efflorescence of creative energy reminiscent of the Renaissance. In this sense we shall not be reactionary in proposing a return to the school of Leonardo – or at least we may to advantage steal a page out of his Note Book.*[43]

Five years later Johnstone again under-lined his commitment to design as part of art school interdisciplinarity, outlining then recent changes in the 'School of Book Production' integrating design and printing in response to the contemporary situation. 'To change and alter the basic training provided by the department required serious thought, but to continue indefinitely along one path, however successful, tends to create a false notion that tradition is a thing of continuity and growth.'[44]

Responsive rather than reactionary, Johnstone's changes at both Camberwell and the Central School sought to work across disciplinary boundaries and to provide students with an art-school training more suited to their individual needs. Rather than reacting to existing unworkable systems, as some felt Coldstream did, Johnstone offered a curriculum that was responsive to the needs of the student.

INTERNATIONALISM (BW)

Johnstone's pedagogy was founded in his internationalism and his international outlook was rooted in his early European and trans-atlantic training and experience. However, it first emerges in his writing in a book titled *Creative Art in England* (1936), later revised and republished in 1950 as *Creative Art in Britain*.[45] This is 'not a history of British Art, but a study of the character of the most intense and creative British work, using the method of comparison'.[46] British art is valued but as part of 'the great European tradition' and set within that context and that – crucially – of European art school training. He argues that both these contextual fram-ings underline the significance of a process of exchange, even if not explicitly. Here, Johnstone proposes a working definition of British art:

> *By British art I do not mean art which refuses to accept the contribution of France, Italy, Russia or China to the world, but rather an art tradition which encourages the British artist to contribute*

at least as much as he receives. He accepts the valuable contribution of France in a creative and assimilative way, rather than a merely imitative spirit. In this way painters abroad will similarly feel able to accept the British contribution to the art of the modern world.[47]

What he seeks is an international dialogue in which British art and artists gain as much as they might contribute. Such a perspective on mid-twentieth century British art was not, necessarily, one commonly shared even by immigrant historians of art. For instance, in his 1955 Reith Lectures on the Home Service of BBC Radio, Nikolaus Pevsner (1902–83) focused on *The Englishness of English Art* and in his introduction to the series emphasised the rigorous use of historical method:

The order in which their Englishness will be expounded is deliberately not chrono-logical. That would lead to a compromise with the technique of the historian. Instead a number of qualities will be chosen which are spectacularly English.[48] In his national geography of art Pevsner

shared little with Johnstone's outward-facing and dialogical perspective. Rather, he is didactic in his approach, offering English art as an exemplar to the rest of the word and noting, 'The English tradition … has much to teach the Continent and America, and foreigners.'[49]

Yet both Pevsner and Johnstone shared a respect for the design teaching of architect Walter Gropius and the pedagogical traditions associated with the Bauhaus. Unfortunately, Johnstone's exchange of letters with Gropius in the USA in 1948 reveals little of their professional relationship, acting merely to frame Johnstone's visit.[50] The American links around architecture were strengthened further in that year through his meetings with Frank Lloyd Wright at Taliesin, Arizona, as well as talks he gave to students at the Taliesin Fellowship.[51]

↓ Fig.2.4 William and Mary Johnstone outside Frank Lloyd Wright's house, Taliesin, Wisconsin, c.1948

What Johnstone was seeking were means of finding international pedagogical models that might have something to offer

art education in Britain, and a means of offering British art education, particularly the Central School, as a model for art education in other countries. So, having turned to Gropius and Lloyd Wright in the USA in 1948, he exchanged ideas with art historian Åke Stavenow at Stockholm's Konstfackskolan in 1959, for instance.[52] In 1964 Stavenow recalled:

The educational pattern at the school has attracted enormous interest of the industrial arts and crafts world outside of this country. Study groups from all parts of the world, and lots of inquiries in writing about the aim of the school and its methods bear evidence to this fact. The great success and recognition a good many of our former students can boast of, and which is reflected in the good reputation Swedish art industry enjoys nowadays, serves as proof of the high standard of the training they have had.[53]

Johnstone's own account of the exchange of ideas between himself and the Konstfackskolan was rather different since he regarded himself as responsible for its success. 'When, in 1959, the new Konstfackskolan was opened in Stockholm by King Gustav, I was honoured that much of the curriculum from the Central School had been used when planning the courses.'[54]

Following his retirement from the Central School of Arts and Crafts, Johnstone continued his enquiry into international art education. In 1961 he was recruited in a consultative role by UNESCO, via the Department of Technical Co-operation of the UK government, to an assignment at the Bezalel School of Arts and Crafts in Jerusalem. His remit was three-fold: firstly, a 'study of the existing curricula of the Bezalel School'; secondly, a 'study of the existing situation in the community and in the nation concerning the arts and crafts as small industries'; and, finally, a 'survey of the "physical plant" and existing equipment in the school'.[55] The pages of draft notes, presumably made by Johnstone during his visit to Bezalel, evidence his view that British art education was superior to what he found in Jerusalem.[56] A subsequent correspondence

with the Principal, Felix Darnell, indicates that significant changes were made and that the School continued to rely on Johnstone in an informal advisory capacity. Darnell wrote about the work involved in revivifying the School: 'as a result of your repost there is a scheme to reconstitute the School on a proper basis, with some hope of getting foreign experts to come and help'.[57] And there were other British artists, educators and critics visiting Jerusalem. In February 1963, for instance, Darnell reports that 'Alan Bowness … was rather astonished that we did not have a general first-year, exclusively devoted to basic design and without any specialisation whatsoever'. Darnell promised to do 'this next year if you agree that this is a good idea. It makes it so much simpler from many points of view and it also gives us a chance to see the students at work for at least a year before we allow them to specialise.'[58]

In his notes towards his UNESCO report Johnstone notes that a 'Basic Design course [is] needed for all students'.[59] The final report is at times ambiguous in its views about international dialogue: Johnstone calls for 'Periodic Fellowships abroad … for teachers, to act as refresher courses and to keep in touch with major art centres in America, France, Finland, Britain, etc.' and suggests that 'annual appointments from overseas could be made on a sort of "busman's holiday" basis'.[60] He also urged Israeli designers to develop their own aesthetic, rather than drawing on Scandinavian design.[61] It is arguable that Johnstone's involvement in the Bezalel project was tainted with a degree of paternalism, perhaps typical of his day. He noted the '[a]pparent wastage of girl students getting married, some getting tired after their first year, or only doinf [sic] a year in order to give themselves a form of social prestige'. Still, he reflects: 'Not to worry. This all helps to spread some standard of visual education throughout the country.'[62]

However it is viewed, Johnstone's internationalist contribution to the development of art education in Britain was truly significant.

CONTRADICTION AND NEGATIVE
CAPABILITY (HW)

↓ Fig.2.5 William Johnstone in his
studio, 1981

Johnstone had a set of guiding principles
for art school education. First, there needed
to be sympathetic relations between the
Principal, the tutors and the students with
emphasis on the latter: 'The school is exclu-
sively for the use and benefit of the students,
and all services must be available to them
whenever they are necessary.'[63] Second, the
education was to be classical in its intent and
idealistic in its goals.

> It is a fault ... that many ... confuse the
> training they have received with Education.
> Training means the development of a
> special skill applicable to a specialised
> job. Education means ... what it meant
> to Erasmus: the drawing out of all the
> qualities of the whole man, enriching him
> with analysis of all previous experiences
> ... a telescoping of the past into the
> present of the residue and essence of all
> previous experiment and experience.[64]

Thirdly, historical models were valuable but
complex: 'The true meaning of tradition is
often misunderstood and derivative, slavish
imitation of previous models is accepted as
tradition. This fallacy makes a spurious and
degenerate art, an art unrelated to our time.
It makes an art form without content.'[65]

Johnstone believed in the elevating
purposes of art and, fearing its debasement
through an increasingly commodified culture,
he maintained an ambivalent view of the
place of design within the art school: 'A school
is ... not a place for the person who could
be most readily used to meet the needs of
commercial salesmanship.'[66] And here there
emerge the contradictions in Johnstone's
legacy. Art pedagogy was not training; it was
a 'drawing out ... the qualities of the whole
man'.[67] A child's ludic ability was a pedagog-
ical principle – yet every student must
demonstrate technical mastery. Industrial
design was promoted, but commercialisation
raised suspicions. The German Bauhaus
was admired and emulated, yet it was a British
idea in the first place. A pedagogical progres-
sive who wanted to throw off the shackles
of recent history, Johnstone remained keenly
aware of the significance of earlier history
for the modern student. His friend and
contemporary Anton Ehrenzweig observes
that as an art educator, Johnstone dedicated
himself to counteracting the 'rigidifying
effects of skill admired for its own sake', yet
above all else he proclaimed the importance
of skill and of controlled craftsmanship.[68]
Johnstone's wide-ranging ideas evade easy
categories and they form his most important
attribute: the strength
to live within contra-
diction, the negative
capability that charac-
terises his artistic and
pedagogical legacy.

THE ART OF ART STUDENTS

In 1965 the curator of the Whitechapel Gallery, Bryan Robertson, described a recent transformation in the character of art schools as their doors opened to the broader art world:

> Ten years ago they were private establishments, as it were, mysterious to the outside world and known only to the students concerned and the respective staffs. Now, at end-of-term shows, you find collectors and dealers – and certainly critics – on the prowl, eagerly intent upon a new discovery, anxious to get in on the ground floor of the career of some new and talented artist.[1]

How was the art school integrated with the world of the art market, critics and dealers? This chapter will consider the confluence of these institutions, and the related metamorphosis of art student into artist, as a symptom of the revival of a long-standing debate within art education and education more generally; namely, the question of purpose.

An instrumental approach, preoccupied with practical or measurable aspects of learning, was imprinted in the institutions of art education from their origins. The nineteenth-century schools of design had functioned under the aegis of the Science and Art Department of the Board of Trade, alongside scientific and technical education. Their history was closely entwined with an industrial fair, the 1851 Great Exhibition.[2] Institutionally, therefore, many art schools had been established to improve design for industrial manufacture; their goal was training for useful or economic ends rather than education pursued for its own sake. By the late twentieth century, fine art – once the exception and catered for by anomalies within the overall sector such as the Royal Academy and the Slade School of Art – began to predominate in other art schools too. Coupled with a gradual decline of manufacturing in the economy at large, the ascent of fine art pushed this instrumentalist attitude into two new forms. Instrumentalism could now define the art school as an institution for the creation of artists, the fruits of which

Bryan Robertson observed above. Or, it could render them institutions for the creation of teachers, an attitude consistent with the national aims and objectives for further and higher education generally.

This chapter reviews these debates about instrumentalism, situates them in wider contexts such as funding, social change and the resulting shift in the profile of the art student, and explains why questions of purpose and value became more pronounced in the 1950s and 1960s. Paradoxically, the increasing preoccupation with these kinds of issues happened at the very moment when fine art – the arena in which these questions naturally muddy – began to take over art schools as the dominant subject area. These debates were not, however, exclusive to art; there are powerful analogies between reforms in art education and reforms elsewhere in the national education system. For example, the creation of a DipAD in art education overseen by the National Council for Diplomas in Art and Design in 1960 resembled the earlier creation of the DipTech overseen by the National Council for Technological Awards in 1955.[3] Similarly, while the art school was increasingly considered for its potential to train teachers, teaching was itself being formally academicised. Its own dedicated degree, the BEd, was created following the Robbins report and taken up across the higher education sector.

These parallels suggest that the history of art schools should be situated in the landscape of shifting education policy. Art school change reflected contemporary social and political history as much as it reflected art historical transitions.

ART STUDENTS AS ARTISTS

For those outside the art school, the 1950s and 1960s witnessed a substantial expansion in the exhibition of art students' work. Previously, such exhibitions had been isolated and irregular: student shows were mounted at the Whitechapel Gallery in 1904, 1910, 1927 and 1931; a *Daily Express Young Artists' Exhibition* was held in 1927 and another in 1955. The date of a precise turning-point is

elusive, but 1949 seems significant in the narrative; this was the year of the first *Young Contemporaries* exhibition.

↓ Fig.3.1 Cover for *Young Contemporaries* exhibition catalogue, 1949.
 Tate Archive

Young Contemporaries made the exhibition of young artists' and art students' work into an annual staple of London's gallery calendar and its success encouraged an increasing number of other institutions to mount similar exhibitions. Galleries which subsequently showcased young art students' work included the ICA and the Whitechapel, whose *New Generation* shows of the 1960s were prominent platforms for artists' early work.[4] New spaces such as the Hayward Gallery (opened in 1968) and the Serpentine Gallery also keenly displayed student work; the latter opened in 1970 with *First Show*, an exhibition of work by post-diploma students from Chelsea, Manchester and Birmingham Schools of Art.

The first *Young Contemporaries* marks an important development in exhibition history; moreover, across the course of subsequent *Young Contemporaries* exhibitions the art student's transformation into professional artist is especially perceptible. Previously, this type of exhibition had been associated with amateurism: the 1904 Whitechapel exhibition was titled *Amateurs and Art Students,* while early *Young Contemporaries* shows were sponsored by *The Artist* magazine (for amateur painters) and toured to non-art-world institutions such as the Tredegar Workmen's Institute and the Chatham Public Library. In the late 1950s, however, the *Young Contemporaries* departed dramatically from this precedent and by 1962 there were international requests for the exhibition to tour to galleries elsewhere in the Commonwealth. Finally, in 1967, the exhibition came to the Tate Gallery, a national art museum.[5]

↪ Fig.3.2 Poster for *Young Contemporaries* exhibition, Tate Gallery, 1967

YOUNG

CONTEMPORARIES

1949

The Arts Council

YOUNG CONTEMPORARIES AT THE TATE 1967

The Tate Gallery 27 Jan - 19 Feb
Weekdays 10am - 6pm Sundays 2pm - 6pm
Major Prizes will be awarded by the
Arts Council and the Peter Stuyvesant Foundation

Indeed, the *Young Contemporaries* articulated an ambition to professionalise its exhibitors very early on. The 1951 call for submissions indicated that the exhibition's formation two years earlier had had restorative aims, to compensate for the effects of national service on the prospects of young artists' careers. The announcement considered its purpose, which was:

> *to give the majority of exhibitors, who at that exhibition were ex-servicemen and women and who would have been practising artists by that time, a chance of showing their work before they left their school, a stepping-stone as it were between the school exhibition and the larger public exhibitions of one of the Art Societies or the Bond Street galleries.*[6]

These professionalising tendencies were reinforced by new interest from commercial galleries, which began to promote work by young artists fresh from art school – sometimes even still in art school. Before the war, few galleries would exhibit unestablished artists: exceptions being the Leicester Galleries, Reid and Lefevre, and Tooths, which had all occasionally ventured into this uncertain territory. In the 1950s and 1960s, Gimpel Fils, the Drian Gallery, Annely Juda, Robert Fraser, Kasmin, the Mercury Gallery, the Molton Gallery, the New Art Centre and the Redfern Gallery would all show young and unestablished artists, and many of them focused on this segment of the market almost exclusively. Carel Weight (1908–97), then teaching at the RCA, wrote in 1967 of the contrast with his own experience as a young painter:

> *'If you haven't hit the jackpot by the time you are twenty-five, you've had it,' said the ambitious young painter, and I could not help thinking back to the 'thirties when I was a student, when London was an artistic backwater boasting of about a dozen dealers' galleries, none of which would seriously consider giving an exhibition to a young painter emerging from art school. The 'sixties have produced a very different picture; there are at least*

a hundred galleries and the hunt for the young genius has until very recently been the order of the day.[7]

If we consider this as an issue of supply rather than of demand, it is worth noting that tutors also helped students to function as fully-fledged artists. Denis Bowen (1921–2006), a tutor at Hammersmith School of Art, formed the New Vision Group with students and helped to organise exhibitions in Notting Hill from 1951; Frank Martin (1914–2004), Head of the Sculpture Department of St Martin's throughout the 1960s, promoted and encouraged his sculpture students, nurturing their engagement with the art world through encounters with critics, gallery owners and other artists.[8] At Camberwell, Carel Weight himself invited visitors from the art world to talk to students and acclimatise them to life after art school. When he was teaching at the RCA later in his career, Weight also played a vital role in the creation of the first *Young Contemporaries*, replacing a scheduled exhibition at the Royal Society of British Artists galleries that had fallen through.[9]

But alongside these piecemeal developments by galleries and individual tutors, some had broader policy anxieties. A *Times* editorial of 1958, titled 'Future of the Art Schools', suggested that 'there are too many young people studying art, not many of whom will be able to earn their living at it, and some of whom are amateurs'.[10] Lecturing Slade students in 1961, the sculptor Reg Butler (1913–81) painted a similarly pessimistic picture: he suggested that the art student would 'acquire little if anything which will enable him to earn his living at the work he has chosen, and suddenly the course is over and the support withdrawn'.[11] Further up the chain, the gap between art and economic viability was noticed by the first Arts Minister Jennie Lee in her White Paper of 1965: '[a]t present the young artist, having finished his schooling, has still to gain experience and has difficulty in obtaining employment [...] Painters, poets, sculptors, writers and musicians are sometimes lost to art for a comparatively small sum of money which would support their start in life.'

The report went on to argue that '[b]y far the most valuable help that can be given to the living artist is to provide him with a larger and more appreciative public'.[12]

EDUCATIONAL REFORM: BUTLER, COLDSTREAM, ROBBINS

Debate about the long-term economic viability of art students was not unprecedented: earlier commentators had been anxious about the fate of young artists. At the end of the nineteenth century, Marcus Huish had asked: 'Whence this Great Multitude of Painters?'[13] In the 1930s, a survey of British Art spoke of a 'crisis of over-production and under-con-sumption',[14] and it was suggested that to ease the fine art bottleneck 'these very clever students should direct their efforts away from the idea of picture painting and go into the decorative and industrial arts'.[15] In the same period, Nikolaus Pevsner (1902–83) had asserted: 'it is wrong, sociologically and morally wrong, to base the organisation of art schools on provision for future painters and sculptors'.[16]

However, in the 1950s and 1960s those anxieties arguably became more pertinent than ever before. Post-war changes in education policy significantly transformed the situation in Britain, adding a 'trend' of longer schooling to the 'bulge' in young population. The main change seemed initially to have taken the form of a virtuous circle of access and increased state dependency: 83% of university funding was public in 1966, compared with 53% in 1946, representing a growth in actual spending from seven million pounds to 157 million pounds per annum.[17] The Butler Act of 1944 prolonged education and empowered Local Education Authorities to grant allow-ances to students above compulsory schooling age. As a result, by 1950, students without means but with two passes in the Higher School Certificate typically had fees and maintenance paid, through a combination of state and university scholarships and county bursaries from Local Education Authorities.[18] By 1958, 90% of students received funding in

one or more of these forms. The Anderson committee on funding was convened to rationalise these supports and after it reported in 1960 the state provided standardised grants for students' fees and maintenance.[19]

The expansion of further and higher education was dramatic in part because access had been so limited before. For all these improvements, a UNESCO survey of 1957 found that still only Ireland, Turkey and Norway were less generous than Britain in provision of university places per capita. Only 4% of British school-leavers went to university, a quarter of the proportion of American school-leavers.[20] The Cold War contributed to concerns about this educational impoverish-ment, both ideologically and practically. How well a society educated its population tended to be used as a measure of its worth and success, while the rush towards technolog-ical progress depended on robust universities and ambitious research.

As art education widened within this larger expansion, its students' demands changed. The historian Howard Singerman has analysed this phenomenon in the USA, where he observed the impact that the GI Bill had on educational support of ex-servicemen: '[t]he gender of the veterans coupled with the career demands that they – or their age and gender – were seen to embody insisted, along with the federal government, on the stream-lining of art teaching and a professionalisation of its goals'.[21] The GI Bill brought some notable students to British art schools too, but a larger, structural parallel existed in the ex-ser-vicemen's grants available in Britain through the Further Education and Training Scheme. These grants were designed to remedy the war's 'severe interruption and distortion of further education and training',[22] a sentiment reminiscent of the motive behind the *Young Contemporaries* exhibitions. From a historical perspective the ex-servicemen's grants could be seen as a prototype, anticipating the demographic changes that state-funded higher education would bring, and acclimatising the state to an extended role in the provision of education. Having completed national service, students were perhaps older and

more worldly, qualities which might also account for increased art school engagement with the art world.[23] Art students were likely to be more socially diverse because state support had broadened the educational franchise: the proportion of assisted students had been 41.1% in 1938–9 but was 75.7% in 1956–7, a shift which meant that even as student numbers underwent dramatic growth, the absolute number of unassisted students dropped.[24] Students could also come from different regions: when an art school was validated for DipAD, those with grants-in-aid from any part of the country could study there.[25] Collectively, these factors point to demographic change, an important context for an analysis of changes in art education, especially those which arguably reflected the needs of the students who could now study art.[26]

TEACHING QUALIFICATIONS AND THE STATE

Accompanying the various species of grass-roots imperatives for the instrumentalisation of art education were demands made on the educational sector by the state itself. The reviewing committees of the 1940s to the 1960s had a strongly utilitarian thrust, which was perhaps vital in arguing the case for state investment in education. For example, the Robbins committee – chaired by an economist – was convened 'to review the pattern of full-time higher education in Great Britain and in the light of national needs and resources to advise Her Majesty's Government on what principles its long-term development should be based'.[27]

After the post-war expansion of secondary education, one of the principal national needs was for more teachers, prompting a contemporary commentator to say of the report on higher education generally: 'In considering the needs of the country in the present and the immediate future, the highest priority of all, even above the expansion of the universities, is given by Robbins to the supply of teachers.'[28] Similar might have been said of Coldstream's earlier report on art education. Robbins later told students in a lecture to

the RCA in 1964 that the key elements of Coldstream's report had been 'entirely in line with our central conception',[29] which explains why his own report scarcely addressed art education: of Robbins's 837 paragraphs, only three mention it.

Another signal of the importance given to training art teachers was the changing nomenclature of art school awards. The Burnham committee reports of the 1940s and 1950s set salary scales every three years for teachers in technical colleges, institutes, art schools and schools, distinguishing between graduate and non-graduate pay. This made the type of qualification art schools awarded materially important to those students who might want to teach. The Coldstream Reports' concerns with awards have often been interpreted ideologically, through a pedagogic lens. The transformation of the NDD into a less craft-specific more liberally-conceived DipAD now readily seems an academicising precursor to the adoption of the BA in art and design in the 1970s, which finally unified art with higher education more generally. It is probable, however, that the original intention was practical and concerned students' subsequent salaries as teachers; Coldstream's correspondence with the Ministry of Education as early as 1950 shows this to have been a bugbear from the moment he began as Director of the Slade.[30]

In this respect the equipping of artists with qualifications for their teaching careers parallels the increasingly professionalising process that transformed students into artists. Schools and art schools were the largest form of state patronage for practising artists since they enabled artists to support their practices by teaching, frequently on a part-time basis. Later, in its review of the data, the Summerson Report found that in 1969, 31% of DipAD students were teaching or working towards the Art Teacher's Diploma; amongst fine art DipAD students this proportionate figure rose to 42%. Summerson concluded: 'it must be accepted that many who receive an education in painting and sculpture will later make their career in teaching or other occupations which may allow them to continue practising as artists'.[31] Shifting the

THE SUNDAY TIMES *magazine*

OCTOBER 5, 19

Fred
Blenkinsop

A Retrospective Exhibition
Tate Gallery 1975

**A young artist dreams
of success.
But will he make it?**
Turn to page 62

award nomenclature was part of a wider instrumentalising process to make the art student more employable.

EDUCATION OR TRAINING, AND THE USELESSNESS OF ART

Increased state funding for education heightened the importance of rebutting charges of indulgence or pointlessness, to which art has always been vulnerable. To this extent both student needs and state demands pushed in the same instrumentalist direction. The art historian and critic Norbert Lynton (1927–2007) sounded a gloomily prophetic note in 1970 when he reflected that, '[i]n view of the philistinism and unimaginative short-term-mindedness of your average tax-payer and voter, the existence of any sort of publicly-financed art education is a very remarkable thing'.[32] Beyond philistinism and short-term-mindedness (which should probably have been attributed to politicians as much as voters themselves) were two further obstacles. One was the enduring perception of art as an elite activity, a view that would make funding art education regressive, as the many would be paying for the few. The other was art education's transparency: the public could engage with art school output, for example, in the form of degree shows, much more easily than with maths degree theses or exam scripts. The cost of this engagement was the disproportionate exposure of art schools to public criticism. As an article titled 'The Shortcomings of Student Art' which appeared in a 1969 art magazine noted, student exhibitions provide 'a window onto the world of art education useful both for those embroiled within it and those who pay for it'.[33]

Faith in accountability and usefulness was nevertheless controversial, touching as it did on a much older debate about education. Adam Smith had argued in 1776 that '[t]he greater part of what is taught in schools and universities [...] does not seem to be the most proper preparation for that business [the real business of the world]'.[34] Art particularly is supposed to be divorced from necessity, as Friedrich Schiller argued twenty years after Smith: '[a]rt is a daughter of Freedom, and must receive her commission from the needs of spirits,

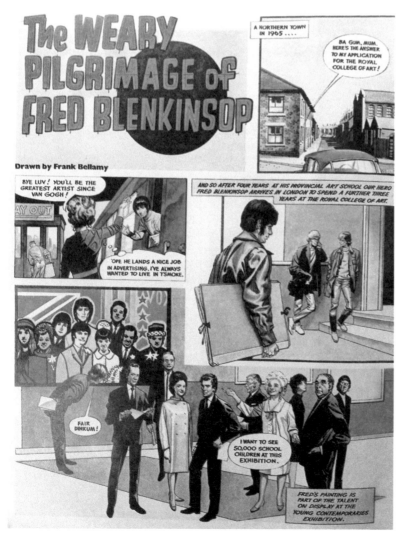

not from the exigency of matter. But today Necessity is master, and bends a degraded humanity beneath its tyrannous yoke.'[35] In art education, these two fields – in each of which freedom from practical application has historically had heightened value – overlap. The instrumentalist emphasis on objectives described, whether concerned with making artists or teachers, confronted those ambitions and ambiguities previously defended both by art and by education.[36]

PEDAGOGIC IMPASSE

This chapter has outlined the efforts made in the middle of the twentieth century to qualify UK art students for teaching and to help them engage with exhibiting and selling work. Despite the efforts made, success seems to have been muted and anxieties about long-term viability remained. Even at the end of the 1960s – after twenty years in which the art student's predicament was far happier than before or after – the problem of absorbing art students into the economy persisted. A 1969 cartoon strip in the *Sunday Times Magazine* called 'The Weary Pilgrimage of Fred Blenkinsop' dedicated three pages (plus the magazine's cover) to the failure of a fictitious promising artist who, having won a place at the RCA and exhibited in the *Young Contemporaries*, found himself with merely a half-day-a-week teaching job. The closing caption stated: 'After 7 years of training our hero cannot earn a living'.[37]

← Figs.3.3–6 Frank Bellamy, 'The Weary Pilgrimage of Fred Blenkinsop', *The Sunday Times Magazine*, 5 October 1969 (cover and inside spreads)

This limit to the instrumentalising ambition for art education perhaps reflected the student numbers involved: the active channelling of students into practice and teaching could only work with space available both in the market and in education for students to fill. Alongside numbers, there may also have been a more substantive hindrance to re-instrumentalising art education. If there were top-down efforts from the state, and bottom-up ambitions of art students, art departments themselves were not always strong proponents of these more practical

aspects of teaching art. The 1976 Calouste Gulbenkian report *Support for the Arts in England and Wales* found that in art education:

> Few of the art courses make any serious attempt to prepare students for life as an artist. Some of the most serious problems facing artists when they emerge from training are these: how to find and pay for studio space and meet the cost of materials and equipment; how to publicise their work and interest galleries in it; understanding how commercial galleries operate and what arrangements should be sought between artist and gallery.[38]

Instrumentalism could indeed be a dangerous objective. At its most extreme, it could lead to a situation where 'the fine art degree is increasingly converted into a business studies degree', as Terry Atkinson of Art & Language phrased it.[39] Even in a more moderate form, it could undermine the potential of education to offer students a socialising experience. As Isabelle Graw recently framed the problem:

> students are often confirmed in the belief that they must focus above all on marketing and professionalising themselves by courses that attempt to provide them with personal market strategies. This increasing penetration of market constraints into art academies promotes isolation – instead of trying to gain the approval of a peer group, students tend to feel that they need to concentrate on looking after their own interests.[40]

Finally, there was the question of status and its ambivalent relationship with the instrumentalising turn in art education. Broadening access to art education stimulated questions of purpose but it could also have revived the anxieties about status that already plagued a discipline characterised by manual as well as intellectual elements. John Carey has argued for a direct correlation between increasing literacy at the end of the nineteenth century – again through progressive educational reform – and the advent of difficult, exclusionary modernist literature.[41] Failure to embrace instrumentalist post-war ambitions for art education may similarly have indicated a desire to preserve status against a tide of social

diversification. Particularly so when exhibition is often bound up with the market and touches on contentious questions about the role of commerce in art. In such a context, the art school curriculum's reluctance to engage with more utilitarian aspects such as exhibition was a re-enactment of market-aversion. It was an entirely conventional – if historically inaccurate – positioning of the art school as an institution for classical education rather than vocational training.

CONCLUSION

Art education confronts the problem of how to make an artist – often considered an impossible endeavour if artists are meant to be born and not made – but it also raises questions of what to do with an artist once created. The expansion of further and higher education in the 1950s and 1960s, and the increases in state spending which accompanied it, amplified these concerns. Across education generally these developments heralded a more sociologically planned conception of education for its civic 'use' to further the national need.[42] Within art education attempts to answer these requirements were more specific; the professionalisation of practice through increasing exposure to exhibition and the promotion of teaching, were developments which were entirely consistent with this dilemma.

As James Boswell (1906–71), an activist artist involved in the Artists' International Association, wrote in 1947 when these issues were beginning to emerge: 'in the end you can't make painters, you can only make opportunities for them'.[43] The historical alignment of art schools with industry suggests art education has long sympathised with this sentiment. The post-war educational changes discussed in this chapter indicated a return to this long-standing interest in the consequences for art education of the new, increasingly post-industrial context. Through focussing on exhibiting and teaching, art schools were answering Boswell's call by helping to make opportunities for art students.

IV

THE MANY LIVES OF THE LIFE ROOM

INTRODUCTION: THE NUDE TODAY

The phrase 'the life room' elicits extreme reactions. It often smacks of reactionary aesthetics and dilettantish Sunday painters, a charge that extends to the belief that only the total eradication of the life room could free artists from a tradition that had strangulated generations. Indeed, by the late 1950s the life room had become synonymous with an old fashioned skills-based approach to the teaching of art that was stultifying innovation.[1]

↓ Fig.4.1 Keith Vaughan, Sketch of the life drawing studio, Central School of Arts and Crafts, 1950. Tate Archive

But in an historical moment when it is not uncommon to hear art students lamenting their lack of any skill-based teaching, the history of the life room can illuminate several elements of contemporary art training. Since the implementation of the Coldstream Reforms in the 1960s, arguments about fine art instruction and specifically the life room have polarised views about the means as well as the ends of art education.[2] Thirty-five years ago, Andrew Brighton addressed this issue gloomily: 'Since the conception was divorced from specific material practices and their traditions of skills and meaning, fine art education has increasingly become a vacuity sustained by institutional momentum, offering the ludicrous spectacle of an anti-academic academy.'[3]

The history of the life room is more complicated than simply a rejection of an outdated paradigm, and the narrative tends to raise more questions than it answers. The absence of a single mention of the life room in the 1960 Coldstream Report – Coldstream himself was one of drawing's most ardent apologists (see figs.4.2, 4.3, for example) – speaks to how the value of drawing was assumed, and its merits rested on an unspoken tradition.

→ Fig.4.2 William Coldstream, Sketchbook showing preparations for

life drawing classes, n.d. [1950s/60s].
Tate Archive

↪ Fig.4.3 William Coldstream with
students at his final life class at the
Slade, 1974

Could it be that the life room disappeared because it failed to develop a theoretical framework to justify itself within the growing conceptualisation of the art world? Artists and tutors individually tried to theorise drawing, but it was never done systematically in the manner of the emerging and competing conceptual art practices.

Though thinkers tried to renew ideas of drawing, the practice never received sufficient theorised attention to rank it as avant-garde and as innovative as any of the other practices taught from 1960 onwards – until perhaps today. Indeed, the recent celebration of contemporary drawing delineates matters clearly: current practice receives institutional validation through its difference to drawing in the period before the 1960s. 'Nowadays, there is no longer a question over whether drawing is a primary rather than secondary or preparatory discipline.'[4]

It is easy and inviting to dismiss such a skills-based attitude: practice and technique will always be bested in an argument about conceptualism, since practice and technique are not conceptual terms. Alternatively, it is too simplistic for those defenders of a figurative tradition to lay blame at predictable culprits. When one embattled figurative artist uttered, 'the Bauhaus fucked up art education', we realise how received ideas about Bauhaus educational philosophy bear little relation to historical accuracy.[5]

It has thus been too easy, for too long, to assume these polarised positions and to pit received ideas about Bauhaus, on the one hand, against assumptions about the 'academy' on the other. When Walter Gropius invited Oskar Schlemmer to lead a course

in drawing from the nude at the Bauhaus in 1921, Schlemmer articulated in his diary the challenges that have wracked art educators throughout the twentieth century: 'Drawing from the nude has fallen into disrepute among the moderns. The odium of academicism clings hard to it'; but he goes on to pose a prescient question: 'So what do we look for from the nude today?'[6] Schlemmer's answer to this question lies in the pages of his rigorous teaching syllabus on the subject of 'Man', which detail, along with notes on the natural sciences, psychology, philosophy, his theory towards a formal vocabulary which would free the human figure from the academy's neo-classical repertoire of forms. Elements of Schlemmer's intensive course in life drawing offered at the Bauhaus in the winter of 1927–8, could read, out of context, like a description for a life class at one of the most experimental art schools in mid century England.[7]

This chapter will revisit the twilight years of the life room in the 1950s as a compulsory component of a British art school education, an historical moment when many artist educators sought to prove its relevance in an increasingly skeptical art world. And I will argue that the incarnation of art education that has prevailed in the years since the Coldstream reforms owed little to those art educators who are credited with starting the revolution. For those artists and pedagogues,

discursive practice did not preclude skill or aesthetic considerations. It is exactly that intellectual underpinning and practical rigour, played out in the drawing studios of those early pioneers for educational reform, that has been long overlooked.

This chapter thus focuses on a short-lived historical moment poised between two art educational teaching paradigms – Basic Design and its pre-Coldstream educational model. At this time, art tutors believed that a reconfigured life room deserved a place in a reformed educational system informed by received ideas of the Bauhaus and filtered through Basic Design. Nevertheless, and despite the imperatives uttered by such progressive pedagogues as Harry Thubron and Richard Hamilton, 'the gap between the disciplines of the life room and the rigours of Basic Design' was not to be bridged, as the life room as a teaching tool disappeared from art schools across the UK.[8]

Disappeared, that is, until now. With the establishment in the twenty-first century of new rigorous courses such as Camberwel or Falmouth's BA in drawing (both schools that, not coincidentally, enjoy significant histories of pre-eminence in drawing), we can identify the true inheritors of the 1950s reformists who dared to craft syllabi underpinned by the connection between skills-based technical facility and theoretical discourse.

By focusing on a few seminal figures within the history of the life room and relying heavily upon archival research, this chapter examines the ideas and assumptions of a practice dismissed as backward-looking, but which in certain schools was wholly avant-garde. Perhaps the life room was never so interesting as in the moment before its death.

SHACKLED TO A CORPSE: REVIVIFIERS AND REJECTERS

Many educational pioneers in the 1950s, with the noted exception of Victor Pasmore, believed that drawing from the figure had a place in the progressive art school studio, and that drawing itself was a primary keystone to the visual arts. William Johnstone said of drawing: 'The facility has to be there. If you have no facility or no grammar … then it's desperate.'[9] Harry Thubron put the matter rather more simply: 'All you need to do is fucking draw. Do as much fucking drawing as you can and it'll stand you in good stead, and then you've got a chance.'[10] On similar lines, Richard Hamilton warned against the wholesale embrace of derivative Basic Design at the expense of the life room:

> The studies now known in Britain as Basic Design are gradually gaining a measure of support […] there is a danger that the methods will be misapplied and the attitudes distorted; the major distortion, to my mind, being the implication that basic design can teach art students to become Modern Artists, that Abstract Art is the objective of basic design studies. […] In art school training, at least, it seems imperative to bridge the gap between the disciplines of the life room and the rigours of basic design.[11]

For many of these artist-tutors, the problem wasn't with the life room as much as the way it had been used.

Unifying these artist-tutors and aligning them with their Bauhaus precursors was their rejection of an academic model of teaching that privileged imitation for the sake of accuracy. Rather than simply looking at an object, these teachers – from Johannes Itten to Thubron – trained their pupils to see the object in its dynamic relationship with other objects as well as the artist himself. In an interview with Maurice de Sausmarez in *Motif 8*, William Turnbull puts matters clearly:

De Sausmarez: *So, you think that each of the various things the student may study,* you mention, for instance life drawing, ought to be thought out in terms of a progressive introduction to the subject in which basic information and experience is gathered – in each case the teaching of a grammar of some sort?

Turnbull: *Yes, it seems to me ridiculous to teach life drawing the way I was taught, where we sat in front of a nude woman and tried to do a correct visual copy … If you were teaching life drawing, so long as you were explaining what is happening in some formal way, it seems to me it would be just as good a way of teaching it as any other. I do not think there is one way that is right and other ways [that] are wrong – it is the approach to the thing that matters.*[12]

But many other art educators viewed the life room as synonymous with regression, and they lacked either the inclination or interest to vivify the method in light of new art practices and materials.

In his series of articles on 'The Future for Art Schools', published in *The Studio* in 1961, Mervyn Levy considers the educational ethos of different establishments across the UK in the light of the Coldstream Report. Levy offers an insight into topical issues of concern at the moment that schools prepared themselves for accreditation on the new DipAD degree. In some cases, the schools viewed this moment as an opportunity to redefine themselves as a place of progressive thinking. After all, and in theory, 'the success of the schools will depend upon their individual interpretation', as Principal P.F. Millard of Goldsmiths observed.[13] For Millard (formerly Principal of St John's Wood and the Regent Street Polytechnic), the life room played an ancillary role in a broader curriculum:

> I am tired of the idea that the life-room should always be considered the nerve centre of the art school … There are many other 'centres' of equal importance during the years of an art student's training … To return to the life class for a moment: I remember Sickert saying to me once

that he considered the posing of a life model on the dais the most unnatural and pointless procedure in the world. At Goldsmiths we think of the life-class not as the Mecca of art training, but as one step in the development of an artist's overall skill.[14]

For these tutors, their attitude to the life room shows their forward-thinking attitudes: pencils and models were outmoded technologies and materials. The extent to which the faculty at Goldsmiths wanted rebranding as a cutting edge institution becomes clear in a discussion about the then recent establishment of an 'Experimental Film Group'. The tutor James Cranmer asserts:

I see no reason why the film should not become an increasingly important element in the pattern of art education. Why should the life-class still be considered the hub of art education? The whole idea of life drawing and painting is a Renaissance concept anyway, and quite out of accord with the spirit of our own time.[15]

Levy concludes his article with an overview. 'In these days of relentless seeking it is not a good thing that anything should be too sacrosanct. One must of necessity, criticize, break-up, even destroy in order to discover.'[16]

Levy's observation that art schools must 'destroy in order to discover' spoke to the spirit of the times: craft and skill were increasingly considered shackles to innovation, and only by destroying the ghosts of former masteries could the new age of new materials arise.

One of the most vocal and vitriolic rejecters of the life room was Victor Pasmore (1908–98). Pasmore's understanding of the Bauhaus informed his Basic Design course at Newcastle, where he taught from 1954 to 1961. Pasmore's conversion from figuration to abstraction (1947–8) played out in his antipathy to life drawing. He insisted upon formalist investigations of forms and materials separate from subjective phenomena: the student was taught to explore the relationship between materials as well as the

relationship of forms; sensual phenomena had little place in his understanding of drawing.

In private correspondence, Pasmore's colleague and successor Richard Hamilton described how Pasmore failed to shut down the life room at Newcastle because of the requirements of evening classes. To prevent this administrative obstacle from distracting promising students, Pasmore did what he could to stop them attending the life class: 'He didn't like figuration and he tried to get people out of the life class. In fact he … he would actually go into the life class and grab somebody who interested him and say, "You shouldn't be doing this. Come out".'[17]

Hamilton adopted a more nuanced approach, through which he taught his students to balance observation against their own invention.[18]

↘ Fig.4.4 Richard Armstrong, 'free' life drawing made during 'Invented Anatomy Week' whilst a student on the Basic Course, Newcastle, c.1964. Richard Hamilton Collection, National Arts Education Archive at Yorkshire Sculpture Park

In the same interview, Hamilton explains his tempering of Pasmore's conviction: 'When he [Pasmore] left I was able to become wider in my foundation thinking, more broader [sic] in its outlook, and I accepted the life class as being a focus of interest as anything else might be.'[19]

Checking Pasmore's polarised approach, Hamilton aligned himself in spirit with his Bauhaus precursors – and also distanced himself from a misconstrued understanding of Basic Design in the UK. These differing ideas and positions would become the major influences of the subsequent institutionalisation of art school curricula in the form of the Coldstream Report only a few years later.

PENCILS AND PARTISANS

A puzzle in the disappearance of the life room is the silence on the subject in the text of the Coldstream Report of 1960. Lisa Tickner cites

a conversation between Linda Morris and William Coldstream in 1985, in which she asked why the Slade kept its life rooms when the first Coldstream Report had, in effect, closed them across the country. Coldstream remembered that:

> while the Committee was sitting Victor Pasmore organised the Developing Process exhibition with Harry Thubron, Richard Hamilton and Tom Hudson, at the ICA [A Developing Process. The New Creativity in British Art Education 1955–65]. They were very successful with the Bauhaus idea and there was little I could do against the tide of opinion ... It should have been called the Pasmore Report, then people would have understood what was happening.[20]

Clearly, Pasmore exerted influence on two fronts. First, his dominant interpretation of the Vorkurs – an understanding that precluded Oskar Schlemmer's life room or Johannes Itten's drawing from the figure classes – explains the Coldstream Report's omission of the life room in the new curriculum.[21]

Second, the Basic Design ideas in the Developing Process exhibition, foregrounding formal and abstract student works, overshadowed the Vorkurs inclusion of more subjective and expressive elements.

Elena Crippa suggests that once Coldstream agreed that the Report should recommend such huge changes, 'the battle for the primacy and preservation of the tradition of realist figurative painting had already been lost'. She notes that if the report was shaped by Pasmore, then 'the end of life study was not an unintended consequence'.[22] Given the historical centrality of the life room to an art school education, it is possible that Coldstream would not have even imagined that it could be wholly forsaken. As a former student of Coldstream, Christopher Le Brun (b.1951) suggests, 'He probably took it for granted that drawing from the figure would remain integrated in some way.'[23] Perhaps Coldstream assumed, like many other educationalists of his era, that a plurality of approaches was feasible, in which drawing from the figure – in whatever manifestation that would be – would play its part.

Given the differences of view amongst members of the Coldstream committee, the silence about the life room must have been a compromise. After all, the broad outlines epitomised in the closing lines of the Report's first page – 'we think art schools should be free to work out their own ideas' – grants autonomy to leaders of individual courses at individual schools. It is clear that a belief existed that a training in figuration would prevail in some corners.[24]

The difficulty arises from the Report's open mandates. For instance, paragraph twelve explains that 'the fundamental skills and disciplines which underlie and sustain any form of specialisation in art and design should be practiced by all students'. Such a directive could have meant, for Coldstream, drawing from the figure; equally, it could have meant, for someone like Roy Ascott at Ealing School of Art, seminars in cybernetics.[25] As Norbert Lynton explained, the Report broadened the scope for art schools to meet the 'passionate demand for self-

direction'. But, by being so accommodating, it failed to protect an accepted practice.[26]

Without this safeguard, and with the explosion of art practices severing ties with an historical past that by 1960 looked decidedly dated, tutors and students turned away from the life room and ventured into the experimental workshop. As the life room was slowly removed, so went any importance attached to the human figure. Sculptor William Tucker remembers feeling 'liberated by the sense that sculpture could be constructed of any material, and its subject need no longer be the human figure'.[27]

In short, the life room had been protected under the status quo ante. There was never a dictate that signalled the end of the life room, but it disappeared from art education once the post-Coldstream curricular freedoms – with each school designing its own curriculum and its own examinations to a national standard – were institutionalised and following the establishment of the NCDAD, its inspections and accreditations. To administer the degree, Sir John Summerson nominated members of his Council to join sub-committees with their own chairmen to determine whether or not a proposed curriculum satisfied the new qualification requirements. Jon Thompson, later Head of Fine Arts at Goldsmiths, remembers:

> I think it was taken for granted at the time of the Coldstream Report that every art school would have life drawing classes, but I think it began to be eroded somewhat by the activities that occurred under the CNAA … The assumption was that drawing in a general sense would be an integrated part of any proposed course but how that was structured and how that was put into operation was looked at in relationship to the whole program.[28]

In the absence of a proviso protecting it, life drawing suffered institutional relegation: concept and process triumphed over product and artifact in the forms of pop art, formal abstraction, minimalism and performance art. In practice, this avant-gardism

was supported by the state: the NCDAD was a national assessment body that granted accreditation.

Pressures arose from within the schools, as well. Art students were eager to put their art in conversation with the work they saw in contemporary galleries: in their glamorous new galleries, dealers were showcasing new and exciting art forms, plucked straight from the student-artist studios. Nothing in these galleries resembled the pedagogical exercise of the life room.

Perhaps of even greater importance for the displacement of the life room was the attitude of its own tutors. The champions of the life room were reluctant to frame their practice in conceptual terms; indeed, they were reluctant even to extend support to each other. In short, a combination of discord and neglect hastened the end of the life room. Within five years, the central locus of an art education not only disappeared from curricula, but also disappeared from the design of art school architecture.[29]

THE WRONG SORT OF DRAWING

It was William Coldstream's misfortune that his name became shorthand to describe the work of the NACAE. In demeanour, Coldstream was sensitive and open minded, and his time at the Slade as Professor (1949–75) shows that he was an accommodating and enabling leader.

→ Fig.4.5 William Coldstream observing the life room from the balcony of his office at the Slade, *Private View*, 1965. Photograph by Snowdon/ Trunk Archive

Coldstream steered an unwieldy NACAE committee of thirty members with different agendas and egos to conclusions – a task no less daunting than that of his colleague, Sir John Summerson, who had to administer the new award with a committee made up of strong personalities, all of whom were invested in the future of art education.

A case study in the new accreditation process illuminates how committees reshaped

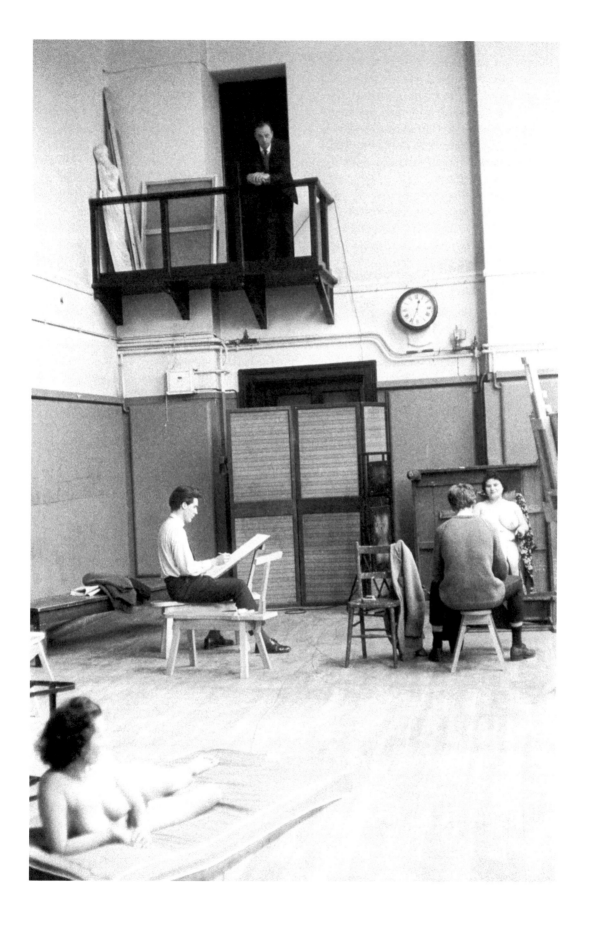

art pedagogy one art school at a time, and how these committees could foster unstated but critical 'tribal' positions that, at times, undermined common interest. For example, artist and tutor Andrew Forge participated in the Summerson sub-committee that in 1965 assessed Lancaster School of Art for accreditation; he explains the idealism behind what was an imperfect process:

> This was at the time when there was a huge amount of agitation about how art schools taught and what they taught, as you know. And the Coldstream Report was supposed to have brought an end to the centralised dictatorship of the Ministry of Ed[ucation], and with its exam, its central exam system, and was supposed to have liberated art schools each to do what it wanted to do … what was Mao's phrase? Let a thousand blossoms bloom or something? That was the idea about the British art schools. Each one would be, would be free to do what it most wanted to do. So that an art school, say, in Stoke-on-Trent would do all the kind of work that would be most appropriate to local conditions, and an art school with a long tradition, say, of printing or printmaking or bookbinding or something would be free to do that. And that was the idea. But of course [what] was completely left out of the count [was] the corruptibility and venality and general feebleness of the human race, and so things began to fall apart rather quickly.[30]

When the Lancaster School of Art failed to receive approval to offer the recently introduced DipAD – indeed, few of the smaller schools received approval on their first applications, and then only if they offered a specialism – the school's administration made new faculty appointments to reshape their curriculum and reapply. In response to the failure, the administration recruited a powerful figure from Leeds: Harry Thubron.

While at Leeds, Thubron constructed the Foundation Course (1955–64), in practice reinterpreting the Bauhaus *Vorkurs*.

↓ Fig.4.6 George Hainsworth, Life drawing made whilst a student on Thubron's Basic Course, Leeds College of Art, n.d. [1957–8]. Collection of the National Arts Education Archive at Yorkshire Sculpture Park

At Lancaster (1964–5), Thubron encountered a more conservative faculty, but he enjoyed working with fellow tutors who possessed highly skilled technical know-how. In Erik Forrest's words, Thubron 'saw the advantages of working with students of a more practical bent; art education here [Lancaster] could be less elitist, more down-to-earth'.[31] But Thubron's efforts and Lancaster's faculty failed to secure DipAD accreditation: in private

discussions and deliberations after review of the school's facilities, syllabi and students, the NCDAD committee rejected Lancaster's second application.

This rejection extended beyond qualitative judgments of the school and its resources. Jon Thompson recalls the preparations for the visit of the Summerson sub-committee, and unpacks the complicated agendas at play:

> I remember we had prepared the ground very carefully because as soon as we knew who the visiting panel were, we had a good idea we would be up against it. We knew they would make an issue out of drawing, so we festooned the college with life drawings that the students had done in the drawing classes so that they could see as soon as they walked through the door that there was no shortage of drawing going on.[32]

As Thompson anticipated, the Summerson sub-committee comprised artists/tutors who shared the Camberwell/Slade belief in an 'objective' approach to drawing. These committee members included Patrick George, former student of Coldstream at Camberwell 1946–9, and tutor/Professor at the Slade from 1949–88; Ian Tregarthen Jenkin, former student of Coldstream at Camberwell 1947–9, Secretary and tutor at the Slade 1945–75, and Principal of Camberwell 1975–85; and Andrew Forge, former student at Camberwell 1947–9, tutor at Slade 1950–64 and Head of Fine Arts at Goldsmiths College 1964–70. Such a committee expected specific things, Thompson believed, and Lancaster failed because it departed from the committee's understanding of drawing:

> The standard of drawing there [at Lancaster] was very, very high: Harry was a brilliant teacher of drawing … The college was lined with wonderful draw-ings, and yet they said there was no, what they called, 'real' drawing. You see, that meant Euston Road drawing, point-to-point drawing … Harry believed in life drawing, he thought it was absolutely essential. But what his view of drawing

was, and what their view of drawing was, were two entirely different things.[33]

↪ Fig.4.7 Experiments in Harry Thubron's life room at Lancaster School of Art, n.d. [1966–8]. Collection of the National Arts Education Archive at Yorkshire Sculpture Park

Personal opinion is always partial, but by all accounts, Thompson and Thubron agreed on this issue. No effort was made to conceal Thubron's strained relationship with certain factions of the art establishment, so tensions were high before the assessment began. Moreover, the visit was directed by Patrick George, who championed Coldstream's approach to drawing, foregrounding precise recording through a system of measurement from fixed points.

Relying on objective measurement and empirical accuracy, this approach had unseated the beaux-arts tradition that domi-nated the Slade before Coldstream's arrival in 1949. In Patrick George's view:

> We felt we had something to say – [that] the work that was being done here really harked back to the whole Beaux-Arts tradition of draughtsmanship – Augustus John – 'drawing based upon anatomy', but [it was] drawing that was already discounted, debased, drawing based on drawing that had been based on anatomy, all removed into an 'art style', so I did feel quite strongly about it.[34]

It was this inheritance of a house style – what George memorably phrases 'drawing based on drawing that *had* been based on anatomy' – that Coldstream sought to transform. He and others found at the Slade derivative work and self-quotation. Coldstream's practice of observational realism thus offered a newly conceptualised paradigm for the life room.

James Hyman argues that the post-war revival of interest in the Euston Road School conflated its achievements with those of Camberwell School of Art.

→ Fig.4.8 The life room at Camberwell, *Private View*, 1965. Photograph by Snowdon/Trunk Archive

As he explains, 'it was largely in this mediated form, through the arrival of students who had studied at Camberwell, that the ethos of the Euston Road School was carried into the Slade'.[35]

What was underway, then, was the reestablishment of a national tradition of drawing. As Hyman explains, 'Young painters now had a template for realism that dispenses with the elegance and refinement and emphasized its basis in hard-won labour … It acknowledged national precedents whilst also creating something new.'[36] Coldstream saw himself within a national lineage, and his respect for continuity with the past is significant: however open-minded he may have been, he believed in the solidity and

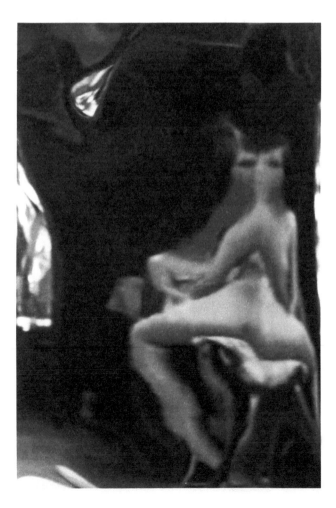

perseverance of an English tradition premised on the study of the life model.[37]

Emma Chambers has written about how Coldstream's arrival at the Slade precipitated changes in drawing instruction, and how he maintained the life room at the heart of the curriculum, but in a modified way.[38] But to many tutors and students alike, these changes were discreet to the point of indiscernibility. Nevertheless, Coldstream's interventions signified a predominant shift in attitudes – as well as furniture:

The refurbished Antique Room: This hitherto hallowed shrine to classical nude sculpture, was transformed with the introduction of indoor plants which turned the room into a kind of conservatory decorated with sculpture. He added an aquarium tank. The casts were still there to be studied but seen in a new environment of still life, for drawing or painting, rather than as dry reminders of academic pedagogy.[39]

In other ways, anachronistic practices such as the continued sexual segregation of the life room (until 1959) compromised Coldstream's reforms: 'There were two life rooms: one for men and the other for women. The male life room was treated with the greatest seriousness and was the home of a clique of Coldstream's "boys".' Paula Rego, a student at the Slade under Coldstream in the early 1950s, recalls that Coldstream considered the time spent by women artists at the Slade was 'ideal preparation for being an understanding wife of an artist'.[40] Coldstream's legacy at the Slade rested on the modifications he effected to the teaching in the life room itself. Perception and process trumped outcome or anatomical precision; observation and sincerity trumped style and method.

Ironically, Coldstream feared that his own approach to draughtsmanship might become a basis for teaching.

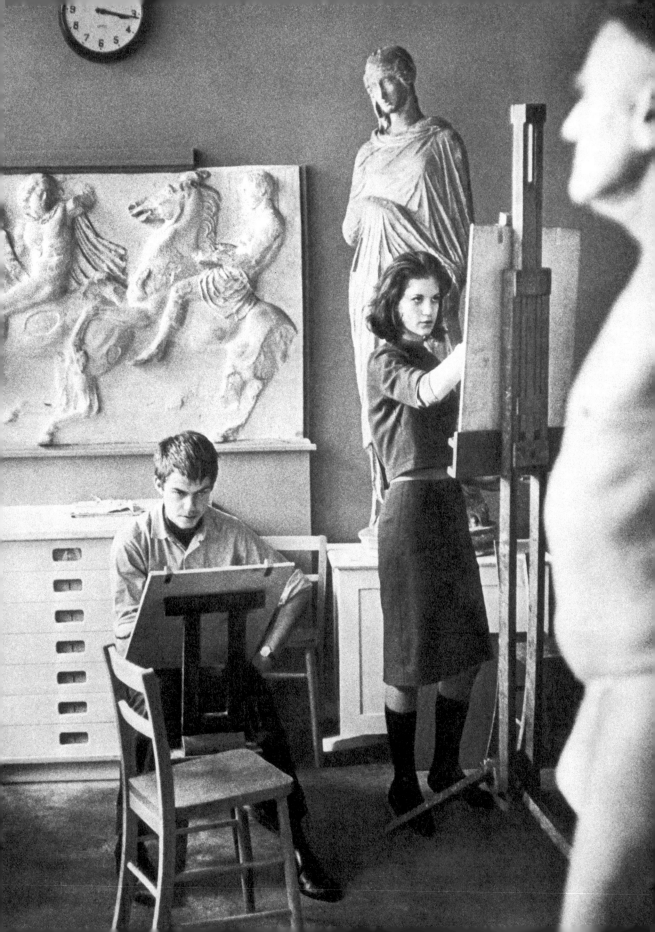

Although Coldstream continued to teach – supervising for many years a small life class, with six-week-long poses for paintings – he emphatically did not want to impose anything of his personal style upon others.[41] Anxieties over a subjective 'method' or 'style' thus led him to open the Slade to a diversity of approaches and influences.

Artist Ken Adams remembers how, during his time as a painting student at the Slade, a student enjoyed a panoply of approaches to the life room.[42] In addition to the dominant Euston Road conventions around the model – plumb lines and measurements – two teachers offered a dialectic to the student. One teacher was Frank Auerbach (tutor at Camberwell 1958–65; tutor at Slade 1963–8). A former student of David Bomberg (1947–53), he was part of the so-called 'Bomberg Movement', who embraced that artist's methods as a way of escaping the prevailing influence of the academic tradition.[43]

↓ Fig.4.9 David Bomberg demonstrating to a student in his life class at the Borough Polytechnic, 1947/8. Tate Archive

Auerbach led the life room on Mondays, and had an energetic teaching method. He would encourage the student to stand back from the easel and apprehend their subject at length before vigorously charging at the canvas. The second teacher worked in the adjacent studio: Harold Cohen (tutor at Slade 1962–5) taught patiently his 'recording of the cerebral process'.[44]

Despite Coldstream's best efforts to foster plurality at the Slade, the teaching and drawing came to be identified with Coldstream's own perceptual approach, as had happened at Camberwell. Coldstream's wariness of a 'subjective method' was not shared by the champions of his ideas. As is often the case with charismatic art tutors, it is the students of a particular tradition, rather than the innovators themselves, who work hardest to keep a tradition alive.[45]

While the Coldstream cadre sought to render the 'rigorous perception of the world's features', Thubron encouraged an awareness of the dialectic between intuitive mark-making and empirical analysis, of working from abstraction and from nature. This focus combined close control with almost anarchic energy – a combination that the evaluating council viewed suspiciously. In their refusal of the application, the committee argued that the work at Lancaster had been the product less of a curriculum than of one strong personality.[46]

After Lancaster was refused accreditation, with no right to appeal, Thubron left and Thompson took over. Forge's account reveals the complexity of the issues at stake: artist-tutors were heavily invested in

shaping the future of art education, yet they disagreed on fundamental principles. Just as Thubron perceived the Slade cohort as prescriptive in their approach, so Forge suspected that the alternative pedagogical approaches were equally oppressive, a further indication that certain factions of the art establishment felt threatened by these new experimental approaches. Forge recalls:

> One of the strongest dogmas had to do with those people who had, from the early Fifties onwards, been trying to resuscitate if you like, the Bauhaus theories of basic, basic form teaching, and Victor Pasmore was fanatically concerned with that. He had several followers, and he had gone up to Newcastle, Lawrence Gowing had taken him up to Newcastle, and he had set up this course, based very very much on the Bauhaus basic form teaching. And he had people like Richard Hamilton helping him there. And many [others such as] Harry Thubron ... and this [...] didn't seem to me at all a good idea.[47]

For Forge, 'basic form teaching', or Basic Design, entailed fundamental differences in pedagogical approach. As Forge explains, 'I firmly believed that young students should be taught to draw in the most straightforward way ... I really believed all the way through, and I still believe, that there are only two ways you can learn anything about painting; one is by working from nature, and the other is by looking at a lot of pictures, and figuring out how they're done.'[48] Forge rehearses a time-honoured position: through the process of imitation, practice and study, a body of visual knowledge is accrued.

Opposed to this view stood Thubron's approach. Thompson's recounting of Thubron's method is useful here:

> Harry saw drawing as a dynamic activity, not a kind of passive recording activity. His classes were a liaison between him and the model ... it was like a combination of anatomy and drawing from observation, but not drawing from observation in a

> point to point way but in trying to match the dynamics of the figure.[49]

Where Forge saw drawing as an engagement with traditional techniques and modes of seeing, Thubron insisted on the unity of experience between seeing and making – a dynamism between eye, hand and intuition.

The issue of the right or wrong way to draw masked a philosophical shift in pedagogies. As viewed by pedagogues like Herbert Read (1893–1968), art and aesthetic experience began in childhood and developed organically to include many different fields of inquiry; in short, this experience grew into a general education through art. Read's ideas offered Thubron and other exploratory tutors a scholarly framework for their pedagogical investigations, and broadened their ideas beyond the society of the art schools.

Read's interest in child art and 'primitive' art encouraged the idea that creativity was innate; Thubron's own experiences of teaching in secondary schools supported this view.[50] It is no surprise, then, that Read used an illustration from Thubron's Lancaster course as an example of the best work going on in English art schools in his book *Art and Industry*.[51] Read had been outspoken about his disillusion with art education. Targeting the RA, RCA and Slade, he argued that they perpetuated 'a defunct tradition'; as early as 1952, he demanded a complete overhaul of the status quo: 'No harm would be done to art, in any vital sense of the word, if all this vast machinery of life classes and antique classes were abolished.'[52] Thompson's experiences coteaching at Lancaster with Thubron underscore the correlations between Thubron's approach and Read's philosophy about how 'learning and acting and thinking all had to come together around the aesthetic'.[53]

There is a clear disjuncture in ideas between Read and Coldstream, 'an establishment academic who still believed in fine art as the necessary adjunct to a training in design'.[54] The two theorists liked and respected each other, but they disagreed on the question of art education. Thompson suggests that there was significant establishment resistance to Read's overriding belief in

holistic learning – specifically, that art educa-tion is integral to general education. Coldstream voiced this resistance, advocating an art education that needed, he believed, 'a broad, intellectual improvement' – a goal he achieved by including compulsory art history in the DipAD curriculum.[55]

Despite their differences about art education, Read and Coldstream neverthe-less embodied an exclusive intelligentsia noted for its 'ineluctable elitis[m]': it had a social conscience but lacked the common touch.[56] Contrarily, Thubron emerged from an entirely different social and political background. Although sharing Read's ideas about the centrality of art education, Thubron demanded a direct engagement with the world that Read's and Coldstream's political idealism neglected. As Thompson explains:

> When you think about their [Coldstream's] backgrounds they all came out of public schools, they were all 'book educated', and they had ended up in a reasonably privileged position. Their art education had taken place alongside of that … so that is the kind of people they were. They were quite antagonistic towards Herbert Read's idea that there was another kind of education that was not being touched upon in this process.[57]

Thompson here broaches the uncomfort-able but unavoidable subject of class divisions. Despite Coldstream's political idealism – for instance, his important work for the GPO, as well as his choice and treatment of subject matter in his own painting – he continued to represent, through his background and standing, a class of 'book educated' profes-sionals.[58] Thubron never fitted this mould, and he remained resolute in his hope for a new model of art education that was 'less elitist, more down-to-earth, more closely related to the "real" life of the country'.[59]

THE LIFE ROOM AS IT WAS LIVED

The irony of this divisive history is that each camp – the Summerson cohort, the

establishment players, Thubron with his cadre – in their own and different ways, worked towards the same end. They all sought a revitalised art educational model that disrupted the prevailing status quo. And despite their antithetical approaches, they all prioritised drawing. As Thubron noted, 'Whatever sort of artist you are, whatever artist you become, the figure is as compelling as it ever was historically.'[60]

That these divided camps should share an appreciation for drawing (if not the approaches to its instruction) is not surprising. Every art tutor of that generation – that is, every art tutor involved in the fracas at Lancaster, for example – had undergone a rigorous art education system, assessed by the Ministry's Drawing Examination, which viewed drawing as a critical foundational skill.[61] Training in drawing was central to the curriculum brought in under the new national qualifica-tions introduced in 1946: known as the Intermediate Examination in Arts and Crafts and the National Diploma in Design [NDD], this degree considered drawing in conjunc-tion with experience in other areas.[62]

From this point until higher art education changed under the Coldstream reforms, students were required to have two years of general studies on the Intermediate course, then two years of more specialised study from a range of art and design areas for the NDD. Despite this examination system's numerous limitations, it represented the last moment in English art education that students learned to draw based on an understanding of representational figuration, a tradition that had begun in the Renaissance.

In this traditional curriculum, the life room became the 'nerve centre' of the art school. The room had its vocabulary of formal terms, and an array of technical tools like the 'donkey' (a kind of easel), plumb lines, mirrors and calipers. Every student from every discipline spent hours in this space. In no small way, the life room offered a shared experience to all art students: despite differences in background and facility, they all began at the same point.

The first Intermediate requirement was a student's demonstrable facility in 'Drawing

from Life'. A typical training session would begin by the tutor's arranging a model in a pose, after which the student would start drawing at the donkey; the tutor circulated the studio, marking the student's attempts. These criticisms most often took the form of 'corrections' drawn in the top corner of the student drawing; occasionally they involved marking the student's work itself. David Annesley remembers the demands of this scrutiny:

It was very hard work in those days. You went in and sat in the studio and worked all day at an incredibly intense level with an incredible amount of criticism and very good teaching … Vivian Pitchforth was very well known, and he was stone deaf, it could be very embarrassing. He would come down and sit on your donkey or next to you, somebody would cart a donkey around for him to sit on, and he would hold forth and he would boom and his horrible comments would be broadcast to the whole room! You would dread him coming round. He would say 'this is how it works, this is how a shoulder's done, your perspective is wrong'. It was seen that you couldn't do art unless you could draw and draw really well, better than average.[63]

Annesley's account shows the significance that a single tutor could have in the life room. A legend in the life room, Vivian Pitchforth ARA ARCA (1895–1982) taught at St Martin's from 1930 to 1965 and at Camberwell from 1926 to 1965.

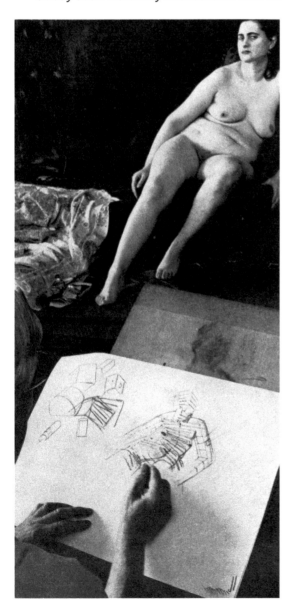

← Fig.4.10 Roland Vivian Pitchforth drawing from life, from an article by Mervyn Levy, 'Draftsman without Portfolio', *The Studio*, January 1962

Jon Thompson's recollections of Pitchforth's facility confirms Pitchforth's skill. He drew in a fluidly linear manner but, for students, Pitchforth developed an instruction method that viewed the figure as composite structures; he did so to emphasise volume and form:

One begins by thinking the three masses of the skeleton. The head, the thorax, the pelvis. Everything hangs on these. Upon their alignment, their movement, and of course upon the movement of the limbs that alter their position and angle… Think these three masses and the effect of their alignment and shape upon the appearance of surface form before you make any mark on the paper. Too many students start to draw before they have thought or seen anything.[64]

In this brief example of Pitchforth's approach – that is, the instilling of a method of

seeing as well as a valuing of a specific type of drawing – his pedagogy and his facility illustrate precisely the force of the institution-alised tradition that students encountered on the NDD.

Many artists found this model of education stifling, often smothering personal creativity with technique. These experiences and reactions brought to light the discipline behind drawing, but also the limitations of its methods of instruction. For this reason, progressive pedagogues hoped to develop new methods of drawing instruction that addressed contemporary culture and new art practices.

Two models nevertheless were predomi-nant in the field. The fundamental difference

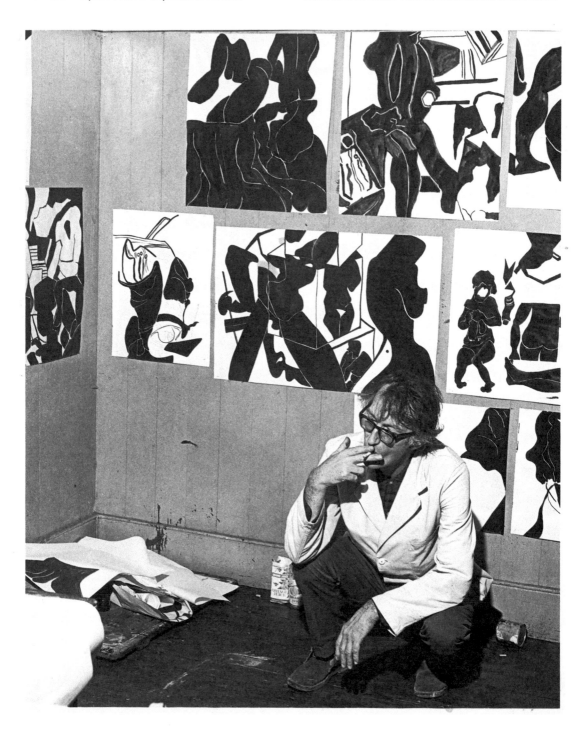

between Thubron's and Coldstream's conceptions of drawing lay in the way that perceptual drawing was understood. The Slade still emphasised close and measured observation. Thubron, contrarily, would allow his students observational drawing only *after* extensive exercises in 'analysis' and 'synthesis': he would examine the modes of perception (through mathematical ratios and sequences), consider tone, colour and shape relationships, and study other artists' treatment of these elements. For Thubron, this blend of analysis and synthesis balanced objective and subjective responses. This method avoided 'the false routes of "copying" or "imitation"':

> as marks were made on the paper or canvas, they were in some way related so the recognition that something new and of individual meaning was being created. The 'mark' was an important concept. 'Man and his mark', Thubron used to say; this phrase indicated the importance of that externalization of the individual's reaction to the universe...[65]

Thubron later reflected that 'Drawing is really a process centred upon a question which in turn demands an objective answer.

Drawing is not a copying process dependent upon manual skills; drawing follows the process of thought and enquiry and is a constructive and emotive response.'[66]

The intellectual energies that Thubron brought to his conception of drawing took physical form in the life room itself. Thubron's life room was aswirl with motion.

← Fig.4.11 Models climbing on scaffold structure during life class at Barry Summer School, n.d.[1961–6]. Collection of the National Arts Education Archive at Yorkshire Sculpture Park

← Fig.4.12 Harry Thubron in front of life drawings, Kingston, Jamaica, 1969–70. Collection of the National Arts Education Archive at Yorkshire Sculpture Park

↓ Fig.4.13 Life models in Harry Thubron's life class, Kingston, Jamaica, 1969–70. Collection of the National Arts Education Archive at Yorkshire Sculpture Park

Four or five models would wander the space; working quickly on large pieces of newsprint on the floor, the students were encouraged to apprehend the dynamic of movement, rather than specific frozen glimpses of the models' aspects – a cinematic rather than photographic sense of the space.[67] Norman Ackroyd remembers the insistence with which Thubron would instruct his students:

'He was, draw, draw, draw.'[68] Thubron's demanding methods worked on the assumption that such energy and rigour could make 'you think quite differently, really'.[69] By making you 'start to think differently', Thubron brought to the life room a vitality that extended beyond intellectual exercise. He challenged his students to encounter the physicality of their work: in contact with the models, with props, and with each other, they would experience the 'presence' of their work.

Obviously, such engagement did not lend itself to neat 'accuracy'. Thubron prevented a student's 'stepping back' from the work: the drawings were immediate, direct and spontaneous. Working with soft charcoal, the students would smudge and smear lines, creating an interplay between what is seen and what is felt – a far cry from Coldstream's measured 'dot and carry'.

Unconscious spontaneity, for Thubron, could release the student from preconceived ideas about what a drawing was meant to be. He broadened the student's vision of the physical space undulating with models, as well as the psychic space of a subjective reaction to this motion. Ripped papers, smeared lines and half-erased forms testified to the spontaneity of response and the release of feeling.

Thubron's experiments were not the only type of reconsidered life room, however. Although historians group Thubron with Basic Design, there were fundamental differences between his approach and the approaches of Pasmore, Hamilton and Hudson. These differences fell chiefly on Thubron's greater emphasis on intuition and 'a more vital and intuitive pursuit of the instinctive mark'.[70] The 'total immersion in a new physical and mental approach to working with the figure' seems to share similarities with the pioneering pedagogical methods developed by Clifford Ellis at The Bath Academy of Art in Corsham.[71]

Like Thubron, Ellis drew heavily from theories of child art. He considered how an unconditioned, untrained child could 'see' more freshly than a well-disciplined student. Ellis shattered assumptions about the life room 'to stimulate intuitive gestural painting'; he effected a 'transformative process' which Peter Lanyon described as 'starting in an extreme awareness of oneself in a place, [and] ends in an extreme awareness of oneself in a painting'.[72] To prevent tutors revealing their prejudices, he encouraged them to teach outside of their specialties: for instance, an abstract painter like Adrian Heath would find himself teaching photography and life drawing. As Margaret Garlake notes, Heath combined this training with his familiarity with cubism, so his life room, too, became a dynamic space: models wandered without poses, and the students rendered their unconditioned responses – often without pausing to lift hand from paper.[73] Such similarities in approach and objective belie the accepted notion that teachers of Basic Design objected to Ellis's methods.[74]

While novel in Britain, Thubron's and Ellis's methods shared characteristics with those of certain teachers of the Bauhaus *Vorkurs*. Itten used his Bauhaus life room to release his students from 'dead conventions', generating a 'wild whirl of production'. He believed in the whole body's involvement in drawing, so he opened his sessions with breathing exercises and massages – an element that Thubron had tried unsuccessfully to introduce in his own classes at Lancaster.[75] Itten emphasised rhythmic drawing and would show by example his understanding of what it meant to draw. The effect was striking, even for his colleagues; as Paul Klee described in a letter:

> He grasps a piece of charcoal, his body gathers itself, as though he was charged with energy … [He draws] two energetic strokes, upright and parallel to one another … the students were instructed to do this as well. The teacher checks their posture. Then he instructs them on the stroke, then he tells them to do the same assignment for homework. It seems to be a kind of bodily massage … One page after the other is ripped up and falls to earth. Some work with such great force that they use several pages of paper at once.[76]

This was not academic draughtsmanship; this was drawing as a full-body performance.

THE CHRONICLE OF A DEATH FORETOLD

Despite the initiatives of a few tutors who saw in the life room a new future for drawing, art schools nurtured a prejudice against the space as traditional and conventional. It was as though closing the life room granted the imprimatur of progressive instruction.

Jon Thompson claims to have been the first to close the life room after he became Head of Fine Art at Goldsmiths. His objections to the life room represent the general theoretical consensus about its power dynamics, particularly gender dynamics, a topic – and this is a telling silence – hardly touched on in this source material:

> What I was not happy with was with what I call the 'drip down' power structure that was the drawing studio. First of all, I didn't like what it did to models … What I could never accept was that they [the drawing tutors] couldn't quite see the fact what they were doing was setting up the woman … always the woman as some kind of object of a certain kind of scrutiny which was justified back over art historically, but in fact represented a kind of power structure that they were at the pinnacle of.[77]

In addition to his concerns about this patriarchal power structure, Thompson worried that the life room damaged the creativity of the student; in his view, it was never a 'neutral discipline'. When confronted by tutor and artist Leonard McComb about the few students in his life room, Thompson parried that 'the standard of drawing in the school is perfectly good; it is not a problem … why should I drive people into the life room when they obviously prefer to draw in some other way or to learn to draw in some other way. So I closed it.'[78]

After formally closing the life room, Thompson employed for a few days per week a handful of models, whom the students could reserve should they wish. Thompson thus paid lip service to the availability of such a resource; in reality, the closing drained any formal instruction from the practice. This erosion spread across art schools around the UK in the decade following the Coldstream Report [1960].[79]

By the mid-1970s, the resistance to the life room was so strong that sculptor Hubert Dalwood was vilified by nearly an entire faculty when he tried making it a requisite component of a sculptor's training.[80] Appointed in 1974 as Head of Sculpture at Central School of Art and Design, Dalwood assumed his position under Head of Fine Art Robert Clatworthy, with whom he shared a commitment to a skills-based training. Dalwood was clear in his intentions: he wanted to reform sculpture instruction, a decision that would require a significant shuffling of school staff.

Central's archives detail the many tensions between Dalwood and faculty. These tensions arose not simply over Dalwood's style of leadership but also his belief in a skills-based curriculum. Disgruntled tutors enumerated their complaints:

> Hubert Dalwood has his first meeting with his staff since starting in the dept. He outlines some details of proposals for next term:
>
> 1. That life modeling should be re-started.
> 2. That there will be regular drawing criticism.
> 3. Attendance will be monitored more closely.
>
> These are given to the meeting as directives.[81]

Dalwood's ideas were considered both reactionary and anachronistic. In a private and confidential letter to the Board of Governors, Dalwood laid out his position:

> As I understand it, the general notion [in the Sculpture Department] was to confront students with the question of

their identity as artists and to question the whole nature of creative activity in general … In my view most students go to art college, because, quite simply, they wish to paint and make sculpture. Esoteric projects do not help them to make decisions about their own direction, and students are often no more than cyphers in experiments with avant-garde notions that the staff happen to be seized of at the time.[82]

Dalwood wanted to restructure the department with the appointment of two full-time lecturers of fine art, replacing part-time tutors.[83] He also wanted to concentrate on the first-year group and its level of drawing instruction. In short, Dalwood intended to establish a 'comprehensive drawing course for painters, sculptors and printmakers'. His intentions infuriated the part-time tutors, but he shared equal vehemence in his criticism of the department's valuing 'process versus product':

> *Projects have tended to be directed towards the production of ART rather than towards the stimulation of student sensibilities which ultimately may lead to art.*

The tutors roundly felt that their reactionary Head of Department was recovering an 'outmoded educational model' and effecting 'a retrogression to a kind of provincialism which the major art colleges managed to break out from some forty years ago'.[84] Dalwood remained resolute in his insistence, justifying his need to appoint new staff on a simple basis: 'I have at the moment too many art-theorists and not enough artists.'[85]

MARGINS AND DISLOCATIONS

Dalwood's delineation between art theorists and artists might be flip, but it identifies the polarised attitudes to the life room. No more a traditionalist than his former colleague Harry Thubron, Dalwood nevertheless was decried as revanchist. For pedagogues like Dalwood and Thubron, the life room was a communal space where students, under rigorous scrutiny, studied the interaction between the artist and the model, and between the artist and the drawing. The life room was nothing short of an immersion in the process of making.

The figure remained essential to these ends since, in Thubron's words, 'Whatever sort of artist you are, whatever artist you become, the figure is as compelling as it ever was historically.'[86] Whether an artist's work relies on mark-making or perceptual realism, the life room challenged students to engage with their subject with an intensity of directness simply irreproducible in any other form. Thubron's insistence on seeing oneself in the process underscores Itten's emphasis on an awareness of one's own self – even one's own body – and its relationship to the process of making. The life room, therefore, does not simply serve perceptual realist art; it also offered a pedagogical tool to further understand the fundamental process of making art, whatever the end product.

Although the Coldstream Report left open the possibilities for art schools to maintain the life room should the school's faculty and administration want it, the reality was rather different. Since each school required accreditation to award degrees, it had to anticipate the tastes and even prejudices of the evaluating councils. For this reason, innovative approaches to the life room were discouraged. Fresh ideas about child art and the organic development of an artist, or under-appreciated elements of the Bauhaus *Vorkurs* were forsaken, because, as we have seen, evaluating bodies had the 'venality and general feebleness of the human race'.[87]

In a piquant turn, the most ardent proponents of the life room could actually have precipitated its demise. They were outliers and dislocated figures who populated the margins of ideas and locations. In fact, all of the new propositions for the life room emerged outside of London.

Such dislocation is not coincidental. At the same time that institutions began enacting Coldstream reforms, provincial art schools were administered by tutors almost uniformly trained at the Royal College of Art. Across the

nation, a large proportion of art tutors had been Associates of the Royal College of Art (ARCA) through the late 1940s and 1950s – exactly the decades anticipating the Coldstream Report. Such an affiliation influenced their perspectives, curricula and teaching methods; nor is it difficult to track the influence of a single tutor at the RCA through generations of regional tutors and their own students.

Given the heavy influence of the RCA among art tutors across the nation, a dominant style had emerged, especially among the Drawing and Painting departments. Under Coldstream's direction, the Slade was considered by some critics as representing the central British tradition. It is thus no coincidence that Coldstream clearly viewed himself as continuous with a national tradition, inspired by Sickert's work as well as Sickert's own positioning of himself at the centre of distinctively English tradition.

Read in this manner, art education strangely tracks a post-colonial model. The capital-trained tutors radiated to the provinces and exerted a national tradition through teaching; but, given the exigencies of local conditions – a point that the Coldstream Report highlighted – these provincial schools became sites of innovation and exploration. When the central governing body evaluated these colonies, the evaluators found pedagogies unacceptable to their views, and they encountered the work of outsiders to the dominant tradition. The life room could thus be read as a casualty of a waning empire – sharing exactly the historical marks of the seismic social changes afoot in the cultural, political and social upheavals of the 1960s.

← Fig.4.14 From William Coldstream, Sketchbook of life studies, 1983. Tate Archive

(V)

ART HISTORY IN THE ART SCHOOL

THE DipAD AND INSTRUCTION IN ART HISTORY

The Diploma in Art and Design (DipAD), introduced in 1960, required art schools to enrich the student's experience intellectually by offering teaching in art history. From that point and for well over a decade, the issue of art history teaching was of key concern both for the art school and for the development in the UK of art history as a discipline. This chapter will take as a case study the teaching career of the art historian Michael Podro to examine how these changes came about and estimate their impact on the development of art education.

The DipAD had gradually replaced the National Diploma in Design (NDD) following Coldstream's recommendation that 'the history of art should be studied throughout the course and should be examined for the diploma'.[1] This was not the only change to the curriculum that Coldstream recommended: 'All diploma courses should include complementary studies. By this we mean any non-studio subjects, in addition to the history of art, which may strengthen or give breadth to the students' training'.[2] The account written later by the painter Robert Medley (1905–94) stressed the importance of this non-studio teaching and described how Coldstream had 'cut through the complications of a piecemeal system at a stroke by proposing the abolition of the old examination and its replacement by a system which gave the individual art schools more autonomy and responsibility'.[3] The new arrangements would allow art schools to devise their own courses and administer their own examinations, properly monitored by external assessors. The study of both the history of art and liberal studies would extend the student's general education to a level proper to the academic status of a degree offered by a university. Medley describes the latter as 'a development with which I had great personal sympathy; as an examiner I came to value a school by the success with which it integrated History of Art and Liberal Studies into its total approach'.[4]

Concern and conflict arose around two aspects of these new curricula requirements:

first, the academic level of the work and second, the time to be spent on it. Art schools admitted DipAD students on the basis of 'O' or Ordinary level passes, typically sat at the age of sixteen. Universities, however, required passes at Advanced level ('A' level) sat at eighteen. On the second point, art history and complementary studies formed fifteen percent of the course and were to be taught and examined alongside the students' practice-based work.[5] However, the report did not set out the syllabus to be studied, suggesting only that 'every course should cover the history of the major arts in several significant periods of time'.[6] This reads as a conventional academic aim but in the context of the early 1960s art schools it was contentious. As writer Susie Harries recognises, 'History of art could easily be projected as formal, elitist, conventional, a subject that put creative but ill-educated art students at an unfair disadvantage'.[7] However, as we shall see, in responding to this concern, and with decisions on course content left to individual schools, opportunities opened up for creative, forward-thinking art historians to teach in art schools.

The NCDAD, chaired by the academically minded architectural historian John Summerson, administered the DipAD. To implement the Coldstream recommendations it set up five specialist panels: Fine Art; Graphic Design; 3D Design; Fashion and Textiles; and the History of Art, which was chaired by Nikolaus Pevsner (1902–83).[8] Where the syllabus requirements for the art history and complementary studies components of the art student's education were vague, the mechanisms deployed to support this aspect of the curriculum were very clear: 15% percent of course time; 20% of the final assessment; failure to meet a minimum standard would lead to referral; specialist external assessors; and specialist evaluation, validation and re-approval of courses. As art historian Conal Shields later reflected: 'These five elements … formed a guarantee of respectability for studies in Art History and Complementary Studies, albeit at a minimum level, and allowed a degree of autonomy in the planning and execution of courses'.[9]

MICHAEL PODRO

In the wake of Coldstream's report, Leonard Daniels (1909–98), then Principal at Camberwell School of Arts and Crafts, began to think about how to structure a new Art History Department.[10] John Nash (1932–2013) and others such as Bernard Cohen (b.1933) and Harold Cohen (b.1928) were already teaching art history at Camberwell, but now a more formal treatment of the subject was needed and the art historian Michael Podro (1921–2008) was recruited to undertake that task.[11] He joined Summerson's DipAD History of Art panel and subsequently became well known for his contribution to the discipline of art history at national level over a fifty-or-so-year period. The development of Podro's career makes him a valuable case study in the present context, especially if we ask how his intellectual commitments informed his approach to art education at Camberwell and, at the same time, how his exposure to artists during this formative period inflected his theory of art and his practice as an art historian. Through the lens of Podro's teaching at Camberwell we will consider the art school dialogue between art practice and art history and frame that dialogue within the broader administrative and bureaucratic shifts in 1960s art education, shifts so often surrounded by tension and protestation. Finally, we will explore a current question: might the teaching of art history once again have a place in the art school curriculum?

Podro worked at Camberwell between 1961 and 1967, joining as a Senior Lecturer aged thirty and becoming Head of Department in 1964.[12] Over the course of his long career he would become a leading art historian, theorist and critic with an international reputation. In his obituary for Podro, Charles Saumarez Smith pointed out that he developed a 'highly independent position as a teacher and person of influence in the field of aesthetics … he helped generations of students and fellow art historians to think widely and deeply about the subject of art, provoking them with frequently opaque, but often quixotically inspirational ideas about the practice of art'.[13] To understand what lay behind Podro's teaching at Camberwell, we are helped by the content and approach he took in his three main publications: *The Manifold in Perception: Theories of Art from Kant to Hildebrand* (1972), *The Critical Historians of Art* (1982) and *Depiction* (1998).[14]

In broad terms, *The Manifold in Perception* presents a series of arguments about art that Podro intertwines with a history of theoretical approaches, which he sees as central to both nineteenth- and twentieth-century art writing. His argument turns on an understanding of how the arts function within the mental life of both artist and viewer. Published ten years later, *The Critical Historians of Art* gives an account of those nineteenth-century German philosophers who contributed significantly to the development of art history as a discipline. The concerns of Gottfried Semper, Alois Riegl, Heinrich Wölfflin and Erwin Panofsky all figure in Podro's account, and are connected in his thinking to the basic philosophic problems of art and aesthetics formulated by Immanuel Kant, Friedrich Schiller and G.W.F. Hegel. Finally, in *Depiction,* Podro argues that the viewer's experience of art is inflected, meaning that the elements of design or composition in a work of art are somehow absorbed by the depicted scene itself in such a way that the experience of it is altered, an idea that is analogous to Podro's earlier discussion of J.F. Herbart's ideas on the interplay of medium and subject.[15] These ideas continue to be important in contemporary aesthetics, for example, in a book by Dominic Lopes. As he states: 'Features of the design may inflect illustrative content, so that the scene is experienced as having properties it could only be seen to have in pictures.'[16]

What bearing did Podro's understanding of British art education and the way that art history was taught in art schools in the 1960s, particularly at Camberwell, have on the ideas that he set out in his later major publications? His project was continuous in that elements of his early ideas would reappear in his mature writings. However, we will primarily be concerned with the themes in *The Manifold in Perception,* published in 1972, immediately after his time teaching at Camberwell. These were ideas which arose

from his own artistic and philosophical background and were informed by his training with F.R. Leavis (1895–1978) at the University of Cambridge (1951–4), at the Slade School of Fine Art (1955–6) and with Ernst Gombrich (1909–2001) at the Warburg Institute (1956–61) as well as by his discussions with Michael Baxandall (1933–2008).[17]

The programme that Podro established at Camberwell offered core courses, taken by all the students and specific courses relating to the different studio specialisms within the art school: sculpture students would study the history of sculpture and textiles students would study the history of textiles and so on. Podro's was art-historical teaching that was precisely tailored to its art school audience. Taking advantage of the loose framing of the DipAD syllabus, he was able to bring his own art-historical interests to bear on the classes he offered the students.

Like other important art educators of the period such as Hudson (1922–97) at Leicester, Thubron (1915–85) at Leeds and Ehrenzweig (1908–66) at Goldsmiths, Podro's interest in art lay in what might be called the human element.[18] His insights lie in his understanding of the viewer's personal relationship with works of art. He did not promote an art-historical method based on any emotional involvement with the work of art; rather, he seems to suggest a degree of emotional detachment that frees the mind up for imaginative reflection. Podro uses Kant's understanding of that emotional freedom as something that enables 'the play of our productive imagination and it allows us intimations of a transcendent reality beyond the world of sense which (he [Kant] assumes) we hope for'.[19] This is a model of making and viewing art that not only allows for but arguably insists upon the freedom to play. This notion of play led Podro to close readings of the ideas of psychoanalysts Melanie Klein, Marion Milner and D.W. Winnicott.[20] In this respect, it might be said to mark an early point on a trajectory from philosophical to psychoanalytic aesthetics. Just as Hudson and Thubron invested their studio teaching with an understanding of the artists' 'internal' experience of making art, Podro similarly turned his attention to the viewer's 'internal' experience of the artwork. The fact that students sometimes requested that Podro offer a critique of their studio work perhaps underlines how his thinking resonated with these young artists. As has been suggested:

> one of [Podro's] great strengths as an intellectual was that he had an unusual understanding of the practice of art, particularly drawing, an affinity for artists as individuals with their own quirks of psychological motivation, and a genuine and deep engagement with the physical experience of the works of art, continuing to believe in the relevance of practical criticism in front of the works themselves.[21]

It is surely significant that in his teaching at Camberwell, Podro recognised the importance to artists of their own histories. Amidst lectures on the Italian Renaissance, the Parthenon, and Paul Cézanne, he developed a ourse called 'The Training of the Artist', in eight lectures and covering the history of the artist's education from the Renaissance to the 1960s. His lectures covered drawing; the figure; perspective; composition; the ideal; proportion; and harmony – an approach that was sympathetic to the art students' needs and interests but also one underpinned by philosophical rigour.[22]

It is this approach to art that Podro developed more fully in the model he worked through in *The Manifold in Perception*. In this book, Podro marks out three sorts of demarcation, or distinctions, used by writers on art who, he explains, 'have aimed to draw distinction between the interest of objects as they confront us in ordinary experience and as they appear depicted within works of art'.[23] So, his book identifies three kinds of criterion that he explains through the close analysis of a group of German philosophers and the way they write about art. The first is what he calls 'objects of attention' focusing less on the art object itself and more on the kind of attention it demands from us, the viewer. Theoretical writings following this principle are those which hold that the artist reveals some aspect of the subject-matter

which escapes us in ordinary experience. Put generally, this kind of criterion for distinguishing the interest of works of art from the interest of the objects represented in them always involves an appeal to an object or aspect of an object, which the work of art reveals.[24] Podro and his own intellectual colleagues were not simply concerned with the object of art as understood in terms of provenance or iconography, for instance. Rather, his interest lay in how and why art is made and exactly what are the questions that preoccupy artists.

The second criterion that Podro marks out in *The Manifold in Perception* concerns the perceptual procedures of the viewer relating to a painting.[25] What concerns him here is how ambiguity and analogy are understood in art. He suggests that the viewer looks at a painting, makes a comparison (between the work of art and what it represents, or between two similar paintings, or between two elements within the same painting) and that this comparison is grounded in form or structure.[26] He suggests the viewer does this in order to understand what they are looking at. In this way, any ambiguity between the artwork and what it represents is resolved through a process of analogy.[27] Once again, Podro's interest centres on the viewer's experience of art, putting forward a process of 'mental analogizing' to better explain how art is understood and to find its place in human experience.[28]

He goes on to identify a third way thinkers on art 'have characterized the distinguishing interest that things take on when included within works of art is by reference to states of mind, feelings or attitudes' most importantly, their 'inward states'[29] – for it is 'through our mental absorption with a work of art, [that] we achieve an emotional equilibrium, a purging or poise or inward harmony, which we do not normally possess'.[30]

In summary, the book that Podro wrote immediately after his experience of art school teaching traced these three criteria as existing side-by-side in the work of Kant, Schiller, Herbart, Hildebrand, Schopenhauer and Fiedler. And, while it is not our task here to analyse his reading of those sources in any more detail, we do need to ask what sort of

art history he and his colleagues taught at Camberwell, how they taught it, and why. The question is, how did this pedagogic experience relate to the ideas about attention, perception and attitudes that were initially expressed in *The Manifold in Perception* and further developed in *The Critical Historians of Art* – texts that manifest Podro's concern with the importance of art history for working artists? Indeed, this was the crucial concern that Podro applied in 1961 in devising the curriculum to be delivered by the new Art History Department at Camberwell. In the midst of his teaching, Podro developed an art-historical approach concerned with the experience of art, with how – in the presence of works of art – artists and viewers alike can touch upon inner worlds and meet with experiences hitherto unknown.

At the same time, Podro tackled more formalist issues. In the essay 'Formal Elements and Theories of Modern Art' (1965), he shows how the artist might master the unknown.

> *Clearly, we can learn to draw the figure, or do exercises in harmony and counterpoint, which would enable us to understand better certain paintings or pieces of music, or produce painting or music of roughly the kind we should be helped to understand. But in these cases it is presupposed that we are discovering and mastering factors that are present in already existing kinds of system or art. But what about the mastery of components which are to be constituents of an art of which we do not already have models?*[31]

Again, Podro's art history touches here on a fundamental question for artists, one which marks out how work in the arts and humanities differs from work in the sciences. In science, a hypothesis is set up and the scientist sets out to test that hypothesis through experimentation, working towards a precise and predetermined idea. The artist, however, often has to work blindly, not knowing where particular explorations might lead, creating new knowledge and understanding without necessarily aiming at any particular result. Podro understood this and

objected to approaches to art education that, in his view, seemed to act against this fundamental requirement for 'not knowing'.[32]

These interests led Podro to develop new and original approaches in both teaching and writing, activities that were associated in his work through their discursive permeability.[33] In 1964, Pevsner recognised Podro's contribution when he invited him to join an extremely distinguished set of colleagues on the NCDAD History of Art panel, 'a potent team that included Ernst Gombrich, Leopold Ettlinger, Norbert Lynton, Quentin Bell, Anita Brookner and Peter Murray from the field of art history, plus Gordon Russell, the philosopher Richard Wollheim and the psychiatrist Anthony Storr'.[34]

BIRKBECK COLLEGE
(UNIVERSITY OF LONDON)
MALET STREET
W.C. 1
LANgham 6622

DEPARTMENT OF THE HISTORY OF ART
HEAD OF THE DEPARTMENT
PROFESSOR N. B. L. PEVSNER, C.B.E., Ph.D.

From:18 Gower Street, WC1 2 January 1964

Dear Podro,

 Having finished the first campaign of the Summerson Council and having accepted twenty-nine schools after having visited about seventy, there are now new applications and revised applications coming in and more visits and reports will be necessary. I am the Chairman of the Panel dealing with the History of Art and Complementary Studies and our Panel has so far worked very harmoniously and to pretty consistent standards. We are unfortunate this session, in so far as several of our members are out of action because of being abroad and for other reasons. I am therefore anxious to extend the Panel and want to invite you to become a member. All it would involve would be a session with me as an introduction and then something like two or three visits to art schools. I can vouch for the job being interesting and I think a preliminary discussion would put you into the picture perfectly adequately. I would be very grateful if you would say Yes.

 Yours,

Dr. Michael Podro
Camberwell School of Arts and Crafts

Peckham Road

↙ Fig.5.1 Letter from Nikolaus Pevsner to Michael Podro, 1964. Birkbeck, University of London

THE NEW CRITICAL HISTORIANS

The legacy of Podro's approach at Camberwell can be traced in the work of some of those who taught there subsequently, including the art historians Alex Potts and T.J. Clark, who were also both important figures for the development of the discipline of art history in the UK and in the USA.

Following Podro's departure for the University of Essex in 1967 and an interim period during which John Nash was Acting Head of Department, Conal Shields became head of the Camberwell Department and in 1970 employed the young art historian T.J. Clark as a Senior Lecturer. Clark had completed his undergraduate studies at the University of Cambridge in 1964 and had then embarked on doctoral research at the Courtauld Institute of Art, University of London, completed in 1973. He lectured in the Department of Art History and Theory at the University of Essex (1967–9), then at Camberwell from 1970–4. Clark's contributions to the discipline of art history then and now focus on the social character and formal dynamics of modern art. Of particular note in this respect are his publications *The Absolute Bourgeois* (1973), *Image of the People* (1973), *The Painting of Modern Life* (1984) and *Farewell to an Idea* (1999).[35]

Alex Potts began his academic career with studies in mathematics and chemistry. It was whilst undertaking research in theoretical chemistry at the University of Oxford in the 1970s that his interest in art history developed, fuelled by his attendance at lectures by Francis Haskell, Edgar Wind and Pevsner. Subsequently Potts registered as a doctoral student under the supervision of Gombrich at the Warburg Institute working on a thesis entitled *Winckelmann's Interpretation of the History of Ancient Art in its Eighteenth Century Context* (1978).[36] From 1971–3 he undertook part-time teaching duties in the Department of Fine Art at Portsmouth Polytechnic, which had come into being following the amalgamation of Portsmouth College of Technology with Portsmouth College of Art and Design in the wake of the government White Paper 'A Plan for Polytechnics and Other Colleges' (1966), which had recommended the re-designation of the most effective colleges (many of them small colleges, including colleges of art and design) as regional polytechnics in a national network for technical education.[37]

Potts's recollections of that period describe a vibrant and exciting scene where teachers regularly explored new approaches and where there was freedom for art historians to teach in a wide variety of forms, from the staging of a Maoist opera to offering classes in Russian socialist realism.[38] It is also clear that Potts's early experience of other disciplines (in his case maths and chemistry) and his interest in Wind, well known for his interdisciplinary approaches to art history, meant that he was particularly suited to the sort of open and creative approach required to successfully teach art history to art school students.

THE NEW SUBJECTS OF HISTORY

Through their art-historical teaching, and addressing Camberwell's students as 'the new subjects of history', Podro and others opened up new possibilities for art history in the art school. Seeking to make art history relevant to students in their contemporary situation was not to claim that all artists of all ages faced precisely the same difficulties and experiences. Rather, it was intended to show how relevance persisted despite the inevitable differences.

During his time at Camberwell, Podro got to know painters such as Frank Auerbach (b.1931) and Ron Kitaj (1932–2007). Podro's great strengths were his unusual understanding of the practice of art, his affinity for artists as individuals with their own quirks of psychological motivation, and his deep engagement with the physical experience of works of art, including his continuing belief in the relevance of practical criticism in front of the works themselves.[39] Kitaj's *The Jewish Rider* (1984–5) is a testament to that affinity

and perhaps acts to evidence Podro's lifelong friendship with the artist.[40]

↓ Fig.5.2 R.B. Kitaj, *The Jewish Rider* 1984–5, Astrup Fearnley Collection, Oslo

↘ Fig.5.3 Michael Podro, photographic portrait used for R.B. Kitaj, *The Jewish Rider* 1984–5

When, late in his life, Podro was made an Honorary Doctor of the University of the Arts, London, he reportedly used the occasion to deliver an unexpected diatribe against what he saw as the bureaucratisation of traditional London art schools.[41] He recalled the distinctive character of Camberwell, but not through any nostalgic reminiscence, his purpose being rather to insist on how specific and distinctive the culture of an art school is.

Podro's notes indicate what he said on that occasion. He argued that students need:

> a sense of a past, of live issues openly debated and face to face experience of visiting artists and designers to gain a sense of what is possible. No legislation from above, certainly no standardization, could achieve this. Art schools may succeed or fail now in one department, now in another, but they do so because of individuals and the chemistry between them; the sheer untidiness of it all may make our Whitehall rulers uncomfortable, but it is a necessary part of generating invention, rather than producing mediocrity. You don't need system change when things are amiss, you need fine tuning.[42]

These arguments make sense when we remember that Podro's approach at Camberwell and elsewhere was a creative one where intellectual freedom was welcomed and encouraged. He loved to argue and his passion for debate and discussion precipitated a vibrant and exciting environment for teaching and learning. Above all, Podro, and those who taught art history with him, and subsequently, did so in a manner that demonstrated their investment not only in the object of art itself, but also in the process and experience of making art.

Podro's approach at Camberwell may have been popular but the teaching of history of art across the post-Coldstream art school sector was inconsistent and its delivery often caused concern, as was made clear in Summerson's report.[43] Such concern, however, was not limited to Britain. In 1965, the International Association of Art (Association Internationale des Arts Plastiques), under the auspices of UNESCO, organised The First International Conference on the Professional Training of the Artist. This was convened by a United Kingdom National Committee and held at University College London from 8–15 June, 1965.[44] Delegates from twenty-eight countries attended and a full conference report duly appeared in October 1968.[45] In his introduction, vice-chairman Morris Kestleman (1905–98) noted concern and controversy regarding 'the place of History of Art and the increasing introduction of non-studio subjects'.[46] The conference devoted one session to 'The Place of Art History' and it was reported that Maurice de Sausmarez (1915–69) was a significant voice in that particular discussion. He referred to a danger inherent in liberal education in British art schools: if the sights were set too high, the standard of entry might become too exacting, so that it would become difficult for a strong artistic talent, which was characterised by single-mindedness, and this before all else must be respected. 'The strongest talent', he said, 'wilts or goes into open rebellion by being kept too long from its appointed field of concentrated study.'[47] While de Sausmarez was resolute on the need for history of art to be taught by trained art historians, he expressed some doubts about the teaching of other subjects like philosophy, psychology and sociology as part of

the artist's education. The French delegate Professor Jean Rudel, on the other hand, called for an integrated approach that would enable students to 'discover that Art History is not just supplementary theory but provides a means of integration and thus a source of life and human intercommunication, of mutual aid between artists over the centuries'.[48] The report makes clear the tension between art history and fine art and the Chairman noted, 'it would be useful to propose some ideas for future activity. The endeavour to get harmony between artists and art historians in teaching could be a very clear resolution.'[49] There is no suggestion in the report as to how that might be achieved.

Staff and student dissatisfaction with the DipAD and history of art in particular was made manifest in the events of 1968 at Hornsey and elsewhere.[50] Nikolaus Pevsner 'was well aware that the history of art programme originally recommended by the Coldstream committee was not working'.[51] Evidence submitted to the NACAE (Joint Committee) was mixed. In his summary of the evidence submitted in relation to history of art and complementary studies, Pevsner was hopeful:

Considering the bulk of paper which we have, the results in my field proved much more meagre than I had expected. Of the 126 pieces of evidence 47 don't discuss H of A and CS. 41 Principals wrote in. Of them 19 are Principals of Non-Dip. Colleges. The range of evidence goes from status quo to lunatic fringe. The latter is mostly in evidence from individuals, the former in evidence from principals. Even they do suggest changes, but within the existing structure. Total absence of complaints or no mention of H of A and CS at all includes Principals of Epsom ... Falmouth ... Wimbledon ... Wolverhampton ... Ravensbourne ... Canterbury ... Liverpool ... So we need not worry too much.[52]

While some schools called for the abolition of art history, yet others called for more. At Chelsea College of Art and Design, for instance, Norbert Lynton (1927–2007) cautioned against the demotion of history of art.[53] Most, however, called for a change in focus and a more fluid approach to teaching and assessment that took greater account of the student's main specialist interest. The committee's job was to take account of these different positions in its overhaul of art education. In Pevsner's view, 'The argument that too much teaching of the history of art is history of painting and sculpture is valid. The textile designer needs no Giotto (or a little will go a long way).'[54]

When the Joint Committee reported in 1970 it specifically addressed the question of history of art and complementary studies in Sections 34–41, remaining committed to history of art being a mandatory requirement: 'We are in no doubt that every student's course must include some serious and relevant studies in the history of art and design.'[55] Now, however, it moved to dissolve the boundary between history of art and complementary studies: 'We believe that 15 per cent of the students' total time on the Diploma course should be spent on complementary studies, including the history of art and design. We fully appreciate that the breadth of options offered must depend upon the judgement and resources of the college.'[56] In Pevsner's view this weakened the place of history of art in the student's education and he included a 'Note of Dissent': regarding the committee's majority report, 'I find myself unable to agree with paragraphs 34–41 of Chapter 31, not so much for what they say as for what they do not say … My dissent is caused by the Chapter's preference for the general at the expense of the specific, and the avoidance of any emphasis on the required discipline of learning'.[57]

Pevsner was not alone in his concern over academic rigour in the art school; Gombrich also spoke out on the subject: 'They should acquire that chronological scaffolding which helps us all to keep some minimum order in our image of the past. As many of them have been very badly taught at school, or not at all, this minimum may well cost them those drops of sweat and tears that may be psychologically good for them … We must fix the

line somewhere and hold to it.'[58] Gombrich had already called for such academic rigour four years earlier when he argued along similar lines in a lecture at the Slade: 'If artists are to survive in our society they must come to terms with its intellectual demands not only by parroting its catchphrases, but by understanding and criticizing them precisely.'[59]

In the early 1970s Kestelman warned against dogmatic approaches to teaching art history and other complementary subjects in the art school whilst, at the time, pointing to the benefits of art history appropriately taught:

> There are, of course, certain subjects which can be usefully discussed in which the student can be introduced to a better understanding of, say, colour, perception, ambivalent or after-images, the observation of natural forms, and a whole range of observations on visual phenomena. The aim here is not one of dogmatic pronouncement, but of stimulating the mind towards the understanding of certain means, or techniques, which are founded on practice. Any theory must be tested by the artist in practice: there are no dogmas. … But there is fertile ground in the study of works of others. Here, the sensitive and relevant use of art-history should help to sharpen critical powers and broaden sympathies.[60]
> Not everyone, however, recognised the potential benefits. The art history courses offered at Camberwell altered over the years but always offered a solid grounding in art history and theory. Several years later, in 1975, it was suggested that the aim of the department was 'to help students form a workable idea of their situation, developing critical acumen vis à vis the present by way of historical sensibility'.[61]

These sentiments fit precisely with Podro's. Faced with student resistance to compulsory art history in art schools, Podro believed that the way forward was to show students the relevance of art history to their own contemporary situation. This is where his ideas on attention, perception and attitudes

– later worked out and published in *The Manifold in Perception* – came most forcefully into play. What he tried to do was to show students how artists of the past faced the same sorts of difficulties in working as contemporary students did in their own practice. Because works of art were used in this way, students had the opportunity not only to empathise with artists of the past, but to recognise their enduring relevance and to learn from them.

SINCE PODRO

It is worth reflecting, in broad terms, on what has happened in art schools since Podro's time. As Jon Thompson has remarked, 'art history teaching has almost ceased to exist, replaced by a new orthodoxy, often referred to as art theory teaching which mostly comprises sociological and psychoanalytic topics drawn from the extended field of cultural studies. The result of this is that generations of fine art students know hardly anything about the history of their chosen form of practice, even those fairly recent histories that have directly helped to shape their own work.'[62] As formal art historical training in the art school fades from view, how might an increased emphasis on the professionalisation of the art student be evidenced in the resulting work? How might that shift in itself be seen to align with others, such as the gentrification of the artist and spaces of art making and display? It has to be asked whether a lack of art-historical training means that art making is cut free from its moorings – and, if that is so, what relevance can be found in such a free-floating practice? The American scholar James Elkins suggests, 'One danger of not knowing the history of art instruction … is that what happens in Wart classes begins to appear as timeless and natural. History allows us to begin to see the kinds of choices we have made and the particular biases and possibilities of our kinds of instruction.'[63] Although Elkins is writing about the teaching of fine art rather than art history in the art school, his views are relevant. If, as he suggests, an ahistorical

approach to teaching art practice is limiting for both teacher and student, then the only way to address that limitation is to reintroduce focused art historical teaching that will enable art students to locate their own practice within a wider frame and thereby open up wider possibilities for its development. This is not about making sense of a practice or achieving a greater degree of clarity of understanding. As Elkins points out, 'In most subjects clarity and sense are ultimate goals, and it is not sensible to criticize them. To "get clear" or "achieve clarity" about a troublesome issue is to understand it thoroughly, to grasp it, to know it perfectly. The principles of physics are best when they are clear … But is the same true of art classes?'[64] In Elkins's view the same is certainly not true of art classes: 'It does not make sense to try to understand how art is taught.'[65] Yet, to continue without any direction whatsoever is unhelpful and puts teacher and student at risk of failing completely. Elkins tells the story of explorers in a gargantuan cave, so large that its size is almost beyond human understanding. Tiny lights on their helmets are able to help guide them to a certain extent: 'Pictures taken on later surveying expeditions show the spelunkers' lights like little fireflies against a measureless darkness.'[66]

Ken Neil of Glasgow School of Art has suggested that historical and critical studies might now act as guiding lights in the otherwise 'measureless darkness' of art school education.[67] This kind of approach offers the art student possibilities without any recourse to didacticism, in fact it is a twenty-first century development of the approach that Podro implemented at Camberwell when art history opened up possibilities, guided students' studio work and acted as a flexible framework within which to take studio work forward.

Arguably, the origins of his whole project lie in Podro's academic beginnings as an English undergraduate at Cambridge under F.R. Leavis. In his book *Education and the University* (1943) Leavis proposed a model for a school of English, not an art school, yet offered hints of what Podro would bring to his art history teaching some twenty years later. Leavis set out what he called a humane education, suggesting: 'We should make our dispositions with an eye to producing neither the scholar nor the academic "star" (the "high-flyer") – the mind that shines at academic tests and examination gymnastic; but a mind equipped to carry on for itself; trained to work in the conditions in which it will have to work if it is to carry on at all; having sufficient knowledge, experience, self reliance and staying-power for undertaking, and persisting in, sustained inquiries.'[68] Podro's approach at Camberwell echoes Leavis's suggestions. Intending to equip the young artist with an independent mind, he nurtured a sense of curiosity and encouraged inquiry, and his students were shown how to look backwards in order to move forwards in their own practice. In this way, their art-historical knowledge did not act as any kind of level or standard to be attained or measured against. Rather, it acted as an enabler to allow new approaches to be ventured and new sorts of work to be made.

VI

SHIFTING FOUNDATIONS: THE PRE-DIPLOMA COURSE

INTRODUCTION: INTERNATIONAL ASPIRATIONS

In its relatively brief life, the Foundation Course in Art and Design has become an essential element in the UK art school curriculum and has come to be regarded as an eminently exportable pedagogical concept. The word Foundation suggests a self-contained, autonomous instruction and an essential grounding in the fundamental elements of a creative education. Moreover, as this chapter explains, this course's offerings expand beyond – even transcend – national tradition. This relationship to a national tradition comes to the fore when charting its trajectory from idea to implementation: the designers of the Foundation course were keenly aware of the course's place within British art school pedagogy and its broader international relevance.

The Foundation course in the United Kingdom was implemented by legislation in 1960, at the precise moment when a renewed engagement with the international art scene was shaping the development of avant-garde art practice in art school studios around the country. The art school Foundation course thus represented broader patterns in 1960s British culture, from which a simple dichotomy emerged: the 'young' and the 'new' were international, the 'old' and 'established' were solipsistically 'English'. Read with these dichotomies in mind, I contend that Foundation offered a glimpse of the kind of cosmopolitan educational exchanges that vivified British education in the late 1950s and early 1960s, but which, ultimately, hardened into a national orthodoxy by marginalising its most fervent pedagogues. The Foundation course, in other words, began with international influences but settled, ultimately, not into a hybrid of influences, but instead a decidedly British version of international influences in pedagogy.

With an eye to an escape from the straitjacket of national tradition, Foundation looked internationally for ideas and influences; as we will see, its designers and early teachers were positively global in their scope and ambitions. In the UK, the new year-long pre-diploma course drew heavily upon experimental Basic courses (that is, 'Basic' as in 'Basic Design') that had already been developed in a handful of progressive art schools across the country during the 1950s. These courses drew heavily upon received ideas about the Bauhaus *Vorkurs* – ideas sometimes more 'interpretative' than 'informed'. While the establishment of the Foundation course in the UK was as much political as ideological, Basic Design provided for it a sturdy infrastructure. But because of the looseness of its guidelines, the first manifestations of the Foundation course, in its earliest versions known simply as 'pre-diploma', varied greatly from institution to institution. Despite these discrepancies, each school saw its own pre-diploma as a new way forward, turning its back on a national tradition that privileged acquisition of skill through imitation and on study in the life room. As this chapter explains, there are many different forces that have shaped our current Foundation course syllabus, and the Foundation course is thus perhaps best read as the product of competing ideas about what makes an artist, and even what makes an artistic tradition.

VAGUE BEGINNINGS

To appreciate the Foundation course's development, it is crucial to consider its precursor, the Pre-Diploma in Art and Design (Pre-DipAD). Requirements for a place on a DipAD (the forerunner of today's BA degrees) included the applicant's being eighteen years old, having passed a minimum of five GCEs ('O' Levels), and the completion of a preliminary course. These requirements were introduced by the first Coldstream Report of 1960 and they were designed to bridge the gap between secondary education and the degree-level diploma courses. School leavers were required to spend one or two years, often at their regional art school, on a pre-diploma course.

The Coldstream committee conceived the Pre-DipAD as the academic equivalent to its precursor, the two-year Intermediate Examination in Art and Craft – the exacting

preparatory course for the two-year NDD. So through its attempts to devise a degree of even greater academic standards, the Coldstream committee added the one-year (minimum) Pre-DipAD to the three-year DipAD.

This additional year was, in the committee's view, crucial for academic rigour as well as artistic preparation. The pre-diploma course prepared students for the DipAD by exposing them to a common training before they specialised in particular fields. This pre-diploma was also understood – at least by its authors – as serving diagnostic as well as portfolio-building functions: at least as far as the Coldstream committee architects understood the project, the student would leave a Pre-DipAD course with a portfolio of many different works, and having been exposed to a common set of ideas and training. Such a goal, they believed, would make for a more advanced applicant pool for subsequent training on the selective DipAD. By making these changes, the Coldstream committee allayed an anxiety that students were specialising too soon, and with an inadequate knowledge of the different disciplines under the aegis of 'art education'.

But the difference between theory and practice was enormous and the nation's art schools struggled to implement these new pre-diploma courses. Their difficulties arose primarily from the absence of any pedagogical precedent or administrative guidance. Schools turned, predictably, to the administrative bodies for some sort of guideline as to what, precisely, a Pre-DipAD syllabus might entail; in response to these enquiries, the NACAE optimistically demurred from taking responsibility: 'Each art school should be free to construct its own pre-diploma courses without any reference to any national body'.[1]

Trusting in art schools' integrity and in their knowledge of their students would have been one matter, but to decline to propose any identifiable objectives is quite another, was that many art educators simply did not know what ideas they should be working out. Despite the liberalising potential of its promises to art teachers, the Coldstream Report had also cautioned:

The general aim of all these courses should be to train students in observation, analysis, creative work and technical control through the study of line, form, colour and space relationships in two and three dimensions. A sound training in drawing is implicit in these studies.[2]

When read closely, this directive encourages art schools to pursue competing (if not outright contradictory) objectives. On one hand, they prescribe a traditional approach based on figuration: the emphasis on 'observation' and 'analysis', as well as the assumption of 'a sound training in drawing' and the importance of 'technical control' could, in the early 1960s, easily have been mistaken as guidance that art education should continue to be rooted deeply within a tradition of image rendering traced back to the nineteenth-century French system known as beaux arts. On the other hand, the Coldstream directive is radical in its open invitation: without any explicit mention of outcomes, the course encourages students to study 'form and space relationships' in a manner that justifies the most forward-thinking of pedagogical experiments. It was no wonder, then, that the most progressive tutors found few substantial UK examples of suitable courses, so they turned to continental Europe's best-known preparatory art curriculum: the Bauhaus's concept of Basic course or *Vorkurs*.[3]

As a result of these sources of confusion – uncertainty about what should be taught on the course itself and the absence of a national validating body – Pre-DipAD courses varied immensely from art school to art school. Many of the courses remained deeply traditional in their training, sending unprepared hopefuls to interview for the modern DipAD courses with old-fashioned portfolios bursting with life drawings. For Pre-DipAD tutors in other art schools, the very mention of figuration was viewed with suspicion. And, taking a third route, still other schools sought to balance traditionalism and progressive models in a way that offered a new visual grammar drawn from Basic Design. These divergent approaches did little to standardise applications for the DipAD, and the Coldstream

committee failed clearly to explain how such different approaches might co-exist. The result, predictably, was that the students and the tutors found themselves in a state of uneasy contradiction between new and old ideas of art practice.

The absence of a coherent approach was only the first of many concerns about the Pre-DipAD course. Many students were under the impression that completing such a course assured them a place on a DipAD. Attempting to clear up this confusion about acceptances and matriculation, the Department of Education and Science issued a letter in May 1964 to local education authorities, instructing them to advise students that such a guarantee of admission was impossible. The confusion led the Coldstream committee to publish in 1966 an Addendum to their First Report; in this amendment, they fault the term 'pre-diploma' itself: 'We therefore recommend that these courses be known as "foundation courses" to indicate the function which they have in practice assumed'.[4] So the initial confusions were at once curricular and semantic.

The fallout from these many confusions and changes enveloped every aspect of art school education. A comparison of different Pre-DipAD prospectuses from these years illustrates the many identities that the course could assume. St Martin's School of Art, for example, had introduced a 'Beginner's Course' as early as 1953, which had metamorphosed by the early 1960s into a course offered by the 'Department of Basic Studies' which settled, later in the decade, into the 'Preliminary Studies Department'.[5]

But beyond the fact that they were known under so many different names, these new Foundation courses also led to a proliferation of teaching positions. For example, at St Martin's, the 'Department of Preliminary Studies' went from employing seven tutors in 1964–5, to employing twenty-seven tutors in their 'School of Foundation Studies' in 1966–7.[6] By 1970, it was by far the largest department in the school, with three full-time members of staff and forty visiting lecturers (double the size of the Painting and Sculpture Departments respectively).

This increase in teaching positions was a result of the deluge of applications. The exponential increase in numbers could not be more vividly illustrated than by the history of the establishment of the Foundation Department at the Central School of Arts and Crafts. From the last-minute recruitment to the brand new Pre-DipAD in 1963, when thirty students were selected by the staff at short notice, to subsequent years when the course was flooded with applications, former Senior Lecturer Tim Shelley recalled that the applications came into Central from all over Britain because few art schools were offering pre-diploma courses of this type. As a result, the course at Central was massively over subscribed.[7]

In a report to the governors in a meeting on 26 October 1967, the Principal of St Martin's reported that the numbers of first-choice applicants for the Foundation course were 585 candidates for seventy-four places.[8]

While this competition might be dispiriting for applicants, there were implicit advantages to having a buoyant Foundation course: after all, it ensured a feeder supply of quality applicants to the degree courses. As early as 1961, the Principal reported to the St Martin's governors that 'of the 130 students in the Beginners Group, it was likely that 104 would be continuing their studies next session'.[9] At Central School, Tim Shelley's recollection was that, although the ethos of the Foundation course was to encourage students to consider other art schools to help them make up their own minds about their final choice, the presence of a strong in-house Foundation course at the Central School quickly came to be regarded as indispensable. Initially, this encouraging of Foundation course students to cast their net widely as they drew up their diploma applications caused tension with many diploma staff within the college, who saw no advantage to the presence of the Foundation course in the school. Over time, tutors on the senior level DipAD programmes gradually came to see the value of having a ready supply of 'in-house' pre-diploma students, who were turning out to be good-quality applicants for the high level qualifications. After some

years, pre-diploma students were encouraged by DipAD tutors to apply for Central School higher qualifications by means of weekly project supervision.[10]

This high demand for pre-diploma or Foundation courses was not, however, confined to the central London art schools. Nationwide, in 1969, 4,627 students applied from Foundation courses for only 2,500 places on courses leading to the DipAD qualification.[11]

The nascent Foundation course's many complications – administrative as well as intellectual – was of utmost concern to the governing authorities. This concern grew such that, by the time of the publication of the 1970 Joint Report of the NACAE and the NCDAD, the Coldstream committee confessed to considering the 'invalid[ation of] the principles and concept of foundation courses as set out in the First Report' of 1960.[12] The committee ultimately overcame these public doubts by revisiting its conviction that such a course's goals were entirely indispensable for a complete art education. In an effort to resolve this impasse, they proposed the provision of 'central guidance to promote greater consistency' – which, in real terms, meant that the courses had to be approved by the NCDAD.

Riddled with contradictions, the fledgling Pre-DipAD course promised an escape from an outmoded traditionalism. In its final manifestation as the Foundation course over the following several years, however, its revolutionary heat cooled into a new orthodoxy drawing on (or, as critics believe, misappropriating) Basic Design.

THE CHALLENGE OF DEVELOPING A CURRICULUM

The Pre-DipAD aimed to prepare students with a common training before they specialised in particular fields. The openness of the remit's terms and the frank inability of art schools to reach a consensus about what a pre-diploma course might entail led to a confusion only resolved through administrative intervention. These ambiguities and tensions informed the debates within art schools themselves about the form and function of a Foundation course.

From the archival minutes of the Pre-Diploma Department staff meeting at Central School in 1963, we glimpse the direction that the new course was assuming. The goal for the new programme was that it would be pedagogically speculative, an approach that was innovative at Central at this date.[13] But as we have seen, confusion was the dominant response to curricular initiatives and this was because most art teachers tended simply to re-purpose for their students their own experiences as students. The idea that a pre-diploma course might be based on innovation rather than on tradition was both novel and perturbing. The teachers were embarking on a process of education as were their students.[14] These meeting minutes, from the outset of these changes, demonstrate that the tension behind the development of the new curriculum arose from the challenge of balancing traditional approaches with new ideas about personal development.

An example of such tensions is useful here. In the nascent Pre-Diploma Department at Central School, under the attentive leadership of Shelley Fausset (1920–94), teaching initially remained rooted in objective studies. At its core, the curriculum emphasised the singular importance of observational drawing in its many forms. The introduction of different media was still considered a progression – even at times a diversion – from this essential point of departure. Thus at this moment, the nurturing of 'student ability' was considered as crucial as the more speculative sense of 'personal development' – an objective that characterised much Foundation teaching latterly. In a progress report to his pre-diploma staff, Fausset describes how every member of staff in his department deployed drawing for a distinct purpose:

> *The primary aim is to re-evaluate our visual experience … the categorising of formal experience and formulation of terms. Tony Hatwell and Jeff Hoare would appear to be coping very well with the need for life drawing and*

development of student ability and appetite is self-generating … Jeff Hoare rationalises drawing pictorially in some exercises, Tony Hatwell approaches it as a sculptor. Tim Shelley balances within his painting classes the corollary of pure observation in controlled exercises, with a tradition of working from the model. Because Garth Evans is treating form more intellectually in wood carving with a proper 'object veneration', I am using the modelling class for study from life – to introduce students to this mode of observation.[15]

From the honing of technical skills to the imbuing of the student with the assurance to pursue her or his particular personal course of direction, the staff grew confident in opening more opportunities for students to develop ideas of their own at an earlier stage. In Tim Shelley's view, the staff were not required to exert full control too tightly for too long.[16] That said, attentive guidance was given to the all-important purpose of portfolio building, which represented the passport for the ambitious Pre-DipAD student for a competitive place on one of the new DipAD courses. In the formative months of the pre-diploma course, it is striking how roundly traditional, in many ways, the expectations of the Pre-DipAD portfolio remained. A solid portfolio was thought to consist of a balance between drawing, painting and sculpture from nature and controlled design projects. As Fausset explained to his pre-diploma staff, portfolios 'contained as a general rule: drawings, paintings, communication studies, black note-books with elements of design and museum study (other sketchbooks only where essential), photographs of three dimensional work.'[17] In these formative days the requirements may have sounded old fashioned, but the quest for a balance between offering students a solid groundwork in what were then considered essential foundational skills and encouraging them to move into unexplored territory was a source of constant tension for pre-diploma tutors.

It is this tension that characterised a department such as that at Central. The tutors on the course constantly scrutinised their approaches and debated the virtues of the old and new pedagogical approaches. Fausset articulated his position to his staff: 'I submit that we need to simultaneously cherish slow, tradition bound developments in a student's work and to expose him to aspects of wilful extremism. This enables him to test and prove his reactions – to "find safety in the unsafe".'[18]

Moreover, from these same meeting minutes, Fausset identifies the potential of fostering such apparently contradictory values within the same department. His solution is to craft the regular staffing of the course: 'I would like to maintain the maximum incompatibility between members consistent with good relationships.'[19]

The chief challenge to the tutors on these nascent courses was, it was generally agreed, how to reconcile 'radical educational needs' – in other words, the need to push students towards innovation in their practice and the need to fulfill traditional portfolio requirements. Of course, at the crux of this dilemma was the underpinning paradigm shift in a clear understanding of what art practice now meant.

This shift was nothing short of the institutional dismantling of modernism. For many art school staff, this change in pedagogical models meant not only rethinking their own educational experiences but also calling into question the requirements of ambiguous national guidelines. It is clear from the minutes of these early meetings at Central that the still-unclear preferences or priorities of the external assessor were a constant source of anxiety to teaching staff.[20] But the concomitant effect of this ambiguity was not necessarily a bad thing: the staff meeting debates were lively and vital, as they hammered out the essential components of what a Foundation course should look like in the absence of any national model. What is admirable about these formative discussions of the pre-diploma course was the desire of the staff to clarify the terms of the debate in the service of the student.

As archival research continually illustrates, the pre-diploma course promised an escape from an outmoded traditionalism. Its many complications, administrative as well as intellectual, invited criticism, but also encouraged innovation. In this early period of the Foundation course, ambitious art educators burned to understand alternative continental models, especially those deriving from the *Vorkurs*. The archives of the Central School hold a great deal of evidence for the excitement and anxieties over the importation of this new model. The then Principal of Central, Michael Pattrick, strove to educate himself in the legacy of the Bauhaus, visiting many art schools abroad, in particular at Essen and Ulm in the spring of 1963.[21] By early summer, he was discussing the possibility of bringing the Stuttgart exhibition of work of the Ulm school to the UK (a project which didn't actually come to fruition).[22]

It is important to note that even as late as 1963, any common understanding of Bauhaus pedagogy was at best vague. Indeed, for many art tutors, their first significant exposure to Bauhaus ideas was the influential exhibition at the Royal Academy in 1968, *50 Years Bauhaus*.

Despite this general ignorance of continental models, efforts continued to be made to introduce new ideas into art schools. The touring exhibition *Sehen* – which showcased the work of Foundation course students from the Staatlichen Werkkunstschule Saarbrucken in Germany – toured the UK, stopping at Central in London, Manchester and Birmingham among other places, in 1968. Directed by Oskar Holweck, the Saarbrucken Foundation studies course traced its origins to the Bauhaus *Vorkurs*.

↓ Fig.6.1 View of the *Sehen* exhibition at Manchester College of Art and Design, Sept. – Oct. 1968

The Saarbrucken Foundation model differed distinctly from the conception of a broad-based Foundation as understood by most British art schools. Holweck's conception was premised on a highly formal abstraction and his pedagogy offered a counter-current to the prevailing and wide-ranging, if slightly

erratic forms of Foundation study then being introduced in the UK. Holweck's students produced highly structured and formal abstract reliefs, constructed with a large element of chance built into exercises.

The significance of this exhibition needs underscoring. In the *Sehen* show, British art tutors saw a fully realised, fully conceptualised model of Foundation studies at a time when British Foundation courses were still trying to articulate their terms. The belatedness of the British Foundation courses prompted art educators to turn to international systems not simply out of a desire to appear cosmopolitan; rather, they found a solid conceptual bedrock upon which they could construct their own pedagogical models.

The irony is that Britain already had, over a decade before, its own group of progressive tutors, whose ideas had been taken on board but hadn't been fully understood. 'Basic Design' became a buzzword, not a comprehensive or even comprehended approach to Foundation studies. Indeed, the career trajectory of one of these tutors – the fact that he became effectively an itinerant educator who ultimately was forced to take his ideas abroad – illustrates just how difficult this implementation of a rigorously conceptualised year of Foundation studies was.

At Leeds, between 1955–64, Harry Thubron (1915–85) taught a Basic Design course that represented a broad and encompassing understanding of basic studies and – crucially, in his view – transcended any notion of a national style or distinction.

Just as Thubron sought to break the bounds of national models, he sought in his classes to break traditional distinctions between faculty and student. He believed in an energy that emerged from group collaborations and a free exchange of ideas and methods of inquiry between faculty and students. With tightly regulated projects, staff and students were prompted to think anew, thus sloughing off traditional art images. Sometimes these innovatory projects took the form of precise and rigorous observation; at other times they derived from wholly intuitive and immediate responses. Because, by turns, the projects were abstract or figurative, he dissolved any easy binary opposition between the two modes. For Thubron, such distinctions prevented the student from perceiving an aesthetic quality in an object or a moment. A firm believer in symbiotic instruction, he encouraged students to engage with the history of art as much as with their own work within the studio.[23]

His zealous convictions about this method – a method that encouraged an openness to intuition with a precision of observation – led to his uneasy fit among his art school contemporaries. He traveled widely, eventually finding himself in 1965 on the art faculty of the University of Illinois-Urbana (where, incidentally, his British contemporaries Tom Hudson and Hubert Dalwood also taught).

But his zeal was coupled with irascibility, and in his practice as a teacher he failed to conform to the American system of marking, credits and degrees. After his period in America, he returned to the UK, only to leave shortly after for a stint in Spain where he taught in Ronda in Andalucia before again departing for Jamaica in 1969. Reflecting on his experiences as a peripatetic pedagogue, Thubron believed that such a wide inclusivity was the hallmark of the modern artist's new freedom to enquire about ideas without recourse to convention or stereotype.[24]

While a few other art tutors in the UK shared Thubron's vision of a synthesised and overarching Foundation model, for the most part Foundation courses in the 1960s lacked a coherent underpinning philosophy. A former tutor responsible for designing the Foundation course at Central in 1963, Tim Shelley recalled that Basic Design was a fashionable label at the time and that students did benefit from certain of its teaching procedures. The weakness of such exercises was that they tended to be impersonal, so to correct that failing the tutors emphasised objective study wherever they could.[25]

John Walker, an art student at Birmingham from 1956 to 1961, was open in his criticism of the nascent Basic Design courses, describing how: 'A melange of activities took place simultaneously and successively. The old and the new existed uneasily side by side in a state of contradiction which no one seemed able or willing to explain.'[26]

But however much these courses lacked a unifying approach, they shared a strong prejudice against the tradition of skills-acquisition. Rather than learning techniques and skills as an end in itself, the new Foundation courses taught skills in the service of an idea. Techniques would be taught or technical questions answered as and when a particular idea needed to be pursued. Then as ever since, the Foundations tutors were interested in the students' development as creative artists, not trained technicians in command of a set of skills.[27]

This emphasis on personal development has characterised Foundation courses across the UK from 1960 onwards. But any early promise that British Foundation studies might become a truly international model was dissipated, and it met its fate entrenched in the bureaucracy of a national standardisation of art education. The Foundation course emerged from a desire for UK art schools to reclaim their international importance after a post-war return to traditional models had stifled a young generation of art students. Grasping for the new yet reluctant to release the old, art schools and national governing bodies tried to marry the two. While progressive tutors in the UK had already explored fresh possibilities for early training of young artists, these prescient tutors were often marginalised, only to have their ideas reaf-

firmed as the unacknowledged bedrock of a new curriculum.

But the history of Foundation carries more significance than simply a story of the tension between artistic generations. The conversations and questions that shaped Foundation are precisely those critical questions that continue to echo in art school studios today: What is the difference between an education in 'attitudes' and an education in 'technical' skills? What is the importance of 'scientific' principles of art and design-making compared to the importance of individual development and self-expression? And what are the respective roles of the art teacher and the critic or philosopher interested in art education concerns? The continued relevance of these questions illuminates the peculiar nature of the Foundation course, a curriculum whose objectives, historically nebulous, remain nevertheless exigent. Revisiting the history of Foundation, in other words, is to read the narrative of a once and future course.

(VII)

BUILDING: THE NEW CHELSEA

INTRODUCTION

Like all architecture in an educational setting, the building in which an art school is housed takes the form of a 'crystallised pedagogy', which teaches in tandem with the curriculum itself.[1] Despite this, the specific issues relating to art school building have attracted only limited scholarly attention, notable exceptions being David Jeremiah's two-part appraisal published in the art and design research journal *Point* in the late 1990s, various contributions to Steven Henry Madoff's recent book *Art School*, and ongoing research by Matthew Cornford and John Beck.[2] Apart from these, art school building is not a subject widely addressed in scholarly writing on architecture.[3]

Not only are the practical design requirements of an art school particularly exacting (including features such as extensive open space, ventilation, north light, reinforced floors, specialist machinery, and both privacy and community), they are continually and unpredictably changing as art practice changes. Furthermore, any feature of the architecture which seems actually to prescribe practice tends to be resisted and subverted by the artists/students working within. There is also an annual timetable which sees studios being transformed from creative workshops into display galleries, and then back again, resulting in a palimpsest of thick grey floor paint interleaved with trace materials of each year's occupants. And, as practice changes, these materials are no longer limited to oil paint, masking tape and cigarette ash. As with any institution, the architecture of an art school is synonymous with its identity, as both home for those belonging to it and as visible symbol to those outside. This is a function that carries extra weight for an institution purporting to teach the visual. The art school building must possess the authority of the academy and yet appear perpetually avant-garde; it must stand for the ethos of the art school, and for art itself; it must be infinitely adaptable yet constant, both iconoclastic and iconic. What all this encapsulates is the essential modernist dilemma between universalism and contemporariness.[4] An education in art is surely the most liberal of pursuits, and municipal buildings for this purpose are emblematic of a truly civilised society. In short, art school building is a utopian act.

In this chapter, we examine 'art school building' (in both senses) and the broader issues of art school building as an imaginative and socio-political act, with reference to national and international examples in order to contextualise the London art schools.[5] The primary case-study is Chelsea School of Art, known now as Chelsea College of Arts, part of the University of the Arts, London, chosen not only for its distinguished reputation but also because the school built remarkable new campuses in both the 1960s and the 2000s, conveniently book-ending our Art School Educated research project.[6]

THE ARCHITECTURE OF EDUCATION IN THE 1960s

The post-war building programme was a belated opportunity for Britain to re-emerge in the mid-twentieth century as *modern*. Artists were actively involved, with Victor Pasmore's role in the construction of the New Town of Peterlee in County Durham being the most prominent example.[7] Concurrently, higher education institutions and architecture developed a potent inter-relationship evidenced by many out-of-town 'new' university campuses.[8] Stefan Muthesius sees this pattern as 'utopianist', rather than 'utopian'[9] and lays out the main issue for 1960s late modernism as a choice between 'old Oxbridge [and] new University Modernism' intended 'to impress through an institutional / architectural image'.[10]

The modernist architectural credo that 'form follows function' wedded very well with the needs of a new university to establish a strong corporate identity; while the modernist architectural aesthetic in educational buildings came to signify modern liberal pedgogy, distinct from that of Oxbridge.[11]

Art school building in post-war Britain was not only part of a general trend of educational and architectural modernisation,

whose audience is particularly visual in sensibility, but of a specific effort to reinvigorate the manufacturing base of the economy. Art schools could no longer be allowed to serve as sanctuaries for a privileged elite pursuing a nineteenth-century bohemian idea, and this had an impact on the architecture needed. Plaster casts after the antique were retired, and specialist technical machinery was installed.[12] Studios were adapted to house facilities, rather than simply to function as ateliers for masters. The model, both pedagogic and architectural was the pre-war German Bauhaus. In addition, post-Coldstream changes to the curriculum and preparations for DipAD inspections encouraged principals and governing bodies to think of their buildings in a modern post-war environment.[13] The changes that were required were often highly contested and the disputes between fine art and design departments over space allocation were not merely the details of institutional administration, but deeply symbolic issues that are still played out in art schools today.[14]

The central problem, as described by Jeremiah in his survey of British art school architecture, was 'to find an architectural expression for an education in transition'.[15] Amongst many other recommendations, William Coldstream told the Government that it should prioritise 'building programmes to the requirements of schools which will run the new diploma courses …'[6] Institutions seized the opportunity and several purpose-built art schools duly appeared, including the Royal College of Art (RCA) on Kensington Gore (1962), the London College of Fashion (LCF) next to Oxford Circus (1963) and Chelsea School of Art on Manresa Road

(1964). Built environments were needed that were flexible enough to accommodate unknowable future demands; buildings that could themselves 'learn'.[17] Instead, all these examples were 'statement builds', and now noticeably 'of their time'. H.T. Cadbury Brown, Hugh Casson and R.Y. Goodden designed the partially privately funded RCA building in-house.[18] Built in the Brutalist style, it is now listed, and was applauded in the architectural press at the time: 'The tough, sculptural treatment admirably expresses the character of the college, and the shuttered concrete, exposed services and structural columns in the workshops provide an unglamourised background to creative work'.[19] However, Jeremiah points out that the design was not, in fact, progressive, preserving as it did the traditional hierarchy of the academy with a grand galleried studio for the principal and reinforcing the separation between art and design by physically housing the disciplines in separate buildings, all in direct opposition to the Bauhaus idea.[20] In contrast, both the LCF and Chelsea projects were assigned to 'job architects' in the Schools Division of the London County Council Architects Department led by Hubert Bennett.[21] These buildings have been less exalted although the LCF still hovers over the Oxford Street 'rag-trade'.[22]

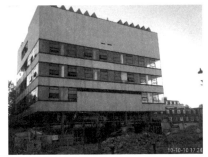

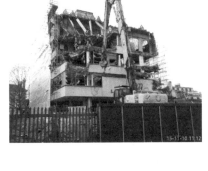

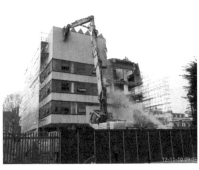

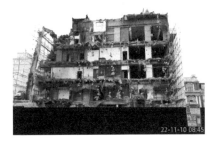

THE OLD/NEW CHELSEA

← Fig.7.1 Demolition of the New School of Art, Manresa Road, Chelsea, 2010

The LCC's Chelsea building stood on Manresa Road, just off the King's Road: the centre both of 1960s cool and 1970s punk. It was demolished in the autumn of 2010 having stood derelict for five years (fig.7.1). That a purpose-built public building, of overt aesthetic ambition, considerable financial investment and high cultural profile, can have such a brief life is indicative of the constant and unpredictable changes in art education practice that form one of the key arguments of this book.[23] The building's five years as a conspicuous ruin provided a dystopian monument to the demise of the British art school. This has echoes of a theme examined by former Chelsea student Peter Doig, in his series of paintings *Concrete Cabin* (1990s) showing Le Corbusier's *Unité d'Habitation*; the spectacle of the old 'New Chelsea' is evoked, not yet in ruins but appearing through trees like the discovery of a lost civilisation.

The new Chelsea building was described by W.F. Houghton, the LCC Education Officer as a:

… reinforced concrete framed building. The frame, where exposed, is finished grey colour and the external finish to the panel walls is white mosaic. The walls to the sculpture department, the kitchen and the students' common room are in dark coloured facing bricks. All metal work, window frames, balustrades, etc., are black; skirtings, door frames and doors are in black softwood and hardwood is given a natural finish; all compressed flax fibreboard is white.[24]

The project had been many years in the planning.[25] In 1957 the headmaster of the School of Art, then under the auspices of Chelsea Polytechnic (soon to become Chelsea College of Science and Technology), Harold Williamson, wrote that art could not remain a department within a college of advanced technology and that 'a new temple of the arts [should be] provided, [allowing] the School of Art … [to] begin an independent existence …'[26] Lawrence Gowing (Principal, 1958–65) over-saw the process of establishing Chelsea as an institutionally independent art school.[27] This was different from what was to become the prevailing pattern a decade later, of art schools being swallowed up by new poly-technics, and is in no small part credit to

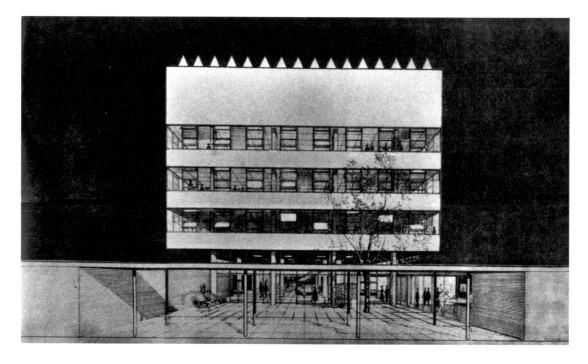

Gowing and his vision for what an art school should be.[28] It was perhaps primarily the new building that fortified Chelsea's reputation and prevented its fate being that of Hornsey.[29] Gowing's vision was manifested in the new building, in terms both of the design and the construction process.[30]

↙ Fig.7.2 Drawing for the New School of Art building, c.1959–61, published in the newsletter: *Chelsea School of Art, Manresa Road, Chelsea, SW3*, September 1962

However, it is difficult to gauge how interested Gowing was in architecture *per se*. It was the functional aspects of the building, as an art school, that mainly occupied him (particularly his painter's concerns about natural light), and also the interior decoration.[31] However, arriving as Gowing had from King's College, Newcastle, an art department in many ways ahead of London art schools in terms of pedagogy at this time, the building can be understood as a statement of intent, if not rhetoric.[32] During the 1950s, Newcastle developed a British version of Bauhaus-style teaching, in the form of the 'Basic Course'.[33] At Chelsea, Gowing employed alumni from King's, Ian Stephenson and Matt Rugg, as conduits for 'Basic Design' and it is no coincidence that 'The New School of Art in Chelsea' evoked the architecture of the Dessau Bauhaus, the foremost bastion of modernist architecture and art school pedagogy, and heralded the arrival of modernist art education in London.[34] The name of the school was decreed in 1957 and the use of the word 'New' is significant given how closely associated was the prestige of Oxbridge with the antiquity of those institutions.[35] Lacking 'dreaming spires',[36] 'New' universities defined themselves in opposition to the traditional and conservative 'old' institutions, and in the art school context 'New' also implied modernist art.

↪ Fig.7.3 Architectural elevations of the New School of Art in Chelsea, 30 January 1959. National Archives, Kew

The architects of the New Chelsea were led by Michael Powell, and included Ronald Robson-Smith, Austin Winkley and, later, Michael Booth.[37] Most of the drawings were made in 1959, and finalised by the end of 1960, after a period of consultation between Winkley, Robson-Smith and Gowing, with a range of interested parties from Coldstream to eminent artists such as Henry Moore and Elizabeth Frink, who had previously taught at Chelsea under the polytechnic.[38] The involvement of a range of such figures in the discussion reflected the trend to distinguish the generic user from the individual, and helpfully augmented Gowing's influence, lessening the danger that the design of the building would be too specifically amenable to him alone rather than to his successors or other users of the building.[39] Student voices, however, were not heard at any point. Since Coldstream was writing the first NACAE Report as the rebuilding of Chelsea was being discussed, his contributions would have been particularly helpful, especially with the prospective Summerson inspections in mind.[40] It is also possible that the practical issues that were being discussed in relation to Chelsea would have had some reciprocal impact on the formation of Coldstream's ideas and on the subsequent recommendations of his committee. In these ways, the architecture, institution and pedagogy of Chelsea were inextricably enmeshed to create a model for 1960s British art education.[41]

The New Chelsea was unashamedly a modernist building, in the International Style, described as 'spartan', if with impact, by the *Architect & Building News*, and 'chunky' by *Interbuild*.[42] It was essentially a white cube, horizontally articulated, floating on glass, and planted on two single-storey wings, as seen from the front.[43] The building was 'designed on a 5ft grid, expressed in the 5ft window pattern'.[44] It was set back from the road, surrounded by space and open to the street. The use of glass to the corners, and the atrium and mezzanine, all contributed to a light airy feeling. The building was metaphorically and literally transparent, featuring a large exhibition space

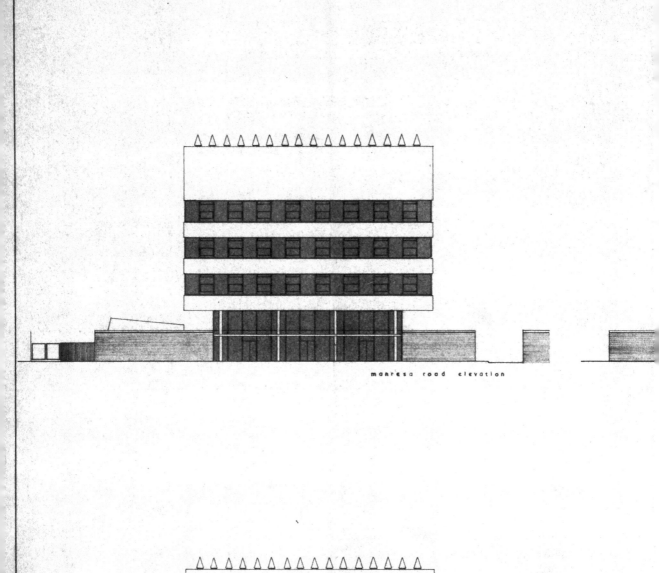

manresa road elevation

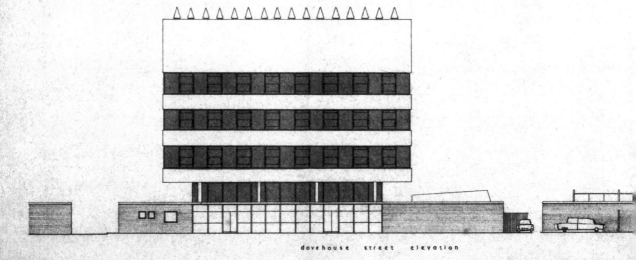

dovehouse street elevation

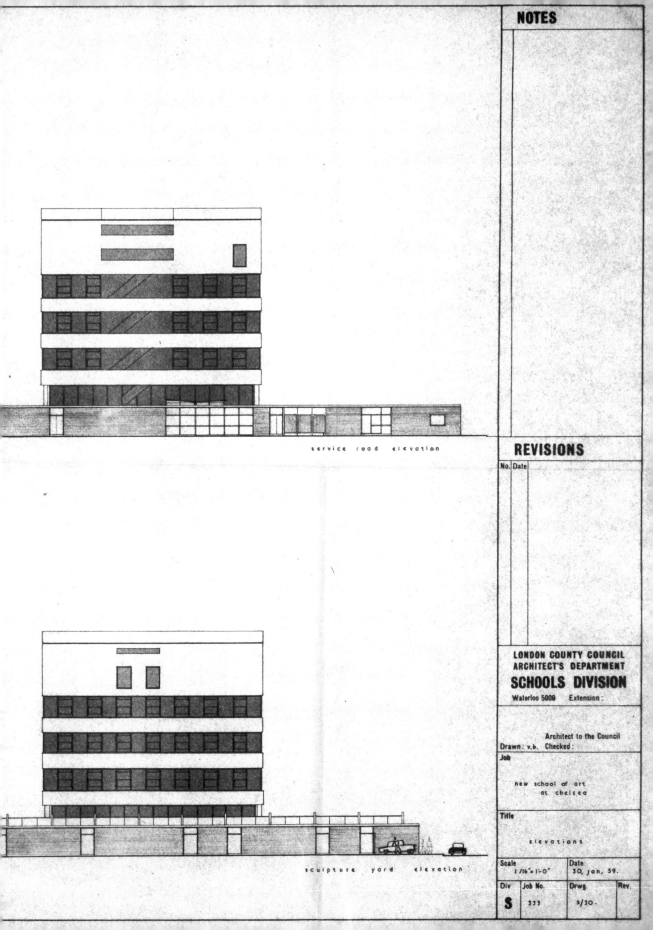

service road elevation

sculpture yard elevation

NOTES

REVISIONS

No. Date

LONDON COUNTY COUNCIL
ARCHITECT'S DEPARTMENT
SCHOOLS DIVISION
Waterloo 5000 Extension:

Architect to the Council
Drawn: v.b. Checked:

Job

new school of art
at chelsea

Title

elevations

Scale	Date
1/16" = 1'-0"	30, jan, 59.

Div	Job No.	Drwg.	Rev.
S	333	s/30.	

immediately upon entering, proclaiming its purpose and visible from the pavement.

↓↘ Figs.7.4 and 7.5 The New School of Art in Chelsea, 1965

This openness to outsiders was not only symbolic but was embedded in all aspects of Chelsea; part-time visiting artist/teachers far out-numbered full-time staff (seventy visiting staff to seventeen in-house, in 1965).[45] The paving slabs of the forecourt continued uninterrupted from the outside environment through the interior and out into the court-yard beyond, where the Henry Moore sculp-ture *Two Piece Reclining Figure No.1* 1959 rested by an ornamental pond.[46]

Off the gallery, on the ground floor, were the dining hall, snack bar and student common room (fig.7.6, overleaf), and also the sculpture department and associated workshops, with access to an outside yard. Above that was the mezzanine, with a conservatory. On the first floor were the library and lecture theatre, administration offices, staff common-room and the principal's office and separate studio. Printmaking, textiles and graphics were on the second floor, as was a photographic dark room. On the roof was a small terrace, and below the building was an underground car park.[47]

Painting studios of various distinct identities occupied the third and fourth floors and, over time, a system was developed, seemingly unique to the Chelsea Painting Department, whereby rooms were perma-nently occupied by staff representing distinct, and often incompatible, approaches to painting, with students aligning themselves to one or another and becoming resident often for the duration of their course. Painting students therefore were housed according to sensibility rather than by year group.[48] The 'studio system' meant opposing aesthetics could coexist within the same art school without any one style becoming dominant. The importance of this to Chelsea's pedagogy cannot be emphasised enough. Although the rooms weren't conceived with these stylistic

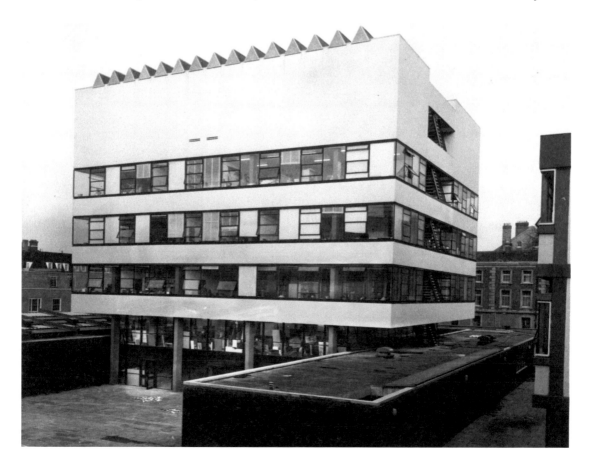

identities (the constructivist studio, the pop studio, the abstract expressionist studio, the life room, etc.) in the original designs, once they had been established, the pedagogic positions were not only located but divided by the walls of the building.[49]

At the heart of the building, and the main means of traversing it, was the cantilevered folded slab '*flying*' staircase.[50] Its geometric structure of heavy timber was conceived as a site of encounter and exchange, a defining factor in the design as utopianist, in Muthesius's terms:

> … *what principally makes the plan of such a utopian settlement, or ideal city, look community orientated is the way it stresses the meeting of people, usually in a central place. 'Rubbing shoulders all the time' was the university founders' and their designers' ideal.*[51]

Robson-Smith and Winkley made certain, by physical rehearsal, that there was enough room for two people to stop and converse while others walked by.[52] Such concern for communal liminal space was paramount throughout the design, which included a variety of areas unclaimed by teaching and learning, and exhibition galleries on each floor. The positioning of the studios denoted, or implied, a hierarchy; the most avant-garde painters were closest to God on the top floor, while the earthly concerns of the sculptors meant that they dwelled on the ground.[53] The fourth-floor students also had the arguable advantage of perusing the whole institution on their journeys up and down the stairwell, while inhabitants of other floors were unlikely to venture above their station.

Light was of great concern and the subject of much correspondence between Gowing and the architects, with natural light favoured and tungsten lights eventually decided upon for winter afternoons and evening classes. Considerable attention was given to the details of blinds (Gowing preferred vertical slats) and variable louvres. The top (fourth)

floor studios featured skylights giving the building its distinctive zig-zag silhouette; '[and] provid[ing] the most constant even light … [it] contrasts with that in the traditional north lit studio on the north side of the fourth floor' commented Houghton.[54] The lecture theatre boasted individually controlled lights to each seat to cater for note-taking when the main lights were off for viewing slides. An innovative detail, particular to the needs of an art school, was extra sections cut out of the walls to the sides of the doors of the studios to allow the removal of large canvases.[55]

The LCC budget, when construction finally started in 1964, was very generous for not only the building but for the fixtures and fittings. Seemingly no expense was spared on the quality of materials: leather upholstery and solid wood. Again Gowing was involved in the design decisions, specifying 'pearl white linoleum' for the floors.[56] Although white floor-covering cannot have been an entirely practical decision, it is not purely an aesthetic choice either, but demonstrates Gowing's prioritising of light above other concerns. Gowing certainly had a taste for modernist design, and ordered two Rietveld *Red and Blue* chairs for use in his own office and studio.[57] Preserved in the Chelsea College

of Arts archives are many catalogues and sample photographs of chairs and desks from companies such as Guy Rogers, Fritz Hansens, and Robin Day's company Hille.[58] The chairs, desks and tables which appear in photographic records of the interiors of Chelsea dating from 1965, are stylish yet functional and office-like, reflecting the building itself and an integrated holistic approach to the creation of a working environment.[59]

↓ Fig.7.6 The student common room of the New School of Art in Chelsea, 1965, photograph reproduced in pamphlet: *Chelsea School of Art – Ceremonial Opening of the New Buildings*, London County Council, 1965

→ Fig.7.7 Lawrence Gowing in Chelsea School of Art, 1965

Despite the aesthetic successes of what we might call Gowing's Manresa Road building in architecture and design, the institution outgrew it almost immediately.[60] The covering over of the central courtyard was mooted within a year,[61] and the interior communal areas were divided up to make more student work spaces. Within a decade arrangements had to be

made to procure two over-spill campuses, and, by the time of the move to Millbank, Chelsea College of Art and Design (as then called) was spread across four sites in Chelsea, Hammersmith and Fulham, two of which were ramshackle ex-primary schools furnished with inherited miniature chairs and tables.[62] Arguably such needs-must buildings provide the most ideal accommodation for an art school, meeting as they do the most basic requirements of four walls and a roof without the imposition of 'purpose', and, in addition, students are left free to make whatever adjustments they require and as much mess as they like. The over-spill workspaces at Bagley's Lane for the postgraduate painting students were huge, with just two sharing. However, even with such attractive annexes, the Manresa Road building was clearly considered to be the primary site of Chelsea. Students moved their shows to Manresa Road after initial display and assessment at their home site and attended lectures and social events there. Although an array of complaints was made about the New Chelsea building (it was overcrowded, it leaked in the rain and was too hot in the summer, the light in the life room was apparently unsatisfactory, and, lacking a large enough service lift, partitions and large artworks had to be manually heaved up and down the stairs),[63] there was an

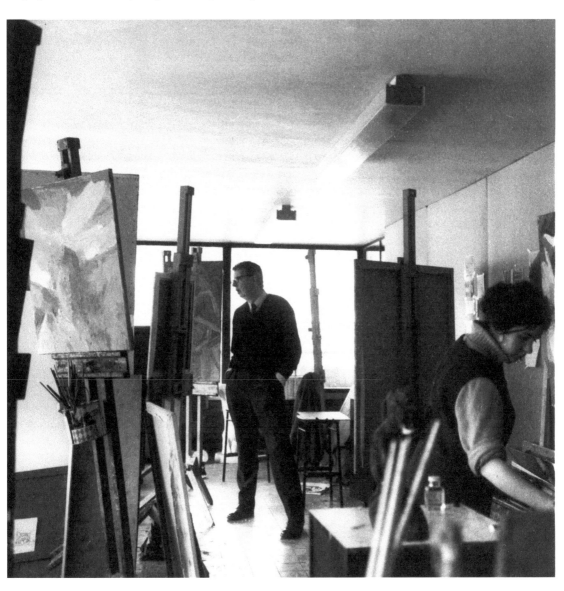

overwhelming fondness for it and real sadness at its demolition. Ex-students have clear memories of seeing the building for the first time, even crediting it with their desire to join the institution and identifying it as a symbol of the institution;[64] at least one ex-staff member still visits the building in his dreams.[65]

LONDON ART SCHOOL BUILDINGS AND CHELSEA NOW

In terms of London art school building, a parallel can be made between the 1960s and the first decade of the twenty-first century. The flurry of activity in the 1960s has been matched recently by the initiation of numerous building projects: for London College of Communication (Allies and Morrison, completed 2003), Goldsmiths (Alsop & Partners, 2004), Chelsea's new site at Millbank (Allies and Morrison, 2005), Ravensbourne (Foreign Office Architects, 2010) and more recently the Haworth Tompkins work for the RCA on the Battersea site and the Stanton Williams development for Central St Martin's at King's Cross.[66] These ambitious flag-ship designs could be taken to indicate a flourishing art school culture, however, in both scale and remit they have little in common with the art school building which took place in the 1960s. If current builds are not 'well-meaning technocratic modernism', then neither are they simply part of the New Labour urban regeneration schemes critiqued by Owen Hatherley in his recent *Guide to the New Ruins of Great Britain*.[67]

The new art schools in fact play an additional role: they contribute to the corporate image of London (and therefore the UK) in the international market. London's twenty-first century art school building programme is in the hands of private development firms, and of the art schools themselves, independent from local government. The art school institutions have grown exponentially, unrecognisably, and although still in the public realm, they are, like the higher education sector in general, effectively now self-funding and run as global businesses.[68]

It is no coincidence then that these new art school buildings tend to appear slick and glamorous.[69] Issues of institutional identity, continual newness and even utopia/dystopia, remain pertinent, but the London art schools now find themselves in a context far-removed from that of their sixties heyday, amongst the 'iconic' architecture of the capital, part of the so-called 'Urban Renaissance'.[70] Alsop & Partners' Ben Pimlott building for Goldsmiths and Foreign Office Architects' work for Ravensbourne can particularly be identified with Hatherley's conception of building as logo.[71] They are architecture as art, form not following function but instead representing it.

The danger in this is articulated by the architect Charles Renfro in his essay 'Undesigning the Art School': 'Unlike the work that occurs inside the art school, a new structure that reflects current architectural practice is doomed to be a relic of a particular time and place. As a pedagogical tool, a purpose-built art school may be rendered obsolete in a generation'.[72]

Whereas this may be an effective characterisation of the prevailing trend for flagship art school buildings, and certainly describes the fate of the old New Chelsea building (which had 'logo' qualities too), the new home of Chelsea College of Arts on Millbank seems to circumvent such problems. Renfro asks, Why build at all? And, despite not embodying the radical conclusion he puts forward (for art schools to reside only in temporary locations), Chelsea is to some extent in accordance with his thinking. In the early twenty-first century Chelsea did not build from scratch, instead they colonised an existing building: the old Millbank Barracks and former Royal Army Medical College. It is, of course, traditional practice for artists to commandeer dilapidated and undesirable buildings or parts of the city, lending the area some bohemian essence which subsequently prices them out: the London borough of Chelsea is a prime example of this pattern.[73] This is, however, clearly not the case with Central St Martin's at King's Cross, or Chelsea next door to Tate Britain. Rather than retreating into the hinterlands, the London art schools have been able to establish themselves in prime locations.

The Allies and Morrison conversion of the Millbank Barracks for Chelsea is subtle and innovative. The appearance of the original late nineteenth-century building could seem conservative, and retrogressive in comparison with the former New Chelsea on Manresa Road, but the site is in fact a very contemporary response to the problems of art school building. The architects have made modest interventions, barely interrupting the Neo-Renaissance façade.[74]

↓ Fig.7.8 Chelsea College of Arts, Millbank site, London. Old and new buildings (exterior), 2012

The most defining external feature of the campus is the expansive open space of the Parade Ground.[75] The constantly changing light strips sunk in the ground have 'wow factor' but do not function as a logo (they are constantly changing, barely visible most of the time and never in their entirety). Art works are installed on the Parade Ground, which is also rented out for commercial events, and for the majority of the year Tate gallery-goers and the general public can walk across it without necessarily being aware of what goes on inside the buildings.[76] The advantages of the purpose-built art school are incorporated with necessary extensions 'dropped in' behind and amongst the original building. The site has custom designed workshops and facilities, communal meeting places and incidental and transitional spaces such as walkways, landings and stairways. As was the case with the Manresa Road building, sculpture staff and technicians were consulted on the design and layout of the workshops and foundry, and in-house skills and expertise was engaged in the fabricating of workshop benches and furnishings.[77]

Throughout the building the relationship between old and new is undisguised; formerly external walls are enclosed in wood and glass, and brickwork is sawn off when necessary.[78] Floating metal stairwells and bridges traverse the structure, and provide surprising transitions from the bright open spaces of the entrance foyer and student canteen, to the studios, and the suite of lounges and original library, which retain the feel of officers' quarters.

↓ Fig.7.9 Chelsea College of Arts, Millbank, London. Old and new buildings (interior), 2010

The numerous subject departments of the college are united for the first time since the mid 1970s, on Chelsea's Millbank site, with fine art and design-based courses occupying the same building, in adherence to the Bauhaus ideal.[79] The institution has not gained any extra space in the move and has in fact lost a number of its specialist facilities, but it has gained flexible-use studios. This contrasts with Manresa Road, which claimed to 'combine the resources of the two [parent institutions] and add considerably to them in many fields'.[80] Although the decisions to lose traditional printmaking and wet photography were certainly pragmatic, and partly the default results of room layouts and pressures on space, they are ideological too. Possibly the etching presses were abandoned because they were no longer in demand, or maybe they were just too difficult or too expensive to transport or replace, but it seems likely that etching was considered anachronistic

within a twenty-first-century art curriculum.[81] Of course, the rule of curriculum instability means that it will be the student's prerogative to adopt printmaking and darkroom photography the moment the practices are not officially sanctioned. However, in conjunction with the abandonment of the Manresa Road studio system for the painters and with the dissolution of distinct disciplines within fine art, this can be seen as symptomatic of an entropic process in parallel to the wider art world which has fragmented from the multiple avant-gardes of modernism, to the individualist subjectivity of postmodernism; so Chelsea has progressed from offering delineated 'options',[82] to providing a platform for an infinite number of practices.[83]

In addition to this, the Millbank conversion lacks the clear physical hierarchy of the old building and is consequently (and perhaps

symbolically) more difficult to navigate, having as it does multiple routes to any given area, rather than a monolithic stairway. That the architecture is much harder to read in terms of art school ideology is both inevitable (because the building is adapted from its original purpose), and befitting.

FANTASY ART SCHOOL

The most illustrious example of a purpose-built art school is surely still held to be the Dessau Bauhaus (1925–6) and it remains a reference point for twenty-first-century designers of art schools.[84] Its elegant form is in accordance with the de Stijl influenced aesthetic with which the school has become synonymous. It appears *constructed*, and emphatically displays its constituent parts and materials: metal, concrete and glass. Although its impact – both architectural and pedagogical – has been extensive, the Dessau Bauhaus only remained in operation for seven years. Any positing of the design of the building as necessarily integral to the activity that took place within its walls is undermined by the fact that it was used as a Nazi training facility during the 1930s.[85] Nevertheless, it can be argued that the building functioned pedagogically in that it embodied an aesthetic and was therefore a statement of values; art school teaching frequently tending towards the provision of a model (the artist/lecturer/master) and a process of osmosis.

Once the Bauhaus was closed, its influence was disseminated by former students and staff, and several other schools were established in different parts of the globe, most notably Black Mountain College in North Carolina, USA (1933–57), and the Hochschule für Gestaltung (Institute for Design), Ulm, Germany (1953–68). Black Mountain College employed ex-Bauhaus teachers Walter Gropius and Marcel Breuer as architects, and the American Alfred Lawrence Kocher. At Ulm, the Bauhaus-trained artist Max Bill was the first Director and his design was a purpose-built complex of studios and living accommodation connected by covered walkways.

Although the curriculum at Ulm eventually rejected Bill's constructivist synthesis of art and design, and moved instead towards a more commercial and industrial remit, before its closure in 1968 the Hochschule für Gestaltung was perhaps the most successful of European utopian art school builds. The 1964–5 Manresa Road New Chelsea building clearly makes visual reference to the Bauhaus tradition of art school buildings and the LCC architects were undoubtedly aware of these earlier incarnations.

The Escuelas Nacionales de Arte (National Schools of Art) on the outskirts of Havana, Cuba, built in the early 1960s concurrently with the New Chelsea but almost certainly out of sight of the LCC, were not only utopian but politically radical, conceived as they were by Che Guevara. The complex aimed to be, and is colloquially known as, the 'City of the Arts'.[86] It has been argued that Ricardo Porro, architect of the Escuela de Artes Plásticas (School of Visual Art), overtly sought to address Cuba's multicultural identity through building design, invoking 'a hybrid of patriar-chal Spanish baroque culture and nurturing matriarchal African culture, both mediated by the sensuality of the tropics'.[87] This art school could not be more different in aesthetic from the European Bauhaus tradition. In response to the revolutionary situation Porro designed an art school specifically for Cuba, and not in the International Style. Instead of modernist precedents, he looked to biological form and the human body, and also to the African village. The complex spreads out horizontally, close to the ground in a single storey. From above it has the appearance of bodily organs, a heart, lung and aorta, or an inner ear. Ovoid cells form a module that repeats throughout the design in a developing pattern. It is conceived sequentially rather than hierarchi-cally. Porro himself uses the term 'negritude' to describe his evocation of an African ethnicity, and although there is some refer-ence to Spanish vaulted cupolas, the building is a radical departure from Western architec-ture.[88] Porro seems most interested in the representation of the sensuous, and even erotic, feminine, and, in a parallel to the discourse of the Urban Renaissance, intended

the building to affect its surroundings: '*La Escuela de Artes Plásticas es la ciudad que se convierte en Eros*.'[89] Despite outwardly being so different to any contemporaneous art school in London, much like the New Chelsea the Escuela de Artes Plásticas was commissioned and sanctioned by the state yet swiftly fell out of accordance with the wider political and cultural environment. It was abandoned in 1965 (but although in partial ruin has now started to function again).

The Yale Art and Architecture Building at New Haven, a Brutalist design by Paul Rudolph (1964), was controversial from the time of its completion and in 1969 was extensively damaged by fire as the result of an arson attack, perhaps by students protesting against the architecture.[90] This seems highly unlikely, but it is true that Rudolph had intentionally set out to make the building mysterious. It was perversely difficult to navigate, featuring thirty levels over nine storeys, and the vast façades of 'corduroy' concrete, both internal and external, are unremitting.[91] The building was extensively reconfigured, then eventually restored, and is still in use.

The Chelsea building on Manresa Road was on a more domestic scale than either Cuba's Escuela de Artes Plásticas, with which it had an ideological connection, or Yale, with which it had an aesthetic connection. Perhaps the extreme example provided by Rudolph at Yale can be used in defence of the Millbank Chelsea's slightly confusing layout. What all these examples show, including the two Chelsea buildings, is that the problem of designing a functioning art school must be understood within a societal context.[92] It is telling that none of them functioned as intended in the original designs for more than a few years, although of course it remains to be seen how the current Chelsea building fares.

CONCLUSION

While it is hoped that this chapter has gone some way towards illuminating the complex relationship between architecture and the art school, it is clear that a resolution cannot be reached, and any building design will ultimately be a sum of constraints from the point of view of the student-artist user. Practicalities such as prohibitive doorway or stairwell dimensions, overcrowding in the studios or the lack of wall or floor space are just some of the minor irritations identified. Brendan D. Moran argues 'any specificity in a design that means to give form to a particular teaching philosophy is bound over time to fail, rendering a chokehold on change in place of being its enabler'.[93] This could be less of a problem in our atomised age, with prescriptive treatises of institutional teaching and learning practice seemingly incongruous within the context of postmodern discourse. However, such accounts are indeed demanded by 'Quality Assurance', and a commissioning brief for the architect cannot be established without some description of the pedagogical aims and requirements of art education, which in turn demands an agreed definition of art itself.[94] As artistic practice cannot be defined or even anticipated with much confidence, a 'future-proof' art school building design is not possible. What then is an art school builder to do? It seems the choice, whether the building is adapted or designed for purpose, is between aspiring to a neutral space, or embracing an idiosyncratic space. If it is accepted that the former is unachievable by definition, then the latter offers either inspiration or at least traction to the art student user.[95]

Jeremiah concludes his account of British art school architecture by bemoaning the failures of the post-war building programme and advocating the co-option of spacious existent commercial and industrial buildings, instead of the purpose-built art school. He argues that whilst minor shortfalls in a building's specifications for use as an art school can be easily overcome by the creative inventiveness of artists, 'the more serious problems arise when stylistic overstatement not only interferes with function but constrains any remedial action'.[96] As studios are still almost always temporarily divided up into booths with chipboard, and art students frequently create their own individual environments irrespective of the architecture, a cavernous hanger lit from above has some

appeal, in that it would be flexible, although perhaps subject to noise disturbance and lacking in a certain humanity.[97] The Haworth Tompkins Sackler Building at Battersea, purpose-built for the RCA, with its factory aesthetic, has perhaps achieved a balance in this respect.

Rather than considering the old New Chelsea building purely as a crystallisation of ideas about art education in the late 1950s and early 1960s, it had a longer history and continued to function as an art school throughout the 1970s and into the early 2000s. As a shell it has housed vastly different artistic practices, even if its exterior remained constant (although gradually deteriorating). It can be concluded that there never was a moment when its architecture was in exact accordance with its pedagogy, and if there was it is likely to have been years before the inauguration; before actual construction began. Although nominally purpose-built, in practice it was just as quirky as any building might be. The plans, elevations, drawings and photographs represent the building spatially, but only for a prolonged moment of inception. To examine the building through time a different methodology would be called for. The gradual evolution of studio usage can be pieced together from the accounts of former staff and students, but mostly people only possess knowledge of a particular corner of the building, over the duration of just a few years, and even then contradictions occur. The transitory presence of personalities arguably has a far greater impact on lived art school experience than architecture does, yet the institutional building remains a powerful totem, visual and manifest. The impact of a building on institutional structure and pedagogic practice can perhaps only be measured comparatively, in retrospect; however, the effect of a building on an individual artist is potent and immediate. Chelsea has, of course, remained Chelsea in its new building (even located on Millbank in Pimlico as it now is, rather than in Chelsea), and is recognisable to itself to a greater extent than the studio practice in the final years of Manresa Road would have been to Gowing. Current students address and

readdress their built environment, or ignore it, consciously or otherwise; they've all heard stories about the old building.[98]

A radical conclusion would be to dispense with the art school building altogether, and establish the institution as an entirely virtual community online. To a certain extent this is happening already, as students' practice is often collaborative and geographically based outside of the studios: manufactured at specialist facilities around the city, produced as site-specific works in the wider environmental context, or located in the digital world. Even the excellent library at Chelsea is no longer such a powerful draw, as images and information are available everywhere.[99] As has long been the case, students cannot afford to live close to campus and now digital technology means that there is less reason to make the journey. The art school building is still a symbolic focus and meeting place, but the importance of exhibition space and social space has been further elevated, as the chance encounter (with people or objects) becomes the primary attribute of any site.[100] In contrast to Chelsea's painting students of the past, working within one of the studios of the 'system', alongside fellows with similar sensibilities and concerns, practice is now so disparate that it is less and less likely that studio space allocation can result in edifying relationships between individuals. Although exchanges between, for example, a sound installation artist, a performance practitioner, a digital image-maker and a painter, in a confined space, have the potential to be mutually beneficial, they can also be fraught and banal; it is not surprising that students increasingly choose not to work primarily within the art school building. Concurrently, art students are losing their grip on personal studio territory – Chelsea is not the only institution that now requires its students to clear out of their workspaces during the holidays, the building being a source of revenue if available for short-course teaching at Easter or for summer schools.[101]

With this new model of the art school in mind, Renfro cites the examples of Delfina Restaurant and the Architectural Association bookshop and café, the latter described as

'one of the liveliest intellectual spaces in all of London'.[102] On the current Chelsea College of Arts site, the Chelsea Café and the CHELSEA space gallery opposite, both open to the general public, operate in similar ways. One of the mythologies of art school has long been that the most important exchanges, between staff and between students, took place away from the institutional building altogether: 'down the pub'. This arrangement, combined with online social-networking, could eventually supersede the institutional building altogether. Shortly after the demolition of the old New School of Art in Chelsea and with art education once again in crisis,[103] it is valuable to re-examine art school building and its attempts to 'crystallise' art education's inherently unstable pedagogy.[104]

COLOUR PEDAGOGY IN THE POST-COLDSTREAM ART SCHOOL

INTRODUCTION

This chapter is not primarily about artists' use of colours as an aspect of their practice. Rather it is about the teaching of an understanding of colour in intellectual and intuitive terms and it seeks to situate that understanding within the pedagogical setting of the British art school post-1960. It begins by considering the history of colour as a discretely taught subject, which was rooted in the early twentieth-century Bauhaus curriculum and later played out in Basic Design courses in Britain but which swiftly disappeared from view. Despite this disappearance, our research shows that there was a continued, if rather fragmented, role for colour within the education of the artist, at least at the beginning of the period covered by this book, that is, in the 1960s. The chapter seeks to unhinge colour from its more formal frameworks of understanding, turning its material absence to its own advantage and re–presenting it as a fluid and pervasive pedagogical theme. Taking the archival film *The Colour Experiment* (c.1968) as a key empirical point of reference for the experimental teaching about colour undertaken by Tom Hudson (1922–97) at Cardiff College of Art, we will be able to see that an understanding of colour remains integral to what artists do. As we shall see, Hudson's pedagogical strategies are taken as emblematic of an approach to colour teaching that sought to balance intellectual and theoretical perspectives against other more intuitive approaches. Through the visually driven narrative of the chapter, individual experiments by a number of colour teachers will be highlighted in order to identify and address key questions, ideas and strategies in colour pedagogy. Always returning to a fundamental argument between intellectual and intuitive understandings of colour, the aim is to bring to the fore the ubiquity of colour in the world around us in contrast with the relative absence of colour pedagogy in the art school. I will ask if the story of colour pedagogy is indicative of the broader turn against the teaching of skills and formal technique that we see for instance with the disappearance of the life room. Transcending medium, in a number of unexpected ways colour might be said to be the quintessential subject of inquiry in the history of the post-Coldstream art school.

UBIQUITOUS YET ABSENT

Precisely why has colour teaching all but disappeared from the art school over the last fifty years? Why would a subject apparently so central to what artists do be stripped from the curriculum? In his book *Chromophobia* (2000), artist David Batchelor (b.1955) focuses not on art school pedagogy but on the wider field of making and understanding art, literature and film. He identifies what he calls a chromophobic impulse and a fear of corruption or contamination through colour, something he understands as a pervasive undercurrent within much of Western cultural and intellectual thought. Elsewhere, Batchelor argues:

> the discourse on colour is not largely an academic discipline; rather it is generated in the course of making things – paintings, sculptures, photographs, installations, films, buildings, novels, songs and poems. It is constituted for the most part in those works and in reflections on those works, both by the people who made them and by others who came into contact with them.[1]

Yet it is surely not that straightforward. And the complexity of reframing 'the discourse on colour' within a pedagogical setting requires us to identify changes in colour teaching, as well as analyse why those changes took place and what their implications might be. At the heart of all discourse on colour, whether historic or contemporary, is a fundamental question about whether an understanding of colour can be taught at all. Batchelor claims 'you teach yourself', suggesting that: 'any colour theory is an attempt to contain what is essentially uncontainable'.[2] Indeed, most discussions of colour pedagogy place intellectual and theoretical understandings in a tight, perhaps irresolvable, association with more intuitive approaches.

When it comes to colour, students can never be free from prior learning; the ubiquity of colour in the world is undeniable and its associations and meanings are myriad. This is not to say that students arrive at art school already versed in the Ostwald and Chevreul colour systems.[3] Rather, it is the case that students are surrounded by colour in their everyday lives and cannot avoid established semiotic indicators relating to colour. Such semiotic associations might shift across time, cultures and geographies, but they will always be present in some form. Therefore, even without any formal colour pedagogy, students must inevitably bring the intellectual (semiotics) and the intuitive (emotions) together to some degree. Since Batchelor's argument seems to question the very possibility, or at least the value, of any intellectual component, it also questions the fundamental dialectic – intellect vs. intuition – at the heart of the discourse on colour.

Stephen Melville's account of colour: 'Color Has Not Yet Been Named: Objectivity in Deconstruction' (1994) is useful [4] and recognises that:

> [t]he linguistic or semiotic approach [to colour] demands a prior semiotization of art that looks at present to be bound to a particular narrow cultural and historical range and is further troubled by questions of color, which would appear to lend itself to semiosis only on the grounds of a return through more obdurately art-historical facts – for example, that what painting for the most part knows is not 'blue' or 'red' nor even, at least until very recently, 'cobalt blue' or 'alizarin red,' but 'Giotto's blue' and 'Titian's red' – so the semiotic construal never quite fights its way free of the art-historical ground it means to undo or overmaster.[5]

Further, Melville suggests: 'that semiotic availability depends upon both a radical shift in the material conditions of painting and the availability of an understanding of art history in which that shift could be actively registered'.[6] This would help to explain why the art student is, in part, always already informed about colour and its associations. What puts that informed position at risk is the fact that art teaching has changed radically in the last fifty years. Coldstream's reforms certainly gave art students a better access to art history, within which colour and colour pedagogy might be understood. *The Elements of Drawing* (1857) – the account of colour and composition offered by the art critic John Ruskin (1819–1900) – provides us with an earlier point of reference that gives sway to an intuitive understanding of colour. Ruskin addresses his reader in dramatic tones claiming that 'to colour well, requires your life. It cannot be done cheaper'.[7] This boldness soon gives way to a detailed description of drawing and colour exercises, which reveal colour as something that underpins all Ruskin's thinking. Despite his laborious and varied instructions, it is an intuitive rather than intellectual understanding of colour that Ruskin champions:

> As to the choice and harmony of colours in general, if you cannot choose and harmonize them by instinct, you will never do it at all. If you need examples of utterly harsh and horrible colour, you may find plenty in treatises upon colour, to illustrate the laws of harmony … If ever any scientific person tells you that two colours are 'discordant', make a note of the two colours, and put them together whenever you can.[8]

In this way Ruskin discredits any scientific or intellectual component in the artist's understanding of colour. Over one hundred years later, in the post-Coldstream art school, Ruskin's anti-intellectual stance on colour was to be further underlined by a general shift away from the teaching of skills and techniques.[9]

THE LEGACY OF THE BAUHAUS

In the context of *The London Art Schools*, it is the pedagogy and colour teaching of the Bauhaus – well rehearsed in other chapters in this book – that provides a pedagogical benchmark against which subsequent

developments in British art education might usefully be considered.[10] As Thierry de Duve summarises it:

> Kandinsky spared no effort to make this utopia, which was pedagogical throughout, into a reality. He would teach at the Bauhaus and write the 'grammar of forms' he had already projected in Über das Geistige in der Kunst, which he entitled Punkt und Linie zu Fläche (From Point to Line to Surface). Itten and later Albers would do the same for the language of colors. Klee would look to nature and its organic laws to find his Organon; Malevich would write a semiotic history of painting starting with Cézanne; Mondrian, El Lissitzky, Van Doesburg, all would write, teach, broadcast their ideas as much as their art.[11]

The influence of the Bauhaus and its teachers was felt acutely in mid twentieth century British art education, particularly in Basic Design teaching, and two Bauhaus veterans, Johannes Itten (1888–1967) and Josef Albers (1888–1976), were – via their writings – important figures in the field of colour teaching in the UK. Through a formal theoretical text, Interaction of Color (1963), and a more pragmatic exploration of colour and form in his Homage to the Square series of paintings (from 1949 onwards), Albers's ideas were made available to a new generation of art teachers and students.

↓ Fig.8.1 Josef Albers, Homage to the Square: Study for Nocturne 1951. Tate

For Albers, working with colour was about engaging with a material in a subjective manner: '[a]s we begin principally with the material, color itself, and its action and interaction as registered in our minds, we practice first and mainly a study of ourselves'.[12] Interaction of Color, however, is not a didactic manual for teaching colour theory. Rather, it offers: 'an experimental way of studying color and of teaching color', where Albers puts a practical exploration of colour above any theoretical concerns.[13]

Alongside Albers, Itten's books The Art of Color (1961) and particularly The Elements of Color (1971) represent a touchstone for formal colour teaching. Itten does not insist upon theoretical training, although he does recommend it, noting:

> In this book I shall try to build a serviceable conveyance that will help all who are interested in the problems of color artistry. One may travel carriageless and by unblazed trails, but progress is then slow and the journey perilous. If a high and distant goal is to be attained, then it is advisable to take a carriage at first in order to advance swiftly and safely.[14]

For both Albers and Itten, the balance to be reached between the intellect and intuition is central to an understanding of colour. Ultimately, while the teaching of colour theory is important in their

pedagogy, the emphasis is squarely upon an intuitive, experiential understanding of colour through making.

THE LANDSCAPE OF BASIC DESIGN IN BRITAIN

Similarly, Basic Design teachers in Britain adopted an exploratory approach to studying and teaching colour that always put the experience of making art before theoretical concerns, even if the nature, focus and method of colour teaching varied from school to school. The approach taken by Harry Thubron (1915–85) at Leeds College of Art (1955–65) allowed for an intuitive way of working within set systematic exercises. With astounding results, Thubron set very simple exercises such as making secondary colours from primary ones, studying the clarity of hue and the intensity of colour, and exploring discordant colour relations.

Norbert Lynton (1927–2007) recalled a winter school run by Thubron in Leeds in 1959, and focusing on colour:

> *One exercise was to adjust Windsor (sic) red, blue and yellow to give them the same visual weight; another was to mix them to make black and then add white and see which hue dominated the resulting greys. I found squeezing colours out of tubes and making a mess with them deeply frightening at first. I did those mixtures and kept adjusting them again and again, to get the colour chord clearer and the grey greyer even though the tints were delicious.*[15]

The shift in Lynton's experience of handling colour, from fear to delight, might be related to a pedagogic shift from instruction to exploration. He recalled that Thubron: 'had turned what had been a focused assignment, demanding my attention, into an opening

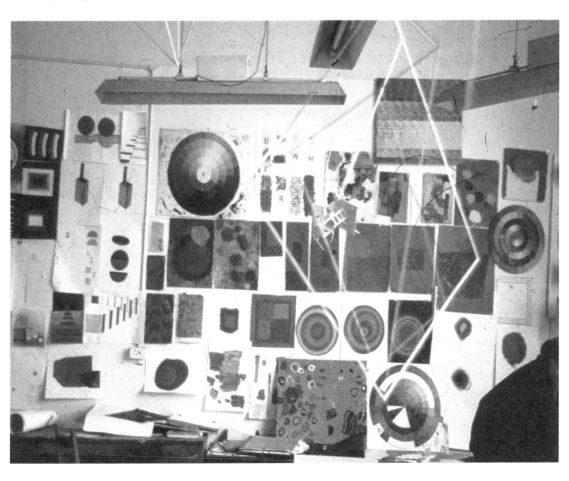

world of discovery and adventure'.[16] The duality of a narrow focus on the one hand and an opening up on the other, is something Lynton later recognised as valuable and central to creative work. Yet it must have been disconcerting suddenly to be expected to work in such different, and relatively unstructured, ways and the experience of colour itself may have been an unsettling one. As psychoanalyst Marion Milner observes, the 'plunge into colour' can be simultaneously terrifying and exciting.[17] She explains the duality of the experience:

> One way had to do with a common sense world of objects separated by outline, keeping themselves to themselves and staying the same, the other had to do with a world of change, of continual development and process, one in which there was no sharp line between one state and the next, as there is no fixed boundary between twilight and darkness but only a gradual merging of the one into the other. But though I could know, in retrospect, that the changing world seemed nearer the true quality of experi-ence, to give oneself to this knowledge seemed like taking some dangerous plunge; to part of my mind the changing world seemed near to a mad one and the fixed world the only sanity.[18]

Thubron's approach to colour teaching seemed to insist upon that 'dangerous plunge', to borrow Milner's words, which is perhaps why Lynton struggled to make sense of his experience at Leeds. Terry Frost (1915–2003) also taught colour at Leeds. He was at the University as a Gregory Fellow (1954–6) and he taught at the College of Art (1956–9) when architect and writer David Lewis was a student on the Basic course. In a letter to Norbert Lynton, Lewis recalls:

> Terry came to the studio with geraniums and leaves and whatnot to demonstrate colour. He asked us to subdivide a board into small squares freehand, and then start with a blob of red. A primary red, in any one of the squares. Now add a tiny bit of yellow, and make another blob next to it. Now a bit more yellow and another blob. And so on, until we build up red into orange into yellow as a series of blobs called the red-yellow range. Now the red again and add a blue, and build up the red-purple-blue range. And so on. Now take a new board, subdivide it again, and make a composition. But the point was that it wasn't theoretical or academic. None of that prism colour-spectrum stuff. It was all to encourage the personal discovery of colour. There was no right and wrong. If you were colour-blind or had only one eye it didn't matter. Whatever you did you were asked to explain and defend.[19]

Frost explains his own ideas about colour in the influential exhibition catalogue *The Developing Process* (1959). He sets out five basic problems that students might come to understand through a study of colour: the grammar of colour mixing, objective drawing, the training of the eye, the training of the hand, and training in seeing. Just as Albers had advocated the co-working of colour and form, Frost recognised that: '[t]he drawing (constructed) and the colour (felt) are both put into one's grasp at the same time'.[20]

During a temporary fellowship at the Department of Fine Art, King's College, Newcastle, University of Durham in 1964, Frost was assigned the task of teaching colour, an interest that dominated his own practice during that period. Artist Brian Morley recalled the close association between Frost's teaching and painting:

> [They] were closely allied and equally important to him. A romantic, to whom feeling and emotion were always more important than reason and intellect, he had a no-nonsense, 'hands–on' approach, which made painting seem as joyful and exhilarating an activity for students as it obviously was for him. One day he might ask all the students to mix black, using red, yellow and blue. Their efforts were then pinned up and discussed; that black was a colour with as many possible

variations as red was something of a revelation to students for whom black had always been black.[21]

Another witness recalls that Frost's colour teaching: '... was an activity that Richard Hamilton preferred to delegate because this was the one area which totally defied any comfortable intellectual analysis'.[22]

← Fig.8.2 Colour exercises conducted as part of Basic Course at King's College, Newcastle, 1964

↓ Fig.8.3 Student colour exercises conducted as part of Basic Course at King's College, Newcastle, 1963. 'Studio Demonstrator': Rita Donagh

In Hamilton's own words:

I always felt very uncomfortable when it came to the question of colour because it did not seem to me to be susceptible to any kind of analytic routine. It is a very subjective thing whether you like one colour more than another, or like one relationship more than another … I was very glad when someone with terrific colour sense like Victor [Pasmore] or Terry Frost would come in and take over that part of the course.[23]

In Hamilton's view, our relationship with colour is a symbolic one and related to the material objects that dominate our everyday lives. He recognised that certain colours had become associated with products or brands and when he did teach colour, Hamilton was most interested in those associations:

I would point to the fact that there were certain colours which had associations over and above that, such as a soft pink which one might associate with toilet paper, for example or a particular kind

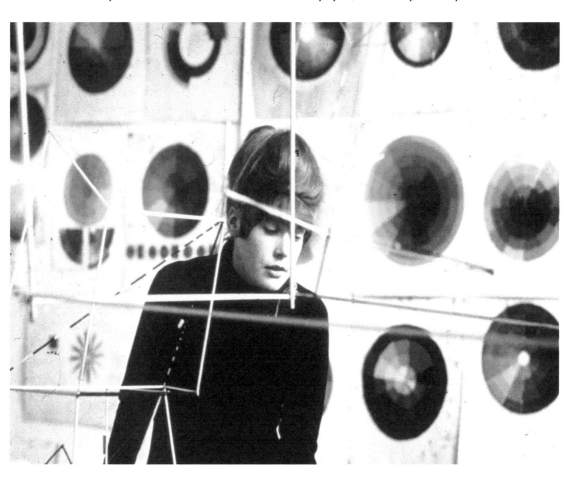

of pink that one might associate with the idea of a Cadillac, or an ice blue that might be associated with a Frigidaire, and there were lots of emotive colours which had nothing to do with the ideas about colour values that had been handed down to us for generations about what was right and proper, and that we should learn about all these other things as well. I mean it wasn't a question of rejecting one thing but widening our relationship to what colour was.[24]

↓ Fig.8.4 Rose Frain, Student life painting informed by colour exercises conducted as part of Basic Course at King's College Newcastle, University of Durham, c.1959–60

→ Fig.8.5 Lesley Kerman, Colour exercise conducted as part of Basic Course at King's College Newcastle, University of Durham, 1961

THE COLOUR EXPERIMENT

Tom Hudson (1922–98) had taught with Thubron and Victor Pasmore since 1954 at summer schools in Scarborough, where the 'Basic Design' course emerged and evolved through exercises in form, space and colour. He joined Thubron at Leeds in 1957 before moving to Leicester College of Art three years later. Hudson had encountered the Fluxus art movement in New York, something that was to inform his approach to teaching during a subsequent period at Cardiff College of Art (from 1964). The film *The Colour Experiment* exemplifies this approach with students at Cardiff c.1968. A montage of fragments of student works and performances, all dealing with the use of colour, reveals something of the exploratory nature of his teaching. In a whole series of experiments, coloured papers, cubes, flaps and levers are variously swung, rolled, flipped and laid out, colour against colour.

In one exercise Hudson takes Albers's squares as his point of departure: his two-dimensional exercises in colour and form are extended into three dimensions and Hudson introduces movement too. Students engage directly with the series of coloured cubes and levers so that the

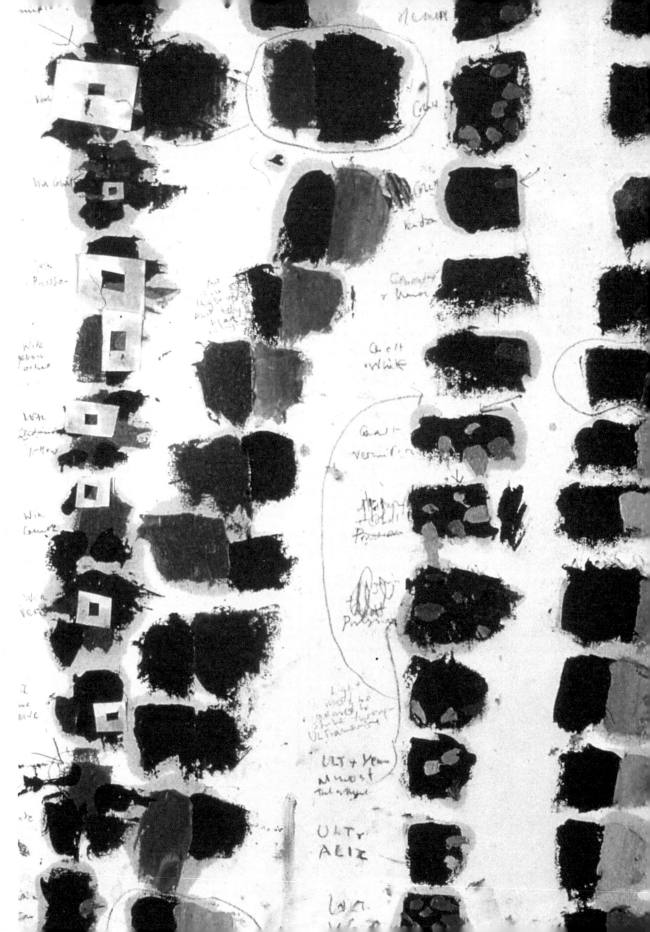

proximity of, and relationship between, different colours is continually changing.

↓ Fig.8.6 Students operating levers to alter colour combinations. Still from Tom Hudson, *The Colour Experiment*, Cardiff College of Art, c.1968. Collection of the National Arts Education Archive at Yorkshire Sculpture Park

We might say that Hudson's exercise represents a performance of Albers's *The Interaction of Colour*, published five years earlier, where students could quickly grasp the relative nature of colour and begin to understand colour relations better. Undoubtedly, Hudson's exposure to Fluxus had some bearing on how he developed these sorts of exercises.[25] Furthermore, fifty years after Albers's book was first published, a new version in the form of an iPad app opens up this kind of performative colour pedagogy still further and certainly gives wider access to the material.[26] Albers's original book consists of over 150 silkscreen colour studies. It is large and heavy and in this form is now only accessible in libraries and special collections.

Hudson's developments were hands-on and ultimately available to a relatively small number of fine art students at Cardiff College of Art in the late 1960s. The recent digital transformation of Albers's study allows users to drag and manipulate sections and plates on iPad screens across the globe to experience colour relations in ways similar to those that Albers's original training intended.

In another of Hudson's colour experiments a young male student was gradually covered with a multitude of luminous coloured circles as fellow students took it in turns to stick small coloured stickers onto the student's face and clothing.

↓ Fig.8.7 Students covered in bright, coloured stickers. Still from Tom Hudson, *The Colour Experiment*, Cardiff College of Art, c.1968. Collection of the National Arts Education Archive at Yorkshire Sculpture Park

As the process continued, he closed his eyes and the pattern of his breathing changed. The scene is reminiscent of the body and breathing exercises Johannes Itten led his Bauhaus students in each morning, exercises he based on those that formed part of Dr Otoman Zar-Adusht Ha'nish's Mazdaznan religion and its manual *Mazdaznan Health and Breath Culture* (1902). As Ha'nish explains: 'Mazdaznan reveals a systematic method of breathing that stirs the negative forces within the body, changing the currents into positive action, producing a quickening power that imparts consciousness to one's individuality, giving joy, freedom and emancipation.'[27] In a second exercise (Sense of Hearing and Intuition) the student is instructed:

[to s]tand erect with arms to the side of the body, head up, chin drawn in sufficiently to show a spirit of independence, eyes steadily gazing upon a spot

about the size of a [small coin] placed not more than seven feet away on the line of vision. The body should be in a perfectly relaxed condition, but the spinal column must be held firm and erect, as the seat of the soul is in the spinal cord.[28]

This is not unlike the pose adopted by the young male student in Hudson's film: calm, focused and relaxed whilst being adorned with increasing numbers of small coloured stickers by other students. Hudson shows his familiarity with Itten's publications such as *Design and Form* (1964) and its discussions of Mazdaznan and the breathing and concentration exercises with which it is associated and which notes that: '[a]s we breathe, so do we think and so is the rhythm of our daily life'.[29] For all their physical, embodied experience of colour, Hudson's colour experiments also encouraged a way of thinking about colour through the attention focused upon it.

Other experiments designed by Hudson called for a multi-sensory engagement with colour.

↓ Fig.8.8 Students experimenting with eggs and food dyes. Still from Tom Hudson, *The Colour Experiment*, Cardiff College of Art, c.1968. Collection of the National Arts Education Archive at Yorkshire Sculpture Park

Students were asked to mix eggs with a selection of food colourings and then cook them in a variety of ways (fried, poached, scrambled) before serving them up to fellow students for lunch. The experience of eating a blue, green or red omelette, for instance, was intended to disrupt established relationships between colour and taste and prove that vision does not work in isolation from the other body senses but alongside them; those senses relating to one another and

generating a unique sensory fingerprint for each object we encounter.[30] This multi–sensory engagement with colour is explored further by Jane de Sausmarez (b.1938) in *Basic Colour: A Practical Handbook* (2008), which aims to 'facilitate an understanding of basic colour theory with an emphasis on the practical aspects of mixing colours', a subject she has been teaching in London art schools for around forty years.[31]

↓ Fig.8.9 Colour exercises from Jane de Sausmarez's colour course, 2013

De Sausmarez's passion for colour stems from childhood and she recounts how certain colours cause her mouth physically to water. Further, she is drawn unconsciously to move towards and touch anything that is mauve or purple in colour.[32] These sorts of responses accord with other well evidenced sensory or emotional responses to colours, such as an eroticised blue.

What seems clear in Hudson's case is that while his colour experiments were partly contained and controlled by the materials and instructions given to the participants, there was an element of chance encounter or unpredictability as students followed their intuition and colours came together in some unexpected ways. That element of unpredictability became even more pronounced when students took to the streets of Cardiff for another experiment.

↘ Fig.8.10 Students in the streets of Cardiff. Still from Tom Hudson, *The Colour Experiment*, Cardiff College of Art, c.1968. Collection of the National Arts Education Archive at Yorkshire Sculpture Park

Two students would walk around the streets with brightly painted faces and clothed in coordinating colours. Another group, with sheets of coloured paper pinned to the fronts and backs of their clothing, would create a chaotic group crossing a main road, halting briefly to perform on the central reservation, before continuing on their way, leaving bemused drivers and passers-by in their wake.

Despite the vibrancy and inventiveness of his colour teaching, Hudson's notes reveal that his pedagogy was more thoroughly embedded in a theoretical and historical understanding of colour than was Thubron's. At the same time Hudson had a continued commitment to intuitive ways of working, and historical perspectives would sit alongside his discussions of optics, nature, harmony and discord, contrast, intensity,

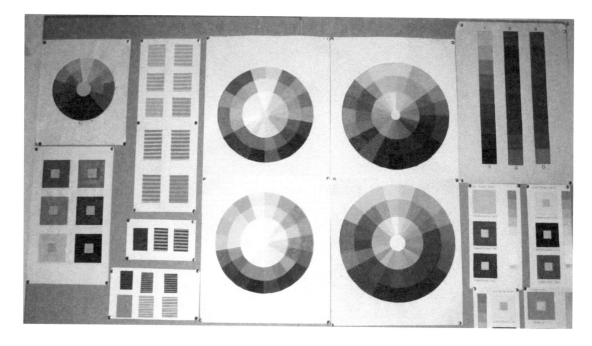

hue, transparency and opacity. There is no certain evidence to show that Hudson's treatment of colour in the teaching studio was any more or less comprehensive than Thubron's but it was certainly more firmly situated in an understanding of colour theory, regardless of their shared commitment to intuitive ways of working.

MAURICE DE SAUSMAREZ

Maurice de Sausmarez (1915–69), Thubron's close teaching colleague at Leeds, published his important book *Basic Design: The Dynamics of Visual Form* in 1964. Later editions of the book, particularly the material on colour, were revised and updated by his widow Jane de Sausmarez in 1983 and again in 2001. In *Basic Design* Maurice de Sausmarez offers his ideas as: 'a spur to the young artist to continue for himself a constant inquisitiveness about the phenomena of pictorial and plastic expression'.[33] In two chapters on colour de Sausmarez describes and defines colour wheels, tonal scales, colour charts, and definitions of 'hue', 'tone', 'chroma' and other terms. He discusses colour analysis and complex systematic colour exercises, and refers to the Ostwald and Munsell colour systems. Yet in the midst of theory and system we find that it is a tacit understanding of colour that dominates de Sausmarez's thinking, not an objective intellectual one: '[e]nergy or inner force is that factor in colour which the artist needs to be most aware of … The "energy" is of course our own psychological reaction'.[34] In summary, it is not a method but an attitude that de Sausmarez recommends.

De Sausmarez's position on colour resonates in interesting ways with the later thinking of the artist and teacher Jon Thompson (b.1936). As a student at St Martin's (1953–7), Thompson was never taught colour theory, nor was colour on the curriculum during his time at the Academy

schools (1957–60), and he countered the omission by seeking out evening classes being run by William Turnbull (1922–2012) at the Central School. Thompson recalls that Turnbull taught basic Chevreul colour theory alongside Ostwald colour theory, each theory complementing the other.[35] Turnbull did not demonstrate. Instead, classes began with a talk, followed by exercises in colour mixing, for example, to achieve a neutral blue, an especially hard effect to achieve.[36] 'You have to start with a blue like cobalt',[37] the next step being: 'to look very, very hard … and decide whether it's moving towards violets or whether it's moving towards green'.[38] Then, 'you can put the minimum corrective in to get it to be neutral'.[39] Turnbull regarded analysis like this as an essential pedagogical tool.[40] At St Martin's, meanwhile, the Head of Painting Fredrick Gore (1913–2009) was against colour teaching. Thompson recalls: '[h]e was wary of it … because people start to make paint-ings to prescription'.[41] In fact, there was a general disquiet that omitting colour from the curriculum would leave the artist without access to an important analytical tool: '… not a way of making paintings, [but] a way of analysing painting'.[42] For Thompson, the entirely intellectual pursuit of colour theory is a corrective to an intuitive or tacit under-standing of colour and something the painter can fall back on when the tacit fails.[43]

We might think of the relationship between tacit and intellectual understandings of colour as something negotiated around what psychoanalyst Jacques Lacan (1901–81) calls a quilting point, or *point de caption* (an anchoring point or upholstery button).[44] Lacan's ideas would more normally be mobilised within the field of clinical psycho-analysis, or psychoanalytic cultural theory. In the realm of colour teaching, however, it might be understood as a chromatic frame within which the intuitive and the intellectual negotiate positions and vie for primacy. In this way an intellectual or theoretical under-standing of colour becomes the quilting point that anchors more free-flowing, intuitive appreciations of colour. As a sort of intellec-tual safety net, it is not unlike Itten's call to the artist: '[i]f you, unknowing, are able

to create masterpieces in color, then unknowledge is your way. But if you are unable to create masterpieces in color out of your own unknowledge, then you ought to look for knowledge.'[45]

ANTON EHRENZWEIG

A similar approach was taken by the art theorist and educator Anton Ehrenzweig (1908–66), putting the experience of art prior to theoretical concerns in his teaching, particularly on the Art Teachers' Certificate (ATC) course at Goldsmiths College in London (1964–6).[46] For Ehrenzweig, theory was a tool to articulate the actual experience or practice of art. And as far as colour theory and teaching is concerned, Ehrenzweig recommended an exploratory rather than a didactic pedagogical approach.[47] By this time, Albers's book *The Interaction of Color* (1963) had become the standard work, despite its failure to address the dependency of strong colour interaction on weak structural form within an image. It was this failure that Ehrenzweig set out to rectify in his own short paper, *Colour and Space* (1966). Discussing Albers's experiments, Ehrenzweig observes:

> Albers first thought that in his 'Homage to the Square' he was really paying homage to a particularly strong design. Only gradually did he begin to realise that he had in fact dedicated himself, not to the study of form, but to the study of colour. He found that strong colour interaction could create its own spatial illusion. His three superimposed squares could once represent a long corridor leading into the depth, once a telescope protruding towards the spectator. There was no intellectual rule that could predict the exact spatial effects.[48]

Ehrenzweig's paper discusses experi-mental exercises he set for ATC students, which used colour to prompt an exploration of pictorial space. The experiment involved the serialisation of colour; students being asked to fill in chess board designs using

permutations of a limited number of colours.[49] The results were not what he expected:

> However arbitrary and even unpleasant the chosen colours in terms of traditional consonance and dissonance, they looked right if distributed over a field according to the rigour of a mathematical (numerical) series ... It was not an entirely welcome result that these chess-boards made almost any colour look pleasing.[50]

In *Colour and Space* Ehrenzweig built on Albers's thinking by introducing the notion of the spreading of colour, which is 'the very opposite to colour interaction'.[51] Imprisoned colours fail to interact. Instead, they seep out of their borders and 'tinge any suitable area with ... [their] own hue'.[52] The resulting effect is a haze of colour that seems to float almost without material existence in front of the image, somewhere between the canvas and the beholder. Albers does discuss the notion of film colour, which certainly approximates the shimmering organza-like hue created by colour spreading.[53] For Albers, film colours: 'appear as a thin, transparent, translucent layer between the eye and the object, independent of the object's surface color'.[54] This translucent layer appears as something static and materially present so that we might imagine it being peeled back and separated to reveal the surface colours beneath it. By contrast, Ehrenzweig describes spreading colours as entirely illusory and hovering like a colour-filled heat haze or mist, just out of reach and impossible to grasp. In Ehrenzweig's terms, this illusion is central to our relationship with colour since '[c]olour seems intellectually unmanageable'.[55]

SYDNEY HARRY

Artist and colour theorist Sydney Harry (1912–91) took a different approach to teaching colour and lectured at art schools throughout Britain from 1944 to the mid 1980s. His 'colour magic' lectures became the staple of a peripatetic programme that took him from his first colour lecture for the Halifax Art Society on 7 November 1963 to his last for students at Bradford and Ilkley Community College (BICC) on 18 July 1984.[56] Harry's meticulous record-keeping throughout his career means that his personal archive lists every one of the almost 900 lectures he delivered between 1944 and 1984. Notable venues included Bradford College of Art, Leicester College of Art, Barry Summer Schools, and in London: the Byam Shaw School of Painting and Drawing, Goldsmiths College, Royal College of Art, St Martin's School of Art, Central School of Art and Design and Hornsey College of Art. Although he did lecture to fine art students, his audience often comprised photography students, textiles students, or those in design or education departments.[57] Harry worked with artists and scientists and maintained a long-running working relationship with W.D. Wright, Professor of Applied Optics, Imperial College, London and founder member of The Colour Group of Great Britain, an organisation that Harry joined in 1968.[58]

Harry's 'lecture–demonstrations' fell into three parts. Part I took place in daylight and considered 'colour as a function of light and perception'.[59] Part II used projectors and took place in a blackened-out room, the focus being on visual responses – that is, '[v]arious "after-image" experiments showing the consequences of retinal adaptation, also loss of eye control. Complementary tinging of greys on coloured grounds. Related effects.'[60] This part of the lecture included the mixing of coloured lights by addition, refraction and diffusion, an exploration of the link between light and painting and an investigation of coloured objects and compositions when illuminated by coloured lights. The third and final part of Harry's lecture/demonstration returned viewers to daylight conditions to consider optical mixtures and chromatic shifts in painting and design using examples of his own work to assist students' understanding of colour effects generated through choice of hue, arrangement and viewing distance.[61]

Harry's ideas on colour were as relevant to the weavers, spinners and dyers of Britain's textiles and carpet factories as they were to art and design students. Harry's own

early training was in dyeing and weaving, and northern England, where he lived and worked, still boasted an important textile industry, certainly at the beginning of his career.[62] Indeed, Harry wrote and illustrated the *'Weaving Plain' Handbook*, an instruction book for teachers requiring knowledge of the use of table looms and simple weaving.[63] Bringing together his ideas on colour, yarns, fabrics and weaving, Harry sought to balance intellectual and intuitive approaches with an understanding of colour, an aim for many of these teachers. In his notes, 'Colour for weavers, spinners and dyers', he recognises that:

> There are, and always have been, successful artists and designers/craftsmen who do not need help from anyone on colour matters. They work intuitively, depending entirely on their own sensibilities, owing nothing to colour theories and definitions of phenomenon. They are the exceptional ones. The majority of colour users, especially in the early stages, usually welcome some guidelines and starting points to enable them to experiment with growing understanding what it is they are handling, thus learning to control colour and gradually develop their own characteristic types of colour usage.[64]

Despite his interest in and commitment to the practical application of knowledge, Harry's methodical approach to colour theory and pedagogy fully acknowledged the role of intuition in understanding colour.

Given the nature of Harry's work, it is not surprising that British artists such as Bridget Riley (b.1931) and Peter Sedgely (b.1930), the co-founders of SPACE studios in 1968, were amongst his acquaintances. In February 1969 Harry recorded:

> Colour lectures. Byam Shaw School of Drawing and Painting. M [Maurice] de Sausmarez. Bridget Riley came and listened, then several of us had sandwiches/beer. Afternoon session, then to Bridget's place with Maurice. Talk,

studios, my folio, whiskey etc. etc. Peter Sedgely turned up. All got on very well. Home to M's place.[65]

The philosopher and art critic Cyril Barrett (1925–2003) cited Harry's work in his book *Op Art* (1970), one of the first authoritative publications on the style of painting that had come to be identified with Bridget Riley and others. In this quotation Barrett discusses Harry's research into colour mixing, suggesting: 'it is hardly going too far to say that on the merits of his discoveries so far he has earned a place alongside Chevreul and Rood and those other investigators of the optical effects of colour.'[66] The importance of Harry's ideas for British art and art education has yet to be fully recounted.

→ Fig.8.11 Sydney Harry, *Duo* 1980

↪ Fig.8.12 Sydney Harry, *Hannelore* 1973

CONCLUSION

Since around 1960, colour teaching has all but disappeared from the art school curriculum. Once taught formally, as an essential element of the knowledge-base from which artists work, later acquired through optional extra-curricular lessons in evening classes or lecture-demonstrations from peripatetic specialists, it seems now to be regarded as unnecessary, anachronistic, or even amateurish in its focus on method and technique. We might view this shift from an intellectual appreciation of colour theory towards a more tacit understanding of colour as: 'a profitable return from grey theory to the perpetual green of experience', to borrow from Freud.[67] In this respect it represents an interesting counterpoint to the broader shifts in post-1960s British art education and is revealing of some fundamental truths about the recent lives of the London art schools. On the one hand, the abandonment of colour teaching does align with Coldstream's call for a model of art education that moved beyond a purely skills-based training for the artist. On the other hand, the development seems

entirely to resist the academic, intellectual and theoretical changes that have increasingly defined and redefined the training of the artist within an academic realm. Whether they are taught it or not, artists continue to work with colour, making judgments about what colour to use in an artwork and where to place it, regardless of materials. Of course, as Thierry de Duve quips: '[a]nyone can judge color. That doesn't prove one judges well.'[68] The questions that remain are: What will the lack of formal training in colour theory mean for the transfer of colour knowledge in the contemporary era? And will the knowledge that artists acquire from a direct engagement with materials increasingly be marginalised in favour of academic research-led practice?[69]

IX

FROM 'CRIT' TO 'LECTURE-PERFORMANCE'

In the post-war period, artists not only gained prominence and became public figures at a younger age, they also increasingly engaged in the public discussion of their work. This chapter explores this development, which can be at least partially situated within the art school, where a new figure of the artist was promoted, as a thinker, as an intellectual and as someone in charge of the conceptual grounding of his or her work. Research for Tate's Art School Educated project found that over a short period of time, artists had to start performing a particular role as 'the artist', that is, as a confident, assertive and self-defined individual, a type modelled on certain prominent American artists of the day. There was also a simultaneous and growing interest in the performing arts, which fostered an acute awareness of and exceptional emphasis on formats of teaching delivery and on instigation of hybrid forms that bridged lecturing and performance. The Sculpture Department at St Martin's School of Art in the early 1960s was at the heart of these developments and was where discursive pedagogies and practices – particularly the formats of group criticism and the lecture-performance – blossomed and became influential models.[1]

THE RISE OF THE 'CRIT'

In Britain, the proliferation of verbal exchanges and written assignments within the art school is conventionally and appropriately discussed in terms of the academicisation of tertiary level fine art education. Following the implementation of the Coldstream Report (1960), art history and complementary studies were introduced into the curriculum in order to grant academic credibility to studio practice, providing a level of education intended to be equivalent with honours degrees in the university sector. At the same time, the renewed perception of the artist as a thinker

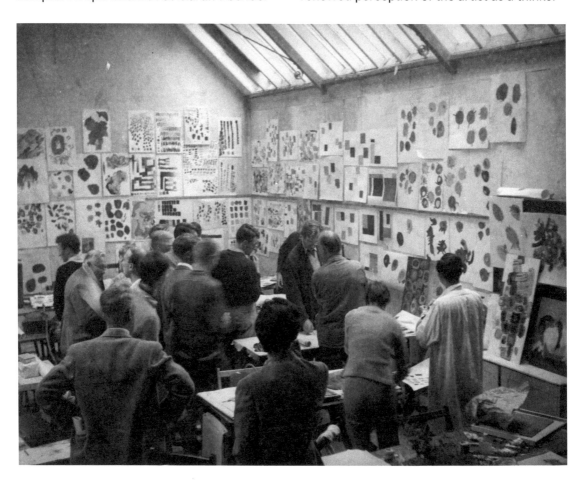

rather than a mere maker, and the parallel development of discursive pedagogies, is also associated with the opening-up of the art school to the development of modern art and, in particular, the shift from figuration to abstraction. The image of the artist was now seen as akin to that of a scientist, working on the establishment of a universal artistic vocabulary. To confirm this new image of the artist, the art schools had to devise new ways of teaching their students, in particular, new critical formats that could be used on the actual work that the art students produced.

The pedagogic mode known as 'group criticism' – in Britain, often shortened to the 'crit' – had its origins in the teaching undertaken in the traditional art academy where there was a long history of intellectual debates among teachers and pupils. Nonetheless, the 'crit', as a format, started to acquire a new and distinctive function when the teaching of art moved from figuration to abstraction. At this historical moment, something was lost which for centuries had acted as the barometer of artistic competence in the academy and had been pivotal in the assessment and discussion of drawing, painting or sculpture, namely, the execution of such works in terms of likeness and of the rendering of the human figure. From the Bauhaus itself to the Bauhaus-derived Basic Design courses taught in a number of British art schools and in university fine art programmes in the 1950s, the teaching of abstract basic forms involved the adoption of the group 'crit' format as key to the discussion and the establishment of new criteria, which could be adopted by teachers and students to guide art-making (fig.9.1).

← Fig.9.1 Session of group criticism, Scarborough Summer School, 1956. Collection of the National Arts Education Archive at Yorkshire Sculpture Park

Across Britain, it was during the 1960s and 1970s that group criticism acquired a more prominent pedagogical role. Stephen Chaplin, as archivist of the Slade School of Art, describes how in the mid 1960s teaching changed from the traditional easel-visit to the 'crit' format that became standard practice in the 1970s, where staff and a group of students would discuss a work by one of their number.[2] For Chaplin, such a move indicated a clear shift in the relationship between the verbal and the visual, playing a major role in the progressive turn of higher art education towards discursive pedagogical formats and practices. As part of this history, it was in the Sculpture Department of St Martin's School of Art, at the beginning of the 1960s, that the 'crit' turned into one of the most distinctive, notorious and influential teaching formats in British art schools, the pattern at St Martin's becoming a model for many other institutions. In fact, group criticism did not just constitute one pedagogical model among others: it became the main occasion for the exchange of ideas on art-making and a forum that acted as a rite of passage for students to be publicly recognised as fully-formed artists.

FRANK MARTIN AND ANTHONY CARO

The 'crit' was just one innovation at St Martin's during the 1960s, when the school became internationally renowned for hosting one of the most innovative Sculpture Departments in the world. Yet, until the mid 1950s, the school had only had a small Modelling Department. Change came about when Frank Martin (1914–2004) was employed as Head of Sculpture in 1952. One of the first part-time tutors Martin employed was Anthony Caro (1924–2013) and the major breakthrough that the department made in its teaching centred on the transition from figuration to abstraction. Although by the late 1950s many established British sculptors were working in abstract modes of expression, the art school curriculum – apart from the teaching imparted through the Basic Design courses – had remained unchallenged by such exterior developments. Beyond those Basic Design courses, it was in the so-called 'Advanced

Course' at St Martin's that, prior to the implementation of the Coldstream Report, the teaching of non-figurative sculpture was conceived and practiced (fig.9.2).

↓ Fig.9.2 Frank Martin (middle-right) teaching in the Sculpture Department at St Martin's School of Art, mid 1950s. Tate Archive, Frank Martin collection

The history of the successful 'Caro school' is relatively well-known.[3] It was for students on the vocational Advanced Course, freed from the need to develop the official curriculum of the NDD and freed from the need to follow pedagogical models rooted in figuration, that the teaching of sculpture underwent important transformations. Early in 1960, after Caro's return from his mythologised trip to New York, Martin and Caro cleared one of the two available sculpture studios of any (and everything) figurative.[4] As the course was delivered, it was the tutors and students working together

who proposed and implemented numerous changes to the pre-existing curriculum – aspects and initiatives such as discarding the pedestal in favour of the ground; discarding casting and modelling in favour of welding and assembling; moving from soft and natural to strong and artificial colours; and from the use of metal, wood and clay to the adoption of new materials, including plain board, plank, rod, scrap metal and fibreglass. The cohesive group of students trained under Caro between the late 1950s and the early 1960s is often referred to as the 'New Generation' sculptors, a name that originated in the 1965 exhibition *The New Generation*, organised at the Whitechapel Gallery by its director Bryan Robertson. Out of the nine young sculptors, whose work was presented in that exhibition, six had studied and then went on to teach in the St Martin's Sculpture Department: they were David Annesley (b.1936), Michael Bolus (1934–2013), Phillip King (b.1934), Tim Scott (b.1937), William Tucker (b.1935) and Isaac Witkin (1936–2006).

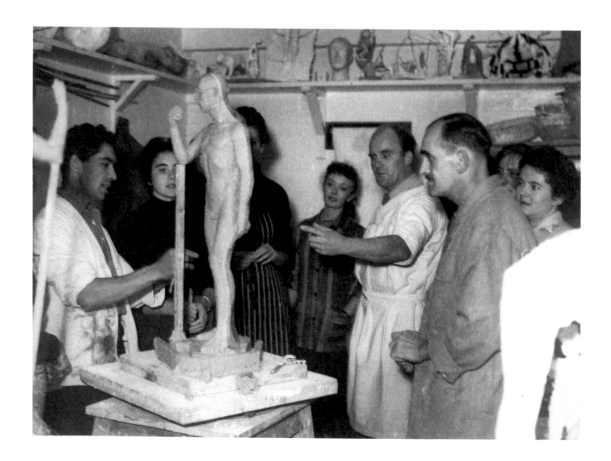

↓ Fig.9.3 Left to right: Lord Snowdon, Frank Martin, Bryan Robertson and Phillip King. Robertson visited the Sculpture Department of St Martin's School of Art with Lord Snowdon, c.1965, prior to the publication of *Private View* (1965). Tate Archive, Frank Martin collection

While, from 1964, sculpture students at St Martin's could enrol on the DipAD, an Advanced Course at postgraduate level continued to exist well into the 1970s.[5] If the history of the course taught by Caro has been the object of a number of publications and exhibitions, what has never been discussed in any depth is the major role that group criticism played in the shaping of such a cohesive and influential group of artists. For both Advanced and diploma students, group criticism constituted one of the most important and distinctive aspects of their learning.

Caro has referred to the continuous discussions that took place among and between tutors and students as crucial in the questioning of conventional assumptions about what sculpture was and how it should be made.[6] As the life room emptied, the sculpture studio filled with discussion, which in turn developed into a distinctive pedagogical format. The studio became a site of conversation and experimentation rather than a place where tutors would teach specific skills and guide students towards traditional subject-matter. Everyone who taught on the Advanced Course valued the role played by the dynamics that existed between individuals, all of which were fostered by the open studio, which they considered to be 'vital for the maximum inter-personal contact'.[7] In this respect, the redefining of sculpture at St Martin's was a group activity, collectively shaped through the teaching and through talking. Caro would go to see the work of his students and they would visit him in his studio, both parties commenting on each other's new work. Caro has explained this as a strong osmotic relationship: 'we were our audience and our critics.'[8]

Unsurprisingly, sculptors from St Martin's, while exploring new territories which had yet to receive critical plaudits, were in need of each other's responses and support. Moreover, a shared moment of appraisal, in front of the physical work, was needed because it had become common, among tutors and students, to work directly on the final object.[9]

↪ Fig.9.4 Courtyard of the Charing Cross building, St Martin's School of Art, used by sculpture students to assemble and display their work, c.1965. Tate Archive, Frank Martin collection

In the making of sculpture, the new techniques of welding and cutting steel dispensed with the processes of sketching, the making of *maquettes* and of scaling-up. The finishing of the sculpted object was effectively the first, dramatic moment when an artist could seek and receive feedback on his or her new work.

Alongside informal discussions, a more clearly formalised type of group discussion was to be conducted by Caro's fellow tutors: this was, the studio 'crit'.[10] It involved the assessment of students' work through

discussions between the student and a number of tutors in front of the work and in the presence of the students' peers. Students were asked to clear an area of the studio in which to set the work up and allow its examination by tutors and fellow students. On these occasions, students were 'asked to comment at length and in depth on the work presented'.[11] All students were requested to attend and participate in the discussions arising from individual 'crits' other than their own since it was felt 'that these discussions often bring up points important in a general as well as individual way'.[12]

It is here argued that the implementation of this new teaching format constituted the necessary outcome of and response to unprecedented shifts in the way that students' work was being produced and assessed. The process of making had undergone a rapid transformation. The abandonment of the long-lasting traditions of life drawing, painting and modelling as processes that were central to the students' education left a void in terms of the criteria for discussing and judging artistic production. How was a student's work now to be discussed and assessed? On the basis of what criteria, if not historically shaped ones? The answer was for

artists – both tutors and students, as equals in a project to devise new principles in the making of art – collectively to establish such new criteria through group discussion.

The informal discussions that started to take place were soon formalised into the weekly group 'crits' or 'forums', which became a distinctive feature of the teaching of the Sculpture Department. In this process, around half a dozen finished works were displayed in the main hall of the college building and much of the work presented was rejected by the other participants. Yet, it was precisely the artists' need to face such disparagement and to defend their work that was considered essential for them to 'forge and sharpen their views'.[13] For Frank Martin, who was in overall charge, the forums were opportunities for students 'to gain confidence, to see themselves as sculptors, to be able to stand by and take responsibility for their work in the face of the devastating criticism of their peers'.[14] In attendance were sculpture tutors and students as well as their peers from other departments and external visitors, such as artists or members of staff from other schools or critics and gallery owners from London, as well as foreign visitors.[15]

On the basis of the classification of the art school's pedagogical models established by academic and critic Thierry de Duve (b.1944), teaching at St Martin's was a direct outcome of the Bauhaus model.[16] The aim of the school was not to train apprentices in a single *metier* but to encourage an understanding of the arts according to the specificity of the medium, while fostering invention. Within this pedagogic framework, students' work was judged in relation to the formal aspects of the work immanent to the medium.[17]

↓ Fig.9.5 'Important Photos – Studio action all year', St Martin's School of Art, c.1966. Tate Archive, Frank Martin collection

THE ROLE OF THE UNITED STATES

In the establishment of an abstract sculptural idiom, a predominant role was played by better insights in London about American abstract painting and direct contact with American artists and critics, who supported abstraction.[18] Howard Singerman argues that in the USA the 'group critique class' first emerged in the 1950s, when painters needed to develop a teaching format that would allow them to get to grips with abstract form and the possible kinds of content it could carry.[19] He argues that as art was becoming increasingly abstract, it expressed more demands on the linguistic abilities of the critic and of the artist discussing his or her work, in the need to make language serve the experience of art. In the Sculpture Department at St Martin's, the demand on artists' linguistic abilities may have been even greater because they needed to do more than bridge the gap between the description and analysis of abstract forms and their possible content or the experience they solicited. Since abstract expressionism was a cultural import, a wider gap had to be bridged before there could be a breakthrough into a new and exciting way of making.

Group criticism was also a useful format in the articulation and adoption of a new way of making art, as the result of a rational and concept-driven process. The curator Lynne Cooke has argued that from the example of abstract expressionism 'the [New Generation] sculptors acquired a proclivity for questioning and examining the very nature of their activity which instilled a conceptual or at least theoretical basis to their understanding'.[20] For Cooke, Tucker's 'keen concern with theoretical issues was very influential within this St Martin's nexus and contributed significantly to the intellectual or conceptual basis underlying their approach'.[21] Tucker himself has otherwise spoken of the importance of the moment of conception, in a way reminiscent of the precepts of conceptual art: 'Sculpture could be made from anything, about anything. Permanence consisted in the strength of the idea, not in the material.'[22]

Nevertheless, the work made by 'New Generation' artists was not 'conceptual' in the sense in which the word would be used in relation to the international movement later known as conceptual art. The conceptual presentation of the work was not to be the result of prolonged reflections on the assumptions regulating art-making and on the language shaping its supporting discourse. Rather, what students were to be judged on was referred to as their *intention*. In the forums

as well as in the studio 'crits', students were 'asked to outline the main intention' of their work.[23] As Caro declared after his 1959 visit to the States: 'There's a tremendous freedom in knowing that your only limitations in sculpture or painting are whether it carries its intentions or not, not whether it's "Art".'[24] For Tucker, the process of making might completely change the aspect of the finished work, but not the original intention: 'In making the image you realize the intention more clearly.'[25] The artist's intention might have not been a fully-formulated theoretical argument supporting the making of the work of art but it was certainly a step in that direction, towards the envisioning of art-making as a concept-based activity.

If the major objective of group criticism was to set new criteria guiding and justifying art-making – constructing a dialogical framework for the making of the work – the 'crit' was inevitably to end up functioning as a regulating apparatus. Despite the initial experimental nature and inquisitive character of the teaching, increasingly tight parameters were to be established for the evaluation of the aesthetic success of the students' work. What was to guide the establishment of these parameters? What were the pre-established trajectories that students were to follow in the articulation of their intention? The major influence was played by the criteria already shaped in the writing of the American critic Clement Greenberg.

GREENBERG

Not only was Greenberg's writing recognised as the most assertive and persuasive US criticism, he also played an important role by supporting and giving greater visibility to the St Martin's department.[26] The criteria for the evaluation of art that were starting to be identified through tutor-student group discussion were inevitably influenced by his contribution. The critic Andrew Brighton, who studied painting at St Martin's and used to attend the sculptor's forums in the mid 1960s, remembers a new vocabulary penetrating the art school's discourse through those sessions.[27] He remembers people suddenly using words hitherto unknown such as 'Rothko' and 'modernism' and reading Clement Greenberg's *Art and Culture* (1961) and Michael Fried's articles in *Artforum*.

By the mid 1960s, by which time American critical references and vocabulary had acquired a discriminating role, the initial phase of open discussion regarding what constituted art was at least partially over. Greenbergian criticism guided the making of art towards a progressive focus on the self-sufficient and the reflexive conditions of the medium and towards a reduction of all the formal aspects, which were not essential to the medium itself. This was reflected in the broadening limitations self-imposed by numerous students on their own work, while the criteria establishing the parameters of good sculpture, as

St Martin's Sculpture Forum

discussion (with slides) of work by three staff members

BUKY SCHWARTZ (now exhibiting at Hamilton Gallery)
RUDY LEENDERS
ROLAND BRENER

Chairman ANTHONY CARO

Thurs 25th May 6 pm room F

rehearsed in the 'crits', seemingly became self-evident. Jean-François Lyotard's *The Postmodern Condition* (1979) is an important reference point when discussing the role played by group criticism in this developing process. Lyotard writes about the legitimation of knowledge through performance within learning institutions. He states that disciplines 'owe their status to the existence of a language whose rules of functioning cannot themselves be demonstrated but are the object of a consensus among experts'.[28] The subscription to these rules is requested, and their implementation is guaranteed by their assimilation and dispersion in a multiplicity of occurrences.

At St Martin's, group criticism ended up acquiring a normative role in legitimising the dominant ways of making. What is more, ingrained rules for art-making were not only related to a specific critical discourse and its vocabulary, but were cemented by a particular performance. The 'crit' constituted a rite of passage by which a practising artist was recognised as such by means of a double act of presentation. On the one hand there was the display of the work of art itself, on the other the discussion of the artist's work in a public arena, in front of a group of peers and respected practising artists. The status of artist was coming to be acquired not so much through public applause but through the endurance of the experience of public discussion.

← Fig.9.6 This poster, advertising a forum in 1967, shows the format of group criticisms. They were structured around the physical presentation of sculpture but could also involve the projection of slides of previous work. Tate Archive, Frank Martin collection

The ritualistic and performative aspect of the 'crits' did not escape the observation of some of the most critical students. Commenting on the 'crits', Bruce McLean (b.1944), a student in the St Martin's Sculpture Department 1963–6) famously stated: 'Twelve adult men with pipes would walk for hours around sculpture and mumble'.[29] As observed by critic Mel Gooding, McLean's observation was a reaction to his realisation: 'that sculpture itself might be secondary to something else, might be simply the focus for the real object of the exercise – pose.'[30] Sculpture provided the occasion for the staging of a routine with relatively fixed formats of discussion and styles of presentation.

↳ Fig.9.7 Anthony Caro smoking a pipe in the company of other tutors from the Sculpture Department, St Martin's School of Art, c.1963. Tate Archive, Frank Martin collection

Such an interpretation suggests that Frank Martin's and Anthony Caro's insistence on organising the forums as staged tournaments for the training of young artists, each needing to stand up for their ideas in front of their peers, may have sowed the seeds amongst the students of a particular interest in posture and the staging of performances and actions. Moreover, McLean's statement points towards the particular nature of the social performance defining the St Martin's forums, in which artists – nearly exclusively men – played the dominant role of the confident and self-centred 'macho' creator, an image which had been promoted and popularised by the first generation of artists of the New York School.

While students training at St Martin's under 'New Generation' tutors felt the generational need to contest the standing and achievements of their predecessors, broader change was undermining the seemingly untouchable authority of 'high modernism'. Already at the beginning of the 1960s, Greenbergian criticism was entering a crisis related to the rigidity of its own parameters and a younger generation of students, who enrolled at St Martin's in the early to mid 1960s, started to challenge the power of this regularly performed knowledge. Lyotard has stated that 'there are two different kinds of "progress" in knowledge: one corresponds to a new move (a new argument) within the established rules; the

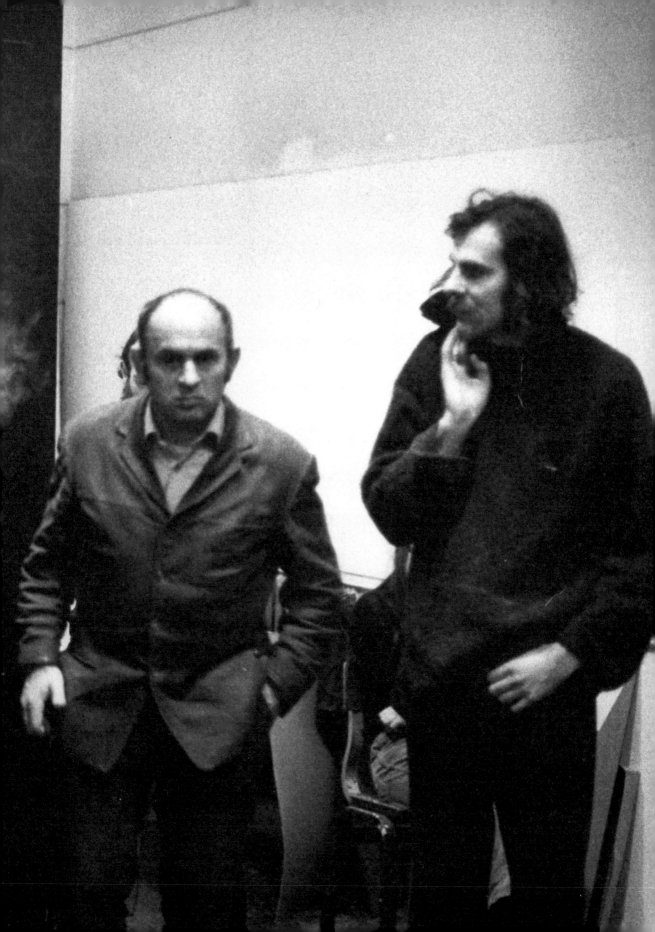

TUESDAY EVENING PROJECTS 1966

An extension to the current individual student project by
asserting physical organisation in other ways than those
employed in the actual making of the sculpture. An attempt was
made by each student to make use of the ideas and aims of his
particular work in a physical demonstration - by the use of his
or her limbs in any way possible with, or without, other props.
It was not to be a 'drama' or ballet and the one or two that
verged on this were patently less successful. The extraordinary
thing was that in fact the most banal series of movements when put
to use in this way could take on a particularly poignant and
dramatic form. It was also extraordinarily revealing method of
showing up differences in personality and aims however similar
particular pieces of sculpture may have seemed.

Make a sculpture expressing a given physical emotion: i.e.
'Having a hot bath'. The object of this exercise was to permit
the maximum freedom of use of materials and technique (no essential
permanence or stability) within the short time span allocated which
necessitates speedy decisions and consequent activity. This necessity,
the necessity to make very quick decisions, seems to have been the main
stumbling block to the success of most of the efforts, and a good deal
of time was spent attempting to describe and elaborate upon this. A
certain resentment was felt at the sheer pressure in which the work was
attempted.

It is felt necessary that, as an extension to the considered work of
projects taking place during the day, periods during which the student
can become entirely absorbed in the processes and attitudes developed
from a single limited notion, and equally, as an extension to the
'formal' information gathering of lectures and seminars, that an
evening period could be devoted to attempts to in any way possible
to break away from the habits of routine. Projects, group actions,
discussions, any physical means will be used to attempt to open up
the habitual assumptions developed during other work periods.

Make a pyramid.
Groups of 3 or 4. Potentially imaginative concept of scale-grandeur-
structure-mass-density-struggle to erect etc:

Five minute crash individual writing on specified subject. i.e. Cubism,
Discussion following individual reading of results.

Quentionnaire
Individual responses for discussion.

Make a sculpture which responds directly to your feelings concerning
another selected work of one of the other students.

Make a colour.

Make a gate.

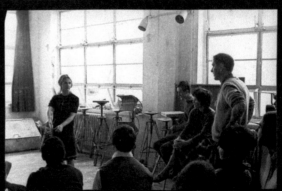

other, to the invention of new rules, in other words, a change to a new game'.[31] If we accept Lyotard's guidance on this principle, we can say that students in the St Martin's Sculpture Department, such as Bruce McLean and Gilbert & George (b.1943 and 1942, in the department respectively 1967–9 and 1965–9), invented a new game by conceiving of hybrid forms of performance and criticism.

In these ways, group criticism contributed to the conceptual and discursive turns in tertiary level art education, in two senses. First, because the artwork could no longer exist independently from its framing discourse, and second because artists were now required to engage in the production or repetition of that same discourse. The next step was for discourse about art to start playing a direct role in the work itself. This gave birth to artworks that took criticism as their starting point while giving that criticism an aesthetic twist. Such artworks expressed critical stances referring to, further articulating, contesting, mocking or making parodies of the criteria that dominated the art production around them. Having given prominence to group discussion as a mode of pedagogy, the Sculpture Department of St Martin's played a central role in the shift by which art discourse started being absorbed into the artwork itself. A younger generation of artists, who studied in a department that was increasingly defined in terms of theoretical studies and group discussion, started conceiving installations and staging performances, which embodied and articulated a counter-discourse to that which dominated the rest of the School.[32] They rejected the notions of art as medium-specific, abstract, formal phenomenon that related only to what was made by individuals; and embraced collaborative practices, a growing concern for the physical experience of the work and the principle that artworks are sites for the establishment of exchanges and interactions between artists and public.

One important and distinctive format adopted by some of these students was that of the lecture-performance. This perfectly embodied the marriage between formats borrowed from the performing arts with a concept-driven and performance-based type of work, casting the artist as a *sui generis* researcher, engaged in the articulation of knowledge but doing so in his or her own terms and combining the oral delivery of art criticism with formats borrowed from the performing arts. In Britain, the development of the lecture-performance happened early and was influential. Although, since the beginning of the twentieth-century, the historical avant-garde had engaged with a variety of live activities that crossed theatre, musical performance and dance, these had only marginally influenced the development of performance-based work within the visual arts. Moreover, the early inclination of St Martin's students towards the performative can predominantly be attributed to specific teaching methodologies developed in the Sculpture Department. If the posing of artists and critics in the forums contributed to the students' interest in performance-based activities, an even more direct source of inspiration came from the teaching of experimental classes and project-based activities.

EXPERIMENTAL CLASSES

In the early to mid 1960s, for the weekly evening classes in the St Martin's Advanced Course, a number of physical activities were conceived as 'situational' projects. For one of those, each student was asked to 'make use of the ideas and aims of his particular work in a physical demonstration by the use of his or her limbs in any way possible with, or without, other props'.[33]

← Fig.9.8 'Tuesday Evening Projects', St Martin's School of Art, 1966. Tate Archive, Frank Martin collection

↪ Fig.9.9 Detail of above

The description of a 'Tuesday Evening Project' from the year 1966 reads: 'the most banal series of movements when put to use in this way could take on a particularly poignant and dramatic form'.[34] One of the projects devised by Tucker for his second-year students, titled

'Make a sculpture using people as elements', comprised two stages: a warming-up period defined as 'a sculptural P.E. [Physical Education] session' and the making of different structures or arrangements on the part of each student, involving as many of their fellow students as was desired.[35] These activities continued into the late 1960s for students enrolled in the DipAD. For example, for the project 'Body Space', devised by Gareth Evans (b.1934), second-year students had to prepare a programme of movement for the other students: 'a kind of human mobile or ballet'.[36]

Physical activities were considered important as a way of breaking with the routine of studio practice and the traditional formats of lectures and seminars, which tended to foster habitual assumptions and procedures. Such a view of the creative function of physical activities reflected positions developed at the Bauhaus, where experimentation and cooperation were conditions often solicited through physical and staged activities.[37] And yet, the practices they fostered certainly exceeded the tutors' expectations. For American performance artist and tutor Charles R. Garoian (b.1943), a pedagogy founded on performance art represents 'a process through which spectators/students learn to challenge the ideologies of institutionalised learning (schooled culture) in order to facilitate political agency and to develop critical citizenship'.[38]

Engaging in performance-based activities in the learning environment invites students to find their own voice rather than take on the normative behavioural pattern inscribed in ongoing academic practices.[39] If the 'crits' seemed to prescribe criteria for judgement, the organisation of performance-based activities played a central role in fostering individual agency through physical play.

→ Figs.9.10 and 9.11 (overleaf) 'Making sculpture from "themselves"', St Martin's School of Art, c.1966. Tate Archive, Frank Martin collection

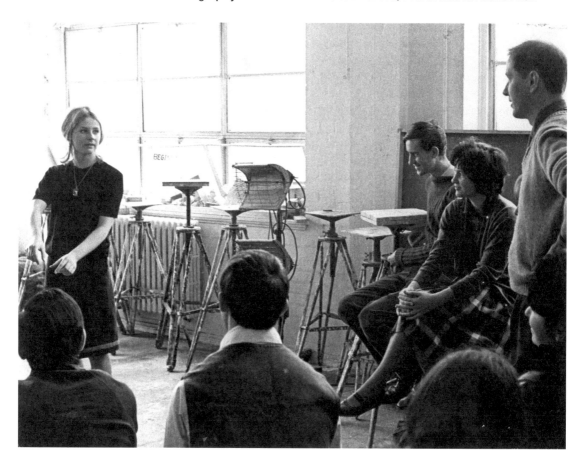

Bruce McLean and Gilbert & George are among the first artists who started to challenge and subvert established ways of making and discussing art by playing with the format of the lecture. They were sensitive to the rhetorical as well as to the choreographed qualities, settings and *décors* of their interventions. They often decided to stage their lecture-performances in lecture theatres, making use of the furniture, decorative elements and technologies typical of an academic setting, such as blackboards and slide projectors.

In October 1968, McLean returned to St Martin's School of Art to deliver what can only be defined as a lecture-performance. The slides he prepared to show were not of existing works or works in progress.[40] Instead, he shot several rolls of slides showing objects seen in the urban environment, such as brick walls, garden edging, park benches and kerb-stones. McLean explained to the audience that the work consisted in observing those different elements and recognising them as sculpture, or as possible sites for sculpture. Mel Gooding defined this public intervention not just as the lecture of a visiting artist but as 'a proto-performance, an exercise in pose, a lecture-sculpture precisely devised for its context'.[41] The lecture was effectively a staged intervention, playing with conventions in the way artists are expected to make and discuss their work. Through his presentation, McLean deliberately undertook a critique of 'New Generation' tutors' disinterest in the conditions of the viewer's encounter with the sculptural object.

McLean also made a number of lecture-performances in collaboration with fellow students Gilbert & George. In April 1969, they realised *Interview Sculpture*, also referred to as *Sculpture in the 60s*, first presented at the RCA, then at St Martin's and finally at the Hanover Grand under the new title *Impresarios of the Art World*. During the performance, Gilbert & George would enquire about particular pieces of work by established artists, from Henry Moore to Anthony Caro and William Tucker, and McLean would respond by physically mimicking the characteristics of the work in question. While McLean acted out the different works, Gilbert & George sat down on a stage applauding, or took photographs of the 'works' being performed, showing a clear awareness of the role of documentation in the currency of performance art.[42] As the curator Marianne Wagner puts it, 'The incorporation of roles and the critique of these roles frequently run parallel in performance lectures': existing works were deconstructed in order to undermine their presumed value.[43]

Although these works have conventionally been defined simply as performances, they undoubtedly

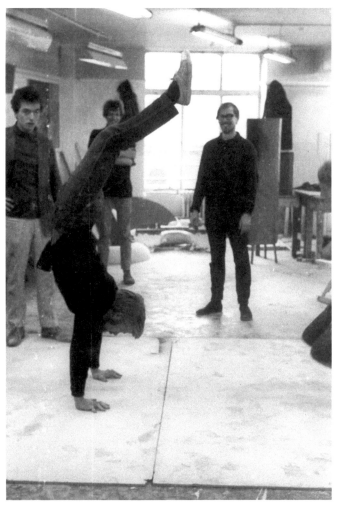

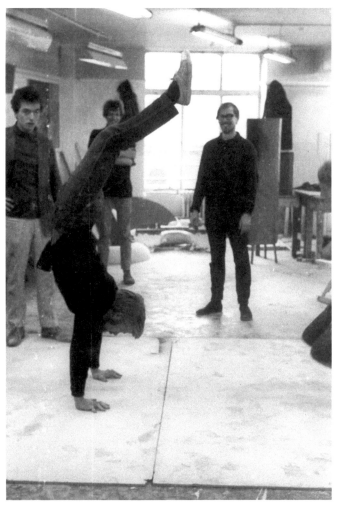

represented a form of critical presentation and articulation of knowledge, albeit on a satirical and mostly plastic rather than verbal level. These early examples of lecture-performances were certainly characterised by a meagre use of language. Nevertheless, they engaged in the critical debate by subverting the traditional oratory strategies and presentation techniques experienced in lectures and group discussions.

On 26 January 1969, art teachers and educationalists turned up at the Geffrye Museum in East London for the first showing of *Reading from a Stick*. It consisted of a one-hour presentation, including the projection of 160 colour transparencies of cross-sections of Gilbert's resin walking stick, accompanied by a commentary delivered by George. The remarks on the slides, including commentaries such as 'especially pretty' or 'extraordinarily imaginative', seemed to be devoid of any content.[44] This work has hardly been discussed, let alone critically assessed. On the basis of the interpretation foregrounded in this essay, it can be argued that *Reading from a Stick*, with

its vacuous comments dissecting an item belonging to the artist, represented a clear parody of the St Martin's sessions of group criticism, in which artists were asked to develop arguments in support of their work. Instead, Gilbert & George, after having turned one of the artist's most important accessories into an object of scrutiny, proceeded to state their refusal to engage critically with it, preferring to indulge in the staging of their own personae as vacuous inhabitants of the everyday.

In May 1969, only a month after staging *Interview Sculpture* at the RCA, Gilbert & George wrote to Frank Martin asking if they might present to the Sculpture Department a lecture titled 'The Meal'.[45]

The lecture, which required a darkened room and would last one hour, was set to involve speech, tape and black-and-white slides. It dealt with a recently realised piece titled *The Meal*: a dinner cooked by Doreen Marriott following a menu from Isabelle Beeton, to be eaten by the sculptors Gilbert & George and their guest David Hockney (b.1937)

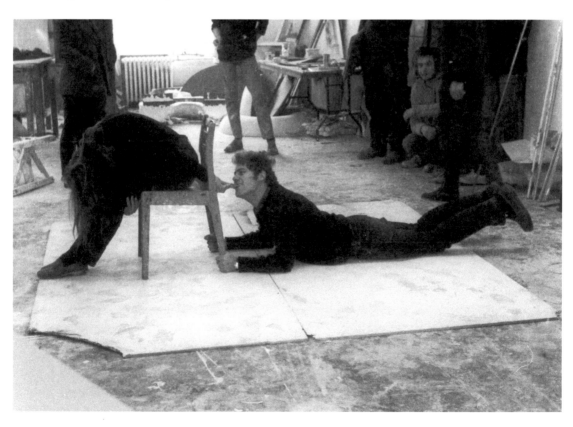

↓ Fig.9.12 Letter from Gilbert & George,
to Frank Martin, 21 May 1969. Tate
Archive, Frank Martin collection

↘ Fig.9.13 Gilbert & George, Letter of
invitation to *The Meal*, 14 May 1969.
Tate Archive, Frank Martin collection

↪ Fig.9.14 Gilbert & George, *The Meal*,
Ripley, Bromley, 14 May 1969. Tate
Archive, Frank Martin collection

Approximately thirty people assisted
at the dinner, which took place in the music
room of a sumptuous property owned by
the Arts Council. For the lecture, a slide show
featured an image of one of the two artists
holding a copy of *Mrs Beeton's Book of
Household Management* which, published
in 1861, was a guide to all aspects of running
a household in Victorian Britain. The book,
which took the form of a repository of much
of what had been preserved as proper to
traditional British housekeeping and cooking,
was an immediate best seller, with millions
of copies published. Other images shown
in Gilbert & George's lecture included photo-
graphs of the set table and of the venue
where – with formats borrowed from the
performing arts – *The Meal* took place, as
well as images and fragments of recipes from
Mrs Beeton's Book.

The artists undoubtedly staged *The Meal*
as part of project to construct their artistic
personae. Presenting such a lecture to
members of the art world, accustomed as
they were to debates focused on art criticism
rather than about household management,
must have constituted a clear act of satirical
provocation, interrogating the image and
role of the artist as someone belonging to a
world – the art world – defined by a different
vocabulary and with separate preoccupations
from those of everyday life. Furthermore,
although the idea of giving a lecture on a
previously realised work has since become
a conventional activity, it was not common in
the late 1960s. *The Meal* is one of the earliest
examples of artists developing a lecture-
performance out of a previous work, as the
extension as well as the formal presentation
of that work.

CONCLUSION

Within the history of performance art, the
development of performance-based work
as the embodiment of a discourse or critical
position has hardly been researched. It sits
between two trajectories: the one concerned

with the body and physical enactment as part of the tradition of theatre and dance; and the one relating to the performance of knowledge through lectures, public discussions and the presentations of papers or audio-visual material. Its development cannot be subsumed in either of the two most influential accounts of the history of performance art: an analysis of performance in relation to the physical embodiment of space in theatre and dance, as championed by RoseLee Goldberg; or as an extension of the painting and sculptural object into the fourth dimension.[46] Neither of these two prominent narratives account for what was specific in the performance-based work developed by students at St Martin's School of Art: the articulation of a critical position through the work. This essay has argued that, at least in Britain, the format thrived among former art students, who had been influenced by what they learned in a reformed type of art school curriculum, within which artists had to engage equally with the making of objects as with the articulation, discussion and public presentation of the critical issues surrounding the making of their work.

As forms of articulation and distribution of knowledge, the formats of group criticism and of the lecture-performance offer a strong contrast. On one side, the 'crit' fostered the collective discussion of ideas, the agreement on shared criteria of assessment, the assimilation of a prominent critical discourse and the posturing of the artist as an assertive and self-defined individual. On the other side, former students staging lecture-performances challenged and rejected the criteria dominating the 'crits' as much as the notions that an artist needs to take on macho postures and that knowledge is imposed from above and shaped through collective reiteration. And yet, these two apparently contrasting positions are ultimately part of the same historical narrative. Their establishment is equally rooted in developments that redefined the art school in the post war, initiating process- and concept-driven ways of making and developing a model in which the artist – as a thinker and intellectual – is in charge of the elaboration and public articulation of knowledge.

If in the present-day art university, an institution increasingly defined in terms of research, the pedagogical format of group criticism remains a prominent and regulating format, it is also the case that artists continue to stage lecture-performances which, then as now, tend to solicit more idiosyncratic, poetic and often more humorous approaches to the making of art, subverting institutionalised forms of articulation and the presentation of knowledge.

THE MEAL.

X

CONCLUSION

In our exploration of the lives of the London art schools, we have been at work in a research field where the present state of knowledge is limited. Art school histories have invariably been seen merely as ways of colouring in some background to more compelling art-historical issues, but in this collection we have tried to apply the material to a more wide-ranging interdisciplinary analysis. These London art schools have revealed discoveries and insights but deep research also needs to be undertaken on a number of additional institutions, important schools located in cities across the UK: for example, Bath, Cardiff, Coventry, Glasgow, Leeds and Newcastle, and several other schools within London itself – Kingston, Ealing, Wimbledon and Hornsey/Middlesex.

Many art school teachers moved between London institutions: Donald Hamilton Fraser (1929–2009) trained at St Martin's in the early 1950s and was taken on by Carel Weight as a teacher at the RCA by the end of that decade. Post-World War Two, Peter de Francia (1921–2012) trained at the Slade and then taught at several art schools, ending up as Professor of Painting at the RCA through to the early 1980s. Fewer were the single institution artists and tutors such as Peter Snow (1927–2008), who joined the Slade as a student in 1953, was taken onto the staff in 1957 and worked there until his retirement. And, as has sometimes been noted in the foregoing chapters, there was also movement of tutors between the London schools and schools outside London or, more often – and this is an impression rather than a proven trend – movement *from* the provinces *to* the capital: Maurice de Sausmarez (1915–69) from Leeds to London or Lawrence Gowing (1918–91) from Newcastle upon Tyne to London to Leeds and then back to London again, or Harry Weinberger (1924–2009), who was a student at Chelsea and at Goldsmiths but was appointed Head of Painting at Lanchester Polytechnic in Coventry in the 1960s, which he found was developing as a leading centre for conceptual art beneath his very (and somewhat surprised) feet. In short, it is clear that many art schools and art school staff outside the capital made remarkable

contributions to curriculum development and that those developments had their impact in London.[1]

This then is the first of our major conclusions: interesting though they are, the lives of the London art schools should not be retold entirely in a cultural, intellectual or geographical vacuum. Indeed, the examination of international comparators has the potential to reveal important insights into the UK material and a number of intriguing questions have already surfaced. Did the maintenance in the later twentieth century of a beaux-arts tradition of art education in Sweden – the very tradition categorically rejected in the UK – help to preserve the high status and autonomy of art schools in that country? Another project would be to undertake an international examination of syllabus groupings around fine art: what subjects are taught alongside one another? What are the strengths and weaknesses of the system that operates in many institutions in China, where art history, aesthetics and art practice are all taught together?

Closer to home, the historical work that we have been engaged in needs to be tied into current debates about present and future art education policy. Especially important are the considerable numbers of revisionist approaches to art school education that are being proposed, discussed and in some cases even implemented. A number of initiatives to provide art education outside the conventional university sector have recently been taken both in London and beyond: Grizedale Arts in Coniston in the Lake District; Islington Mill Academy in Salford and Open School East in Hackney, London have recently been grouped by commentators as part of an 'alternative' trend.[2] For obvious reasons, these initiatives are being greeted with concern within the university sector where other alternatives are also being considered. Stephen Farthing (b.1950), Professor of Drawing at the University of the Arts London, has presented an alternative model for art schools, which reworks the original intentions of the nineteenth-century founders of the then South Kensington Museum (now the Victoria and Albert Museum and Royal

College of Art) which brought together a museum and an art school under a single roof. Farthing argues that art teaching should be closely associated with – and actually take place in – art museums with collections of contemporary art. An example would be a closer institutional linkage between geographical neighbours Tate Britain and Chelsea College of Art and Design, with such a linkage centring on art education.

Our research has also revealed that there are great opportunities for investigation into the sociology of the art schools. Since artists invariably work in isolation or very occasionally in pairs as working units (the Chapman Brothers, Gilbert & George), art schools offer a collective means of categorising a set of individuals. But who are these individuals? Apart from informal perceptions and one or two famous cases (Anish Kapoor [b.1954], Gilbert [& George] Prousch [b.1943]), little is known about the impact that overseas students have had on the London art schools. Indeed, scholars have tended to shy away from undertaking detailed work on such questions and discussions of art school history tend not to make good use of the data that is available on student demographics. Now that the art schools have for some years been firmly embedded in the university system – for better or worse – careful work by scholars using the numbers published annually by the Higher Educational Statistical Agency (HESA) should start to bear fruit.

In relation to the methodologies needed for writing art school histories, in the Introduction to this book I suggested that art school histories should not place excessive reliance on the artist interview and oral history and I signalled the need for art school historians to check individual recollections against other documentary evidence when establishing the historical events. In addition to this 'caution' about methodology we need to emphasise that there is a dearth of published material of the kind that the field needs. We require a greater number of detailed technical accounts of pedagogic practice in fine art as well as deep, contextualised historical sociologies of the art-school enterprise. Most startling of all is the shortage of historical analysis that gives serious attention to questions of gender difference.[3] A research project on 'female and male students and female and male tutors in the London art schools' would be likely to yield a fascinating yet sobering set of results that could provide a much richer context for future understanding of the subject.

At present, the bookshelf marked 'Art School History' is understocked and this is something that future scholarship needs to challenge. We are unaware of anything as serious in the UK as the Swedish project being led by the Uppsala sociologist Marta Edling, which explores the artist's profession with scientific precision, looking for correlations between gender, individual merit and career progress. One outcome from Edling's project, which has already struck a chord with the Art School Educated research team, was the discovery that art students are perceived to be more influential in the management of their own art schools than are students in other disciplines in their own institutions. It would be fascinating to test this hypothesis on British material and to seek explanations.

VERBAL AND NON-VERBAL

At the centre of our subject has been the structural paradox that by *writing* about education in the *visual arts* we were seeking to transcend the incompatibility of the verbal and the non-verbal. How can historians use written language, spoken accounts and documentary evidence to describe the inculcating of skills in the education of artists, something that many hold to be – self-evidently – a visual and manual process? But as with all aspects of the history of art education, the elements in the equation are less stable than it might appear. In recent years, there has been a significant re-emphasising of verbal skills as part of the Foundation course curriculum and a number of essays in this collection have charted the seemingly inexorable shift in art education away from manual skills towards an understanding of theory, which is expressed verbally even if it

is applied visually.[4] In addition, there has been an unrelenting process over the last twenty or so years, to bring art education within mainstream higher education. One important facet of this process – one aimed at countering the claimed exceptionalism of art teaching, that is, the oft-repeated claim that art is distinctly different from other subjects and needs to be taught on a different basis – has required art school teachers to work like all other university academics across the UK higher education system and engage in two kinds of scholarly activity within the art school workplace, namely, teaching and research. The former is directed at managing ever greater student numbers within an ever tighter framework of accountability and quality assurance. The outcomes from the latter, research activity, are subject to the evaluative processes of UK government funding council 'selectivity' exercises, which even after many years of adaptation and accommodation do not permit research-active, fine art academics simply to submit their creative outputs as evidence of 'research excellence' without verbal commentary. The Handbook for the most recent such process, the 2014 REF, is of course accommodating of fine art, alongside all other university research fields:

> All types of research and all forms of research output across all disciplines shall be assessed on a fair and equal basis. Panels have been instructed to define criteria and adopt assessment processes that enable them to recognise and treat on an equal footing excellence in research across the spectrum of applied, practice-based, basic and strategic research, wherever that research is conducted; and for identifying excellence in different forms of research endeavour including interdisciplinary and collaborative research, while attaching no greater weight to one form over another.[5]

Despite the equity implied in this statement, the quality of the research has to be discernible by the assessors exclusively in published outputs and here, each subject area REF panel has had to create its own set of parameters. In the case of fine art, it was decided that outputs to be evaluated should include 'research from all aspects of the history, theory and practice of art and design … outputs, in whatever genre or medium, that meet the definition of research … The sub-panel acknowledges the diversity and range of related methods of academic study and artistic practice, and therefore adopts an inclusive definition of its remit.[6] This meant that much of the output submitted by fine arts practitioners in their portfolios benefited from and perhaps even required verbal commentary to pin-point the research excellence that the evaluators would be unable to see simply from the works themselves: 'In their criteria documents panels may request additional information relating to outputs if required for the assessment of research … Panels may request any of the following: a. Details about the research questions, methodology or means of dissemination, where these are not described within the output itself. This applies to practice-based outputs, for example, an exhibition, performance or artefact'.[7] In accommodating the REF, fine art academics have had to confront the fact that visual skills alone do not suffice, with the result that a whole research industry has arisen engaged in exploring the theory and practice of practice-based research.[8]

Another way to explore the verbal/visual paradox in relation to art education is to ask: where might the boundaries be between art practice, art theory and art history? In relation to this, it has been argued recently that the role of the art historian in an art school is to mediate or translate from one disciplinary culture to another. Jennie Lee has described the arrangement at Nottingham Trent University, which developed what is described as an 'open curriculum' where students undertook their own self-directed research into both art practice and art history or theory. This approach self-consciously follows the lead set out by French philosopher Jacques Rancière (b.1940) in *The Ignorant Schoolmaster. Five Lessons in Intellectual Emancipation* (1987), where it is argued that

teachers should not offer explanations or examples or attempt to verify what a student finds. The task of the teacher is simply to verify that the student has undertaken such a search. Rancière has been highly influential in the UK art school sector, his theories seized on as justifications against 'instruction' in 'skills', and the art school historian frequently encounters echoes of his ideas in the recollections of tutors, in syllabus statements and enshrined in learning objectives.

Art School Educated was a research project that set out to operate between several disciplinary stools. In that it was an art-historical project based at Tate, it sought to make a contribution to the history of the visual arts in Britain by considering the impact of the learning experience of many of the artists, whose works illustrates that history and who are represented in the British national collection held at Tate. We kept at least one eye on what can be described as art history's primary purpose, asking, 'Why was this work of art made and why does it take the form that it takes?' We were assuming that a deeper understanding of the circumstances that applied for artists in their formative years would help us understand why their work looks as it does. However, as we soon discovered, the art school tutors who regarded themselves as artists (the vast majority) denied that there were any explicable links between training and practice. If this is indeed the case, it will be another sign of the historical singularity of the contemporary art scene in Britain, since in every other art-historical field known and in influential art-historical studies too numerous to cite here, it is possible to find partial if not complete explanations for artistic outputs through an examination of the artist's training.

THE LATER HISTORIES

The London art schools have witnessed dramatic changes of scale, purpose and governance over the period covered by this book. The pattern of events at Wimbledon is exemplary in this respect: this one case allows us to identify stages such as consolidation, independence, specialisation, growth, competition and merger. In the early years of the twentieth century, Wimbledon art school had its origins in a consortium of small local facilities on the borders of outer southwest London and Surrey, which became an independent local authority run school of art in 1930. A rare and distinctive interest in theatre design is notable at Wimbledon from as early as 1932 and a department on this subject was eventually founded in 1948. In 1963, the DipAD in theatre was approved for Wimbledon and the lead in that subject, Peter Bucknell (1923–93), was duly appointed Principal in the following year. The DipAD in fine art (painting) was approved in 1966 and in fine art (sculpture) four years later and the development of courses in theatre design and sculpture led directly to new investment in built infrastructure in these subject areas. In 1974, the CNAA approved BA Hons courses and in 1981 an art teaching qualification, the PGDip. In 1980, the MA in fine art printmaking was established and five years later another MA, in site specific sculpture, and then yet another in fine art and theatre in 1990.

With the ending of the binary divide between universities and polytechnics and with the passing of the CNAA, Wimbledon School of Art achieved independence from its local authority (by then, the London Borough of Merton) and it was given Higher Education Corporation status in 1993 with its degree programme accredited by the local University of Surrey. Under its Principal from 1997, Roderick Bugg, the School brought in a new part-time BA in practice and theory in art and design, launched a new Drawing Centre and started awarding PhDs (in 2001) and a Foundation Diploma (in 2002). Having initially remained independent from the consortium of art, design, fashion and media colleges that in 1986 had come together to form the organisation known as 'The London Institute', in 2006, Wimbledon took the name 'Wimbledon College of Art' and joined the successor grouping, known from 2003 as the University of the Arts, London (UAL).

There had long been concerns over the survival rates of the small London art schools. Even in the 1970s, institutions needed to be

bigger to generate teaching fee income and this tendency shows no signs of changing over forty years later. In 1972, the *Times Higher Education Supplement* reported plans that were under discussion to create a London federation of art schools under the auspices of the ILEA in response to the first wave of post-polytechnic mergers. It was reported that Chelsea, Camberwell, Central and St Martin's were already holding talks and had it come off, the Principal at Camberwell at the time was quoted as hoping that the merger would allow his college to expand student numbers from 450 to 700. Wimbledon stayed outside those discussions but within UAL it now forms a distinct element in a single administrative and budgetary unit together with Camberwell College of Art and Chelsea College of Art and Design. At this point in its century-long journey, Wimbledon art school is now one part of what is known within the University of the Arts, London simply as 'CCW'.

LIFE STORIES

The history of the art schools is in keeping with the heterodox quality of art production in later twentieth- and early twenty-first century Britain. What is more, despite odd moments where the historian can establish definite linkages, the life stories of the artists themselves suggest that the links between artists and their teachers are mostly tenuous and that 'house styles' in the art schools – those master-pupil 'schools' so character- istic of the old accounts of the history of art – are hard to trace or describe with any consistency.[9] In trying to establish patterns we find ourselves trying to lead an unruly beast down a narrow path. Phyllida Barlow (b.1944) studied at Chelsea and then at the Slade and taught first at Camberwell and then at the Slade where her pupils included Rachel Whiteread (b.1963), Tacita Dean (b.1965), Douglas Gordon (b.1966) and Martin Creed (b.1968); despite this, historians of contemporary art would show extreme caution before talking about this list of prize-winning artists as the 'School of Phyllida Barlow'.

During the life of the research project underpinning this book, a great many significant artists died and their own stories illustrate these contradictions. Roger Ackling (1947–2014) attended St Martin's School of Art in the mid 1960s where he was an asso- ciate of Richard Long (from 1968) and Hamish Fulton, but though he used the sun's rays to transform detritus he taught not at 'experi- mental' St Martin's but at Wimbledon and then at Chelsea. Having studied at the RCA in the mid 1950s, the conceptual artist David Troostwyck (1929–2009) became a teacher at Camberwell and then at the Slade, a school so often associated with figurative painting. We have already engaged with Crippa's thesis (chapter IX) that the intellectual and self- reflective practice encouraged by teachers such as Anthony Caro in the St Martin's Sculpture Department in the 1960s led directly to conceptual art,[10] yet Caro (1924–2013) trained at the more traditional Royal Academy Schools. One of his pupils, Barry Flanagan (1941–2009), was an exceptional applicant for a place as an art student in that he carefully sampled several London art schools, eventu- ally choosing St Martin's in 1961 having encountered Caro's teaching in a 'taster' class.

Continuities and discontinuities of art school employment and association and teaching policy cut across the battle lines around style, process and purpose – the kinds of categories that in the past have helped art historians to cut the UK art world up into pieces of suitable size for description. Gerald Laing (1936–2011) ignored the rough brushes provided by the St Martin's painting tutors in the early 1960s and painted with minute precision in emulation of black and white newsprint dots. Brian Taylor (1935– 2013), a figurative sculptor in bronze who trained at the Slade in the 1940s and won a scholarship to the British School at Rome, then taught sculpture at Camberwell from 1965–84. He remained a passionate believer in the primary importance of drawing and in the value of the life room, the closure of which in so many colleges was for the most part a symbolic act. Such closures moved to the margins that traditional practice, associ- ated as it was with punctuality, regularity,

old-fashioned professional values and an amateur reliance on drawing. Today, drawing is no longer a site of conflict but a choice among many and students are amazed that drawing was ever a site of contest.[11]

In conclusion, the lives of the London art schools suggest that the curriculum that they deliver teaches their students how to be artists, perhaps more than it teaches them how to make art. The schools themselves, and their increasingly hard-pressed staff, yearn to be able to show an independence of spirit that is increasingly hard to maintain in the current higher educational environment. Art Schools now manifest a turn towards the contemporary and the future away from the past. Taken with the current exhibiting strategies of many of the great museums, this would seem to indicate that art will not for very much longer be seen as a subject with a generally understood historical past – a trend that is taking longer to develop than one might have thought. In the late 1940s, Kenneth Clark made a typically prescient comment to this effect in his *Landscape into Art*: 'The kind of art which interests young people, arouses their curiosity and excites them to argument, is the art of their own time.'[12] And, as we saw above, the Stephen Farthing model, which links the art school to the art museum, relies on an art collection which includes the contemporary. The most powerful sign of the place of history in the contemporary art school is perhaps the interest in the archive, seen not simply as an historical repository but as a genre of contemporary practice. At Kingston University there is a project to assemble and create an archive on the history of the Kingston School of Art from the 1870s to 1992.

As this book has shown, dramatic changes have overtaken the London art schools over the last two generations. In managing their activities they have had to find ways of gaining benefit from the university systems with which they have been merged. In their pedagogy they have shifted the focus towards the production of emergent artists, away from the acquisition of skills towards the gaining of other professional and vocational competences and reinforcing the image of the artist as an assertive intellectual rather than a manual trickster. These days, the curriculum tends to bypass art history in favour of cultural theory. Much of what is current has its origins in changes that took place in and around the 1960s and, as we have seen, many of those changes were driven by symbolic acts as much as they were the outcomes of careful policy-making. Whatever the motives of their 1960s forebears, the London art schools continue to struggle with the consequences of those changes, although the contemporary art scene that the schools contribute to is, by every rational measure, more successful than ever before.

NOTES AND BIBLIOGRAPHY

Long references for substantial sources are listed in the Bibliography (p.173). Important archival sources are also listed there.

I. INTRODUCTION:
 HISTORIES AND CONTEXTS

1 Renamed the Central School of Art and Design on 1 May 1966 and then merged to form Central St Martin's College of Art and Design in 1989; see Appendix.

2 Alan Reynolds, *Summer* 1954. Oil on board. Acquired 1956 (T00105).

3 For the theory of oral history and life history research see Perks and Thomson 2006. For debates about methodology see the pages of journals such as *Oral History* and *Oral History Review*.

4 Moreen Docherty recalling Gerard Mansell, *Guardian*, 10 Jan. 2011.

5 See Hans Ulrich Obrist's interview with Michael Baxandall in *RES* May 2008 and Onians 2010, p.45.

6 For a detailed study of the demise of the local art school see Beck and Cornford 2012, pp.58–83.

7 [Robbins] 1963.

8 For the history of university expansion and its visual cultural impact see Muthesius 2000, p.94ff. For a near-contemporary account see Beloff 1968.

9 For more on this see Robinson 1968. See also W.A.C. Stewart, 'The Rise of the Polytechnics', in Stewart 1989.

10 The first DipAD was awarded in 1963 and the last NDD in 1967. See Tickner 1968, p.106.

11 Quinn, 'The pedagogy of capital: Art history and art school knowledge' in Potter 2013.

12 See the diagram setting out the early degree courses at Sussex in Muthesius 2000, p.109, where 'Art' is offered in no fewer than three Schools of Study – a position that was maintained until the very early twenty-first century.

13 The present studies by Massouras (Chapter III) and Crippa (Chapter IX) are directly on this topic.

14 See Bourriaud 2002 and Bourriaud, Schneider and Herman 2002. For responses to Bourriaud, see Bishop 2004, Dezeuze 2006, and Downey 2007.

15 For more on student protest in the early part of our period see Cockburn and Blackburn 1969.

16 The wider issue of cultural value is also under intense scrutiny in the mid-2010s. See, for example, the final report of the Warwick Commission (http://www2. warwick.ac.uk/research/ warwick-commission/futureculture, accessed

Apr. 2015) and the work of the AHRC-funded Cultural Value programme (http://www.ahrc.ac.uk/ Funded-Research/Funded-themes-and-programmes/Cultural-Val-ue-Project/Pages/default.aspx, accessed Apr. 2015).

17 The National Gallery in London has now abandoned the term for its new series of catalogues: see http:// www.nationalgallery.org.uk/ paintings/research/the-national-gal-lery-catalogues, accessed Feb. 2015.

18 For the historiographic tradition see Nigel Llewellyn, 'The History of Western Art History' in Bentley 1997, pp.828–50.

19 da Costa 1967.

20 Ibid., p.392.

21 The picture is Musées du Louvre inventory 5661l; it was Largillièrre's reception piece for academic membership in 1686. The picture is oil on canvas and measures 2.32 x 1.87 metres

22 See Chapter IX of this book.

23 da Costa 1967, pp.407–8.

24 da Costa 1967, p.479.

25 See http://results.ref.ac.uk/Results/ ByUoa/34, consulted Feb. 2015.

26 Beyond the confines of the REF see Candy 2006.

27 A point made by Westley in her presentation to the College of Art, Paris seminar on Foundation courses in 2013.

28 For the original sources see, for example, Klee 1968.

29 On this see Potter 2013, an exercise in seeing historical continuities in art education.

30 Potter 2013.

31 Quinn, in Potter 2013.

32 Goethe 1970. The translator was Sir Charles Lock Eastlake (1793–1865), Director of the National Gallery, London, who explains to the reader that he has added some notes to Goethe's text in an effort to connect the philosopher's theory to the practice of the Italian painters: see p.xxxiii.

33 The term is disputed. See Crippa and Williamson 2013, pp.6–13.

34 Bellori 1672.

35 For this I benefited from Professor Judith Mottram's paper delivered at the Uppsala symposium in Autumn 2010.

36 'Introduction' in Potter 2013.

37 White 1957. In his final chapter, 'Present problems', White signals in a footnote that he has been talking to Ivon Hitchins, whose works seemed to White 'to reflect a fully developed synthetic type of perspective' (p.276). See also Wittkower 1967: in the preface to this third edition, Wittkower, Professor at UCL from 1949, tells

us that the book has had an impact on a 'young generation of architects'. See too Reyner Banham's comments in *Architectural Review*, Dec. 1955. What excited the younger architects was the fact that good architecture was not simply a question of aestheticised pleasure but of theory and practice – that is, an intellectu-alised approach. For Gombrich's own reflections on his Slade teaching see https://gombrichar-chive.files.wordpress.com/ 2011/04/ showdoc34.pdf

38 It is an intriguing possibility that one of the consequences of the migration into the UK of German-speaking art history scholars was that by being exposed to their daunting presence in Bloomsbury, Coldstream felt that the British national art school curriculum needed an intellectual lift. The Art & Language response to Pevsner's standpoint is instructive. See Elena Crippa, Chapter IX in this collection.

39 Pevsner 1940, p.vii; see also Chapter VII on nineteenth-century academies. For a contemporary exploration of Pevsner's study see Salaman 2008.

40 http://www.hesa.ac.uk/free-statis-tics, accessed 23 Jan. 2015.

41 This was Cooper's own assessment as communicated to a journalist on *Wimbledon Borough News*, 26 June 1964.

42 Lanzi 1847, p.188.

43 Perks and Thomson 2006, p.69.

44 Ibid., pp.2–3, 70.

45 Coldstream was Chairman of the National Advisory Council in Art Education between 1958 and 1971.

II. WILLIAM JOHNSTONE:
 INTERNATIONAL AND
 INTERDISCIPLINARY
 ART EDUCATION

1 Alan Powers claims that Johnstone's time at Central was as important as Robin Darwin's 'reign as rector of the Royal College of Art', yet 'he has not yet been accorded a secure place in the history of either 20th Century painting or of art education'. Powers, 'William Johnstone and the Central School' in Backemeyer 2000, p.65.

2 Johnstone 1975, p.90.

3 Ehrenzweig 1959, p.146.

4 Johnstone 1975, p.146.

5 Ibid., p.88.

6 Ibid., p.90.

7 Johnstone employed Collins and Halliwell first at Camberwell and then at Central. See Johnstone 1980, p.188.

8 Ibid., p.221.

9 Ibid., p.90.

10 Johnstone, 'The Central School of Arts and Crafts', n.d. All references to material at CSM are made Courtesy of Central Saint Martins Museum and Study Collection.

11 Johnstone 1980, p.120.

12 Ibid.

13 Ibid., p.142.

14 Johnstone's introduction to these discussions, as well as his new vocation, was Senior Inspector of Art for the London County Council R.R. Tomlinson. Tomlinson was instrumental in securing for Johnstone the post of assistant art teacher at Lyulph Stanley and Haverstock Central Boys' School.

15 Johnstone 1980, p.170.

16 Johnstone 1941, pp.1–2.

17 Johnstone, 'Staff and Student Address', n.d.

18 For a fuller account of Gropius's London connections and the significance of his 1935 publication *The New Architecture and the Bauhaus* in disseminating his ideas, see Yeomans 1987, p.71. All references to Yeomans's unpublished thesis are made by kind permission of Richard Yeomans.

19 Johnstone, 'Lethaby's centenary', n.d.

20 Johnstone 1980, p.211.

21 Ibid., p.229.

22 Johnstone, 'The Central School of Arts and Crafts', n.d.

23 Johnstone had employed both Pasmore and Hamilton at Central before they taught at King's College Newcastle, University of Durham.

24 Coleman 1959, p.1.

25 Cited in Yeomans 1987, p.77.

26 Ibid., p.78.

27 Chronology given in *William Johnstone: Marchlands*, 2012, pp.78–84.

28 Johnstone 1980, p.263. For an account of Stavenow's interest in design see Stavenow and Huldt 1961.

29 Cited in Carol Hogben, 'Design Introduction' in Hawkins and Hollis 1979, p.63.

30 Johnstone 1980, p.263.

31 Chronology set out in *William Johnstone: Marchlands*, 2012, pp.78–84.

32 For more on Johnstone and Ehrenzweig see Williamson 2015, pp.97–101.

33 At this time, the Central School was made up of a School of Drawing, Painting, Modelling, Etching and Allied subjects; a School of Book Production and Graphic Design; a School of Interior Design and Furniture; a School of Textiles; a School of Theatrical Design; and a School of Silversmiths' Work and Allied Crafts. See Johnstone 1980, p.220. Johnstone's important place in the development of Basic Design courses is marked in a letter inviting him to take part in a discussion about an exhibition, *The Developing Process*, devoted to the problem of Basic Design courses. See Alloway 1959. All references to the Papers of William Johnstone are made Courtesy and © Estate of William Johnstone.

34 Johnstone 1980, p.224. Johnstone's views on creativity here were well aligned with those of art theorist Anton Ehrenzweig, who he had employed in the role of Dye Technician in the Printed Textiles Department at the Central School of Arts and Crafts. See Williamson 2015, pp.97–101.

35 Letter from Peter Townsend to William Johnstone, 17 Aug. 1966. Papers of William Johnstone, National Library of Scotland, Acc. 8877/4.

36 Galley proofs of interviews, lightly annotated by Johnstone. Papers of William Johnstone, National Library of Scotland, Acc. 8877/4.

37 Ibid.

38 Copy letter dated 21 Aug. 1966 from William Johnstone to Peter Townsend. Townsend replied on 24 Aug. 1966, agreeing to publish Johnstone's comments in the October issue of *Studio International*. Papers of William Johnstone, National Library of Scotland, Acc. 8877/4.

39 Johnstone 1980, p.280.

40 Johnstone 1948, pp.6–9.

41 Ibid., p.6.

42 Ibid., p.7.

43 Ibid., p.9.

44 Johnston 1953, p.60.

45 Johnstone 1936 and Johnston 1950.

46 Johnstone 1950, p.xxiii.

47 Ibid, p.210.

48 Nikolaus Pevsner 1955, pp.3 and 9. Pevsner's series of Reith Lectures were broadcast weekly at 9.15pm on the BBC Home Service from 16 Oct. to 27 Nov. 1955. With lecture titles such as 'The Geography of Art' and 'The Genius of the Place', it is not difficult to sense his focus.

49 Ibid, p.8.

50 Johnstone travelled to America in 1948 to conduct a London County Council survey on the training of students in industrial design. It was during this trip that he met Walter Gropius and Frank Lloyd Wright. Gropius's replies to Johnstone's correspondence following the trip are dated 26 Oct. and 1 and 7 Dec. 1948. Papers of William Johnstone, National Library of Scotland, Acc. 8877/2. For a detailed chronology see *William Johnstone: Marchlands*, 2012, pp.78–84.

51 Letters from Frank Lloyd Wright and the staff of the Frank Lloyd Wright Foundation concern arrangements for Johnstone and his wife to visit Taliesin in 1948 and follow-up correspondence in 1949. Five letters from The Frank Lloyd Wright Foundation to William Johnstone, dated 13 March 1948, 21 Apr. 1948, 20 June 1948, 1 Dec. 1948, and 14 March 1949. Papers of William Johnstone, National Library of Scotland, Acc. 8877/2.

52 Johnstone refers to his friendship with Stavenow in his autobiography: see Johnstone 1980, pp.263, 328. Archive correspondence spans the period 1959 to 1970. Two letters from Stavenow to Johnstone dated 8 May and 22 May 1959 outline his trip to Stockholm for the official opening of the Konstfackskolan. An earlier letter, on 1 May 1959, from the American Express Company Inc., outlines his travel options for the September visit. A letter from L.S. Houghton, an Education Officer for the London County Council on 2 June 1959 approves Johnstone's expenses for the trip to the sum of £45. All Papers of William Johnstone, National Library of Scotland, Acc. 8183/13. At the time of his death, Johnstone's library contained several books by Stavenow, some with personal dedications. See Campbell 1990, which lists four books by Stavenow and one related publication amongst Johnstone's collection: Åke Stavenow, *Silversmeden Jacob Ängman 1879–1942*, Stockholm 1955; Åke Stavenow, *Einar Foreseth. Swedish Painter*, trans. Thorsten Odhe, Sweden 1956; Åke Stavenow, *Gamala Konstfack*, Sweden c.1960; Åke Stavenow, *Konstfackskolan*, Sweden 1964; and Arthur Hald and Miron Grindea, *Swedish Design*, Stockholm 1958.

53 Stavenow, 1964, n.p.

54 Johnstone 1980, pp.263–64.

55 Letter dated 4 Aug. 1961 from D.C. Finch, Department of Technical Co-operation, Whitehall, London to William Johnstone. Papers of William Johnstone, National Library of Scotland, Acc. 8183/3. This letter is accompanied in the archive by a series of letters written to Johnstone from Felix Darnell, Principal of Bezalel School of Arts and Crafts.

56 Papers of William Johnstone, National Library of Scotland, Dep. 332/5.

57 Letter dated 9 Dec. 1962 from Felix Darnell to William Johnstone, typed on Bezalel School of Arts and Crafts headed notepaper. Papers of William Johnstone, National Library of Scotland, Acc. 8183/3.

58 Letter dated 5 Feb. 1963 from Felix Darnell to William Johnstone, typed on Bezalel School of Arts and Crafts headed notepaper. Papers of William Johnstone, National Library of Scotland, Acc. 8183/3.

59 Johnstone's preparatory notes for the commissioned UNESCO report on the future of Bezalel School of Arts and Crafts, Jerusalem. Thirteen pages, unsigned and undated, typed on Bezalel headed notepaper. Letter dated 9 Dec. 1962 from Felix Darnell to William Johnstone, typed on Bezalel School of Arts and Crafts headed notepaper; this quotation taken from p.12 of 13. Papers of William Johnstone, National Library of Scotland, Dep. 332/5.

60 Ibid.; quotations taken from pp.2–3. Papers of William Johnstone, National Library of Scotland, Dep. 332/5.

61 Ibid.; quotation from p.11. Papers of William Johnstone, National Library of Scotland, Dep. 332/5.

62 Ibid.; quotation from p.1. Papers of William Johnstone, National Library of Scotland, Dep. 332/5.

63 Johnstone, 'Address to Staff and Students', n.d.

64 Ibid.

65 Ibid.

66 Johnstone, unpublished typescript, n.d.

67 Johnstone, 'Address to Staff and Students', n.d.

68 Ehrenzweig 1959, p.146.

III. THE ART OF ART STUDENTS

1 Robertson and Russell 1965, p.137.

2 See generally Denis and Trodd 2000 and Stewart 1989.

3 Robinson 1968, pp.25–6.

4 See Garlake 1987, p.483.

5 Young Contemporaries 1949–69, ACGB 121/1176. Letter from Mark Glazebrook to Mr Tomory, director of the City of Auckland Art Gallery, dated 17 December 1962, declining an invitation to send the exhibition to New Zealand.

6 ACGB 121/1176, folder 1 of 5.

7 Westley 2007, p.124. This appeared in a special issue of *Queen* dedicated to the RCA.

8 For example in the Sculpture Forum on Fridays, where the guest speakers spanned critics, gallery owners and so on. See Westley 2007, p.124.

9 Carel Weight interviewed in Courtney 1991–2, recording C466/07, tape 26; Weight 1962.

10 Anonymous, 'Future of the Art Schools', *The Times*, 18 January 1958, p.7.

11 Butler 1962, p.69.

12 Lee 1965, paragraphs 83 and 88 respectively.

13 Huish 1892, p.720.

14 Hinks, 'Patronage in Art To–Day' in Lambert 1938, p.73.

15 Anonymous 1934, p.9.

16 Pevsner 1937, p.219.

17 Muthesius 2000, p.95.

18 Stevens 2004, p.16.

19 See Timmins 2001, p.202. Funding was not, however, centralised: for example, the London County Council funded the Central School and St Martin's, but not the Slade or the RCA. See Sandlands 1960, p.6. The Royal Academy schools offered free tuition.

20 Hollis 1997, p.298.

21 Singerman 1999, p.128.

22 War Cabinet meeting minutes of 3 May 1944, National Archives CAB/66/49/39, p.1. The Cabinet recorded that before the war, universities' arts faculties had generated 5,000 graduates annually, of whom 3,200 were men; after 1942 this had dropped to 2,000 annually, of whom only 200 were men.

23 The post-war Keeper of the Royal Academy Schools, Philip Connard (1875–1958), also found the war's interruption 'in some cases [...] blunted the edges of [students] and left them aggressive, over-confident in their own judgment and unaware of their own experience'. *Annual Report from the Council of the Royal Academy to the General Assembly of Academicians and Associates for the year 1946*, London 1947, p.28.

24 Murray 1958, p.393.

25 Medley 1983, p.222. 26 E.g. John Hilliard, who said of the DipAD, 'It was my parents who were gratified [by the qualification]'. Interview with the author, 16. Aug. 2011.

27 Robbins 1963, cmnd. 2154, p.3.

28 Morris 1964, p.10.

29 Robbins 1966, pp.108–9. The speech was originally delivered to the Royal College of Art on 10 July 1964.

30 Slade Archive, 1.D.ii.b, Sundry Papers.

31 The First Report of the NCDAD 1964, p.46, paragraphs 145 and 161.

32 Lynton 1970, p.167.

33 Sweet 1969, p.59.

34 Smith 1809, p.631.

35 Schiller 1981, p.26.

36 See Evans 2004, p.124 and its criticisms of the Quality Assurance Agency and the Research Assessment Exercise (currently the Research Excellence Framework).

37 Lacey and Bellamy 1969, Tate Gallery Archive 200329/1/29. It is unclear whether it is a coincidence that Arthur Blenkinsop was the name of a Labour MP in the 1950s and 1960s who had been involved with the North Eastern Association for the Arts.

38 Redcliffe–Maud 1976, p.143.

39 Atkinson 2009.

40 Graw 2010, p.86.

41 Carey 1992.

42 W.A.C. Stewart points out that the idea of universities' civic purpose had pre-welfare-state precedent in educational literature such as Clarke's *Education and Social Change* of 1940 and Mannheim's *Freedom, Power and Democratic Planning* of 1951. See Stewart 1989, p.77.

43 Boswell 1947, quoted in Garlake 1998, p.10.

IV. THE MANY LIVES OF THE LIFE ROOM

1 David Annesley, quoting former tutor and colleague Anthony Caro in the studios of St Martin's Sculpture Department in the early 1960s: 'We are shackled by craft and that will stop us from becoming radical'. David Annesley in conversation with the author, 5 Jan. 2006; all references to this interview are made by kind permission of David Annesley.

2 The report of the NCDAD encouraged, in its terms, the instilling of 'an attitude' towards art rather than a practical mastery, an ideological positioning to art and the art market that concerns itself less with artifact than with artistic identity.

3 Brighton 1981, p.42.

4 Stout 2012, p.94.

5 'I do believe that true freedom in art is hard-won and that art and its freedoms are often confused since the Bauhaus fucked up art education.' Ron Kitaj in *Artscribe*, no.5, 1977, cited in Brighton and Morris 1977, p.33.

6 Schlemmer 1971, p.41.

7 Richard Hamilton cites Oskar Schlemmer as a resource during the mid 1950s, the years that Basic Design was formulated as a curriculum. Yeomans 1982, p.5.

This and subsequent references to Hamilton material are made courtesy of Rita Donagh.

8 Richard Hamilton, 1961, p.17.

9 William and Mary Johnstone in conversation with David Fraser Jenkins and Richard Morphet, Tate Gallery, 18 Sept. 1981, Tate Archive TAV 320A (author's transcription).

10 Harry Thubron cited by Norman Ackroyd in Courtney 2010, C466/293, track 15.

11 Hamilton 1961, p.17.

12 Turnbull 1961, p.7.

13 Millard 1961, p.74.

14 Ibid.

15 Ibid.

16 Ibid., p.75.

17 Yeomans 1982, p.5. Yeomans gained the impression that Hamilton's recollection was that after his conversion to abstraction Pasmore would, on occasion, use his full tutorial authority to keep these students away from the life class.

18 Yeomans 2005, p.198.

19 Yeomans 1982, p.5.

20 http://thehornseyproject.omweb. org/modules/wakka.LindaMorris-Paper, cited in Tickner 2008, notes to pp.89–90, 171.

21 As Erik Forrest has noted, the images selected for the *Developing Process* exhibition recall work from the Bauhaus *Vorkurs* under Maholy-Nagy rather than under Johannes Itten. This curatorial decision underscores fundamental differences between Harry Thubron's emphasis on the intuitive and personal and Pasmore's interest in the formal and analytical. See Forrest 1983, pp.136–7. This and subsequent references to Forrest material are made by kind permission of Erik Forrest.

22 Crippa, pp.47–8. Courtesy of Elena Crippa.

23 Christopher Le Brun in conversation with the author, 25 June 2012, and in email correspondence, 14 Oct. 2013. This and subsequent references to Le Brun material are made by kind permission of Christopher Le Brun.

24 Anonymous [Ministry of Education] 1960, p.1.

25 Ibid.

26 Lynton 1969, p.58.

27 William Tucker in email correspondence with the author, 15 Nov. 2005.

28 Jon Thompson in Courtney 2012, C466 312, track 26, author's transcription. This and subsequent references to Thompson material are made by kind permission of Jon Thompson.

29 For example, in the late 1960s the new premises of the Fine Art Department of Trent Polytechnic, now Nottingham Trent University, were designed and built with no studio for life drawing.

30 Andrew Forge in Courtney 1999, C466/36/19, tape F7058A.

31 Forrest 1983, p.202. For further discussion on the place of technical skill and aesthetic sensibility in Thubron's teaching, see ibid., pp.205–6.

32 Jon Thompson in Courtney 2012, track 26, author's transcription.

33 Ibid.

34 Patrick George cited in Laughton 2004, p.160.

35 Hyman 2001, p.63.

36 Ibid., p.58.

37 In 1950, in an unpublished essay, Coldstream assesses his own place within an English tradition. See Hyman, p.63.

38 Chambers, 'Prototype and Perception: Art History and Observation at the Slade in the 1950s' in Potter 2013.

39 Laughton 2004, p.160.

40 Hyman 2001, n.20, p.220.

41 Laughton 2004, p.161.

42 Ken Adams in conversation with the author, London, 30 Sept. 2011. Art School Educated Audio Archive, Tate Research.

43 Bomberg taught at the Borough Polytechnic from 1945 to 1953, and his pupils exhibited as the Borough Group (1947–50), which shared stylistic affinities, and as the Borough Bottega (1953). The 'Bomberg Movement' also comprised such names Leon Kossoff and touched figures outside of their group such as Andrew Forge. See Courtney 1999, tape F7058A.

44 Laughton 2004, p.224.

45 David Bomberg is a germane example of just such a charismatic tutor. After his untimely death in 1957, his influence continued to haunt the life room. Bomberg's intuitive approach has been described by Richard Cork as a 'mature perception of form as the artist's consciousness of mass appeared unbridled and heretical'. Frank Auerbach, who joined Bomberg's class in 1947, described Bomberg as 'probably the most original, stubborn, radical intelligence that was to be found in art schools'. See Cork 1988, p.40. Bomberg was disillusioned with contemporary art education – and drawing instruction, specifically. See Miles Richmond in interview with the author (Courtney 2007, C466/263, track 8). Bomberg believed that he could revivify the instruction of drawing; in a letter he wrote to William Coldstream in 1953, Bomberg claims that the 'Slade has lost its prestige as the first school of drawing in the world' and describes how his commitment to the teaching of drawing could reinvigorate outmoded traditionalism. See William Coldstream Archives, Tate Archives, document 8922.4.50. In a letter dated 7 Oct. 1953, Coldstream rejects Bomberg's application to teach at the Slade. William Coldstream Archives, Tate Archives, 8922.4.81.

46 For further insight into the Lancaster debacle, see John Jones's account housed in the National Art Education Archive, Bretton Hall. The archive also houses a copy of a film made by Jon Thompson about Thubron's teaching at Lancaster, *All Sherry Trifle and No Bread*. According to Jones's account: 'When the CNAA representatives came to the college (the most unlikely people to respond to Harry's ardent anti-establish-ment-ism) they were impressed by what they saw, but the story goes, they said it was the direct consequence of Harry's presence… In dismissing the work Patrick George called it "all sherry trifle and no bread". This is the title Thompson took for his film.' Archival ref: HT/PL/92.

47 Andrew Forge in Courtney 1999, tape F7058A.

48 Ibid., F7058B.

49 Jon Thompson in Courtney 2012, track 26. Author's transcription.

50 For further reading about Thubron's experience of working with Herbert Read, see Forrest 1983, pp.171–2.

51 Read 1957.

52 Read 1952, pp.66–7. For a fuller discussion of Read's sympathy with the Basic Design pedagogues see Thistlewood 1981, p.40.

53 In his life story interview, Thompson describes sessions for technical students at Lancaster that he and Thubron ran, and that illustrate Thubron's belief in such an aesthetic education. In these classes, they introduced the students to the life room, and then asked them to reevaluate their technical tasks with an eye to the formal attributes of the experience: 'I definitely learnt that those kind of aesthetic questions can have a relevance to everybody, and they can greatly enrich all those processes which are thought to be routine.' Courtney 2012, track 26. Author's transcription.

54 Tickner 2008, p.85.

55 Lisa Tickner in conversation with David Page, cited in Tickner 2008, p.85. Coldstream included a clause in the 1960 Report that would not preclude from consideration those talented students who lacked the necessary academic credentials.
56 Garlake 1998, p.21.
57 Jon Thompson in Courtney 2012, track 26. Author's transcription.
58 Lisa Tickner explains this point further. 'Coldstream himself came from a professional family of doctors, lawyers, soldiers and civil servants: his father was a doctor, his brother a brigadier, and his first cousin Secretary to the Lord Chancellor.' Tickner 2008, p.168. Harry Thubron, in contrast, came from a modest background in the North East. Art school in Sunderland offered Thubron and others of his generation an escape from high levels of unemployment and widespread poverty.
59 Forrest 1983, p.202.
60 Thubron n.d. All references to Thubron material are made courtesy of the estate of Harry Thubron.
61 Before the NDD, the Ministry's Drawing Examination required mastery in general fields before specialisation. These fields included drawing and painting from memory and knowledge, anatomy, architecture, drawing from the cast and perspective. Two more years of study prepared the student to specialise for Examinations in advanced subjects like painting or modelling. The Ministry's Drawing Examinations were administered centrally, a practice that the NDD sustained.
62 Ministry of Education 1946. The new Intermediate Examination comprised eight tests: drawing from life; drawing and painting from memory and knowledge; anatomy; architecture; drawing the figure in costume; creative design for craft; modelling; and general knowledge.
63 David Annesley, conversation with author, 5 January 2006. Jon Thompson's recollection of Pitchforth corroborates this view: 'He [Pitchforth] produced the most marvellous drawings. He used to do it as a trick. People would gather around him sitting on the donkey – he had this unmodulated voice because he had both his ear drums blown out in the war – and he would get his fountain pen out and say, "If you start with the thumb here and go round the finger here and up the arm and think of that muscle there and you come to the

neck and you see that little bit where the bone sticks out..." And he would go right around the figure and end up where he started, and you would think, "My God, how did he do that?"' Jon Thompson in Courtney 2011, track 16, author's transcription. In Pitchforth's obituary in the Times, it was noted: 'The strength in his teaching was due in large measure to the clarity of his illustration. In spite of his deafness, or perhaps because of it, his life classes became more concentrated and animated. One could hear much of what was being said, with the word "form" echoing round the room'. Times, 8 Sept. 1982.
64 Levy 1962, p.13.
65 For an examination of Thubron's curriculum, see Forrest 1983, pp.90–101.
66 Thubron n.d.
67 Using multiple models in the studio space was not unprecedented; a century earlier, Rodin was a notable practitioner of this method. Novel to Thubron's approach was his integration of multiple models within an educational programme. There are later examples of multiple models in the art school life room (see for example Anthony Wishaw's description of life room teaching at St Martin's in Hester R. Westley, Art School Educated, Audio Archive, Tate Research, 2012), but few of these have Thubron's heuristic complexity.
68 Norman Ackroyd provides a vivid account of Thubron observational drawing instruction: 'You're getting the life without actually having to draw the tree photographically. So, analyse something, and draw, draw the marks that go in the direction of it, or, that mean something within it that hint at the thing without just drawing it. And then you actually bring that principle the next time you come to draw the life model. You think, actually it's the shadow down the thigh and the shadow just under the belly, the shadow on the inside of that thigh, and the shadow on the neck and the breasts. And suddenly you're not drawing the model, you're drawing the parts of the model that are in shadow, and you're analysing the shades. But you're still drawing the model... He made you start to think differently really.' Courtney 2010, track 15.
69 Ibid.
70 Harry Thubron cited in Coleman 1959.
71 Forrest 1983, p.154.

72 Garlake 1998, p.30.
73 Ibid., p.31.
74 See Griffiths 1979 and Morgan 1992.
75 Forrest describes how at Leeds, Thubron sometimes brought in Indian dancers and musicians playing raga; see Forrest 1983, p.101. Jon Thompson elaborates on Thubron's attempts at Lancaster to begin each session with bodily exercises: 'He always thought the day should start with sensing one's own body...' Courtney 2012, track 26. Author's transcription.
76 Hochman 1997, p.117.
77 Jon Thompson in Courtney 2011, track 11. Author's transcription.
78 Ibid.
79 Art schools that continued to offer formal instruction in the life room included the Royal Academy Schools, the Slade, Norwich College of Art, and Camberwell. Some art schools continued to keep a life room available to students, such as in the Painting Department at St Martin's for example, but they offered little by way of formal instruction. The extent to which subsequent generations of art students continued to encounter the life room was as an introductory component of the Foundation course where life drawings bolstered portfolios.
80 It is little coincidence that Hubert Dalwood taught alongside Harry Thubron when he was Gregory Fellow at Leeds 1955–8.
81 From a document detailing the chronology of events in the Sculpture Department between May 1973 and Feb. 1974, compiled by the 'Staff association of the Sculpture Department', 24 Feb. 1974, Central Saint Martins Museum and Study Collection. This and subsequent references to material at CSM are made by kind permission of Central Saint Martins Museum and Study Collection.
82 Hubert Dalwood, 'Letter to the Governors', Feb. 1975, Central Saint Martins Museum and Study Collection.
83 'Proposal for restructuring the Fine Art Department', 17 Feb. 1975, Central Saint Martins Museum and Study Collection.
84 Ibid., p.4.
85 Hubert Dalwood, 'Letter to the Governors', February 1975, Central Saint Martins Museum and Study Collection. This cohort of part-time tutors also agitated for Clatworthy's resignation, although the reasons for this aim are not clear.
86 Thubron n.d.

87 Andrew Forge in Courtney 1999, tape F7058A.

V. ART HISTORY IN THE ART SCHOOL

1 The NDD was phased out gradually: the first DipAD was awarded in 1963 and the last NDD in 1967. Anonymous [Ministry of Education] 1960, p.8.
2 Ibid.
3 Medley 1983, p.221.
4 Ibid.
5 Anonymous [Ministry of Education] 1960, p.17.
6 Ibid, p.8.
7 Harries 2011, p.692.
8 NCDAD Minutes and Reports, 'Minutes for the 2nd Academic Committee meeting of October 10, 1961'. A panel of ten members was proposed for the History of Art (National Archives, DB4/21).
9 Shields 1978, p.5.
10 Camberwell School of Arts and Crafts was renamed Camberwell College of Arts in 1989 and is now part of the University of the Arts London.
11 Letter dated 3 May 1961 from Leonard Daniels to Michael Podro. The letter invites Podro to interview for the position of Head of the Department of General Studies. The papers of Michael Podro, uncatalogued archive. All references to the papers of Michael Podro are made by kind permission of Charlotte Podro.
12 Michael Podro, Curriculum Vitae, 1966, partial copies of which are lodged in The Warburg Institute Archive and accompany his letter to Gombrich applying for a Senior Fellowship. The letter of application is written on Camberwell School of Arts and Crafts headed notepaper and dated 8 March 1966. The file also includes letters from Richard Wollheim and L.D. Ettlinger recommending Podro for the fellowship: Warburg Institute Archive, WIA, GC, M. Podro to E.H. Gombrich, 8 March 1966. Although Podro's CV records him as fulfilling the role of Head of Department from 1964, he was not formally appointed to the role until April 1965 (letter dated 10 May 1965 from Inner London Education Authority to Michael Podro). The offer of appointment is backdated to April 1, 1965. The papers of Michael Podro, uncatalogued archive.
13 Saumarez Smith 2008.
14 Podro 1972; Podro 1982; Podro 1998.
15 Podro 1972 pp.87–9.
16 Dominic McIver Lopes's ideas in his book Sight and Sensibility (Oxford 2005) are cited in Bence Nanay, 'Inflected and Uninflected Experience of Pictures', in Abell and Bantinaki 2010, pp.181–207.
17 Podro 1972, p.viii. Podro's doctoral research (from 1956) led to his dissertation (Konrad Fiedler's Theory of the Visual Arts), co-supervised by E.H. Gombrich and Richard Wollheim. Michael Podro, Curriculum Vitae, 1966: see n.12 above. This information is contextualised in Saumarez Smith 2008 and Potts 2008. For a more in-depth study of Podro's commitments see Potts 2011, pp.251–72.
18 For more on Ehrenzweig's work at Goldsmiths and elsewhere see Ehrenzweig 2000. See also Williamson 2009, pp.237–48, and Williamson 2015.
19 Podro 1972, p.122. For a closer look at Podro's thinking on Kant, and particularly on his exploration of the Critique of Judgment (1790) see Ibid., pp.7–35. Schiller's development of Kant's ideas follows in subsequent chapters: Ibid., pp.36–60. See also pp.89–91 where the notion of detachment is reasserted in Podro's discussion of Herbard's ideas.
20 For his mature thinking on psychoanalytic aesthetics see Podro, 'On Imaginary Presence' in Caldwell 2000, pp.63–73, and Podro, 'Destructiveness and Play: Klein, Winnicott, Milner' in Caldwell 2007, pp.24–32.
21 Saumarez Smith 2008.
22 Podro's lecture synopses for eight lectures for the course 'The Training of the Artist', to be given at Camberwell School of Arts and Crafts, were located amongst his personal archive. The papers of Michael Podro, uncatalogued archive.
23 Podro 1972, p.1.
24 Ibid., pp.1–2.
25 Here Podro is also interested in the perceptual procedures of the reader of, say, a poem, but I have omitted that from this discussion for the sake of simplicity.
26 See especially his analysis of Herbart's thinking on analogy and ambiguity in his Allgemeine practische Philosophie (1808). Podro 1972, pp.74–6. As he says on the first page of this excerpt: 'we could say that an aesthetic relation between two discrete features always involves seeing each of the two features in reciprocally inhibiting and fusing ways, and vice versa, that each case of seeing something in reciprocally inhibiting and fusing ways involves making an analogy between the two terms'.
27 My understanding of analogy here is partly an everyday one taken from Judy Pearsall (ed.), The New Oxford Dictionary of English, Oxford 2001, p.58. More important are the Kantian ideas explored by Podro in his chapter on Kant. Podro 1972, pp.7–35.
28 Ibid., pp.2–4.
29 Ibid., p.5.
30 Ibid., p.5.
31 Podro 1966, pp.335–6.
32 I take this notion of 'not knowing' from artist and teacher Rebecca Fortnum. Fortnum curated the symposium 'On Not Knowing: How Artists Think' at Kettles Yard, Cambridge, 29 June 2009; a transcript of Fortnum's introduction along with some of the day's papers can be found at http://www.kettlesyard.co.uk/exhibitions/symposium.html (accessed 9 Sept., 2013). See also Fisher and Fortnum 2013.
33 I borrow this notion of discursive permeability from artist Naomi Salaman who deploys it to explain the relationship between her written and visual work. Salaman 2008; for digital copies of abstract, introduction, first chapter and five chapter maps see http://eprints.gold.ac.uk/2299/
34 Harries 2011, p.619.
35 Clark's important publications include The Absolute Bourgeois: Artists and Politics in France 1848–1851, Berkeley, CA 1999; Image of the People: Gustave Courbet and the 1848 Revolution, Berkeley, CA 1999; The Painting of Modern Life: Paris in the Art of Manet and his Followers, Princeton, NJ 1984; and Farewell to an Idea: Episodes from a History of Modernism, Berkeley, CA 1999.
36 Potts's ideas were further developed over the years: see Potts 1994. The sorts of tensions that Potts explores in Winckelmann's work resonate, in broad terms, with the tensions in the relationship between art history and art practice in the art school.
37 See the Department of Education and Science's 1966 report 'A Plan for Polytechnics and Other Colleges'. For a detailed exegesis of the development of the polytechnic system in England and Wales see Robinson 1968; the 5 April 1967 Parliamentary Statement by the Secretary of State for Education and Science, the Rt Hon. Anthony Crosland

MP is reproduced in Appendix A of Robinson's book. Crosland's statement proposed thirty polytechnics in total; seventeen of those listed subsumed previously autonomous art schools. Ibid., pp.242–5.

38 Alex Potts interviewed by the author for Tate's Art School Educated research project. Potts was interviewed over one session in July 2010. The recording consists of one track [track 01] totalling approximately one hour.

39 Saumarez Smith 2008.

40 For an interesting analysis of The Jewish Traveller see Wolff 2008, pp.77–98. Wolff's essay first appeared in James Aulich and John Lynch (eds.), Critical Kitaj: Essays on the work of R.B. Kitaj, Manchester 2000, pp.29–43.

41 Saumarez Smith 2008.

42 Michael Podro, unpublished transcript of acceptance speech for his appointment as Honorary Doctor of the University of the Arts, London, c.2006. The papers of Michael Podro, uncatalogued archive.

43 See Tickner 2008, pp.48–9.

44 The UK National committee is listed on the third page of the report: Richard Carline (Chairman), Morris Kestelman (Vice-Chairmen), Claude Rogers, OBE (Honorary Treasurer), Valentine Ellis (Honorary Secretary), Ernest Fedarb (Hon. Assistant Secretary), Joan Hurley (Secretary), Griselda Bear, Sir William Coldstream CBE (Honorary Members), Henry Moore OM, Victor Pasmore, CBE and Graham Sutherland, OM (Members), Robin Campbell, DSO (Arts Council of Great Britain Representative).

45 The following countries sent delegates: Austria, Belgium, Brazil, Canada, Czechoslovakia, Cuba, Denmark, Eire, France, Germany, India, Israel, Italy, Japan, Korea, Netherlands, Norway, Poland, Portugal, Romania, South Africa, Sweden, Tunisia, USA, United Kingdom, Yugoslavia. See AIAP 1968.

46 Ibid., p.7.

47 Ibid., p.26.

48 Ibid., p.29.

49 Ibid., p.30.

50 Tickner 2008, pp.48–9.

51 Harries 2011, p.695.

52 Nikolaus Pevsner, 'Summary of all 126 pieces of evidence as far as they relate to History of Art and Complementary Studies and entry requirements and exit requirements', letter to Joint Committee.

NACAE Papers, National Archives, ED206/17, NACAE (SC) (69) 11.

53 Ibid. Pevsner notes Lynton's evidence lodged as Evidence 101 in NACAE Papers, National Archives, ED206/15, Evidence: NACAE (SC) (68) EV 90-118.

54 Nikolaus Pevsner, 'History of Art and Complementary Studies in Colleges of Art', Letter to Joint Sub-committee. NACAE Papers, National Archives, ED206/11, NACA (SC) (68) 9. I would like to thank Marie McLoughlin, University of Brighton, for first bringing this material to my attention. See McLoughlin 2010, Chapter 7, which provides a thorough treatment of the workings of government changes to art education in this period.

55 Anonymous 1970, Section 39, p.11.

56 Ibid., Section 40, p.11.

57 Ibid., pp.48–9.

58 Gombrich quoted in Harries 2011, p.723. From NACAE Papers, National Advisory Council on Art Education: Agenda, Minutes and Papers, National Archives ED206/19, NACAE (SC) (69) 20–31 evidence and NACAE (SC) (69) EV 137–140.

59 E.H. Gombrich, 'Reflections on teaching art history in art schools, paper given 4th January 1966'. Gombrich Archive, http:// gombricharchive.files.wordpress. com/2011/04/showdoc34.pdf, accessed 3 Sept. 2013.

60 Morris Kestelman, 'The Aim and Content of Art Education' in Piper 1973, vol.1, p.51. Although this book, After Hornsea, and its companion volume After Coldstream were published in 1973, the essays were the result of two symposia held at the Institute of Contemporary Arts in April and May 1971.

61 Camberwell College of Arts, Course Prospectus for 1975–6, p.49.

62 Jon Thompson, 'Art Education: from Coldstream to QAA', Critical Quarterly 47, nos.1–2 (2005), p.222.

63 Elkins 2001, p.1.

64 Ibid., p.190.

65 Ibid.

66 Ibid.

67 Ken Neil, 'Authority and Pragmatism in the 21st-Century Art School'. Paper given as part of the conference 'Constructing the Discipline: Art History in the UK' organised by Professor Richard Woodfield and held at the University of Glasgow and Glasgow School of Art, 25–27 Nov. 2010.

68 Leavis, 1948, pp.59–60.

VI. SHIFTING FOUNDATIONS: THE PRE-DIPLOMA COURSE

1 Anonymous [Ministry of Education] 1960.

2 Ibid.

3 This double nature of the Pre-DipAD – either entirely progressive or wholly traditional – arises from the ambiguity of the term 'drawing'. Does it emerge from studies of the figure (in the form of the life class)? Or, does it, as the innovative pedagogues of the 1950s proposed, begin in the Bauhaus Vorkurs?

4 Anonymous 1966.

5 St Martin's School of Art, Student Prospectuses 1953–65, consulted in the Central Saint Martins Museum and Study Collection, Central Saint Martins. All references to material at CSM are made Courtesy of Central Saint Martins Museum and Study Collection.

6 For discussion around the establishment of the new department at St Martin's, see the Principal's report in the minutes from the Governors' Meeting, 14 Feb. 1963: 'That in view of the great importance attached to the preparatory studies, and of the size and scope of the existing Beginners' course at St Martin's School of Art, the Governors do strongly recommend that this course be recognized as a Department of Preparatory Studies'. Mr. D.H. Holden, ARCA, ARWS, was appointed as Senior Lecturer in charge of the Beginners' course in 1958 and was promoted to Head of Department from 1 Sept. 1963. Minutes from St Martin's governors' meetings, Central Saint Martins Museum and Study Collection, Central Saint Martins.

7 Shelley 2008, p.5. This document has been consulted in the Museum and Study Collection at Central Saint Martins. It is unpublished and, at the request of Shelley's family, is not quoted here.

8 Minutes from governors' meetings, St Martin's School of Art, 26 Oct. 1967. Central Saint Martins Museum and Study Collection.

9 Note 11(d) of Principal's Report, Minutes of governors' meetings, St Martin's School of Art, 1 June 1961. Central Saint Martins Museum and Study Collection.

10 Shelley 2008, pp.10–11.

11 The gender implications of this subject are outside the scope of this paper, but warrant further attention. For an insight into the early challenges facing the Pre-Dip courses and how they shared

responsibility for processing arts graduates in gender specific ways, it is worth revisiting Madge and Weinberger 1973. In their study, they identify notable differences in confidence among students on the Pre-Dip courses, with boys predominating among those whose confidence had increased after a series of tutorials. Male students were far more successful than female students in gaining high staff approval, and hence, in gaining admission to diploma courses in fine art and graphic design. Female students were more likely to proceed in courses in textiles and fashion. Those women who did follow the diploma course in fine art were also segregated by sex: the women worked in the painting studio, while the men worked in the sculpture studio.

12 Anonymous 1970.
13 Shelley 2008, p.2.
14 Ibid., p.6.
15 Note 2 from staff meeting of the Pre-Diploma Department on 22 Nov. 1963. Central Saint Martins Museum and Study Collection.
16 Shelley 2008, p.6.
17 Note 2 from Pre-Diploma staff meeting, 6 March 1964. Central Saint Martins Museum and Study Collection.
18 Note 2F, 'A Consideration of the work done this year leading to modifications in the course', from Pre-Diploma staff meeting, 29 May, 1964. Central Saint Martins Museum and Study Collection.
19 Ibid.
20 Ibid., Note f.IV.
21 Minutes of the Board of Studies meeting, Central School of Arts and Crafts, 13 March 1963 (agenda item 13). Central Saint Martins Museum and Study Collection.
22 Minutes of the Board of Studies meeting, Central School of Arts and Crafts, 8 May 1963 (agenda item 3) and 29 May 1963 (agenda item 2). Central Saint Martins Museum and Study Collection.
23 For further information on Thubron, see Forrest 1983.
24 For a more detailed account of Thubron's experiences teaching abroad, see Forrest 1983, pp.210–14.
25 Shelley 2008, p.6.
26 Walker 1981, p.28.
27 Shelley 2008, p.7.

VII. BUILDING: THE NEW CHELSEA

1 David Orr, 2004, pp.112–13.
2 Jeremiah 1995, pp.34–47; Jeremiah 1996, pp.47–61; Brendan D. Moran, Charles Renfro and 'Projects' 1–10, cited in Madoff 2009. Beck and Cornford 2012, pp.58–83. See also Beck and Cornford 2014.
3 For instance art school architecture is not the focus of Boys 2011; it is also not examined in Muthesius 2000.
4 As discussed in Muthesius 2000, p.286.
5 'Building' as a verb and as a noun.
6 The RCA also built important buildings in both the 1960s and 2000s, for which see below. For the Art School Educated project see Chapter I of the present volume.
7 Other examples are the architectural projects of Stephen Gilbert and John Forrester, discussed in Gathercole 2006, pp.887–925.
8 Defining examples of out-of-town campus universities of architectural note, established and built in the early 1960s, include Sussex (Basil Spence), York (Andrew Derbyshire) and the University of East Anglia (Denys Lasdun). Older universities also built significantly in the 1960s: the 1963 Oxford University Library (by Leslie Martin and Colin St John Wilson), the 1964 History Faculty building at Cambridge (James Stirling), and the 1965 University of Glasgow Library (William Whitfield). See Muthesius 2000, and Maxwell 1972, pp.100–127.
9 Muthesius 2000, pp.6, 290–1. I, however, choose to refer to 'utopian' in the opening section here, thus retaining the implication of 'dystopian', the necessity of which will become apparent forthwith.
10 Muthesius 2000, p.2.
11 The phrase 'form follows function' was originally coined by Louis Sullivan in his 1896 essay 'The Tall Office Building Artistically Considered', and subsequently adopted by the modernist design movement in general.
12 Illustration 13: 'The antique as ornament', in Jeremiah 1996, p.55.
13 David Jeremiah argues that unchanging art pedagogy often remained in modernist buildings. Jeremiah 1996, p.50.
14 Known by the author from personal experience; see also an Art School Educated interview with Alan Graham, Space Manager, Chelsea College of Arts, 26 Oct. 2010.

15 Jeremiah 1996, p.50.
16 Anonymous [Ministry of Education] 1960.
17 Phrase borrowed from Brand 1997.
18 Funding further to the Government support was provided by the Gulbenkian Foundation.
19 Webb 1969, p.27.
20 Jeremiah 1996, p.50.
21 As Lead Architect to the LCC, Bennett was not directly involved in the Chelsea or LCF designs, but was seemingly sympathetic to such projects, and maybe to Chelsea particularly. He had from 1935–40 taught at the Regent Street Polytechnic, one of the institutions that amalgamated to become Chelsea School of Art in 1964. Bennett oversaw building at the Central School of Arts and Crafts: see Anonymous 1957, pp.196–8. Despite the presumed enthusiasm for educational building projects, the Schools Division architect Austin Winkley remembers on two occasions preparing the office, and work on Chelsea, for inspection by Bennett only to be disappointed (telephone conversation with the author, 28 March 2011).
22 Anonymous 1963, pp.1303–6.
23 The incongruity of heritage concerns with modernism's original aims is discussed in Hatherley 2008, pp.3–6. Chelsea alumni made at least one attempt to purchase the Manresa Road building and open it again as an art school.
24 Houghton 1965.
25 The art school was built as part of a complex of new buildings including a student hall of residence and the Chelsea Fire Station, with its distinctive drill tower, which still stands.
26 Quoted from the Sixty-Second Annual Report of Chelsea Polytechnic, Session 1956–7, p.15, held in the Foyle Special Collections Library, King's College London, Chancery Lane.
27 I have been told by Lady Jenny Gowing (Gowing's widow) that Antony Armstrong Jones, Lord Snowdon, photographed Gowing precariously balanced astride the partially built rooftree, for Robertson, Russell and Snowdon 1965. This photograph does not appear; instead there is one of Gowing and Kate Stephenson at his desk.
28 Gowing was considered to be an authority on the running of art schools; the Tate Archives holds a letter dated 28 Apr. 1966 to Gowing from John Bell, an editor at Oxford University Press, asking him to write a book on the subject.

29 Hornsey College of Art was absorbed by Middlesex Polytechnic in the late seventies, losing what had been a distinct identity, at the time of the famous student occupation in May 1968. See Tickner 2008.

30 Confirmed by Lady Gowing, telephone conversation with the author, March 2011, and by Kate Stephenson, his assistant throughout this period, interviewed by the author 16 March 2011.

31 See correspondence, minutes of meetings and other documents held in archival collections at Chelsea College of Arts, the National Archives and the London Metropolitan Archives.

32 Rhetoric and discourse in relation to modernist university architecture is discussed in Muthesius 2000, pp.281–91.

33 For Basic Design see Chapter II.

34 The arrival of modernist art education in London had been anticipated since Charles Ginner and Edward Wadsworth attempted to establish the New Art School in 1920, an unrealised project, for which see an advertisement in the journal *Art Work* of 1919. Aspirant modernist artists went instead to Europe for their education.

35 LCC Memorandum, from the Education Officer to the Architect(s), dated 27 June 1957, in the London Metropolitan Archives. Gradually the 'New' was dropped and the building was simply known as Chelsea School of Art. Once other campus sites were opened, the building was referred to in-house as 'Manresa Road'. The word 'new' as an adjunct to 1960s educational building projects, in favour of the 'experimental', 'radical', 'progressive' or 'Modern', is discussed by Stefan 2000, pp.2–3.

36 Matthew Arnold (1822–88) famously described Oxford's university architecture thus.

37 This is not stated clearly in official records, but was explained to the author by Austin Winkley. The initials R.R.S., A.S.W. and R.C.M.N., and the signature 'M. Booth', can be seen on architectural plans and elevations held in the London Metropolitan Archives. A document entitled *Credits for Chelsea School of Art* is also kept, which names Hubert Bennett, F.G. West, Michael Powell, Peter Jones and D.R. Stark, before Robson-Smith and Booth as Job Architects; Winkley, who did a large amount of the drawings during his time with the LCC Architects Department, Schools Division, 1959–60, is not credited at

all in this document. The same line-up appears in the account published in *The Architect & Building News*: see Anonymous 1965, pp.157–68.

38 Most of the plans and elevations at the National Archives and London Metropolitan Archives are dated 1959. See Gowing in the *Sixty-Sixth Annual Report of the Chelsea College of Science and Technology*, 1960–1: '…The drawings of the building, which has been the subject of so much consultation, were completed'. All quotations from, or references to, material held at Chelsea are made courtesy of Chelsea College of Arts Library, University of the Arts London. Winkley remembers a staff meeting at St Martin's School of Art. The official Advisory Committee for the New School, recorded in documents held in the National Archives, included six representatives of the LCC; six further members appointed by the LCC in consultation with Chelsea College of Science and Technology; four members nominated by the governing body of Chelsea College; and four by that of Regent Street Polytechnic. Amongst these were Sir Hugh Casson, Sir William Coldstream, James Fitton, Ashley Havinden, Henry Moore and John Piper.

39 Discussed in Muthesius 2000, p.287.

40 Chelsea applied for DipAD status at the first opportunity in 1961, and was directly awarded it for fine art (painting) and graphic design in 1963, with sculpture as a discrete discipline added in 1964. Accreditation was not granted for textiles and fashion (although it continued to run with a County Certificate Award attached), 'for reasons of the regional distribution of courses'. Letter from W.F. Houghton, 4 April 1962. See Chelsea School of Art files held at the National Archives, Kew.

41 Further connections can be made between Gowing and Coldstream, the former having been educated under the latter at the Euston Road School in the late 1930s. Additionally, Gowing followed Coldstream as Principal of the Slade School of Fine Art in 1975.

42 See Anonymous 1965, caption to photographs, p.165. The building is described thus on p.10 under the heading 'School of Art' in the New Buildings section of *Interbuild*, vol.12, no.3, March 1965, pp.10–22. Chelsea School of Art's own newsletter of Sept. 1962 described

it as 'the fine new building', Chelsea School of Art, Manresa Road, Chelsea, S.W.3.

43 What appeared as wings from the front are actually joined together around the back, enclosing a central courtyard.

44 *Interbuild*, vol.12, no.3, March 1965, p.16.

45 Anonymous 1965, p.164.

46 Henry Moore sold *Two Piece Reclining Figure No.1* to Chelsea School of Art for £7,500 in 1963, and it was installed at the new site on 25 March 1964. See De Samarkandi and Smith's 2010 book *Don't Do Any More Henry Moore: Henry Moore and the Chelsea School of Art* and the exhibition of the same name at CHELSEA space, 12 May – 12 June 2010. Figurative curvilinear sculpture to offset and complement modernist architecture is something Moore felt strongly about (see letters to and from Paule Vézelay held uncatalogued in the Tate Archives). The sculpture was originally intended to slowly rotate on its plinth, but it seems this plan did not come to fruition. Once the courtyard was covered up, the sculpture was moved to the front of the building. It now resides on the current Chelsea site in its own courtyard on Atterbury Street, facing Tate Britain. In an email of 29 March 2011, Donald Smith, Director of Exhibitions, CHELSEA space, addresses the suggestion that the Henry Moore Foundation refused permission to Chelsea to name this courtyard after Henry Moore because they had already granted the name 'Henry Moore Court' to the developers of the Manresa Road site.

47 See material held at the National Archives, Kew and plans and elevations at the London Metropolitan Archives and at Chelsea College of Arts Library.

48 From the prospectuses held in the Chelsea College of Arts Library, it seems that the studio system was in place from at least 1970 until the 1990s. See also Bury 2008, pp.265–73.

49 The Chelsea studio system was in many ways the defining feature of the institution for forty years and much remains to be researched and written about it, but there are no manifestos or written records of individual studio practices. As it was so habitually related to the layout of the building it is not surprising then that the system did not survive the move from the Manresa Road building to the new site on Millbank in Pimlico.

50 *Interbuild*, vol.12, no.3, March 1965, pp.10, 16. In an email to the author dated 8 April 2011, Brian Dunce, who taught at Chelsea from 1968–80, recounts that the stairwell was considered a hazard by the fire officer.

51 Muthesius 2000, p.6.

52 Austin Winkley described this to the author in a telephone conversation of 28 March 2011.

53 In the original plans (held in the National Archives), all four studios on the fourth floor were labelled as life drawing or life painting studios. The life room overseen by Myles Murphy until 1974 was, however, on the third floor, as was the constructivist studio run by Anthony Hill, John Ernest and Gillian Wise.

54 Houghton 1965.

55 This feature has gained an almost mythological status. Winkley described to me the doorways he designed as doors-and-a-half, extra flaps which increased the diagonal measurement of the opening. The painting tutor Brian Young apparently proposed slots cut into the wall and these have also been described to me. Were they a late addition to solve the problem of students suddenly working on a larger scale than had been anticipated, due to the influence of American abstract expressionism, or are they a traditional studio device? Certainly the size of students' paintings increased significantly at this time, a fact bemoaned by Coldstream in consultation with Winkley and Robson-Smith on the Chelsea designs.

56 Correspondence between Gowing and the LCC (Chelsea College of Arts Library).

57 Ibid. The chairs are still at Chelsea awaiting restoration.

58 In conversation with the author on 16 March 2011, Gowing's then assistant Kate Stephenson remembered looking through such catalogues with him.

59 Photographs of the interiors of the building appear in the aforementioned 1965 *Architect & Building News* article, the *Interbuild* article of the same year, and in Houghton 1965.

60 The original requirement for the building was that it should accommodate 220 full-time students, seventeen full-time teaching staff, seventy visiting teachers, twenty non-teaching staff and sixty-eight evening students. *The Architect & Building News*, no.30, vol.227, 28 July 1965, p.164.

61 The discussion is documented in minutes dated 17 May 1966 (London Metropolitan Archives).

62 Chelsea had four sites: Manresa Road (eventually used only for fine art), Bagley's Lane (Foundation studies and postgraduate painting), Lime Grove (mural painting, glass, mosaic and ceramics, textile, interior and product design) and Hugon Road (graphic design). Bagley's and Hugon were ex-school buildings; Lime Grove was purpose-built in the late nineteenth century as Hammersmith School of Building and Arts and Crafts, and is the only ex-Chelsea site which remains in use by the University of the Arts London (LCF).

63 Even Gowing was wholly dissatisfied with the door handle mechanisms, and was not above billing the LCC for repairs to his three damaged suits (which had caught on the protrusions), as evidenced by a copy of a letter from the Secretary, Chelsea School of Art, dated 22 March 1965. That the parquet flooring was already damaged by rain leaking in to the building by the summer of 1965 is recorded in a letter to the Inner London Education Authority, dated 20 July 1965 (London Metropolitan Archives).

64 Ellie Yannas, Chelsea student 1972–5, states that she 'fell in love with the building' upon arrival from Greece (interview with the author, 5 November 2010). A certain romantic mythologising is at play here – a powerful force in the creation of an artist persona and 'origin story', for which the physical building, and memories of it, are catalysts.

65 Brian Dunce, email to the author, 8 April 2011.

66 Art school building in London did of course take place in the intervening decades, but the 1960s and 2000s are significant for a concentration of new art school builds.

67 Hatherley 2010, p.XIII.

68 In 1965 the LCC Education Officer could boast that Chelsea had forty-eight students enrolled for the fine art diploma – 'the largest number of any school of its kind in the country' – and that the number of full-time students enrolled at this time was 223 (see Houghton 1965). When Chelsea applied for DipAD accreditation in 1961 the student numbers were under 300 in total, including part-timers. There are now over 1,400 degree students at Chelsea and close to 20,000 at the parent institution University of the

Arts London. The Chelsea College of Arts website states that by 2000 over 30% of Chelsea students were from outside of the UK. See http://www.arts.ac.uk/45726.htm, accessed 13 April 2011. The current cohort of students on the MRES Arts Practice course at UAL is entirely international. In the 1990s Chelsea took student work to biennales in Barcelona and Maastricht with the express intention of establishing the college's reputation internationally.

69 This is not a phenomenon unique to London (see the Liverpool John Moore's University Art & Design Academy, or the University of Plymouth, Roland Levinsky Building).

70 The term 'Urban Renaissance' has been in use since the 1999 government White Paper *Towards an Urban Renaissance* by the Urban Task Force led by Richard Rogers, who, with Norman Foster, has done much to shape the twenty-first-century cityscape.

71 Hatherley 2010, p.XXVIII.

72 Charles Renfro, 'Undesigning the Art School', in Madoff 2009, p.161.

73 Manresa Road has what property developer Nick Candy called a 'golden postcode'. Quoted by Spackman 2004. Although Chelsea has been an expensive area for some time, students in the 1970s found it possible to squat in the borough.

74 The architecture of the original building is perhaps best described as Neo-Renaissance pastiche in a late-French style.

75 The Rootstein Hopkins Parade Ground was designed by landscape architects Planet Earth.

76 A marquee sometimes occupies the Parade Ground, for example for a Burberry fashion show in September 2010.

77 Lady Gowing confirmed, in a telephone conversation in March 2011, that sculpture staff had similarly been involved in the Manresa Road workshop designs.

78 A particularly good example of this is outside the library.

79 Under the leadership of William Calloway, fine art and design were split into two separate schools and the name Chelsea College of Art and Design was adopted in 1989; this structure was devolved in the transition to the Millbank site under Roger Wilson. Currently Chelsea offers courses in a full range of subject areas with other options at postgraduate level.

80 *Chelsea School of Art, Manresa Road, Chelsea, S.W.3*, leaflet newsletter, Sept. 1962 (copy in the

Chelsea College of Arts Library). Austin Winkley, the architect, even invented a new machine for steaming fabric for the Printmaking Department.

81 Chelsea still has excellent workshop facilities for wood and metalwork.

82 In addition to the various painting studios to choose between, complementary studies was also structured as the 'Options Programme' under Gowing at Chelsea.

83 I invoke Brendan D. Moran's use of the term 'platform' in his essay 'Aesthetic Platforms', in Madoff 2009, pp.33–7.

84 For example, Paul Appleton of Allies and Morrison referred to the Dessau Bauhaus in discussion with the author on the development of the brief for the Millbank site of Chelsea College of Arts, 9 Dec. 2010.

85 It is suggested that the '... flexibility of Gropius's geometric plan may have mirrored the modularity of the Bauhaus pedagogy ...'. See 'Project 2: Bauhaus Building' in Madoff 2009, pp.68–9, with the caveat described above.

86 See the website of Cuba's Ministerio de Cultura, http://www.min.cult.cu/loader.php?sec=instituciones&-cont=cneart, accessed 28 March 2011.

87 Loomis 1999, p.57.

88 It should be noted that both the Escuelas Nacionales de Arte and Black Mountain were geographically located in the hinterland, not in the urban centre like the majority of the art schools discussed here.

89 Porro, quoted in Loomis 1999, p.60.

90 See Stoller and Nobel 1999, and 'Project 5: Yale Art + Architecture Building' in Madoff 2009, pp.114–15.

91 The building was intended to be stimulating for its occupants rather than antagonistic to visitors; Rudolph expected the art and architecture students to learn their way around his building and then enjoy their secret knowledge. See Stoller and Nobel, p.5.

92 The international examples are termed here 'fantasy art schools' because the author has not herself visited them.

93 Moran in Madoff 2009, p.34.

94 The Quality Assurance Agency (QAA) was established in 1997 to ensure parity in standards for the UK university sector. See Thompson 2004.

95 Paul Appleton, one of the architects of the Millbank Chelsea site, visits the Chelsea degree show every year and takes photographs of student works that in some way respond to the building, a type of critique and feedback an architect is not often afforded, and which he finds fascinating.

96 Jeremiah 1996, p.59. A recent example is the University of Plymouth's Roland Levinsky Building (completed 2007), where fine art students were apparently prohibited from using oil paint or solvents because the vast glass walls of the studios do not have opening windows. There are many similar untested anecdotes along these lines.

97 This in itself signifies a pedagogical change from the taught class, where the teacher addressed the students communally, to individual practice, where the teacher visits each student in turn. Paul Appleton, in conversation with the author 9 Dec. 2010, used Antonello da Messina's 1475 painting St Jerome in His Study to exemplify the art students' creation of their own space irrespective of the building.

98 Gleaned from conversations with current Chelsea students, and interviews recorded on video for the Art School Educated research project archive, on the occasion of the private view for the exhibition Shelagh Cluett Sculpture 1977–1980, CHELSEA space, 9 Nov. 2010.

99 Established by Gowing to focus on 'art of the last 100 years', and overseen subsequently by Michael Doran, Clive Philpott and Stephen Bury.

100 Renfro advocates the foregrounding of "spaces of presentation and discussion over spaces of creation and production"; see Madoff 2009, p.162. This is not, however, a new idea; LCC architects included copious exhibition and social space in their original designs for the Manresa Road building.

101 This is a reversal of Chelsea's policy, established on moving into the Manresa Road building, not to allow amateurs and evening class students to use the studios, giving DipAD students a privileged status and 'ownership' of the building. See the letters between the various parties dated July to Nov.1964 (National Archives, Kew).

102 Renfro in Madoff 2009, p.165.

103 Since the 1960s and well before, art education has frequently been described as being 'in crisis': see, for instance, Heron 1971. See too a paper by Sutapa Biswas, who was on the staff of Chelsea College of Arts at the time: 'Through the Looking-Glass: Questions of Governance, the Art School in Crisis', presented at the Association of Art Historians' 37th Annual Conference, March – April 2011.

104 A version of this text, based on the Art School Educated Tate research project and entitled Art School Building: the Old/New Chelsea was published in International Journal of Art & Design Education, vol.33, no.2, pp.258–271, June 2014.

VIII. COLOUR PEDAGOGY IN THE POST-COLDSTREAM ART SCHOOL

1 Batchelor 2007, p.15.

2 David Batchelor interviewed by Beth Williamson on 13 Nov. 2012 for Tate's Art School Educated research project. Interview includes brief conversation with Batchelor's assistant, Tim Holmes. The recording comprises two tracks totalling approximately one hour and two minutes. Batchelor is quoted here from track 01 at 36:32 and 37:09–37:11.

3 Colour theories were well established before the Ostwald and Chevreul systems. However, the theories of these two thinkers should be marked out as influential from the dates of their emergence and enduring well into the twentieth century: Chevreul 1839; Ostwald 1904. Artist Jon Thompson (b.1936) explains clearly how Chevreul theory assumes a tonal scale while Ostwald theory assumes each tone is equal with its own wavelength. Courtney 2012, track 23. This and subsequent reference to the interview are made courtesy of Jon Thompson.

4 Melville in Gilbert-Rolfe, 1996, pp.129–46.

5 Ibid., p.132. Here Melville takes issue with the thinking of the art historian Norman Bryson, particularly in his Looking at the Overlooked: Four Essays on Still Life Painting, Cambridge, MA 1990.

6 Ibid, p.229.

7 Ruskin 2010 (1857), p.137.

8 Ibid., pp.160–1.

9 For a case study on how this affects contemporary art practice, see Mottram 2006, pp.405–16.

10 For the standard work on the groundbreaking pedagogical concepts of the Bauhaus see Wick 2000.

11 Thierry de Duve, 'The Readymade and the Tube of Paint', Artforum, May 1996, pp.110–21, repr. in de Duve 1996, pp.190–1.

12 Albers 2006, p.52.
13 Ibid, p.1.
14 Itten 1970, p.7.
15 Norbert Lynton, 'Letter 6: Norbert Lynton to David Lewis', May/June 1999, repr. in Lewis 2000, p.71.
16 Ibid.
17 Field 1950, p.38.
18 Ibid., p.40.
19 David Lewis, 'Letter 5: David Lewis to Norbert Lynton', n.d., repr. in Lewis 2000, pp.61–3.
20 Frost 1959, p.47.
21 Morley quoted in McNay 2013.
22 Yeomans 1987, pp.245–6. This and subsequent references to Yeomans's thesis are courtesy and © Richard Yeomans.
23 Richard Hamilton interviewed by Richard Yeomans at Northend Farm, 15 Jan. 1982, in Yeomans 1987, p.246. This and subsequent references to Hamilton material are made courtesy of Rita Donagh.
24 Hamilton, interview with Peter Sinclare, 1974, later transcribed by Richard Yeomans. West Bretton: National Arts Education Archive at Yorkshire Sculpture Park, BHRY/TP/00007, 1974. Hamilton's sentiments here are neatly summarised in Yeomans 1988, p.166.
25 This extends further in Hudson's lecture-performance 'The Matisse Lecture' sponsored by the Welsh Arts Council. Tom Hudson, *The Matisse Lecture. An Academic Performance*, TH/PL/76, National Arts Education Archive. This and subsequent references to Hudson material are courtesy and © Tom Hudson Estate.
26 'The Interaction of Color by Josef Albers' iPad app, Yale University, July 2013, http://yupnet.org/interactionofcolor/.
27 Zar-adusht Ha'nish 2013 (1902), p.3.
28 Ibid., p.12.
29 Itten 1964, p.11.
30 The sensory fingerprint is a concept used in sensory testing, particularly in the fields of product evaluation and marketing. I am grateful to philosopher Professor Barry Smith for bringing this concept to my attention. Smith is co-director of the University of London's Centre for the Study of the Senses and specialises in flavour and smell.
31 de Sausmarez 2008, p.9.
32 de Sausmarez interviewed by Beth Williamson on 17 Nov. 2011 for Tate's Art School Educated research project. The recording comprises four tracks totalling approximately one hour and 2 minutes. This quotation from track 04.

33 de Sausmarez, 2001, p.11.
34 Ibid., p.106.
35 Courtney 2012, track 23.
36 Ibid. Thompson's vivid recollections of this exercise go some way to explaining why he devotes an entire essay to the colour blue in Thompson 2011.
37 Ibid., 00:06:25.
38 Ibid., 00:06:27.
39 Ibid., 00:06:47.
40 Ibid., 00:11:36.
41 Ibid., 00:13:60.
42 Ibid., 00:15:43.
43 Ibid., 00:14:58.
44 Lacan 1997. See especially pp.258–70.
45 Itten and Birren 1970, p.7.
46 For more on Ehrenzweig's contribution to art education and art theory see Williamson 2015.
47 In the same year that *Interaction of Color* was first published in English, Ehrenzweig was reading the ideas of psychologist Hans Wallach on colour perception. Wallach had studied under Wolfgang Köhler, who went on to found the Gestalt school of psychology. See Wallach 1963, pp.107–16. I discovered a reprint of this article amongst Ehrenzweig's personal papers, now lodged in the Tate Archive, Anton Ehrenzweig collection (TGA 201010). This scientific paper supports Albers's observations.
48 Ehrenzweig 1966, p.2.
49 Ehrenzweig's diagram of colour serialisation on the front cover of the original edition of *The Hidden Order of Art* was of a similar design to those design exercises. Colour interaction is much stronger on the upper section, with squares inside squares, than in the lower section, with circles inside circles.
50 Ehrenzweig 1966, p.9.
51 Ibid., p.6.
52 Ibid., p.7.
53 Albers's use of the notion of film colour goes back to its origins in the ideas of David Katz. See Katz 1935, especially pp.1–28 for an introduction to Katz's thinking on film and surface colour, and how colours appear as space.
54 Albers 2006, p.45.
55 Ehrenzweig 2000, p.152.
56 List of lectures, Papers of Sydney Harry, uncatalogued personal archive. Harry's record-keeping reveals that his lectures go back to 9 Jan. 1944, although it would be almost twenty years later before he would begin lecturing on colour. This and subsequent references to Sydney Harry material are made courtesy and © Sydney Harry Estate.

57 Ibid. For example, Harry lists lectures for fine art students at Leicester College of Art on 22 Nov. 1968, Byam Shaw School of Drawing and Painting on 14 Feb. 1969, and Leeds College of Art on 24 Apr. 1969. Meanwhile, he lectured Foundation-year Textiles students on 15 Oct. 1968, Art Teachers Certificate (ATC) students at Goldsmiths on 16 Jan. 1969, and interior design students at Leicester Polytechnic on 16 Oct. 1969. Papers of Sydney Harry, uncatalogued personal archive.
58 Sydney Harry, 'Curriculum vitae', compiled 2 Aug. 2006. Supplied courtesy of the Estate of Sydney Harry.
59 'Colour: Lecture/demonstrations by Sydney Harry', The Bradford College of Art and Design, n.d. Papers of Sydney Harry, uncatalogued personal archive.
60 Ibid.
61 Ibid.
62 Harry attended Leeds College of Art in 1924 aged twelve and undertook training in fine art, woven textiles and photography. From c.1933–7 he was employed as a Junior Lecturer, then Lecturer in textile design, also at Leeds College of Art. From 1937–75 he fulfilled roles as Lecturer, then Senior Lecturer in woven textiles and Senior Lecturer in colour and perception studies, both at Bradford College of Art. During this period he also taught weaving classes in the Junior Art Department, Bradford technical college. Papers of Sydney Harry, uncatalogued personal archive.
63 Harry n.d. Papers of Sydney Harry, uncatalogued personal archive.
64 Harry, 'Colour for weavers, spinners and dyers', n.d. Papers of Sydney Harry, uncatalogued personal archive.
65 Diary entry for 14 Feb. 1969. Papers of Sydney Harry, uncatalogued personal archive.
66 Barrett 1970, p.177. Barrett regarded Ogden N. Rood's *Modern Chromatics* (1879) to be a considerable advance on Chevreul's theory. Barrett had visited Harry the previous August to see and discuss his work. Harry, diary entry for 13 Aug. 1969: 'Cyril Barrett came to Bradford to see my work and talk. He will include me in his Studio Vista book on *Op Art*, with an illustration of my "Perm 4".' Papers of Sydney Harry, uncatalogued personal archive.
67 Freud 2001, p.149.
68 Thierry de Duve, 'When Form Has Become Attitude – And Beyond' in

Foster and deVille 1994, p.196.

69 This concluding question developed out of exchanges between the author and Professor Judith Mottram in 2013.

IX. FROM 'CRIT' TO 'LECTURE-PERFORMANCE'

1 The expression 'lecture-perfor-mance' has recently become commonly used to describe a wide range of performance-based work realised as lectures and speech acts, among other formats. It has been used retrospectively as well as to refer to recent developments. See *Lecture Performance*, ed. by Kathrin Jentjens and others (Belgrade: Museum of Contemporary Art of Belgrade and Kölnischer Kunstverein, 2009).
2 Chaplin 1988.
3 For a full account of this history see Westley 2007.
4 Frank Martin interviewed by Melanie Roberts (1997), *National Life Stories: Artists' Lives*, British Library catalogue reference C466/58.
5 See Council for National Academic Awards, 'Report on a visit to St Martin's School of Art', 19 Nov. 1975, Tate Archive, Frank Martin collection (TGA 201014). All references to the Frank Martin archive are made courtesy of Frank Martin Estate.
6 'DipAD Sculpture – 2nd year, 1967/68', Tate Archive, Frank Martin collection (TGA 201014).
7 'Project 68: London Sculpture Centre', 1968, n.p. Tate Archive, Frank Martin collection (TGA 201014).
8 Caro, interviewed 21 Jan. 1994 for Batiste and Wegner 1996, n.p.
9 This practice was made popular by Anthony Caro, who began to construct abstract sculptures by welding together elements of scrap metal, working without preliminary drawings. See *Sculpture and Construction*, exh. cat. Oxford: Ashmolean Museum, 1979, p.2.
10 This is the expression used in Peter Kardia, 'From Floor to Sky', 2010. See http://fromfloortosky.org.uk/artists.html (accessed 20 Jan. 2011).
11 R. Leenders, 'Dip.A.D. Sculpture – 2nd year – 1967/68', October 1967, Tate Archive, Frank Martin collection (TGA 201014).
12 Ibid.
13 Introduction to *St Martin's South Bank Sculpture*.
14 'Project 68: London Sculpture Centre', 1968, n.p. Tate Archive, Frank Martin collection (TGA 201014).

15 'CNAA Quinquennial Review, Fine Art', 1975, p.30. Tate Archive, Frank Martin collection (TGA 201014).
16 Thierry de Duve, 'When Form Has Become Attitude – And Beyond' in Foster and deVille 1994, pp.23–40.
17 Harrison 1972, p.222.
18 On this subject see Spicer 2009.
19 It is Lucy Soutter who summarises in these terms what she identifies as one of the main arguments developed by Singerman in *Art Subjects: Making Artists in the American University* (1999). See Soutter 2006, p.177.
20 Cooke, 'New Abstract Sculpture and its Sources' in Nairne and Serota 1981, p.175.
21 Ibid., p.180.
22 See Tucker 1969, p.13.
23 'Dip.A.D. Fine Art 1, Project no. 1, 13.4.66 – 4.5.66', 1966. Tate Archive, Frank Martin collection (TGA 201014).
24 Alloway 1961, p.1.
25 Lynton 1964, p. 199.
26 On this subject see Walker 2001, pp.44–61.
27 Andrew Brighton interviewed by Alexander Massouras, 22 Sept. 2010.
28 Lyotard 1984, p.43.
29 Dimitrijevic 1981, p.7.
30 Gooding 1982, p.16.
31 Lyotard 1984, p.43.
32 For more information on the theoretical studies introduced in the department by the artist-tutor Peter Kardia, see Westley 2010, pp. 28–56.
33 'Tuesday Evening Projects 1966'. Tate Archive, Frank Martin collection (TGA 201014).
34 Ibid.
35 'B. Tucker, DipAD. Sculpture – 2nd Year – 1967/68'. Tate Archive, Frank Martin collection (TGA 201014).
36 'DipAD. Sculpture – 2nd year – 1967/68. Projects covering occupation of a new space, Sept 67: Body Space: G. Evans'. Tate Archive, Frank Martin collection (TGA 201014).
37 See Itten 1964, pp.11–12, and Koss 2003.
38 Garoian 1999b, p.39.
39 Garoian 1999a, p.57.
40 This account derives from Gooding 1982, pp.47–8, and an interview with Bruce McLean by the author. The lecture was not documented and the slides presented have been lost.
41 Gooding 1982, p.47.
42 Stuart Morgan, 'A Rhetoric of Silence' in Nairne and Serota 1981, p.203.
43 Wagner 2009, p.27.

44 Jahn 1989, p.77; see also Moynihan 1970, p.196.
45 Letter dated 21 May 1969 from Gilbert & George to Frank Martin. Tate Archive, Frank Martin collection (TGA 201014).
46 See Goldberg 2001; Ferguson and Schimmel 1998.

X. CONCLUSION

1 Consider the situation at King's College, Newcastle, now Newcastle University, where figures of national significance worked: Lawrence Gowing (1918–91), who was Professor of Painting 1948–58, Victor Pasmore (1908–98), who was Head of Painting (1954–61) in tandem with Richard Hamilton, who was in that role 1954–66.
2 http://www.theguardian.com/education/2013/oct/21/alternative-art-schools-threaten-universities consulted 14.04.2015
3 But see Strickland's essay in the Potter anthology.
4 A point made by Kelly Chorpening in her contribution to the ASE final conference in Sept. 2014. The verbal and the visual has been conflicted territory for art history since well before Panofsky's theorising of iconology in the 1930s.
5 REF Feb. 2011 p.4.
6 'Panel criteria and working methods' in REF Jan. 2012, p.6.
7 REF Feb. 2011, p.25.
8 This is not just an issue in fine art teaching. See this phrase from the website of a powerful university research group at a distinguished drama and performance department: 'As well as making text-based research, we make practice-based research, including workshops, performances …' http://www.sed.qmul.ac.uk/drama/research/pbr/index.html consulted on 11 APR 2015.
9 Much older in the historiography of painting in China, the notion of a school of painting seems to come into western historiography in the later eighteenth century, perhaps through the authorship of Luigi Lanzi (*Storia Pittorica delle Italia* …, Florence 1792: 'Libro primo. Scuola Fiorentina; Libro seconda. Scuola Senese', etc).
10 See Crippa 2013.
11 See Anita Taylor in her contribution to the final ASE conference, Tate Britain, Sept. 2014.
12 Clark 1949. Introduction, p.15.

BIBLIOGRAPHY

Catherine Abell and Katerina Bantinaki (eds.), *Philosophical Perspectives on Depiction*, Oxford: Oxford University Press 2010.

AIAP, The United Kingdom National Committee International Association of Art, *Official Report of the First Conference on the Professional Training of the Artists*, London 1968.

Josef Albers, *Interaction of Color*, revised and expanded edn, New Haven, CT and London: Yale University Press 2006.

Lawrence Alloway, 'Letter to William Johnstone', 3 Apr. 1959, William Johnstone Archive, National Libraries of Scotland, Inventory Ref: ACC 8183/2.

Lawrence Alloway, 'Interview with Anthony Caro', *Gazette*, no.1, 1961.

Anonymous, 'The Changing Aspect of Art: Sir William Llewellyn's Advice to Young Painters', *The Times*, 1 March 1934, p.9.

Anonymous, 'Four Educational Buildings for London County Council', *The Builder*, 2 August 1957.

Anonymous, 'Future of the Art Schools', *The Times*, 18 Jan. 1958, p.7.

Anonymous [Ministry of Education], *First Report of the National Advisory Council on Art Education*, London 1960.

Anonymous, 'The London College of Fashion', *The Builder*, 27 December 1963.

Anonymous, 'Chelsea College Redevelopment', *The Architect & Building News*, vol.227, no.30, 28 July 1965. pp.157–68.

Anonymous, *First Report of the National Advisory Council on Art Education Addendum*, London 1966.

Anonymous, *The Structure of Art and Design Education in the Further Education Sector: Report of the Joint Committee of the National Advisory Council on Art Education and the National Council for Diplomas in Art and Design*, London: HMSO 1970.

Anonymous, *Towards an Urban Renaissance*, Government white paper arising from the work of the Urban Task Force, chaired by Lord Rogers, London: HMSO 1999.

Arts Council GB Archive, *Young Contemporaries 1949–69*, ACGB 121/1176.

Terry Atkinson, 'The Turner Prize: Ordering the Avant-Garde', in *Ongoing Work from the 1990s to the Present*, exh. cat., Coventry: Lanchester Gallery Projects, 2009.

Sylvia Backemeyer (ed.), *Making Their Mark: Art and Design at the Central School 1896–1966*, London: Herbert Press 2000.

Cyril Barrett, *Op Art*, London: Studio Vista 1970.

David Batchelor, *Colour*, London and Cambridge, MA: The MIT Press 2007.

Sarah Batiste and Nicholas Wegner, *Interviews with the Artists*, London: Visual Art Research 1996.

John Beck and Matthew Cornford, 'The Art School in Ruins', *Journal of Visual Culture*, no.11, Apr. 2012, pp.58–83.

John Beck and Matthew Cornford, *The Art School and the Culture Shed*, Kingston upon Thames: The Centre for Useless Splendour 2014.

Michael Beloff, *The Plateglass Universities*, London: Secker & Warburg 1968.

G.P. Bellori, 'L'Idea del Pittore...' in *Le Vite de' Pittori Scultoriu ed Architetti Moderni*, Rome 1672.

M. Bentley (ed.), *Companion to Historiography*, London: Routledge 1997.

Claire Bishop, 'Antagonism and Relational Aesthetics', *October*, no.110, Fall 2004, pp.51–79.

Joseph Boswell, *The Artist's Dilemma*, London: The Bodley Head 1947.

Nicolas Bourriaud, *Relational Aesthetics*, Dijon: Les presses du réel 2002.

Nicolas Bourriaud, Caroline Schneider and Jeanine Herman, *Postproduction: Culture as Screenplay: How Art Reprograms the World*, New York: Lukes & Sternberg 2002.

Jos Boys, *Towards Creative Learning Spaces: Re-Thinking the Architecture of Post-Compulsory Education*, London and New York: Routledge 2011.

Stewart Brand, *How Buildings Learn, What Happens After They're Built*, revised edn, London: Phoenix 1997.

Andrew Brighton, '"Where are the Boys of the Old Brigade?": The post-war decline of British traditionalist painting', *Oxford Art Journal*, no.4, 1 July 1981, pp.35–45.

Andrew Brighton and Lynda Morris (eds.), *Towards Another Picture*, Nottingham: Midland Group 1977.

Stephen Bury, 'From Machine to Metaphor: Artists and Computers at Chelsea School of Art 1960–1980', in Paul Brown et al (eds.), *White Heat Cold Logic: British Computer Art 1960–1980*, London: The MIT Press 2008.

Reg Butler, *Creative Development: Five Lectures to Art Students, given at the Slade School in June 1961*, London: Routledge & Kegan Paul 1962.

Lesley Caldwell (ed.), *Art, Creativity, Living*, London: Kamac Books 2000.

Lesley Caldwell (ed.), *Winicott and the Psychoanalytic Tradition: Interpretation and Other Psychoanalytic Issues*, London: Kamac Books 2007.

Fiona Campbell, *Books from the Library of William Johnstone*, catalogue 29, London 1990.

Linda Candy, *Practice Based Research: A Guide*, http://www.creativityand-cognition.com/resources/PBR%20 Guide-1.1-2006.pdf, 2006.

John Carey, *The Intellectuals and the Masses: Pride and Prejudice among the Literary Intelligentsia 1880–1939*, London: Faber & Faber 1992.

Stephen Chaplin, 'Slade Archive Reader', unpublished, Slade Archive, UCL Special Collections, 1998.

Michel Eugène Chevreul, *The Law of Harmonious Colouring*, 3rd end., London: Henry G. Bohn 1839.

Kenneth Clark, *Landscape into Art*, London: J. Murray 1949.

F. Clarke, *Education and Social Change: An English Interpretation*, London: Sheldon 1940.

Alexander Cockburn and Robin Blackburn (eds.), *Student Power: Problems, Diagnosis, Action*, Harmondsworth: Penguin 1969.

Richard Coleman, *The Developing Process*, exh. cat., London: Institute of Contemporary Art 1959.

Richard Cork, *David Bomberg*, New Haven, CT and London: Yale University Press 1988.

Cathy Courtney (Project Director), *National Life Story Collection: Artists' Lives*, audio project, ongoing from 1990, produced as a collaboration between the British Library and Tate Archive: http://www.bl.uk/nls/artists.

Elena Crippa, *Performing Criticism: The Development of Discursive Pedagogies and Practices in British Art Schools*, unpublished PhD thesis, London Consortium/Birkbeck University of London, 2013.

Elena Crippa and Beth Williamson, *Basic Design*, London: Tate, 2013.

Felix da Costa, *The Antiquity of the Art of Painting*, ed. George Kubler, New Haven, CT and London: Yale University Press 1967.

Thierry de Duve, *Kant after Duchamp*, Cambridge, MA and London: The MIT Press 1996.

Rafael Cardoso Denis and Colin Trodd (eds.), *Art and the Academy in the Nineteenth Century*, Manchester University Press 2000.

Jane de Sausmarez, *Basic Colour: A Practical Handbook*, London: A&C Black 2008.

Maurice de Sausmarez, 'Diploma Daze', *The Guardian*, 27 June 1963.

Maurice de Sausmarez, *Basic Design: The Dynamics of Visual Form*, 2nd edn, London: A&C Black 2001.

Anna Dezeuze, 'Everyday Life, Relational Aesthetics and the Transfiguration of the Common-place', *Journal of Visual Art Practice*, vol.5, no.3, Nov. 2006, pp.143–52.

Nena Dimitrijevic, *Bruce McLean*, exh. cat., Basel: Kunsthalle Basel, 1981.

Anthony Downey, 'Towards a Politics of (Relational) Aesthetics', *Third Text*, vol.21, no.3, May 2007, pp.267–75.

Anton Ehrenzweig, 'William Johnstone, Artist and Art Educator', *Studio*, May 1959, pp.146–8.

Anton Ehrenzweig, *Colour and Space: Comments on the Exhibition 1966 at University of London Gold-smiths College, 1965/6*, London: Goldsmiths College 1966.

Anton Ehrenzweig, *The Hidden Order of Art: A Study on the Psychology of Artistic Perception*, London: Phoenix Press 2000.

James Elkins (ed.), *Art History versus Aesthetics*, London & New York: Routledge 2006.

James Elkins, *Why Art Cannot be Taught: A Handbook for Art Students*, University of Illinois Press 2001.

Mary Evans, *Killing Thinking: The Death of the Universities*, London: Continuum 2004.

Russell Ferguson and Paul Schimmel (eds.), *Out of Actions: Between Performance and the Object 1949–1979*, London: Thames & Hudson 1998.

Joanna Field (Marion Milner), *On Not Being Able to Paint*, London: William Heinemann Ltd 1950.

Elizabeth Fisher and Rebecca Fortnum (eds.), *On Not Knowing: How Artists Think*, London: Black Dog, 2013.

Erik Forrest, *Harry Thubron: His Contribution to Foundation Studies in Art Education*, unpublished PhD thesis, Ohio State University, 1983.

Stephen Foster and Nicholas deVille (eds.), *The Artist and the Academy: Issues in Fine Art Education and The Wider Cultural Context*, Southampton 1994.

Sigmund Freud, 'Neurosis and Psychosis', in *The Standard Edition of the Complete Psychological Works of Sigmund Freud*, trans. James Strachey, London: The Hogarth Press 2001.

Terry Frost, 'Colour Analysis from Nature', in *The developing process: work in progress towards a new foundation of art teaching as developed at the Department of Fine Art, King's College, Durham University, Newcastle upon Tyne, and at Leeds College of Art* (with contributions by Victor Pasmore, Harry Thubron, Richard Hamilton, Tom Hudson, and others), Newcastle upon Tyne: Durham University, King's College 1959.

Margaret Garlake, *The Relationship Between Institutional Patronage and Abstract Art in Britain c.1945–1956*, unpublished PhD dissertation, University of London, Courtauld Institute of Art 1987.

Margaret Garlake, *New Art New World: British Art in Postwar Society*, New Haven, CT: Yale University Press 1998.

Charles R. Garoian, 'Art as Critical Pedagogy in Studio Art Education', *Art Journal*, vol.58, no.1, Spring 1999, pp.57–62.

Charles R. Garoian, *Performing Pedagogy: Towards an Act of Politics*, Albany, NY: State University of New York Press 1999.

Sam Gathercole, 'Art and Construction in Britain in the 1950s', *Art History*, vol.29, no.5, 2006, pp.887–925.

Johann Wolfgang von Goethe, *Theory of Colours*, trans. Charles John Eastlake, Cambridge, MA: The MIT Press 1970.

RoseLee Goldberg, *Performance Art: From Futurism to the Present* (1979), 3rd edn, London: Thames & Hudson 2011.

Mel Gooding, *Bruce McLean*, Oxford: Phaidon Press 1982.

Isabelle Graw, *High Price: Art between the Market and Celebrity Culture*, Berlin and New York: Sternberg 2010.

H. Griffiths, *The Bath Academy, Corsham Court, Wiltshire, 1946–1955*, unpublished MA Report, London: Courtauld Institute of Art, 1979.

Walter Gropius, *Letters* (see the Papers of William Johnstone, National Library of Scotland, Acc. 8877/3).

Douglas Hall, *William Johnstone*, Edinburgh University Press, 1980.

Richard Hamilton, 'About Art Teaching, Basically', in 'A Visual Grammar of Form', *Motif*, no.8, Winter 1961, pp.3–26.

Susie Harries, *Nikolaus Pevsner: The Life*, London: Chatto & Windus 2011.

Charles Harrison 'Educating artists', *Studio International*, vol.183, no.944, May 1972, pp.222–4.

Sydney Harry, *'Weaving Plain' Handbook*, Bradford: Recruitment, Education and Training Department of the Wool (and Allied) Textile Employers' Council n.d.

Owen Hatherley, *Militant Modernism*, Winchester: Zero Books 2008.

Owen Hatherley, *A Guide to the New Ruins of Great Britain*, London: Verso 2010.

Jennifer Hawkins and Marianne Hollis (eds.), *Thirties: British Art and Design Before the War*, exh. cat., Hayward Gallery 1979.

Patrick Heron, 'Murder of the Art Schools', *Guardian*, 12 Oct. 1971, repr. in Patrick Heron, *On Art and Education*, Wakefield 1996, pp.28–35.

Elaine Hochman, *Bauhaus: Crucible of Modernism*, New York: Fromm International 1997.

Patricia Hollis, *Jennie Lee: A Life*, Oxford University Press 1997.

W.F. Houghton, *Chelsea School of Art – Ceremonial Opening of the New Buildings*, London 1965.

Marcus Huish, 'Whence This Great Multitude of Painters', *Nineteenth Century*, no.32, 1892.

James Hyman, *The Battle for Realism: Figurative Art in Britain During the Cold War 1945–1960*, New Haven. CT and London: Yale University Press 2001.

Johannes Itten, *Design and Form: The Basic Course at the Bauhaus*, trans. John Maass, London: Thames & Hudson 1964.

Johannes Itten with Faber Birren, *The Elements of Color*, London: Van Nostrand Reinhold Company 1970.

Wolf Jahn, *The Art of Gilbert & George, Or An Aesthetic of Existence*, trans. David Britt, London: Thames & Hudson 1989.

Kathrin Jentjens et al (eds.), *Lecture Performance*, Belgrade: Museum of Contemporary Art of Belgrade and Kölnischer Kunstverein 2009.

David Jeremiah, 'The Culture and Style of British Art School Buildings: Part One: The Victorian and Edwardian Legacy', *Point: Art and Design Research Journal*, no.1, Winter 1995, p.34–47.

David Jeremiah, 'The Culture and Style of British Art School Buildings: Part Two, Twentieth Century Opportunism and Conformity', *Point: Art and Design Research Journal*, no.2, Summer 1996, pp.50–9.

William Johnstone, *Creative Art in England*, London: Stanley Nott 1936.

William Johnstone, 'Unity of Art and Industry: Science as the Key to Partnership', *Times Review of Industry*, new series, vol.2, no.23, Dec. 1948, pp.6–9.

William Johnstone, *Creative Art in Britain*, London: Macmillan & Co. Ltd 1950.

William Johnstone, 'Graphic Design at the Central School', *The Penrose Annual: A Review of the Graphic Arts*, no.47, 1953, pp.58–60.

William Johnstone, 'The Central School of Arts and Crafts', n.d., unpublished typescript, Museum and Study Collection, Central Saint Martins, London Archive

William Johnstone, 'Lethaby's centenary', n.d., unpublished typescript, Museum and Study Collection, Central Saint Martins, London.

William Johnstone, 'Staff and Student Address', n.d., Museum and Study Collection, Central Saint Martins, London.

William Johnstone, 'A Survey: In Conversation', *Studio International*, vol.189, no.974, March/April 1975, pp.88–92.

William Johnstone: Marchlands, exh. cat., Edinburgh: The Scottish Gallery, 2012.

William Johnstone, *Points in Time: An Autobiography*, London: Barrie & Jenkins 1980.

William Johnstone, *Child Art to Man Art*, London: Macmillan 1941.

Peter Kardia, 'From Floor to Sky' (2010) <http://fromfloortosky.org.uk/artists.html>

David Katz, *The World of Colour*, London: Kegan Park, Trench, Trübner & Co. Ltd 1935.

Lesley Kerman, *The Memory of an Art School*, Devon: Little Silver 2013.

Paul Klee, *Pedagogical Sketchbook*, ed. Sybil Moholy-Nagy, London: Faber & Faber 1968.

Juliet Koss, 'Bauhaus Theater of Human Dolls', *The Art Bulletin*, vol.85, no.4, Dec. 2003, pp.724–45.

Jacques Lacan, *Le Seminaire III, Les Psyochoses*, Paris 1981; repr. as *The Seminars of Jacques Lacan, Book III*, ed. Jacques-Alain Miller, trans. Russell Grigg, New York and London: W.W. Norton 1997.

Robert Lacey and Frank Bellamy, 'The Weary Pilgrimage of Fred Blenkinsop', *Sunday Times Magazine*, 5 Oct. 1961.

R.S. Lambert (ed.), *Art in England*, Harmondsworth: Pelican 1938.

Luigi Lanzi, *Storia Pittorica della Italia* [*The History of Painting in Italy*], vol.1, trans. Thomas Roscoe, London: Henry G. Bohn 1847.

Bruce Laughton, *William Coldstream*, New Haven, CT and London: Yale University Press 2004.

F.R. Leavis, *Education and the University*, London: Chatto & Windus 1948.

Jennie Lee, *A Policy for the Arts: The First Steps*, London: HMSO, 1965.

David Lewis (ed.), *The Incomplete Circle: Eric Atkinson, Art and Education*, Aldershot: Scolar Press 2000.

Mervyn Levy, 'Draughtsman without Portfolio', interview with Vivian Pitchforth, *The Studio*, vol.163, Jan. 1962, pp.11–18.

John A. Loomis, 'School of Plastic Arts: Ricardo Porro', in *Revolution of Forms: Cuba's Forgotten Art Schools*, New York: Princeton Architectural Press 1999.

Dominic McIver Lopes, *Sight and Sensibility*, Oxford University Press 2005.

Norbert Lynton, 'Latest Developments in British Sculpture', *Art and Literature*, no.2, 1964, pp.195–211.

Norbert Lynton, 'Waiting for Coldstream', *Studio International*, vol.178, no.917, 1969, p.58.

Norbert Lynton, 'Coldstream 1970', *Studio International*, vol.180, no.927, Nov. 1970, pp.167–8.

Jean-François Lyotard, *The Postmodern Condition: A Report on Knowledge*, trans. Geoff Bennington and Brian Massumi, Manchester University Press 1984.

C. Madge and B. Weinberger, *Art Students Observed*, London: Faber & Faber 1973.

Steven Henry Madoff (ed.), *Art School (Propositions for the 21st Century)*, Cambridge, MA and London: The MIT Press 2009.

Karl Mannheim, *Freedom, Power and Democratic Planning*, London: Routledge 1951.

Alexander Massouras, *Patronage, professionalism and youth: the emerging artist and London's Art Institutions 1949–1988*, unpublished PhD thesis, London Consortium/Birkbeck University of London 2013.

Robert Maxwell, *New British Architecture*, London: Thames & Hudson 1972.

Marie McLoughlin, *Fashion, the Art School and the role of Muriel Pemberton in the introduction of degree level fashion education*, unpublished PhD thesis, University of Brighton, 2010.

Michael McNay, 'Obituary for Terry Frost', *Guardian*, 3 Sept. 2003.

Robert Medley, *Drawn From The Life: A Memoir*, London: Faber & Faber 1983.

Stephen Melville, 'Color Has Not Yet Been Named: Objectivity in Deconstruction', 1994, repr. in Jeremy Gilbert-Rolfe (ed.), *Seams: Art as a Philosophical Context*, Amsterdam: G + B Arts International 1996, pp.129–46.

P.F. Millard, 'The Future for Art Schools: Goldsmiths College School of Art', interview by Mervyn Levy, *The Studio*, vol.162, no.820, Aug. 1961, pp.72–5.

Ministry of Education, *Examinations in Art*, London 1946.

Jessica Morgan, 'Basic Design: pedagogy or aesthetic?', unpublished MA Report, London: Courtauld Institute of Art 1992.

Charles Morris, 'The Robbins Report', *British Journal of Educational Studies*, vol.13, no.1, Nov. 1964, pp.5–15.

Judith Mottram, 'Contemporary artists and colour: Meaning, organization and understanding', *Optics and Laser Technology*, vol.38, nos.4–6, June–Sept. 2006, pp.405–16.

Michael Moynihan, 'Gilbert and George', *Studio International*, vol.179, no. 922, May 1970, pp.196–7.

Keith Murray, 'The Development of the Universities in Great Britain', *Journal of the Royal Statistical Society*, Series A (General), vol.121, no.4, 1958, pp.391–419.

Stefan Muthesius, *The Postwar University: Utopianist Campus and College*, New Haven, CT: Yale University Press 2000.

Sandy Nairne and Nicholas Serota (eds.), *British Sculpture in the Twentieth Century*, London: Whitechapel Art Gallery 1981.

John Onians, 'Michael David Kighley Baxandale, 1933–2008', *Proceedings of the British Academy*, no.166, 2010, pp.27–46.

David Orr, *Earth in Mind: on Education, Environment, and the Human Prospect*, new edn, Washington, DC: Island Press 2004.

Friedrich Wilhelm Ostwald, *Malerbriefe* [*Letters to a Painter*], Leipzig: Hirzel 1904.

R. Perks and A. Thomson (eds.), *The Oral History Reader*, 2nd edn, London: Routledge 2006

Nikolaus Pevsner, *An Enquiry into Industrial Art in England*, Cambridge University Press 1937.

Nikolaus Pevsner, *Academies of Art: Past and Present*, Cambridge University Press 1940.

Nikolaus Pevsner, *The Reith Lectures: The Englishness of English Art*, London: British Broadcasting Corporation 1955.

David Warren Piper, *Readings in Art and Design Education*, 2 vols., London: Davis-Poynter 1973.

Michael Podro, *The Manifold in Perception: Theories of Art from Kant to Hildebrand*, Oxford: The Clarendon Press 1972.

Michael Podro, *The Critical Historians of Art*, New Haven, CT and London: Yale University Press 1982.

Michael Podro, *Depiction*, New Haven, CT and London: Yale University Press 1998.

Michael Podro, 'Formal Elements and Theories of Modern Art', *British Journal of Aesthetics*, vol.6, no.4, 1966.

Matthew Potter (ed.), *The Concept of the 'Master' in Art Education in Britain and Ireland, 1770 to the Present*, Aldershot: Ashgate 2013.

Alex Potts, *Flesh and the Ideal: Winckelmann and the Origins of Art History*, New Haven, CT and London: Yale University Press 1994.

Alex Potts, 'Obituary for Michael Podro', *Guardian*, 3 Apr. 2008.

Alexander Potts, 'Michael Podro, 1931–2008' in Ron Johnson (ed.), *Proceedings of the British Academy*, no.172, 2011.

Herbert Read, *Art and Industry*, London: Faber & Faber 1957.

Herbert Read, *Philosophy of Modern Art*, London: Faber & Faber 1952.

Lord Redcliffe-Maud (ed.), *Support for the Arts in England and Wales*, London: Calouste Gulbenkian Foundation 1976.

[Lionel Robbins], *The Report of the Committee Appointed by the Prime Minister under the Chairmanship of Lord Robbins 1961–63*, London: HMSO 1963.

Lionel Robbins, *The University in the Modern World and Other Papers on Higher Education*, London: Macmillan 1966.

Bryan Robertson, John Russell and Lord Snowdon, *Private View*, London: Thomas Nelson1965.

Eric Robinson, *The New Polytechnics*, Harmondsworth: Penguin 1968.

John Ruskin, *The Elements of Drawing*, (1857) repr. Chicago: Aquitaine Media Corp. 2010.

Naomi Salaman, *Looking back at the life room; Revisiting Pevsner's 'Academies of Art: Past and Present'*, unpublished PhD thesis, London: Goldsmiths College, 2008.

Natasha De Samarkandi and Donald Smith, *Don't Do Any More Henry Moore: Henry Moore and the Chelsea School of Art*, London: CHELSEA space 2010.

G.S. Sandlands, 'London County Council as Patron of Art: I', *The Studio*, vol.159, no.801, Jan. 1960, pp.6–10.

Charles Saumarez Smith, 'Obituary for Michael Podro', *Independent*, 1 Apr. 2008.

Friedrich Schiller, *On the Aesthetic Education of Man*, trans. Reginald Snell, New York: Frederick Ungar 1981.

Oskar Schlemmer, *Man. Teaching Notes from the Bauhaus*, ed. Heimo Kuchling, Cambridge, MA: The MIT Press 1971.

Tim Shelley, 'The Central School of Art and Design Pre-Diploma/Foundation Studies: the beginnings, the ambitions the progress, the setbacks, 1963–1973', unpublished document, 2008.

Conal Shields, 'CNNA Conference on Art and Design Courses, December 1977', *Bulletin of the Association of Art Historians*, No.7, Oct. 1978.

Howard Singerman, *Art Subjects: Making Artists in the American University*, Berkeley, CA: University of California Press 1999.

Adam Smith, *An Inquiry into the Nature and Causes of the Wealth of Nations*, Edinburgh: Mundell, Doig and Stevenson, 1809.

Lucy Soutter, 'What Lies Beneath', *Frieze*, no. 101, Sept. 2006, pp.176–9.

Anne Spackman, 'Sweet Sell of Excess: Our Property Editor Meets the Brothers Behind the World's Most Expensive Apartment', *Times*, 7 May 2004.

Frank G. Spicer, *Just What Was It that Made U.S. Art So Different, So Appealing?: Case Studies of the Critical Reception of American Avant-Garde Painting in London, 1950–1964*, unpublished doctoral thesis, Cleveland, OH: Case Western Reserve University 2009.

Åke Ludvig Stavenow and Åke H. Huldt, *Svenske Form*, Göteborg: Gothia 1961. Published in Swedish.

Åke Stavenow, *Konstfackskolan: The Swedish State School of Arts, Crafts and Design*, Sweden: Konstfackskolan 1964.

Robert Stevens, *University to Uni: The Politics of Higher Education in England since 1944*, London: Politicos, 2004.

W.A.C. Stewart, *Higher Education in Postwar Britain*, London: Macmillan 1989.

Ezra Stoller and Phillip Nobel, *The Yale Art + Architecture Building*, New York: Princeton Architectural Press 1999.

Katharine Stout, 'More to Meet the Eye: Contemporary Drawings at Tate Britain', *Tate Etc*, no.XXIV, Spring 2012, pp.94–7.

David F. Sweet, 'The Shortcomings of Student Art', *Art and Artists*, vol.4, no.1, Apr. 1969.

David Thistlewood, *A Continuing Process: The New Creativity in British Art Education 1955–65*, London: ICA, 1981.

David Thistlewood, 'Disciplined Irrationality', in *The Teaching of Art: The Roots of Self-Deception*, Aberystwyth: The University College of Wales 1981.

Jon Thompson, 'Art Education: from Coldstream to QAA', *Critical Quarterly*, vol.47, no.1–2, 2004.

Jon Thompson, *The Collected Writings of Jon Thompson*, Manchester: Ridinghouse 2011.

Harry Thubron, 'Drawing from the Figure', handwritten, unpublished note, n.d., National Art Education Archives, Bretton Hall.

Lisa Tickner, *Hornsey 1968 The Art School Revolution*, London: Frances Lincoln 2008.

Nicholas Timmins, *The Five Giants: A Biography of the Welfare State*, London: HarperCollins 2001.

Peter Townsend, *Letters, Gallery proofs of interviews, etc*, in Papers of William Johnstone, National Library of Scotland, Acc. 8877/4.

William Tucker, 'An Essay on Sculpture', *Studio International*, vol.177, no.907, Jan. 1969, pp.12–13.

[William Turnbull], 'William Turnbull Talks to Maurice de Sausmarez', in 'A Visual Grammar of Form', *Motif*, no.8, Winter 1961, pp.3–26.

John A. Walker, 'The Basic Faults of the Basic Design Courses', *Art Monthly*, no.46, 1981, pp.27–8.

John A. Walker, 'A Vexed Trans-Atlantic Relationship: Greenberg and the British', *Art Criticism*, vol.16, no.1, 2001, pp.44–61.

Hans Wallach, 'The Perception of Neutral Colors', *Scientific American*, vol.208, no.1, Jan. 1963, pp.107–16.

Michael Webb, *Architecture in Britain Today*, Feltham: Country Life 1969.

Carel Weight, 'Introduction', in *Towards Art? An Exhibition showing the contribution which the College has Made to the Fine Arts 1952–1962*, exh.cat., Royal College of Art, London, 1962.

Carel Weight, 'Retrospect', *Queen*, 21 June 1967, pp.41–5.

Hester R. Westley, *Traditions and Transitions: St Martin's Sculpture Department 1960–1979*, unpublished doctoral thesis, London: Courtauld Institute of Art 2007.

Hester R.Westley, 'The Intellectual Metronome: Peter Kardia at St Martin's', in Roderick Coyne et al (eds.), *From Floor to Sky*, London: A&C Black 2010.

John White, *The Birth and Rebirth of Pictorial Space*, London: Faber & Faber 1957.

Rainer K. Wick, *Teaching at the Bauhaus*, Ostfildern 2000.

Beth Williamson, *Anton Ehrenzweig: Between Psychoanalysis and Art Practice*, unpublished PhD thesis, University of Essex, 2008.

Beth Williamson, 'Paint and Pedagogy: Anton Ehrenzweig and the Aesthetics of Art Education', *International Journal of Art and Design Education*, vol.28, no.3, Oct. 2009, pp.237–48.

Beth Williamson, 'Art History in the Art School: The Critical Historians of Camberwell', *Journal of Art*

Historiography, no.5, Dec. 2011.

Beth Williamson, 'Recent Developments in British Art Education: 'Nothing Changes from Generation to Generation except the Thing Seen', *Visual Culture in Britain*, vol.14, no.3, 2013, pp.356–78.

Beth Williamson, *Between Art Practice and Psychoanalysis Mid-Twentieth Century: Anton Ehrenzweig in Context*, Burlington, VT and Hampshire: Ashgate 2015.

Rudolf Wittkower, *Architectural Principles in the Age of Humanism*, 3rd edn, London: Tiranti 1967.

Janet Wolff, 'The impolite boarder: "Diasporist" art and its critical response', in *The Aesthetics of Uncertainty*, New York: Columbia University Press 2008, pp.77–98.

Richard Yeomans, Interview with Richard Hamilton, 15 Jan. 1982, unpublished transcript, National Art Education Archives, Bretton Hall.

Richard Yeomans, *The Foundation Course of Victor Pasmore and Richard Hamilton, 1954–1966*, unpublished PhD thesis, London: University of London Institute of Education, 1987.

Richard Yeomans, 'Basic Design and the Pedagogy of Richard Hamilton', *Journal of Art and Design Education*, vol.7, no.2, 1988, repr. in M. Romans, *Histories of Art and Design Education: Collected Essays*, Portland, OR and Bristol: Intellect Books 2004.

Otoman Zar-adusht Ha'nish, *Mazdaznan Health and Breath Culture*, First six exercises, 1902, repr. illustrated and appended by Ian Whittlesea, Kingston: Open Editions and Stanley Picker Gallery 2013.

A prominent feature of London's art schools in this period has been cross-fertilisation among them. Significant faculty often taught in several institutions either sequentially or simultaneously, and art students frequently progressed between schools – necessarily so in the case of those institutions that only taught postgraduates. Institutional identities nevertheless persist; our contributors have created outline histories from c.1960 for those schools of particular interest to this publication. While these profiles are by no means comprehensive, the division of each institutional history into elements such as qualifications, building location and faculty means that significant details can be compared.

INSTITUTIONAL HISTORIES

CAMBERWELL

DEPARTMENTS AND QUALIFICATIONS

At the start of this period, Camberwell was organised into three departments: Painting and Sculpture; Design and Crafts; and Printing and Bookbinding. An Art History Department was formally established in 1961 and Foundation Studies were introduced in 1962. By 1968 the School was organised into eight departments: Painting; Sculpture; Graphic Design; Ceramics and Metalwork; Textiles; Foundation Studies; Art History; and Printing. Paper conservation courses began in 1970, and in 1974 the CNAA approved BA degrees in painting; sculpture; graphic design; printed and woven textiles; and ceramics (with silversmithing and metalwork introduced in 1976). Vocational courses in printing and typographical design were phased out at the beginning of the 1980s, and in 1983 the textiles degree course was lost. In 1986 Camberwell became a constituent college of the London Institute. In 1989 it was renamed Camberwell College of Arts, and courses were organised into two schools: Applied and Graphic Arts; and Art History and Conservation. Between 1990 and 1993 five new courses were begun in line with the London Institute's Academic Development Plan: BA Conservation; MA Conservation; a part-time BA in graphic design; BA Joint Honours in art and design; and an MA in printmaking. In 1993 the London Institute was granted the right to award degrees in its own name. In 1996 a new international MA Book Arts course was launched, built around the activities of the Camberwell Press. In 1998 the college launched a new framework for its BA courses, offering students the opportunity to focus on a specialist discipline supplemented by chosen elective subjects. Art History closed in 2000 and courses in personal and professional development (focusing on skills such as teamwork, client liaison, self-promotion) were launched the same year. From 2011 Camberwell ran the only Foundation course within the CCW triumvirate.

BUILDINGS AND GEOGRAPHY

From its opening at the end of the nineteenth century, Camberwell adjoined the South London Art Gallery. A new sculpture building was opened in 1953, providing new workshops for modelling in clay, bronze casting, plaster casting, stone, and woodcarving. Between 1966 and 1971, additional accommodation was opened in Meeting House Lane (principally for painting) and Lyndhurst Grove (for textiles, ceramics, graphic design and Foundation studies), and a purpose-built sculpture annex was completed in 1969. In 1971 a new extension of 50,000 square feet was begun on the existing school's site; it opened in 1974 and provided a further forty-two studio workshops and classrooms, new assembly and lecture halls, library and common rooms. In 1976 the former premises of Wilson's Grammar School was taken over by the school.

STUDENT BODY AND PROFILE

Robert Medley in *Drawn from the Life* (1983) recalled Camberwell as 'a typical and by no means especially prestigious example' of an art school, despite its Coldstream legacy. It was defined by its south London location and its social ambitions, evidenced – for example – by the North Peckham Estate murals painted by textiles students in the mid 1970s, or by the free 'live art' classes for the unemployed launched in 1984. The initiative attracted government funding and its champion Vera Russell hoped 'to bring illumination to lives that are pretty grim at present'. In the inaugural publication from the Camberwell Press in 1984, Eileen Hogan noted that 'while the Camberwell Press will form an important part of the practical and theoretical work carried out at the School, one of its more valuable purposes will be to share some of the concerns of the School with the world outside. The measure of any educational establishment may, in part, be counted by its contribution to the well-being of the community of which it forms a part'. Whilst emphasising the advantages of being part of the much larger London Institute, the prospectus of 2000 noted Camberwell was renowned for a friendly and supportive atmosphere amongst staff and students. The sorts of collaborative and community-minded ventures outlined above might now be viewed as early points of reference for community-based projects such as Peckham Space, opened in 2010. As the sole centre for Foundation training in CCW, Camberwell now takes around 750 Foundation students each year.

SELECTED FACULTY

Michael Podro was Head of History of Art 1964–67, having joined in 1961. In 1966 staff included Frank Auerbach, Garth Evans, Peter Hobbs, Frank Martin, Robert Medley, Patrick Proctor, and Euan Uglow. T.J. Clark taught art history (1970–4) as did the artist Mary Kelly (1975–85) and Alex Potts (1981–9). Tony Carter was Principal Lecturer and Course Leader in sculpture (1986–9). Paul de Monchaux fulfilled various roles including Principal Lecturer in sculpture, Head of Painting and Head of Fine Art. Eileen Hogan set up and directed the Camberwell Press from 1984–96 and was Dean from 1989–97. During the 1988-9 academic year, cuts to fine art courses at Camberwell were planned by the London Institute. Wendy Smith, Head of the Department of Fine Art, and Tony Carter resigned in protest, returning when the cuts were reduced. Susan Johanknecht joined in 2001, heading the MA in book arts.

CENTRAL SCHOOL

DEPARTMENTS AND QUALIFICATIONS

Central was among the first UK colleges to be accredited across all of the DipAD's four main areas (fine art [painting], graphic design, 3D design and fashion textiles). In the 1960s, it gradually intellectualised and diminished its earlier craft emphasis, establishing history and liberal studies, a Pre-Dip/Foundation Department, and the library. 'Central School of Arts and Crafts' became 'Central School of Art and Design' in 1966. In 1967, the NCDAD designated a joint centre for post-graduate studies composed of Chelsea School of Art for Fine Art and Central for Design. This mandate was a harbinger of the programme and school mergers of subsequent decades. In 1984, the ILEA spearheaded the first merger, in response to financial pressure and claims of London's over-provision for art education: St Martin's and Central merged their fine art and graphic design courses. The new BA Fine Art was divided into four subject areas: painting, sculpture, printmaking, and film. Central and St Martin's then combined the Department of Fine Art into a 'School of Art'. By 1989, the schools merged to form 'Central Saint Martin's College of Art and Design' (CSM). Under its first Rector John McKenzie, art schools were renamed 'Colleges', and the term 'School' denoted the combination of former departments. The post of 'Principal' became instead the 'Head of College', and Deans were created to head up the new-style schools. The Byam Shaw School of Art (founded in 1910) was merged into Central Saint Martin's in 2003, which was itself absorbed by the University of the Arts in 2004.

BUILDINGS AND GEOGRAPHY

Central School occupied its historic Arts and Crafts custom-built premises on Southampton Row from 1908 until 2012. The architecture of the school influenced the level of interdisciplinary interaction, which conspired to create an empire of autonomous departmental kingdoms. From the early 1960s, the Painting Department was located on the top floor; Sculpture in the basement; Jewellery was located on the second floor; and Industrial Design on the third floor. In 1962 Central expanded into new premises in Red Lion Square and the Jeanetta Cochrane Theatre opened soon after. In 2011, Central Saint Martin's relocated to a converted mid-nineteenth-century granary building in King's Cross, bringing together almost all of the courses offered by the College under one roof.

STUDENT BODY AND PROFILE

The first intake of DipAD students arrived in 1962, and students were socially diverse, and reasonably international. Small class sizes were a feature of the early 1960s, with staff-student ratio of 1:10, although over-whelming numbers of applications for the new DipAD soon changed this ratio. Even before the rising significance of DipAD degree shows, considerable importance was placed on the annual student exhibition at Central. There were clear guidelines regarding the sale of student work: all work sold should contribute a percentage to the School Fund, and students should be admonished for working on commissions – a means of securing cheaper work that could therefore undermine professional rates of pay. During the 1960s, Central began to manage more deliberately its incoming student demo-graphic. Board notes reveal a growing concern between Principal Michael Pattrick and other members about the desirability of continuing with students on day-release from prison, for instance. Meanwhile, the increased demand for new media led to discussions about the provisions for teaching photography. A blend of photography and film enjoyed flourishing interest from a growing segment of incoming students. By the mid 1970s, the Fine Art Department had approximately ninety students working for the DipAD degree, with an annual intake of twenty painting and ten sculpture students. The merger with St Martin's in the 1980s was difficult for many of the staff at Central, given its difference of character and departmental structure. Former Dean of Central Saint Martins, Jane Rapley, recalls: 'Central was many small departments and they were quite British Museumy and Bloomsbury in nature … its primacy was in the 1950s, and it was a bit more measured and quieter.'

SELECTED FACULTY

Central's heyday for pedagogic innovation was in the 1950s under its then Principal William Johnstone, who retired in 1960, to be succeeded by Michael Pattrick. Maurice Kestleman led the Painting Department from 1951–71 and during this period it had a relatively traditional profile. Staff such as Cecil Collins (1951–75) contrasted with a more progressive line-up of visiting tutors. The Fine Art Department's staff comprised the Head; a Senior Lecturer in painting; a Senior Lecturer in sculpture; and around fifty part-time visiting staff. Brian Wall was Head of Sculpture 1962–72. Shelley Fausset ran the Foundation Department from 1963–82. The appointment of Hubert Dalwood as Head of Sculpture in 1974–6 coincided with Robert Clatworthy's ascension as Head of Fine Art, which precipitated debate around studio-based practice in the face of increasingly conceptually-focused curricula. After the first merger, Ian Simpson (then Principal of St Martin's) became Head of Fine Art, supported by John Edwards in painting, Steve Furlonger in sculpture, David Glück in printmaking, and Malcolm Le Grice in film. By 1986, the ILEA, headed by William Stubbs, formed the London Institute. Its Rector, John McKenzie, emphasised that he wanted Central and St Martin's to preserve their distinct identities despite sharing resources and students. With its hierarchy clarified – a Rector overseeing Heads of Colleges overseeing Deans – Central Saint Martin's saw David Sherlock assume the first Head of College role (1988–91); he was succeeded by Margaret Buck, and she by Jane Rapley. Rod Bugg was Dean of Art from 1993–7, Chris Wainwright from 1997–2007 and Mark Dunhill followed on after him.

CHELSEA

DEPARTMENTS AND QUALIFICATIONS

A new Chelsea School of Art, directly managed by LCC, was formed in 1964 when the original art school split from Chelsea College of Science and Technology and amalgamated with the Polytechnic School of Art, Great Titchfield Street (previously the West London School of Art and part of the Regent Street Polytechnic). In 1975, Hammersmith School of Building and Arts and Crafts (established 1881) merged with Chelsea. In January 1986 Chelsea School of Art became a constituent college of the London Institute, formed by the ILEA, becoming Chelsea College of Art and Design in 1989. Chelsea College of Arts is now part of a creative triumvirate 'CCW' together with Camberwell College of Arts and Wimbledon College of Art within the 'University of the Arts London' framework. It had been accredited for diplomas in painting and graphic design in 1963, and sculpture in 1964. In 1965, it was approved to offer a postgraduate diploma in fine art (which became the MA in 1974). From 1958, Lawrence Gowing integrated history and theory with practice, employing artists rather than art historians to teach art history and theory, and introducing seminar 'options' which included workshops on experimental music, poetry, artists' books, psychoanalysis, philosophy and anthropology. New courses since 1989 include the conversion of three HNDs – mural design, textile design, and interior/product design – into a BA Honours in design, and MAs in the history and theory of modern art, and the theory and practice of public art (the latter revalidated in 1998 as the multi-disciplinary MA in design for the environment). The design portfolio has expanded, and in place of separate pathways, the BA Honours courses in graphic design for communication, interior and spatial design and textile design are now individual degrees. MAs in critical writing and curatorial practice and graphic design communication have also become part of the College's portfolio.

BUILDINGS AND GEOGRAPHY

Chelsea was historically London's bohemian quarter. In 1965, Chelsea's purpose-built Manresa Road site opened. By 1975 Chelsea had acquired the Bagley's Lane site – a hastily converted primary school campus. This was used as an annex to Manresa Road. Following amalgamation with Hammersmith School of Building and Arts and Crafts, Chelsea gained Lime Grove, a late nineteenth-century Arts and Crafts building, which included purpose built artists' studios and workshops. Lime Grove became the hub for design courses including mural painting, glass mosaic and ceramic, textile design and interior/product design. In 1981 Chelsea acquired additional premises at Hugon Road, a converted Victorian primary school where graphic design activity was based. Chelsea relocated to a single site at Millbank, opposite Tate Britain, in January 2005.

STUDENT BODY AND PROFILE

Initially many students were native Londoners; this has now changed with many students coming from abroad. In 1965 the LCC Education Officer boasted that Chelsea had forty-eight students enrolled for the fine art diploma – 'the largest number of any school of its kind in the country' – and that the total number of full-time students enrolled at this time was 223. The first cohort of PGDip students staged their end of year show in 1967. Chelsea graduate Jonathan Harvey (1971–2) co-founded Acme Studios in 1972 to provide affordable studio space, residencies and awards. Acme now supports a Studio Award for final year BA Fine Art students from Chelsea. When the DipAD qualification was first replaced with the BA (for the cohort graduating in 1975), students occupied the building overnight and staged a rooftop protest. Painting students benefited from a unique 'studio system'. Prospectuses dating from the 1980s describe 'small close-knit groups of students and artists brought together by similar interests and by the need for similar resources'. A similar system operated in the sculpture workshops where students of all stages, from Foundation to undergraduate and postgraduate, mixed. By 2011 numbers had risen to 1,400 degree students.

SELECTED FACULTY

Lawrence Gowing took over as Head in 1958 and was succeeded by Fred Brill in 1965 (who was Head until 1979). John Hoyland led the postgraduate diploma course from 1965. Ian Stephenson taught basic design and painting 1959–66, and later ran the postgraduate programme, including the MA Fine Art from its inauguration in 1974 (Stephenson retired in 1989). Other teachers at the time of the inauguration of the new school included Michael Andrews, Frank Auerbach, Patrick Caulfield, Prunella Clough, Anthony Hill, Leon Kossoff, Norbert Lynton, Myles Murphy, Norman Norris and Matt Rugg. Stephen Bury was Librarian from 1979 to 2000. John Barnicoat was Principal 1980–9. William Callaway became Head of College in 1989, the same year Colin Cina became the first Dean of Art and Bridget Jackson the first Dean of Design. Euan Uglow taught at Chelsea during this time. Jackson followed Callaway as Principal from 1992–7, and was succeeded by Colin Cina from 1997–2003. Roger Wilson led the College from 2003–6. Chris Wainwright is now Head of Colleges for Chelsea, Camberwell and Wimbledon.

GOLDSMITHS

DEPARTMENTS AND QUALIFICATIONS

In 1964 the DipAD in textiles at Goldsmiths, with embroidery as the main subject and printed textiles and weaving as subsidiary subjects, was the first to be ratified in Britain. In 1969–70 the Art Teachers' Certificate course was the most sought after in the country and 331 students applied for sixty-three places. From 1968, Jon Thompson sought to unify the Painting and Sculpture Departments, making for ease of mobility for students between the two. In the second half of the 1970s, the School of Art and Design expanded undergraduate courses and worked to establish postgraduate courses, with higher degrees and in-service courses as well as research degrees, MPhils and PhDs. In 1978 the first students embarked on a new MA in fine art, and forty students registered for the new communication studies degree in the Department of Visual Communications. An approved BA in art/history of art began in 1981, and the CNNA soon after approved single honours degrees in fine art and embroidery textiles. In 1983 the Art Teacher's Certificate course moved to the Faculty of Education. In 1985 the University began a new BA Art (Studio Practice) and History of Art degree to replace the Institute of Education degree. 1987 saw the creation of a new Faculty of Arts, including Humanities Departments as well as Creative and Performing Arts. Goldsmiths received its Royal Charter in 1990. A re-branding exercise in 2007 dropped the word 'College' from the institution's name, and new degrees continue to be introduced, such as the MFA in computational studio arts.

BUILDINGS AND GEOGRAPHY

Various buildings on the New Cross site have at different times housed the Department's staff and students. Negotiations for the lease of additional accommodation at Surrey Docks were completed before the 1972–3 session began. Working parties of staff and students set about converting the space. Fine art, history of art and textiles all moved to the newly acquired Millard Building (St Gabriel's site) in Camberwell in 1978 after expiry of the Surrey Docks lease. In 1988 the move from the Camberwell site back to the main New Cross site became possible when space was liberated by the building of the new college library. January 2005 saw the unveiling of the new Ben Pimlott Building, designed by architects Alsop & Partners to house the Department of Art. Almost immediately, however, growing student numbers meant the spaces provided were inadequate.

STUDENT BODY AND PROFILE

Goldsmiths began primarily as an institution specialising in education and the training of primary and secondary school teachers. Those early years informed a continuing concern with education and pedagogical practices in general which seems to have acted as a point of departure for art education. In 1961, 211 full-time students were recruited to the School of Art. Annual Reports note that by 1972 student numbers had reached around 300. Critic Richard Shone in *From Freeze to House* (1998) suggests that, at Goldsmiths, 'the impact of the teaching in the 1980s produced a remarkable generation. Their example and several important early shows that they themselves devised became a source of energy that affected a mass of students in other schools and paved the way for the [...] seemingly unstoppable exposure of new British art'. At the beginning of 1988 Angus Fairhurst, a second year student at Goldsmiths, organised a show in the Bloomsbury Gallery of the Institute of Education. Damien Hirst was already planning for an ambitious three-part show *Freeze* later in the year to be held in an empty London Port Authority warehouse loaned by the London Docklands Development Corporation. On the occasion of Goldsmiths' centenary in 1991, A.E. Firth noted that in the *British Art Show* of 1990 (which featured forty artists under the age of thirty-five, selected from 2,800 nationally), thirteen of those exhibited had studied at Goldsmiths.

SELECTED FACULTY

In 1963–64 Seonaid Robertson, a teacher on the Art Teacher Certificate course and a follower of Herbert Read, delivered a lecture in Tokyo titled 'Art Education in the Computer Age'. From 1964–6 Anton Ehrenzweig, along with Tony Collinge, ran a radical new ATC course. In 1968 Jon Thompson joined as lecturer in charge of the first year DipAD in painting and sculpture, becoming Head of Fine Art in 1970 (the year of Andrew Forge's departure). Constance Howard retired as Head of Textiles in 1975, to be succeeded by Audrey Walker, who in 1988 was succeeded by Christine Risley. In 1994 Rosalind Floyd and Shirley Craven retired and Janis Jeffries became Head of the Textiles Study Area. In the 1970s Maurice Agis taught sculpture. Philip Rawson became Dean of the Faculty of Arts in 1980. In 1983 Harry Thubron retired after ten years at Goldsmiths. In 1987 Nick de Ville became Head of Department. Michael Craig-Martin taught between 1974–88, and returned 1994–2000. Richard Noble, a philosopher by training, joined Goldsmiths initially as a part-time Lecturer in the Department of Visual Art in 2003, before becoming Head of Department.

ST MARTIN'S

DEPARTMENTS AND QUALIFICATIONS

Fine art at St Martin's comprised painting and sculpture, of which painting was the more popular. In 1964 the two departments temporarily – and notionally – merged in order to gain DipAD accreditation. Sculpture's 'Advanced Course' enabled talented students to work in a quasi-graduate studio environment. By c.1965, there was a Foundation Department in addition to a smaller History of Art and Complementary Studies Department. In the early 1970s the 'A' course taught conceptually inclined sculpture undergraduates, and the 'B' course catered for those interested in 'object' sculpture. The Painting Department refreshed its understanding of the discipline, positioning painting as the core of a wider range of activities that included photography, film, print-making in various media, as well as traditional features like the life room. A free-standing Film and Video Unit was officially established in 1976. The bias toward painting remained into the 1980s: in 1980–1, of fine art students (in BA and Advanced courses) 119 were painters and 58 were sculptors, with another 103 Foundation students. Sculpture foundered and was closed by the CNAA in 1983. In 1984 the ILEA merged fine art and graphic design courses at Central and St Martin's (see Central entry).

BUILDINGS AND GEOGRAPHY

St Martin's School of Art was the most centrally located of the London art schools; it occupied its Charing Cross Road building from 1939 until 2011, and its location was significant. Close proximity to Soho meant that students were immersed in popular culture, fashion and music, as well as close to galleries and museums. Its premises always struggled to accommodate student numbers, and intramural arrangements were unconventional. The Sculpture Department occupied impractical upper floor rooms as well as basement and courtyard spaces that accommodated, respectively, the welding workshop and an impromptu display and storage area. In an effort to accommodate growing numbers of students, St Martin's leased space on Archer Street, Greek Street and 145 Charing Cross Road. In 1979 they acquired a building at Long Acre (used by Graphic Design, the Film and Video Unit and some of the Painting Department) until a new site in Red Lion Square was acquired in 1998. Moving premises was a long-standing ambition of the school, realised eventually in 2011 with its move to the King's Cross location.

STUDENT BODY AND PROFILE

St Martin's did not enjoy an established, illustrious history, but rather invented a reputation from the 1960s, quickly becoming one of the most renowned fine art and design schools in the UK. In 1961–2 there were 166 painting students compared with forty-seven sculpture students. Its success was indicated by graduates establishing names as practitioners, and by high numbers going on to graduate programmes at the RCA. St Martin's was a very large school: in 1961 there were over 500 full-time students and amongst this number a strong international presence was consistently counted. By the start of the 1978 academic year, it had 650 full-time students. Former Dean of Central Saint Martins, Jane Rapley, recalls that 'St Martin's was Soho … It was about three tower blocks [Art, Fashion and Graphic Design] who fought each other, and they were street fighters … St Martin's primacy was very 1960s, 1970s … very out there and up front'. Of the eventual merger between Central and St Martin's in the 1980s, she says: 'It is interesting but it is the St Martin's cultural heritage that has dominated CSM despite the fact that Central was in a better shape than St Martin's was, in my view, when we merged.' John McKensie, the first Rector of the London Institute, brought a business sense to the merger, broadening the outreach for students, drawing heavily from an international pool of students. Still, McKensie wanted both schools to preserve their identities, even as they worked together with shared resources and students. However, from 2011, the sharing of the King's Cross location erased what remained of a discrete legacy of a uniquely St Martin's – as opposed to CSM – culture.

SELECTED FACULTY

Edward Morss was Principal from 1946–72. Frederick Gore (Vice Principal from 1961–79) headed painting, Frank Martin sculpture, and Ken Bale the Foundation course. Martin recruited progressive sculptors as tutors in his department. Heterogeneous practices enriched the Department, which included both object makers (Anthony Caro and New Generation sculptors) and conceptualists (Barry Flanagan, Gilbert & George). Erosion of media boundaries was evidenced by Malcolm Le Grice's 1967 establishment of an Experimental Film Unit. Ian Simpson was Principal from 1972–88. At the beginning of the 1970s, the Painting Department employed one full-time staff member supported by twenty-five visiting lecturers (Sculpture employed two full-time lecturers with twenty-three visiting tutors, while Foundation Studies employed three full-time members of staff and forty visiting lecturers). Tim Scott took over as Head of Sculpture in 1981, following Frank Martin's retirement.

ROYAL COLLEGE OF ART

DEPARTMENTS AND QUALIFICATIONS

Since 1967, when the college was granted a Royal Charter endowing it with university status and the power to grant its own degrees, the Royal College of Art has been the only wholly postgraduate university institution of art and design in the UK. If the Coldstream Report stated that 'students should not specialize too narrowly', emphasising that a unified fine art area rather than courses focusing intensely on one subject were unsuitable for the diploma, such a directive did not apply to the RCA. As an exclusively postgraduate college, the RCA continued to run mostly independent schools of painting, sculpture, printmaking, graphic design, industrial design, textile and fashion. Initially, the master qualification was denied to fashion students, a decision which caused an internal uproar. In the late 1950s and 1960s, courses in industrial design and vehicle design were introduced. In the 1970s, two short-lived but influential courses were established: environmental media (under Peter Kardia) and the Film and TV Department. In 1971, Bruce Archer was invited to create the Department of Design Research, which he ran until it was closed, not without controversy, in 1984. In the 1980s, the Department of Interior Design was split into two courses: architecture and interior design. In the 1980s and 1990s, the Product Design Department grew significantly while Animation became a Department in its own right and a Humanities Department was established. In 1989, the Fashion and Textile Departments were amalgamated. The department of Conservation was founded in 1987 in association with the Victoria and Albert Museum, and a course in Visual Arts Administration (then Curating Contemporary Art) was founded in 1992 in association with the Arts Council of Great Britain (Arts Council England from 1994). In 2014, the RCA offers twenty-four distinctive postgraduate programmes across art and design.

BUILDINGS AND GEOGRAPHY

In the 1950s, Robin Darwin engaged in what he defined as a 'difficult battle' to convince the Ministry of Education of the need to found a large, centralised building. Referring to the erection of a purpose-built gallery within the new college (1962), Darwin explained his ambitions in relation to the new large hall of the new building: 'This Hall has been designed primarily as an exhibition centre which we hope may be used for important exhibitions organised by the Arts Council and others.' In 1962, all design and applied art courses moved to the new Darwin Building in Kensington Gore, while painting remained housed in Victorian studios on Exhibition Road, adjacent to the Victoria and Albert Museum, until 1992, when the college opened the new Stevens Building in Kensington Gore. In 2008, after many years of the sculpture studios being housed in an agglomeration of temporary structures, the Sculpture Department found a permanent home in a refurbished building at Howie Street, Battersea. By 2012, with the completion of the Dyson Building at Battersea, the School of Fine Art, including the Painting, Photography and Printmaking Departments, alongside the Sculpture Department, were brought together in one location.

STUDENT BODY AND PROFILE

Narrating the history of the RCA in the post-war period in Exhibition Road (1988), former Rector Christopher Frayling asserted that: 'Successive Government Ministries and Boards, under whose aegis the College came, continually emphasised what they saw as an unquestionable need for the College to train designers for industry, not "fine artists" who might compete with the Royal Academy Schools.' Yet, the RCA managed to remain an art school as well as a design school. The RCA magazine *ARK* (1950–78) bears testimony to the collaboration and cross-pollination of design students and painters, especially with the development of the pop movement. The 1950s and 1960s saw the RCA at the centre of the explosion of pop art culture (students included Peter Blake, Joe Tilson, Derek Boshier, David Hockney, Allen Jones, R.B. Kitaj and Patrick Caulfield in the School of Painting and Pauline Boty in the School of Stained Glass). In 1968, when it became a purely postgraduate institution, the RCA numbered some 550 students. The majority of students up to the 1970s were enrolled in the Painting Department. At present, approximately 75% of the students and staff are design oriented.

SELECTED FACULTY

Robin Darwin was the College's Principal from 1948 to 1967 and Rector between 1967 and 1971. He was succeeded by Jocelyn Stevens (1984–92), Anthony Jones (1992–6), Christopher Frayling (1996–2009) and Paul Thompson (2009– present). Misha Black was the first Professor of Industrial Design (1959–75). Professors of Printmaking have included Edwin laDell (1955–70), Alistair Grant (1970–90) and Tim Mara (1990–7); Professors of Painting encompass Carel Weight (1957–72), Peter de Francia (1972–86) and Paul Huxley (1986–98); and Professors of Sculpture include Bernard Meadows (1960–80), Phillip King (1980–90) and Glynn Williams (1990–2009). Among notable part-time and visiting teachers of painting are Ruskin Spear (1948–75), Sandra Blow (1961–75) and Peter Blake, who also taught in the Printmaking Department (1964–76).

SLADE SCHOOL OF FINE ART

DEPARTMENTS AND QUALIFICATIONS

At the Slade, the areas of study since 1960 were for the most part divided into painting, sculpture, printmaking, media and theatre design. Today these areas are painting, cculpture and fine art media. The UK's first film course was introduced in 1960 (seemingly at postgraduate level initially), and was led by Thorold Dickinson who subsequently became a professor, before retirement in 1971. Film was joined in 1972 by a computer department, the Department of Experiment, whose developments reflected the efforts of Malcolm Hughes and Chris Briscoe. A postgraduate diploma was formally introduced in the mid 1960s. In 1970, art history and anatomy turned from compulsory into optional subjects for the University of London diploma in fine art. Section directorships were phased out in favour of a structure of senior lecturers supported by visiting tutors. Bernard Cohen introduced an Art History chair, MA, MFA and Doctoral programmes under his directorship. The Slade Centre for Electronic Media in Fine Art (SCEMFA) opened in 1995.

BUILDINGS AND GEOGRAPHY

The Slade is at the heart of UCL on the western edge of Bloomsbury, and students have been encouraged to engage with other departments such as Engineering, especially from the 1950s onwards; Hamilton's *Growth & Form* at the ICA in 1951 shared its title with the series of lectures given the biologist John Z. Young. Students also attended lectures in the Anatomy and Psychology Departments. In 1963 the Antique Room was dismantled. Postgraduates moved to the Pearson Building in 1975; in 1991 postgraduate painting moved around the corner to the former Courtauld Gallery on Woburn Square. Extensive renovations were carried out in the mid 1990s, when mezzanines controversially divided the painting studios, and the sculpture studios below ground were modernised. Structural alterations are an illuminating sign of departmental shifts: for instance, faculty meeting minutes of 8 November 1976 record the proposal to expand photography facilities by cutting into what were increasingly under-used models' bathrooms and shower areas.

STUDENT BODY AND PROFILE

James Hyman in *The Battle For Realism* (2001) characterised the early Slade as a patrician school, citing Frank Auerbach's view that it had 'many more upper-middle class students' than the RCA, and Paula Rego, who claimed 'The Royal College seemed plebeian compared to the Slade'. There was a distinctive administrative engagement with students: a staff/student committee began in 1968, and in 1973 there was a student demonstration complaining about the Slade's poor library resources. Stephen Chaplin's *Slade Archive Reader* (unpublished, 1998) identified a change around 1964, when 'Teaching changed from the easel-visit current from Poynter's time, to the group tutorial, or "crit" of the 1970s, where groups of students would discuss one of their number's work with staff'. By the 1970s the Slade's cerebral character led to debates about art's role in society featuring prominently in the school. The student population has been reasonably stable: for much of this period there have been around 200, evenly divided between undergraduate and postgraduate levels. The current population is approximately 140 undergraduate students and 120 postgraduates, the slight growth reflecting increased availability of space after the 1990s renovations. A notable change has been the cessation of part-time study; in the 1950s and 1960s part-time students were a substantial minority of the student population, but in the 1980s they were discontinued.

SELECTED FACULTY

William Coldstream significantly increased the number of visiting and assistant tutors during his period as Principal from 1949–75. In the early 1960s Claude Rogers and Andrew Forge both left. Alfred H. Gerrard was Professor of Sculpture 1949–68. Ian Tregarthen Jenkin was a support to Coldstream, and also retired in 1975. Lawrence Gowing took over as Slade Professor until 1985, to be succeeded briefly by Patrick George (who had been there from 1949, and notably ran the F studio where undergraduate students worked alongside postgraduates). Bernard Cohen was Slade Professor from 1988, then John Aiken took over, to be succeeded by Susan Collins. From 1959 Leopold Ettlinger was the Durning Lawrence chair of Art History, and oversaw its migration into a separate faculty in UCL in 1964. Euan Uglow, Norman Norris, Tess Jaray and David Hepher were among the more prominent tutors of the Painting Department.

BIOGRAPHIES, ACKNOWLEDGMENTS, CREDITS

ELENA CRIPPA is Curator, Modern and Contemporary British Art, Tate Britain. In 2013, she completed her PhD as an outcome of the Tate research project Art School Educated. Since then, her research on post-war British art has focused on the relationship between teaching and making in the art school and on artist-initiated exhibitions. Recent exhibitions and displays include: *Basic Design* (with Beth Williamson, Tate Britain, 2013, and Hatton Gallery, 2014) and *Frank Auerbach: Paintings and Drawings from the Lucian Freud Estate* (Tate Britain, 2014).

LUCY HOWARTH studied fine art at various art schools in the UK and abroad, before going on to complete a PhD in art history at the University of Plymouth in 2009. She has taught in both subject areas at undergraduate and postgraduate levels, with a particular interest in modernism in western art. She was a post-doctoral researcher on the Art School Educated research project 2010–2011. Her current work includes curating a display on Marlow Moss, which has toured from Tate St Ives to the Jerwood Gallery in Hastings, to the Leeds Art Gallery and to Tate Britain.

NIGEL LLEWELLYN was the Principal Investigator on the Art School Educated research project and recently stepped down as Head of the Research Department at Tate, which he established in 2007. Prior to that he taught history of art at the University of Sussex and worked for the AHRC. He was trained at UEA by John Onians and at the Warburg Institute by Michael Baxandall and E.H. Gombrich. He works on commemoration and the visual culture of the death ritual, on aspects of historiography and on early modern European art. He co-curated the *International Baroque* exhibition at the Victoria and Albert Museum in 2009.

ALEXANDER MASSOURAS combines art history with art practice. His work is in collections including the British Museum, the Victoria and Albert Museum, and the Rhode Island School of Design Museum. He read Law and then Art History at Cambridge, and wrote his PhD thesis about the concept of the 'emerging artist'. He undertook this research at the London Consortium as a member of the Art School Educated project. He was awarded a Paul Mellon Postdoctoral Fellowship in 2014, and is now a Leverhulme Early Career Fellow at Oxford University's Ruskin School of Art.

HESTER R. WESTLEY completed degrees at Cambridge and the Sorbonne Paris IV and a PhD at the Courtauld Institute of Art. She has held teaching positions at universities in both the United States and Great Britain, as well as a four-year post-doctoral research fellowship at Tate, where she co-curated a display on moments of rupture in traditional art pedagogy as a member of the Art School Educated research team. An oral historian, she interviews extensively for the National Life Stories' 'Artists' Lives' project at the British Library. She has published widely on post-war British sculpture and twentieth-century art education.

BETH WILLIAMSON's writing, research and curatorial projects focus on post-war British art and pedagogy. She has a PhD from the University of Essex (2009) and was a post-doctoral Research Fellow on the Art School Educated project and Co-Investigator for the AHRC research project 'Transforming Artist Books'. She has taught at undergraduate and postgraduate level and she co-curated the *Basic Design* display (with Crippa, 2013–14). Her book, *Between Art Practice and Psychoanalysis mid-Twentieth Century: Anton Ehrenzweig in Context* (2015) was supported by the Paul Mellon Centre for Studies in British Art, and her current research on William Johnstone is supported by the Barns-Graham Charitable Trust.

ACKNOWLEDGMENTS

There are many people to thank for their help and encouragement in the course of preparing this book. It is one result of Tate's Leverhulme Trust-funded research project, Art School Educated. I would, therefore, like to thank the Trust without whose support and encouragement the scholarship that lies behind these words would not have been possible. The project's Steering Committee – Rod Bugg, Christopher Frayling, Maryanne Stevens, Lisa Tickner gave us valuable advice over several years. At Tate, Victoria Walsh was instrumental in shaping the project and supporting its development. I would also like to acknowledge the skill and tenacity of all the members of the research team – Elena Crippa, Lucy Howarth, Alexander Massouras, Hester R. Westley and Beth Williamson – and of the support offered by the Tate Research Department in the form of Catherine Antoni, Helen Griffiths and Ailsa Roberts.

The contributions of staff and students, current and past, of the London art schools that are at the heart of our study have been instrumental in identifying important themes, moments of change, drama and crisis, key developments and significant shifts in approaches to teaching and learning. Further, several taught programmes offered at art schools outside London, such as Leeds, Leicester, Newcastle and Cardiff in the 1950s and 1960s, have had a lasting impact across Britain: the recollections of staff and students in those schools have been important too. Without all these people willing to share their memories this would be a very different book.

Two conferences at Tate Britain, in 2011 and 2014, and two panels at the Association of Art Historians annual conference, in 2011 and 2013, provided the research team with an important context for the development of our ideas: our thanks go to the speakers and delegates on all those occasions. Similarly, the teaching of an associated MA module at the University of York in 2011 and 2012 enabled our researchers to set out new research material and to develop their thinking about it. Our thanks are extended to staff at York and to the two cohorts of students, whose ideas, at times, challenged our findings and assessments.

Art School Educated also led to the presentation of collection displays at Tate Britain and elsewhere and these curatorial interventions allowed the research team to think differently about their material and to offer new perspectives. In this context, our thanks are extended to Penelope Curtis and Chris Stephens for selecting the displays and to Jennifer Powell for her curatorial support. Rarely can research be conducted without the assistance of library and archive professionals, curators, artists' estates, museums and other custodians of art, and Art School Educated was no exception to this rule. There are too many names in this category to list here but I thank them all for their assistance in navigating the archives, obtaining images and securing permissions for material under copyright. Every attempt has been made to obtain permission to reproduce copyright material but if the proper acknowledgment has not been made, copyright holders are invited to inform the publisher of the oversight and it will be corrected if at all possible.

Quite late in the day, Beth Williamson took on a heavy additional load of editorial duties, which she undertook to the highest professional standards: she deserves a special vote of thanks for her work from the whole research team. At Tate Publishing, Rebecca Fortey has earned the gratitude of the whole research team and of the editor especially for her enthusiasm and her professionalism and, most of all, for her patience.

Finally, the authors would like to extend special thanks to a number of individuals: Ken Adams, Parveen Adams, David Annesley, Paul Appleton, Leonard Bartle, Derek Boshier, Anna Bowman, Andrew Brighton, Kelly Chorpening, Eileen Cooper, David Peters Corbett, Cathy Courtney, Rita Donagh, Emily Down, Marta Edling, Erik Forrest, Teresa Gleadowe, Adrian Glew, Gustavo Grandal-Montero, Eileen Hogan, Mark Hudson, Bruce McLean, Lynda Morris, Judith Mottram, Andrea Phillips, Charlotte Podro, Prue Saunders, Jane de Sausmarez, Donald Smith, Fitz Smith, Frances Spalding, Lettie Tanner, Jon Thompson, Rebecca Ungpakorn, Judy

Willcocks, Austin Winkley, Richard Woodfield and Richard Yeomans. Acknowledging the support and help from so many individuals should not be taken as a signal that they will all agree with everything that we have written. The views expressed here are those of the authors, alone.

– Nigel Llewellyn

INDEX